Travellers' Tales

Narratives of home and displacement

Edited by George Robertson,
Melinda Mash, Lisa Tickner, Jon Bird,
Barry Curtis and Tim Putnam

ROUTLEDGE

London and New York

Funded by
THE
ARTS
COUNCIL
OF ENGLAND

First published 1994
by Routledge
11 New Fetter Lane, London EC4P 4EE

Simultaneously published in the USA and Canada
by Routledge
29 West 35th Street, New York, NY 10001

Editorial matter © 1994 George Robertson, Melinda Mash,
Lisa Tickner, Jon Bird, Barry Curtis, Tim Putnam

Individual contributions © 1994 individual contributors

Typeset in Times by Florencetype Ltd, Kewstoke, Avon

Printed and bound in Great Britain by Biddles Ltd,
Guildford

British Library Cataloguing in Publication Data
A catalogue record for this book is available from the
British Library

Library of Congress Cataloging in Publication Data
Travellers' tales : narratives of home and displacement /
[edited by] George Robertson . . . [et al.].
p. cm. – (Futures, new perspectives for cultural analysis)
Includes bibliographical references and index.
1. Intercultural communication. 2. Travel. 3. Ethnicity.
4. Culture conflict. 5. Travel in literature. I. Robertson,
George, 1950– . II. Series.
GN345.6.T73 1994
303.48′2–dc20 93–23698

ISBN 0–415–07015–5 (hbk)
ISBN 0–415–07016–3 (pbk)

Travellers' Tales

Travellers' Tales is the second of a series which brings together theorists from different disciplines to assess the implications of economic, political and social change for intellectual enquiry and cultural practice. The series arises from and continues the concerns of *BLOCK* (1979 to 1989), the journal of visual culture.

Most of us, at various moments in our lives, either adopt a tourist identity or are 'framed' within another's tourist experience. *Travellers' Tales* investigates the future for travelling in a world whose boundaries are shifting and dissolving. The contributors bring together popular and critical discourses of travel to explore questions of identity and politics; history and narration; collecting and representing other cultures.

Travellers' tales oscillate between the thrill of novel experiences and unexpected pleasures, and the alienation and loneliness of exile in a strange land. The contributions review recent work on the discourses of tourism, travel and cultural politics; the effects of global interactions and local resistances; and the ways in which records, memorials and signs have all been used to describe the experience of encountering the 'other'.

The editors – George Robertson, Melinda Mash, Lisa Tickner, Jon Bird, Barry Curtis and Tim Putnam – all lecture at Middlesex University.

The contributors: Sunpreet Arshi, Stephen Bann, Iain Chambers, Annie E. Coombes, Barry Curtis, Nélia Dias, Carmen Kirstein, Bracha Lichtenberg-Ettinger, Anne McClintock, Chantal Mouffe, Riaz Naqvi, Rob Nixon, Claire Pajaczkowska, Falk Pankow, Griselda Pollock, Jacques Rancière, Adrian Rifkin, Madan Sarup, Trinh T. Minh-ha, Peter Wollen.

FUTURES: New perspectives for cultural analysis

Edited by Jon Bird, Barry Curtis, Melinda Mash,
Tim Putnam, George Robertson and Lisa Tickner.

Recent postmodern philosophers have undermined the viability of social and cultural futures as an urgent priority for cultural theory. The 'Futures' series sets out to reinstate the discussion of the future in cultural enquiry through a critical engagement with postmodernity. Each volume will draw together new developments in a range of disciplines that have taken as their common focus some particular aspect of social transformation and cultural analysis.

In memory
Madan Sarup 1930–1993

Contents

Figures

Notes on contributors

Sunpreet Arshi teaches Communication Studies and Philosophy at the University of East London. He is a past editor of the *Magazine of Cultural Studies*. **Carmen Kirstein** and **Falk Pankow**, based at Humboldt University in East Berlin, are currently engaged in graduate research studies in Britain. **Riaz Naqvi** is a London solicitor who is currently researching the Black presence in England. As a group, they have been engaged in a joint project on travel and tourism.

Stephen Bann is Professor of Modern Cultural Studies at the University of Kent at Canterbury, where he has taught since 1967. His books include *The Clothing of Clio* (1984), *The True Vine* (1989) and *The Inventions of History* (1990). His book on John Bargrave, *Under The Sign*, is due for publication in 1994.

Jon Bird is Reader in the School of History and Theory of Visual Cultural Studies at Middlesex University. He is a founding editor of *BLOCK*, a co-editor (with Lisa Tickner) of a forthcoming art history series for Routledge, and has written extensively on contemporary art.

Iain Chambers teaches courses on contemporary British culture, cultural theory, and aesthetics at the Istituto Universitario Orientale, Naples. He is the author of *Urban Rhythms: Pop Music and Popular Culture* (1985), *Popular Culture: The Metropolitan Experience* (1986), *Border Dialogues: Journeys in Postmodernism* (1990) and *Migrancy, Culture, Identity* (1994).

Annie E. Coombes teaches History of Art and Cultural Studies at Birkbeck College, University of London. She is co-editor of *The Oxford Art Journal* and author of the forthcoming *Re-Inventing Africa: Museums, Material Culture and Popular Imagination in Late Victorian and Edwardian England*.

Barry Curtis is Head of the School of History and Theory of Visual Culture at Middlesex University. A founding editor of *BLOCK*, he is researching architectural and cultural theory in postwar Britain.

Nélia Dias is Assistant Professor at the Department of Social Anthropology, University of Lisbon. She is the author of *Le Musée d'Ethnographie du Trocadéro 1878–1908. Anthropologie et Muséologie en France* (Paris, 1991) and of articles on the history of French anthropology in the nineteenth century.

Bracha Lichtenberg-Ettinger is an artist and psychoanalyst born in Tel Aviv and working in Paris. She has held one-person exhibitions at The Museum of Modern Art (MOMA) in Oxford (1993); The Russian Museum (Ethnography, in St. Petersburg (1993); Le Nouveau Musée at Villeurbanne (1992); The Museum of Fine Arts, Calais (1988); and Centre Pompidou in Paris (1987). Her books and articles include: *Matrix et le Voyage à Jerusalem de C.B.*, Artist Book (1991); *Matrix. Halal(a) – Lapsus. Notes on Painting 1985–92* (1993); *Time is the Breath of the Spirit* (1993); *A Threshold Where We Are Afraid* (1993); 'Matrix and Metramorphosis' in *Differences* (1992); and 'Metramorphic borderlines and matrixial borderspace', in J. Welchman (ed.) *Rethinking Borders* (in press).

Melinda Mash teaches Women's Studies at Middlesex University.

Anne McClintock is an Associate Professor at Columbia University where she teaches Gender and Cultural Studies. She is the author of *Imperial Leather. Race, Gender and Sexuality in the Colonial Contest* (1994) and co-editor of *Out of Bonds: Postcolonialism and the New World Disorder*.

Chantal Mouffe is a political philosopher teaching at the Collège International de Philosophie in Paris. She is the author (with Ernesto Laclau) of *Hegemony and Socialist Strategy. Towards a Radical Democratic Politics* (1985). Her most recent work is *The Return of the Political* (1993).

Rob Nixon is an Associate Professor of English and Comparative Literature at Columbia University. He is the author of *London Calling: V.S. Naipaul, Post-colonial Mandarin* (1992) and *Homelands, Harlem and Hollywood. South African Culture and the World Beyond* (1994).

Claire Pajaczkowska is Senior Lecturer in the History and Theory of Visual Culture at Middlesex University.

Griselda Pollock is Professor of Social and Critical Histories of Art and Director of the Centre for Cultural Studies at the University of Leeds. Her most recent book is *Avant-Garde Gambits 1888–1893* (1992).

Tim Putnam is Reader in History of Material Culture at Middlesex University. He has co-written *The Industrial Heritage* (1991) with Judith Alfrey, and co-edited *Household Choices* (1990).

Jacques Rancière is Professor of Philosophy at the University of Paris VIII. His books include *The Rights of Labor* (1989), *Courts Voyages au Pays du Peuple* (1990) and *The Ignorant Schoolmaster: Five Essays in Intellectual Emancipation* (1991).

Adrian Rifkin is Professor of Fine Art at the University of Leeds. He has written extensively on French art and culture, most recently in *Street Noises, Parisian Pleasure 1900–1940* (1993).

George Robertson is part of the Scottish diaspora.

Madan Sarup was born in Simla, Punjab, and came to Britain at the age of 9. He was, for many years, a Lecturer in the Sociology of Education at London University. His publications include *Jacques Lacan* (1992) and *An Introductory Guide to Post-Structuralism and Postmodernism* (1993). He died in November 1993 as this book was going to press.

Lisa Tickner is Professor of Art History at Middlesex University. She is a founder-editor of *BLOCK*, a member of the editorial advisory board of *Women: A Cultural Review*, and co-editor (with Jon Bird) of a series of art history books in preparation for Routledge. She is author of numerous articles on art history and theory and of *The Spectacle of Women: Imagery of the Suffrage Campaign 1907–1914* (1988).

Trinh T. Minh-ha is an internationally acclaimed film-maker, and author of *Women, Native, Other: Writing Postcoloniality and Feminism* (1989), *When the Moon Waxes Red: Representation, Gender and Cultural Politics* (1991) and *Framer Framed* (1992). She is Visiting Professor at Harvard University and Professor of Women's Studies and Film at the University of California, Berkeley.

Peter Wollen is Professor of Film at the University of California, Los Angeles. He has directed independent films and curated a number of international art exhibitions. He is the author of *Signs and Meaning in the Cinema* (1969), *Readings and Writings* (1982) and *Raiding the Icebox* (1993).

Acknowledgements

This book originates like our first volume, *Mapping the Futures* (1993), with a conference at the Tate Gallery, London (*Travellers' Tales*, 1992). We are very grateful to the Tate Gallery for hosting it; to Richard Humphreys, Head of the Education Department, for his continuing support and collaboration; to Julie Gomez and Deborah Robinson for invaluable assistance; and above all to Sylvia Lahav for her extraordinary patience and powers of organization. We thank all our participants for a stimulating occasion and our contributors, in particular, for their work on this book.

We gratefully acknowledge the support of the Visual Arts Department of the Arts Council of Great Britain, and of many colleagues at Middlesex University including in particular John Lansdown, Dean of the Faculty of Art and Design, and Penny Chesterman, Departmental Secretary. A tip of the topee must go to Aurelio Campa for his help in guiding us through the jungles of DOS, and to Françoise Pajaczkowska for last-minute assistance with the translation of Chantal Mouffe. We would also like to thank Elaine Chang for giving us permission to use an extended extract from her essay, 'A not-so-new spelling of my name'; Hélène Hourmat for permission to reproduce her work; and Aki Yamamoto for the cover photograph. At Routledge we owe much to Rebecca Barden and Virginia Myers for their advice, encouragement and unfailing good humour. We are also very grateful to our copy editor, Sandra Jones, for her patience, thoroughness and eagle-eyes.

Finally, four of us are very much indebted to the other two: George Robertson and Melinda Mash bore the brunt of the editing process, one way and another, with remarkable forbearance. We offer them our special thanks.

As the world turns: introduction

'And just how far would you like to go in?' he asked and the three kings all looked at each other. 'Not too far but just far enough so's we can say that we've been there.'[1]

The process of editing is one of selection, ordering and construction – in effect, of narration – composing a tale for the reader to travel through. The introduction becomes a route-map (tracing the most efficient course), or a tour guide (pointing out significant sights and sites). But the tidy helpfulness of an introduction as metanarrative, or map, threatens to undermine our project. There is no single route through the conflicts and ambiguities attending a range of explosive futures for the relations between travel, community, identity and difference. Perhaps the ideal form would be a collection of postcards home, from which the reader would create his or her own preferred itinerary but, given the structure of books, there has to be a beginning, a middle and an end. So the 'foreword' is offered here in the spirit of holiday snaps or a guidebook read when the journey is over, as an *aide mémoire*, and for the pleasures of musing rather than mapping. Trinh Minh-ha's chapter serves as a prologue – charting the territories through which the following essays move, outlining possible boundaries, and proposing routes through the modern flux of shifting and sometimes violently abrading identities – and Iain Chambers gives us our epilogue, revisiting themes from the essays in between, acknowledging both the continuing power of historical narratives and the ultimate impossibility of final destination and closure.

Any atlas index resonates now with images of violent displacement: Bosnia, Cambodia, Ethiopia, Kurdistan, Los Angeles, Mozambique, Palestine, Romania, Rostock, Somalia . . . the world witnesses what is probably the largest ever movement and migration of peoples dispossessed by war, drought, 'ethnic cleansing' and economic instability. A conference at the Tate Gallery in 1992 and a few thousand readers of this book

contemplating 'narratives of home and displacement' from their armchairs might seem irrelevant to this global drama of violence and misery. We hope nevertheless that on its own territory this book can be seen as a positive attempt to unravel the meanings and desires located in *ideas* of self, home, nation, travel and encounter.

A minimal definition of travel would involve a movement from one place to another – between geographical locations or cultural experiences – but we can expand this common-sense definition to look at how movement functions psychically and metaphorically. Several of our contributors argue that identity is founded on imaginary trajectories of here and there, I and not-I, and hence on metaphors of movement and place. Metaphor as a linguistic operation is itself a displacement producing new figurations (the Greek *metaphora* means both 'metaphor' and 'transport' or 'movement'). The transformations that mark the movement from one space to another have their micro- as well as their macro-level: as Jacques Rancière puts it, 'the slight move which shapes the mapping of a *there* to a *here*' is at the same time 'the narrow and vertiginous gap which separates the inside . . . from the outside'. The travelling narrative is always a narrative of space and difference. It may not always broaden the mind but it prods at it. It provokes new concepts, new ways of seeing and being, or at the very least, when the old ways of seeing and being have been stubbornly imported into foreign territory, subjects them to strain and fatigue.

One of the founding travellers' tales of Western culture is that of the movement of the people of Israel through the desert and out of it. For Bracha Lichtenberg-Ettinger such tales are to be understood as analogous to psychological transformations, aesthetic experiences and patterns of cognition. Therein lies their power and their analytic fruitfulness, and both Lichtenberg-Ettinger and Rancière invoke 'the desert' as a space of indeterminacy where there is no 'here' or 'there'. In our last collection, Dick Hebdige pointed to the way in which the desert metaphor in postmodernist rhetoric functions 'as a place of origins, endings and hard truths: the place at the end of the world where all meanings and values blow away; the place without landmarks that can never be mapped; the place where nothing grows and nobody stays put'. He contrasted this with 'precise indigenous knowledges about particular wilderness ecologies':[2] for those familiar with any particular desert, 'desert' just isn't the metaphorically freighted term it is for the rest of us.

The point is taken, but Lichtenberg-Ettinger's focus is precisely upon this recurrent representation of the desert as 'a no-place fit for an emptying of identity', and on the process by which the Hebrew narrative of what happens in the desert (and who God is) reduces in translation such that 'difference' and 'becoming' are transposed to 'presence' and 'the present'. She goes on to argue that this parallels the foreclusion

of a feminine dimension of subjectivity she calls the *Matrix* ('multiple and/or partial strata of subjectivity . . . in which the *non-I* is not an intruder').

Griselda Pollock's 'Territories of desire' moves from a feminist account of the triangulation between Gauguin and his Danish and Tahitian wives, via the story of the Book of Ruth, to an autobiographical narrative of a South African child with divided attachments to a white mother and an African nanny. In each instance she seeks to 'disorder the standard narratives' of displacement and exile by focusing on 'woman-to-woman' relations in which – as with Lichtenberg-Ettinger – we glimpse alternative, repressed configurations of otherness, identity and desire. Repressed configurations are brought into consciousness, into contact with the other-than-phantasmatic world, through communication in language, and particularly in metaphor. Metaphor can be a process in which material realities are veiled in literariness; but it is also – as Hebdige has reminded us – a powerful impulse to new ways of thinking with the potential to create

> a focus for collective as well as personal identification in an always unfinished narrative of historical loss and redemption . . . a virtual space – blank, colourless, shapeless, a space to be made over, a space where everything is still to be won.[3]

Loss, redemption and 'a space to be made over' lie at the heart of several essays in this volume. In Part II of the book, 'Home and Away', three kinds of travellers' tales are explored: the migrant's tale, the exile's tale and the nomad's tale. Griselda Pollock illustrates the 'becoming' of self-hood in autobiographical encounters with the Other, in which an 'under-developed' identity acquires definition but is always a provisional 'rough proof'. A similar story, differently framed, emerges in Madan Sarup's extended meditation on the nature of 'home' – as that from which we are constantly displaced, but which we try constantly to re-place. The migrant, journeying from 'there' to 'here', becomes a stranger in a strange land. In Rob Nixon's study – an even more poignant tale of displacement, where exile is forcibly imposed – the dream of home and eventual return is shattered at the longed-for moment of re-entry. The homeland that was left, forever lost, survives only in traces and memories, but the returned exile becomes a Janus-faced 'translated person', a migrant with a cross-border hybrid identity and, in this instance, a particular cultural 'voice'. In his fascinating book, *The Road to Botany Bay*, Paul Carter records the '*spatial* fantasies' of the early transported convicts in Australia. The stories, tales, myths and dreams they recounted, he argues, 'represented strategies for constructing a believable place – a place in which to speak and, no less important, a place from which to escape'.[4] Many of the narratives in this volume conform to this pattern: they are imaginative

constructions that offer up the hope and possibility of a better – or at least a *different* – place in which new homes and identities can be forged.

Other stories, meanwhile – fuelled by more sinister concepts of national identity, culture and home – precipitate whole peoples (if they avoid a local and more bloody fate) into the trauma of involuntary exile. The dissolution of the old binaries of Western and Eastern Europe, 'capitalism' and 'communism' conventionally understood, has, as Chantal Mouffe points out, produced a formidable challenge to democracy in the West and the East: in the East, because the old unity has evaporated in the wake of a multiplication of warring identities (ethnic, regional and religious), and in the West, because Western democracy has been destabilized by the loss of the enemy it defined itself against. Mouffe argues that liberal thought is powerless in the face of antagonism, but must come to terms with it; the crucial question is not how to arrive at a consensus without exclusion, or at an 'us' without a corresponding 'them', but how to locate and productively manage antagonism, by seeing the 'other' not as an enemy to be destroyed but as a counterpart who might be in our place. At this point, and despite its different focus and tone, Mouffe's essay begins to broach some of the same concerns as Lichtenberg-Ettinger's: she is alert to the political dangers of presuming a fully rational, liberal subject just as Lichtenberg-Ettinger is alert to the social potential of her psychoanalytic model of 'matrixial' relations.

These stories are rooted in the past: they are embedded in historical tales of exploration, empire or nation. The nomadic narratives of the present flow from the expansionist mythologies of yesterday. One instance of this is figured in Anne McClintock's study of the relations of power and desire in the imperial narratives of nineteenth-century Britain. She looks specifically at how soap advertisements sought to legitimize racist conceptions of the Other, by fetishizing cleanliness and 'whiteness' and exporting 'civilized' forms of commodity fetishism to the 'dark continent'. Back in the imperial 'homeland' this process leads to a transformation of the Victorian middle-class home into 'a space for the display of imperial spectacle and the reinvention of race', where Africans 'are figured, not as historic agents, but as frames for the commodity, for their *exhibition* value alone.' This mirrors the spectacularization of the Other addressed by Stephen Bann and Nélia Dias: *how* the West appropriates, categorizes and displays its 'Others' – a story of everyday activities in the anthropological and museological fields – is a matter of knowledge and power as well as narration. Local values and linear time determine our attitude to those who 'stay put'. They are over there. We are over here *and* over there. They are simply being. We are being *and becoming*. Frozen in our objectifying gaze, 'they' are at once the record of our journey and the benchmark of Western progress. Bringing it all back home is nevertheless a dialectical move-ment. The home we return to is never the home we left, and the

baggage we bring back with us will – eventually – alter it forever. The assemblage of memories, images, tastes and objects that clings to our return will mark the place of that return. Travel is corrosive. Bann's 'Frenchman's finger' is never a relic or talisman only, but always a pointer in new directions.

New directions, adequate to the interplay and representation of different cultures, feature prominently in contemporary debates in the fields of museology and curatorship. Annie Coombes argues – in the context of a discussion of 'hybridity' and what Peter Wollen calls 'creolization' – that we must take care to avoid reading the products of (specifically located) material cultures 'over there' through our own particular Western templates. Behind both Coombes's and Wollen's essays lies the memory of the *Magiciens de la Terre* exhibition at the Pompidou Centre in 1989, one of the few – if controversial – examples in recent years of an attempt to recognize the plurality of the local within an expanded definition of global artistic activity. The universalizing categories that guided the curators in their selections were inevitably construed as the imposition of a Western aesthetic sensibility on the difference of other cultural histories. However, many of the works displayed by artists – or perhaps we should say agents – marginal to the circuits of the international art market seemed more powerfully expressive and significant than anything from the historical centres. Wollen – in his call for an almost utopian cosmopolitanism – suggests a way out of the impasse, urging us towards the pluralities of denationalized cultures as an alternative to the core–periphery model of global cultural relations. His chapter invokes the figure of Anacharsis Cloots as the embodiment of a revolutionary cosmopolitanism and the emblem of a culture at once unified and heterogeneous: a decentred international culture of 'dis-patriation'.

In the wake of this exchange of cultures and objects, people follow, and we arrive eventually at that most profoundly privileged and subjective form of modern travel – tourism. 'Travel' is cognate with 'travail' (both descend from the medieval Latin *trepalium*, a three-pronged instrument of torture), and tourism may be in its own indulgent way one of the more tortuous forms of travel we undertake. Barry Curtis and Claire Pajaczkowska consider tourism as one of the principal symbolic experiences available to the modern self. The imperative to travel signifies the quest for the acquisition of knowledge and a desire to return to a utopian space of freedom, abundance and transparency. Psychic desires are displaced in partial and vicarious participation in another set of relations (another place and time), and the self becomes realized as the hero of its own narrative of departure and return. Both Adrian Rifkin, and Sunpreet Arshi, Carmen Kirstein, Riaz Naqvi and Falk Pankow, consider in this context that pivotal study of travel, Claude Lévi-Strauss's *Tristes Tropiques*. Rifkin's tour is through the transmutations of ethnographic study and travellers' tales into

fictional explorations of the Western city as the crucible of the modern self. Arshi, Kirstein, Naqvi and Pankow offer a critical reading of the entropic crises in the work of Lévi-Strauss and compare his self-referential narrative with another key text in travel theory, Mary Louise Pratt's recent *Imperial Eyes*. It may be that in the move from travel to mass-tourism, travel writing – which writes around and to one side of it, as though it doesn't exist – may lose itself and its subjects. The rhetorical trap awaiting the unwitting writer of ethnographic, anthropological and documentary narratives is the unuttered assumption that 'we' are travellers while 'they' are merely tourists. Tourism may be the limit case for not only travel writing but also pleasurable travel itself. In the end both Rifkin and Arshi *et al.* pose the troubling question: 'why bother?'

Perhaps, then, the thing to do is not to tour but to detour or *detourn*; as Roland Barthes put it in another context, 'to change the object itself, to produce a new object [and] point of departure'.[5] If one 'detourned' motif, one transformed and hybrid object, one new point of departure, pervades this collection it is Elaine Chang's 'blue frog', as recounted by Trinh Minh-ha. The blue frog slips through the textual undergrowth, a no less impassioned and resonant object when we recognize its origins in mis-recognition and mis-translation. Its affective charge is not diminished under the knowing gaze of rational inquiry. Like the 'marvels and wonders' sought for by early explorers and travellers, it speaks to an impossible search for discovery and completion conducted with all the baggage of the place from which we have come. Life is a journey, even for the stay-at-homes, and we are all exiles whose return is always deferred.

NOTES

1 Bob Dylan, 'Three Kings' (sleeve notes), *John Wesley Harding* LP, CBS Records, 1968.
2 Dick Hebdige, 'Training some thoughts on the future' in Jon Bird *et al.* (eds) *Mapping the Futures*, London, Routledge, 1993, p. 275.
3 Ibid., p. 278.
4 Paul Carter, *The Road to Botany Bay: An Essay in Spatial History*, London, Faber, 1987, p. 296.
5 Roland Barthes, 'Change the object itself' in *Image. Music. Text*, London, Fontana, 1977, p. 169.

Forwards

Chapter 1

Other than myself/my other self

Trinh T. Minh-ha

Every voyage can be said to involve a re-siting of boundaries. The travelling self is here both the self that moves physically from one place to another, following 'public routes and beaten tracks' within a mapped movement, and the self that embarks on an undetermined journeying practice, having constantly to negotiate between home and abroad, native culture and adopted culture, or more creatively speaking, between a here, a there, *and* an elsewhere.

TRAVELLING TALES

> A public place around a train station. In Marrakesh. In Fez. In a city of words, told by a husky voice. In a body full of sentences, proverbs, and noises. There, a story is born. This body is a fountain. Water is an image. The source travels. A crowd of children and women wait in line in front of the well. Water is scarce. Stories heap up at the bottom of the well. . . .
>
> These images land in disorder. They reach me from afar and speak to me in my mother tongue, an Arabic dialect riddled with symbols. This language which one speaks but does not write is the warm fabric of my memory. It shelters and nourishes me.
>
> Can it withstand the travel, the shifts, the extreme mobility in the new clothes of an old foreign language? Out of modesty, it retains its secrets and only rarely does it give itself in. It is not it that travels. It is I who carry a few fragments of it.[1]

The source moves about; it travels. Tahar Ben Jelloun's fountain-body unfolds through movements of words, images of water, sensations of mother-memory, and sounds of travelling fictions. These come in disorder, he wrote, doubting that Mother's language at home – or Language – will ever be able to withstand the mobility of the journey. Never quite giving itself in, however, Language remains this inexhaustible reservoir

from which noises, proverbs and stories continue to flow when water is scarce. Thus, it is not 'It' that travels. It is 'I' who carries here and there a few fragments of It. In this cascade of words, where and which is the source finally? I or It? For memory and language are places both of sameness and otherness, dwelling and travelling. Here, Language is the site of return, the warm fabric of a memory, and the insisting call from afar, back home. But here also, there, and everywhere, language is a site of change, an evershifting ground. It is constituted, to borrow a wise man's words, as an 'infinitely interfertile family of species spreading or mysteriously declining over time, shamelessly and endlessly hybridizing, changing its own rules as it goes.'[2]

It is often said that writers of color, including anglophone and francophone Third World writers of the diaspora, are condemned to write only autobiographical works. Living in a double exile – far from the native land and far from their mother tongue – they are thought to write by memory and to depend to a large extent on hearsay. Directing their look toward a long bygone reality, they supposedly excel in reanimating the ashes of childhood and of the country of origin. The autobiography can thus be said to be an abode in which the writers mentioned necessarily take refuge. But to preserve this abode, they would have to open it up and pass it on. For, not every detail of their individual lives bears recounting in such an 'autobiography', and what they chose to recount no longer belongs to them as individuals. Writing from a representative space that is always politically marked (as 'coloured' or as 'Third World'), they do not so much remember for themselves as they remember in order to tell. When they open the doors of the abode and step out of it, they have, in a sense, freed themselves again from 'home'. They become a passage, start the travel anew, and pull themselves at once closer and further away from it by telling stories.

A shameless hybrid: I or It? Speaker or Language? Is it language which produces me, or I who produce language? In other words, when is the source 'here' and when is it 'there'? Rather than merely enclosing the above writers in a place recollected from the past, the autobiographical abode propels them forward to places of the present – foreign territories, or the lands of their adopted words and images. 'The writer writes so that he no longer has a face,' T.B. Jelloun remarked:

> One relapses into memory as one relapses into childhood, with defeat and damage. Even if it were only to prevent such a fall, the writer sees to it that he is in a layer of 'future memory', where he lifts and displaces the stones of time.[3]

Journeying across generations and cultures, tale-telling excels in its powers of adaptation and germination; while with exile and migration, travelling expanded in time and space becomes dizzyingly complex in its repercussive effects. Both are subject to the hazards of displacement,

interaction and translation. Both, however, have the potential to widen the horizon of one's imagination and to shift the frontiers of reality and fantasy, or of Here and There. Both contribute to questioning the limits set on what is known as 'common' and 'ordinary' in daily existence, offering thereby the possibility of an elsewhere-within-here, or -there.

An African proverb says, 'A thing is always itself and more than itself.' Tale-telling brings the impossible within reach. With it, I am who It is, whom I am seen to be, yet I can only feel myself there where I am not, *vis-à-vis* an elsewhere I do not dwell in. The tale, which belongs to all countries, is a site where the extraordinary takes shape from the reality of daily life. Of all literary genres, it is the one to circulate the most, and its extreme mobility has been valued both for its local specificity and for its capacity to speak across cultural and ethnic boundaries. To depart from one's own language of origin, to be able to acknowledge that 'the source moves about', to fare like a foreigner in this language, and to return to it via its travelling fragments, is also to learn how to be silent and to speak again, differently. T.B. Jelloun opens, for example, his well-known tale of Moha the Fool, Moha the Sage (*Moha le fou, Moha le sage*) with an epigraph which reminds the reader of the political death of a man and goes on to affirm: 'It doesn't matter what the official declarations say. A man has been tortured. To resist the pain, to overcome the suffering, he resorted to a strategy: to recollect the most beautiful remembrances of his short life.'[4] And on this statement unfolds the telling of the man, as captured and transmitted by Moha, or as written by Jelloun himself.

A STRANGER IN A STRANGE COUNTRY

'He's a stranger,' Louise said joyfully. 'I always thought so – he'll never really fit in here.'

'How long are you going to keep me prisoner?' he asked.

'Prisoner?' answered the director, frowning. 'Why do you say prisoner? The Home isn't a jail. You weren't allowed to go out for several days for reasons of hygiene, but now you're free to go wherever you like in the city.'

'Excuse me,' said Akim, 'I meant to say: when can I leave the Home?'

'Later,' said the director, annoyed, 'later. And besides, Alexander Akim, that depends on you. When you no longer feel like a stranger, then there will be no problem in becoming a stranger again.'[5]

Much has been written on the achievements of exile as an artistic vocation, but as a travelling voice from Palestine puts it, exile on the twentieth-century scale and in the present age of mass immigration, refugeeism, and displacement 'is neither aesthetically nor humanistically comprehensible'. This 'irremediably secular and unbearably historical'

phenomenom of untimely massive wandering remains 'strangely compell-
ing to think about but terrible to experience' (Edward Said).[6] For people
who have been dispossessed and forced to leave for an uncertain destiny,
rejected time and again, returned to the sea or to the no man's land of
border zones; for these unwanted expatriated, it seems that all attempts at
exalting the achievements of exile are but desperate efforts to quell the
crippling sorrow of homelessness and estrangement. The process of rehabi-
litation, which involves the search for a new home, appears to be above all
a process by which people stunned, traumatized and mutilated by the shifts
of event that have expelled them from their homelands learn to adjust to
their sudden state of isolation and uprootedness.

Refugeeism, for example, may be said to be produced by political and
economic conditions that make continued residence intolerable. The irre-
versible sense of 'losing ground' and losing contact is, however, often
suppressed by the immediate urge to 'settle in' or to assimilate in order to
overcome the humiliation of bearing the too-many-too-needy status of the
homeless-stateless alien. The problem that prevails then is to be accepted
rather than to accept. 'We are grateful. We do not want to be a nuisance',
said a Vietnamese male refugee in Australia who, while feeling indebted to
his host country, believes that only in Vietnam can a Vietnamese live
happily.[7] Or else, 'We are a disturbance. That's the word. Because we
show you in a terrible way how fragile the world we live in is . . . You didn't
know this in your skin, in your life, in every second of your life', said a less
grateful Cambodian woman refugee in France who considers Paris to be, in
the racial distances it maintains, 'a city of loneliness and ghosts'.[8]

Intensely connected with the history and the politics that have erupted to
displace them, refugees are unwanted persons whose story has been an
embarrassment for everyone, as it 'exposes power politics in its most
primitive form . . . the ruthlessness of major powers, the brutality of
nation states, the avarice and prejudice of people'.[9] Dispossessed not only
of their material belongings but also of their social heritage, refugees lead a
provisional life, drifting from camp to camp, disturbing local people's
habits, and destabilizing the latter's lifestyle when they move into a neigh-
borhood. However they are relocated, they are a burden on the commu-
nity. On the one hand, migrant settlements can turn out to be 'centres of
hopelessness' which soon become 'centres of discontent'. On the other
hand, both those who succeed in resettling are blamed for usurping the
work from someone else, and those who fail to secure happiness in their
adopted lands are accused of being ungrateful, worsening thereby a situ-
ation in which exclusionary policies have been advocated on the ground
that the rich host nations will soon be put in 'the poorhouse' by the flood of
refugees – because 'they multiply'.[10]

Great generosity and extreme gratitude within sharp hostility; profound
disturbance for both newcomers and oldtimers: the experience of exile is

never simply binary. If it's hard to be a stranger, it is even more so to stop being one. 'Exile is neither psychological nor ontological', wrote Maurice Blanchot: 'The exile cannot accomodate himself to his condition, nor to renouncing it, nor to turning exile into a mode of residence. The immigrant is tempted to naturalize himself, through marriage for example, but he continues to be a migrant.'[11] The one named 'stranger' will never really fit in, so it is said, joyfully. To be named and classified is to gain better acceptance, even when it is question of fitting in a no-fit-in category. The feeling of imprisonment denotes here a mere subjection to strangeness as confinement. But the Home, as it is repeatedly reminded, is not a jail. It is a place where one is compelled to find stability and happiness. One is made to understand that if one has been temporarily kept within specific boundaries, it is mainly for one's own good. Foreignness is acceptable once I no longer draw the line between myself and the others. First assimilate, then be different within permitted boundaries: 'When you no longer feel like a stranger, then there will be no problem in becoming a stranger again.' As you come to love your new home, it is thus implied, you will immediately be sent back to your old home (the authorized and pre-marked ethnic, gender or sexual identity) where you are bound to undergo again another form of estrangement. Or else, if such a statement is to be read in its enabling potential, then, unlearning strangeness as confinement becomes a way of assuming anew the predicament of deterritorialization: it is both I and It that travel; the home is here, there, wherever one is led to in one's movement.

WANDERERS ACROSS LANGUAGE

Our present age is one of exile. How can one avoid sinking into the mire of common sense, if not by becoming a stranger to one's own country, language, sex and identity? Writing is impossible without some kind of exile. Exile is already in itself a form of *dissidence* . . . a way of surviving in the face of the *dead father*. . . . A woman is trapped within the frontiers of her body and even of her species, and consequently always feels exiled both by the general clichés that make up a common consensus and by the very powers of generalization intrinsic to language. This female in exile in relation to the General and to Meaning is such that a woman is always singular, to the point where she comes to represent the singularity of the singular – the fragmentation, the drive, the unnameable.[12]

Perhaps, 'a person of the twentieth century can exist honestly only as a foreigner',[13] suggests Julia Kristeva. Supposedly a haven for the persecuted and the homeless, Paris – which has offered itself to many stateless wanderers as a second home ever since the late nineteenth century – is

itself a city whose houses, as Walter Benjamin described them, 'do not seem made to be lived in, but are like stones set for people to walk between'.[14] The city owes its liveliness to the movements of life that unfold in the streets. Here – by choice or by necessity – pedestrians, passers-by, visitors, people in transit can all be said to 'dwell' in passageways, strolling through them, spending their time and carrying most of their activities outside the houses, in the intervals of the stoneworks. Such a view of Paris would contribute to offsetting the notion of home and dwelling as a place and a practice of fixation and sameness. For after all, where does dwelling stop? In a built environment where outside walls line the streets like inside walls, and where the homey enclosures are so walled off, so protected against the outside that they appear paradoxically set only 'for people to walk between', outsiders have merely brought with them one form of outsideness: that very form which others, who call themselves insiders, do not – out of habit – recognize as their own insideness.

'Modern Western culture', remarks Said, 'is in large part the work of exiles, émigrés, refugees.'[15] If it seems obvious that the history of migration is one of instability, fluctuation and discontinuity, it seems also clear for many Third World members of the diaspora that their sense of group solidarity, of ethnic and national identity, has been nourished in the milieux of the immigrant, the refugee and the exiled. Here, identity is a product of articulation. It lies at the intersection of dwelling and travelling and is a claim of continuity within discontinuity (and vice-versa). A politics rather than an inherited marking, its articulation and rearticulation grows out of the very tension raised between these two constructs: one based on socio-cultural determinants; the other, on biological ones. The need to revive a language and a culture (or to reconstitute a nation out of exile as in the case of the Palestinian struggle) thus develops *with* the radical refusal to indulge in exile as a redemptive motif, and to feel uncritically 'at home in one's own home', whether this home is over there or over here. Such a stance goes far beyond any simplistic positive assertions of ethnic or sexual identity, and it is in this difficult context of investigation of self that, rather than constituting a privilege, exile and other forms of migration can become 'an *alternative* to the mass institutions that dominate modern life'.[16]

Home and language tend to be taken for granted; like Mother or Woman, they are often naturalized and homogenized. The source becomes then an illusory secure and fixed place, invoked as a natural state of things untainted by any process or outside influence (by 'theory' for example), or else, as an indisputable point of reference on whose authority one can unfailingly rely. Yet, language can only live on and renew itself by hybridizing shamelessly and changing its own rules as it migrates in time and space. Home for the exile and the migrant can hardly be more than a transitional or circumstantial place, since the 'original' home cannot be

recaptured, nor can its presence/absence be entirely banished in the 're-made' home. Thus, figuratively but also literally speaking, travelling back and forth between home and abroad becomes a mode of dwelling. Every movement between here and there bears with it a movement within a here and a movement within a there. In other words, the *return* is also a journey into the layer of '*future* memory' (Jelloun). The to-and-fro motion between the source and the activity of life is a motion within the source itself, which makes all activities of life possible. As regards Mother and Woman, she remains representatively singular (on His terms) – despite the very visible power of generalization implied in the capital M and W used here. For, unless economical necessity forces her to leave the home on a daily basis, she is likely to be restrained in her mobility – a transcultural, class- and gender-specific practice that for centuries has not only made travelling quasi impossible for women, but has also compelled every 'travelling' female creature to become a stranger to her own family, society and gender.

It is said that when Florence Edenshaw, a contemporary Haida elder, was asked 'What can I do for self-respect?' by a woman anthropologist who interviewed her and on whom Edenshaw's dignity made a strong impression, Edenshaw replied: 'Dress up and stay home'. Home seems to take on a peculiarly ambiguous resonance; so does the juxtaposition of 'dress' and 'stay'. One interpretation suggests that such a statement reflects the quiet dignity of members of non-state societies who rarely travel for the sake of some private quest, and deliberately risk themselves only when it is question of the whole community's interest. Home then is as large as one makes it.[17] The profound respect for others starts with respect for oneself, as every individual carries the society within her. Read, however, against the background of what has been said earlier on Mother and Woman, Edenshaw's answer can also partake in the natura-lized image of women as guardians of tradition, keepers of home, and bearers of Language. The statement speaks of/to their lack of mobility in a male economy of movement. Women are trapped (as quoted) within the frontiers of their bodies and their species, and the general cliché by which they feel exiled here is the common consensus (in patriarchal societies) that streets and public places belong to men. Women are not supposed to circulate freely in these male domains, especially after dark (the time propitious to desire, 'the drive, the unameable' and the un-known), for should anything happen to them to violate their physical well-being, they are immediately said to have 'asked for it' as they have singularly 'exposed' themselves by turning away from the Father's refuge. Yet, Edenshaw's statement remains multi-levelled. It ultimately opens the door to a notion of self and home that invites the outside in, implies expansion through retreat, and is no more a movement inward than a movement outward, towards others. The stationariness conveyed in 'stay

home' appears artificial – no more than a verbal limit – as 'stay' also means 'reach out'.

For a number of writers in exile, the true home is to be found not in houses, but in writing. Such a perception may at first reading appear to contradict Kristeva's affirmation that 'writing is impossible without some kind of exile'. But, home has proven to be both a place of confinement and an inexhaustible reservoir from which one can expand. And exile, despite its profound sadness, can be worked through as an experience of crossing boundaries and charting new ground in defiance of newly authorized or old canonical enclosures – 'a way of surviving in the face of the *dead father*'. Critical dissatisfaction has brought about a stretching of frontiers; home and exile in this context become as inseparable from each other as writing is from language. Writers who, in writing, open to research the space of language rather than reduce language to a mere instrument in the service of reason or feelings, are bound like the migrant to wander from country to country. They are said to be always lost to themselves, to belong to the foreign, and to be deprived of a true abode since, by their own passionate engagement with the tools that define their activities, they disturb the classical economy of language and representation, and can never be content with any stability of presence. Nothing remains unmoved; everything safe and sound is bound to sink somewhere in the process.

THEIR COUNTRY IS MY COUNTRY

Love, miss and grieve. This I can't simply deny. But I am a stranger to myself and a stranger now in a strange land. There is no arcane territory to return to. For I am no more an 'overseas' person in their land than in my own. Sometimes I see my country people as complete strangers. But their country is my country. In the adopted country, however, I can't go on being an exile or an immigrant either. It's not a tenable place to be. I feel at once more in it and out of it. Out of the named exiled, migrant, hyphenated, split self. The margin of the center. The Asian in America. The fragment of Woman. The Third within the Second. Here too, Their country is My country. The source continues to travel. The predicament of crossing boundaries cannot be merely rejected or accepted. Again, if it is problematic to be a stranger, it is even more so to stop being one. Colonized and marginalized people are socialized to always see more than their own points of view, and as Said phrases it, 'the essential privilege of exile is to have, not just one set of eyes but half a dozen, each of them corresponding to the places you have been. . . . There is always a kind of doubleness to that experience, and the more places you have been the more displacements you've gone through, as every exile does. As every situation is a new one, you start out each day anew.'[18]

Despite the seemingly repetitive character of its theme and variations, the tale of hyphenated reality continues its hybridizing process. It mutates in the repercussive course of its reproduction as it multiplies and displaces itself from one context to another. It is, in other words, always transient. But transience is precisely what gives the tale its poignancy. Having grown despite heavy odds in places where it was not meant to survive, this poetry of marginalized people not only thrives on, but also persists in holding its ground (no matter how fragile this ground proves to be) and sometimes even succeeds in blooming wildly, remarkable in its strange beauty and fabulous irregularity. Some familiar stories of 'mixed blessings' in America continue to be the following:

So, here we are now, translated and invented skins, separated and severed like dandelions from the sacred and caught alive in words in the cities. We are aliens in our own traditions; the white man has settled with his estranged words right in the middle of our sacred past.

(Gerald Vizenor)

I could tell you how hard it is to hide right in the midst of White people. It is an Art learned early because Life depends on dissimulation and harmlessness. To turn into a stone in the midst of snakes one pays a price.

(Jack Forbes)

Our people are internal exiles. To affirm that as a valid experience, when all other things are working against it, is a political act. That's the time when we stop being Mexican Americans and start being Chicanos.

(Judy Baca)

There is no doubt in my mind that the Asian American is on the doorstep of extincton. There's so much out-marriage now that all that is going to survive are the stereotypes. White culture has not ackowledged Asian American art. Either you're foreign in this country, or you're an honorary white.

(Frank Chin)

Sometimes/ I want to forget it all/this curse called identity/ I want to be far out/ paint dreams in strange colors/ write crazy poetry/ only the chosen can understand/ But it's not so simple/ I still drink tea/ with both hands.

(Nancy Hom)

If you're in coalition and you're comfortable, then it is not a broad enough coalition.

(Bernice Johnson Reagon)

The possibilities of meaning in 'I' are endless, vast, and varied because

self-definition is a variable with at least five billion different forms . . .
the I is one of the most particular, most unitary symbols, and yet it is
one of the most general, most universal as well.

(Cornelia Candelaria)

I've avoided calling myself 'Indian' most of my life, even when I have
felt that identification most strongly, even when people have called me
an 'Indian'. Unlike my grandfather, I have never seen that name as an
insult, but there is another term I like to use. I heard it first in Lakota
and it refers to a person of mixed blood, a metis. In English it becomes
'Translator's Son'. It is not an insult, like half-breed. It means that you
are able to understand the language of both sides, to help them under-
stand each other.[19]

(Joseph Bruchac)

Translators' sons and daughters, or more redundantly, translators' trans-
lators. The source keeps on shifting. It is It that travels. It is also I who
carry a few fragments of it. Translations mark the continuation of the
original culture's life. As has been repeatedly proven, the hallmark of bad
translation is to be found in the inability to go beyond the mere imparting
of information or the transmittal of subject matter. To strive for likeness to
the original – which is ultimately an impossible task – is to forget that for
something to live on, it has to be transformed. The original is bound to
undergo a change in its afterlife. Reflecting on the translator's task,
Benjamin remarked that:

> just as the tenor and significance of the great works of literature undergo
> a complete transformation over the centuries, the mother tongue of the
> translator is transformed as well. While a poet's words endure in his own
> language, even the greatest translation is destined to become part of the
> growth of its own language and eventually to be absorbed by its
> renewal.

Defined as a mode serving to express the *relationship* between languages
(rather than an equation between two dead languages), translation is
'charged with the special mission of watching over the maturing process of
the original language and the birth pangs of its own'.[20]

THE BLUE FROG

Identity is largely constituted through the process of othering. What can a
return to the original be, indeed, when the original is always already
somewhere other than where it is thought to be; when 'stay home' also
means 'reach out', and native cultures themselves are constantly subject to
intrinsic forms of translation? Here, Third is not merely derivative of First
and Second. It is a space of its own. Such a space allows for the emergence

of new subjectivities that resist letting themselves be settled in the movement across First and Second. Third is thus formed by the process of hybridization which, rather than simply adding a here to a there, gives rise to an elsewhere-within-here/-there that appears both too recognizable and impossible to contain. Vietnamese francophone poet and novelist Pham Van Ky, for example, raises the problematics of translated hyphenated realities specifically in the following terms:

> Mother. A word released, a word with precise contours, which crushes me but does not cover me up entirely, but does not articulate my Parisian existence; already a decision hardens within me . . . this abyss of secrets, reticences, obscurities, hollow dreams and foul haze between Mother and me: nothing clear, a series of disagreements, of bitter trails where grass never grows, a chain of vague pains jumping at my wrist and around my chest, seeking to restrain my breathing and the circulation of my blood. . . . In the Bois de Vincennes, I reread the cablegram: Mother seemed near me. I tried to draw her closer to me: she became distant again. Because I had forgotten about her, did I feel less tied to her by life? Why conceal her from myself? She had carried me in her haemorrhage; I did not pull out a single hair which was not a bit hers.[21]

Another instance of working with between-world reality is that of Elaine K. Chang, who, in an attempt to situate herself (via an essay significantly entitled: 'A not-so-new spelling of my name: notes toward (and against) a politics of equivocation'), has this unique story of travelling metaphor to offer:

> Within the North American 'Asian community', I am sometimes called a banana; it is said that I may have a yellow skin, but I am white on the inside. I am considered ashamed of my yellowness, insofar as I apparently aspire to master the language, culture and ideology of white people. *Banyukja* is . . . a Korean translation of the Spanish *Vendida* – the Korean who has forgotten, or never known, her heritage, her language. . . . I cannot properly answer to these names, especially to and in a language I have lost. I cannot tell those for whom I am a banana, or worse a *banyukja*, that my exile from them is not entirely self-imposed, that I am not ashamed and have not forgotten. Nor can I respond in so many English or broken Korean words that the ignorance they ascribe to me, the silence they expect from me, themselves cooperate to estrange me: that what I do understand of what they say serves to alienate me. . . . If I could rename myself . . . I think I would have to select a figure not female, not divine, not even human: the blue frog. My mother's story about the blue frog was my favourite childhood story. The blue frog never does anything his mother tells him to do; in fact he does precisely the opposite. I pestered my mother to tell the

story over and over; each time she told it, the frog-mother's requests and the blue frog's responses seemed to become more outrageous. The ending, however, remained soberly the same. Loving and knowing her son, and knowing she is about to die, the frog-mother makes her last request: that her son bury her body in the river – of course thinking her son, due to his contrary nature, will bury her in the ground. When his mother dies, however, the blue frog is so remorseful for his life-long disobedience that he chooses to observe her final wishes. So every time it rains, the blue frog cries, thinking that his mother's body is washing away in the river.

It wasn't until I was considerably older, and she had not told the story for years, that I asked my mother if she remembered the little blue frog. Confused at first, she remembered after I'd recapitulated the basic plot structure. Blushing, my mother informed me that the frog was not, in fact, blue; she had not yet mastered colours in English when she first told me the story. Old as I was, I was crushed by this information: it was all along just some ordinary green frog. What had compelled me about this particular frog – this frog whose story quite accurately . . . re-sembles the story of my relationship with my mother – was his blueness. . . . I would invoke the blue frog as my inspiration because of this coding and recoding of the color of his skin; the ambiguity of his colour registers the sorts of small but significant ironies that distinguish my experience as a westernized child of immigrant parents. My mother shared with me a Korean folktale that acquired something new in its translation into English. . . . The blue frog is a (by-)product of cultural and linguistic cross-fertilization – a small and mundane one, to be sure, but one that I would take as my emblem. . . . Do blue frogs have a place in academic discourse?[22]

Tale-telling is what it takes to expose motherhood in all its ambivalence. The boundaries of identity and difference are continually repositioned in relation to varying points of reference. The meanings of here and there, home and abroad, third and first, margin and centre keep on being displaced according to how one positions oneself. Where is 'home'? Mother continues to exert her power from afar. Even in her absence she is present within the teller, his blood, his source of life. From one generation to another, mothers are both condemned and called upon to perfect their role as the killjoy keepers of home and of tradition. In Kristeva's fable of dissidence, Mother (with capital M) may be said to partake in the 'mire of common sense' (common to whom?) and to represent Meaning as established by the 'dead father'. Therefore, it is by resisting Her powers of generalization that a woman becomes a stranger to her own language, sex and identity. In Jelloun's tale of time, Mother is the benevolent travelling source that, in fact, does not travel on her own. She is, rather, the

transmitter of 'a body full of sentences, proverbs and noises', and the originator of the 'warm fabric of [his] memory' that 'shelters and nourishes [him]'. Like language, mother (with small m) retains her secrets and it is through her son that she travels and continues to live on – albeit in fragments.

For Pham Van Ky, Mother is what he fiercely rejects without feeling any less tied to her by life. In a conventional gender division, she – the guardian of tradition – represents his Oriental, Vietnamese, Confucian past and the Far East over there; while he – the promoter of modernity – can go on representing change and progress, and the Far West over here. But as he admits to himself, mother can neither be discarded nor easily appropriated: 'I did not pull out a single hair which was not a bit hers.' In fact, the travelling seed has never had an original location that could simply be returned to. For Elaine Chang, Mother is the imperfect transmitter of a folktale whose voyage in time, across language and generation, has allowed it to acquire something new in its translation. The coding and recoding of the skin color of the frog speak to the sadness (/blueness) of both the daughter's and the frog's inappropriate experience of translation. In both cases, mistranslation results from a two-way imperfection in the triangular relationship of mother, child and language. The source is never single and the home-and-abroad or land-and-water trajectory is a mutual voyage into self and other. Travelling in what appear to be opposite directions, the two parties meet only when 'meet' also comes to mean 'lose' – that is, when mother or the story can no longer be returned to as redemptive site. Understanding and consciousness emerge in one case, when the frog realizes its mistake in carrying out a literal translation of his mother's request after she has passed away; and in the other case, when the daughter's natural identification with the blue frog comes to an end to make way for a 'politics of equivocation' in the articulation of hyphenated identity. The ability to assume anew the responsibility of translation thereby opens up to an elsewhere, at once not-yet- and too-well-named within the process of cultural and linguistic cross-fertilization.

I-THE MIS-SEER

Every voyage is the unfolding of a poetic. The departure, the cross-over, the fall, the wandering, the discovery, the return, the transformation. If travelling perpetuates a discontinuous state of being, it also satisfies, despite the existential difficulties it often entails, one's insatiable need for detours and displacements in postmodern culture. The complex experience of self and other (the all-other within me and without me) is bound to forms that belong but are subject neither to 'home', nor to 'abroad'; and it is through them and through the cultural configurations they gather that the universe over there and over here can be named, accounted for, and become

narrative. Travellers' tales do not only bring the over-there home, and the over-here abroad. They not only bring the far away within reach, but also contribute, as discussed, to challenging the home and abroad/dwelling and travelling dichotomy within specific actualities. At best, they speak to the problem of the impossibility of packaging a culture, or of defining an authentic cultural identity.

For cultures whose expansion and dominance were intimately dependent upon the colonial enterprise, travelling as part of a system of foreign investment by metropolitan powers has largely been a form of culture-collecting aimed at world hegemony. In their critical relation to such a journeying practice, a number of European writers[23] have thus come to see in travelling a socio-historical process of dispossession that leads the contemporary traveller to a real identity crisis. Through this 'nightmare of degradation', the traveller seems to have become so banal, outdated and disintegrated in certain images he projects that it is not unusual to ask whether he is still . . . a possibility. One among some fifty million globe-trotters, the traveller maintains his difference mostly by despising others like himself. I sneeze at organized tours, for the things I see in the wild or in the remote parts of the world, are those You can't see when You abide by prepaid, ready-made routes. Furthermore, You don't see all that I know how to see, even if You go to the same places. In the arguments used here to preserve one's difference, there is an eager attempt to define one's activities by negating them. The role of the traveller as privileged seer and knowledgeable observer has thus become quasi impossible, for it is said that the real period of travelling always seems to be already past, and the other travellers are always bound to be 'tourists'.[24]

The search for 'micro-deserts', the need to ignore or the desire to go beyond the beaten tracks of pre-packaged tours are always reactivated. Travelling here inscribes itself as a deviance within a circularly saturated space. Adventure can only survive in the small empty spaces of intervals and interstices. As soon as something is told, there is nothing more to discover and to tell, so it is believed. All that remains for the real traveller is 'the privilege of a certain look, in the margin of the Standard Point of View as signaled in the tourist guides'. Constantly evoked, therefore, are the blindness and myopia of the tourist, whose voracity in consuming cultures as commodities has made hardship and adventure in travelling a necessary part of pre-planned excitement rather than a mere hindrance. Cutural tourism is thus said to challenge the dichotomy that separates the expert ethnologist from the non-expert tourist. 'The traditional traveller's tragedy is that he is an imitable and imitated explorer.' Therefore, in order not to be confused with the tourist, the traveller has to become clandestine. He has to *imitate* the Other, to hide and disguise himself in an attempt to inscribe himself in a counter-exoticism that will allow him to be a non-

tourist – that is, someone who no longer resembles his falsified other, hence a stranger to his own kind.[25]

Ironically enough, it is by turning himself into another falsified other (in imitating the Other) that the traveller succeeds in marking himself off from his falsified other (the tourist). He who is easily imitable and imitated now takes on the role of the imitator to survive. The process of othering in the (de)construction of identity continues its complex course. Rather than contributing to a radical questioning of the privileged seer, however, the traveller's 'identity crisis' often leads to a mere change of appearance – a temporary disguise whose narrative remains, at best, a confession. As discussed earlier, striving for likeness to the original without being powerfully affected by the foreigner (the Other) is the hallmark of bad translation. The traveller as imitator may perform the task of a faithful reproducer of meaning, but to become a (good) translator, he would have 'to expand and deepen his language by means of the foreign language'.[26] To travel can consist in operating a profoundly unsettling inversion of one's identity: I become me via an other. Depending on who is looking, the exotic is the other, or it is me. For the one who is off- and outside culture is not the one over there, whose familiar culture I am still a part of, or whose unfamiliar culture I come to learn from. I am the one making a detour with myself, having left upon my departure from over here not only a place but also one of my selves. The itinerary displaces the foundation, the background of my identity, and what it incessantly unfolds is the very encounter of self with the other – other than myself and, my other self.

In travelling, one is a being-for-other, but also a being-*with*-other. The seer is seen while s/he sees. To see and to be seen constitute the double approach of identity: the presence to oneself is at once impossible and immediate. 'I can't produce by myself the stranger's strangeness: it is born from [at least] two looks.'[27] Travelling allows one to see things differently from what they are, differently from how one has seen them, and differently from what one is. These three supplementary identities gained via alterity are in fact still (undeveloped or unrealized) gestures of the 'self' – the energy system that defines (albeit in a shifting and contingent mode) what and who each seer is. The voyage out of the (known) self and back into the (unknown) self sometimes takes the wanderer far away to a motley place where everything safe and sound seems to waver while the essence of language is placed in doubt and profoundly destabilized. Travelling can thus turn out to be a process whereby the self loses its fixed boundaries – a disturbing yet potentially empowering practice of difference.

> 'The word is more important than syntax. . . . It is the blanks that impose themselves . . . I am telling you how it happens, it is the blanks that appear, perhaps under the stroke of a violent rejection of syntax . . . the place where it writes itself, where one writes . . .

is a place where breathing is rarefied, there is a diminution of sensorial acuity . . .'

'Would a man, in his sexuality, show the blank just like that? Because it's also sexual, this blank, this emptiness.'

'No, I don't think so; he would intervene. I myself do not intervene.'[28]

It seems clear for writers like Marguerite Duras, who lets herself return to 'a wild country' when she writes, that one can only gain insight by letting oneself go blind as one gropes one's way through the overstated and overclarified morass of one's language. 'Men are regressing everywhere, in all areas', she remarked. 'The theoretical sphere is losing influence . . . it should lose itself in a reawakening of the senses, blind itself, and be still.' For scarcely has an important event been experienced before men, always eager to act as theoretical policemen,

> begin to speak out, to formulate theoretical epilogues, and to break the silence . . . here silence is precisely the sum of the voices of everyone, the equivalent of the sum of our collective breathing. . . . And this collective silence was necessary because it would have been through this silence that a new mode of being would have been fostered.

Duras called such arresting of the flow of silence 'a crime and a masculine one', for if it has in innumerable cases stifled the voices of the marginalized others, it has in her own case certainly made her 'nauseous at the thought of any activism after 1968'.[29]

If the space of language is to resonate anew, if I am to speak differently, He must learn to be silent – He, the traveller who is in me and in woman. For s/he who thinks s/he sees best because s/he *knows* how to see is also this conscientious 'mis-seer to whom the tree hides the forest'.[30] Without perspectives, deaf and myopic to everything that is not microscopic, the non-tourist-real-traveller operates, often *unknowingly*, in a realm of diminished sensorial acuity. On the one hand, s/he develops a highly refined ear and eye for close readings, but remains oblivious to the landscape and the 'built environment' which make the traveller-seer's activities possible and communicable. On the other hand, deliberate mis-seeing is necessitated to bring about a different form of seeing. When the look is 'a three-way imperfection' developed among the subject observed, the subject observing, and the tools for observation, the encounter is likely to resonate in strangely familiar and unpredictable ways. The translator transforms while being transformed. Imperfection thus leads to new realms of exploration, and travelling as a practice of bold omission and minute depiction allows one to (become) shamelessly hybridize(d) as one shuttles back and forth between critical blindness and critical insight. I-the-Seer am bound to mis-see so as to unlearn the privilege of seeing, and while I travel, what I

see in every ordinary green frog is, undeniably, my blueness in the blue frog. In the zest of telling, I thus find myself translating myself by quoting all others. The travelling tales.

NOTES

1 Tahar Ben Jelloun, 'Les Pierres du temps', *Traverses* 40, 1987, p. 158. Unless indicated otherwise, all translations from the French are mine.
2 Gary Snyder, *The Practice of the Wild*, San Francisco, Northpoint Press, 1990, p. 7.
3 Tahar Ben Jelloun, 'Les Pierres du temps', *Traverses* 40, 1987, p. 159.
4 T.B. Jelloun, *Moha le fou, Moha le sage*, Paris, Seuil, 1978, p. 10.
5 Maurice Blanchot, *Vicious Circles*, trans. P. Auster, Barrytown, New York, Station Hill Press, 1985, p. 19.
6 Edward Said, 'Reflections on exile', in *Out There. Marginalization and Contemporary Culture*, eds. R. Fergusson *et al.*, New York, The New Museum of Contemporary Art and MIT Press, 1990, pp. 357–8.
7 Quoted in Bruce Grant *et al.*, *The Boat People. An 'Age' Investigation*, New York, Penguin Books, 1979, p. 182.
8 Ibid., p. 173.
9 Ibid., p. 195.
10 Terms used by a Halifax woman with regards to Canada and the flux of South East-Asian refugees in the late 1970s, reported in ibid., p. 174.
11 Maurice Blanchot, *Vicious Circles*, op. cit., p. 66.
12 Julia Kristeva, in *The Kristeva Reader*, ed. T. Moi, New York, Columbia University Press, 1986, pp. 298; 296. Original italics.
13 Ibid., p. 286.
14 Quoted in Hannah Arendt's introduction, in Walter Benjamin, *Illuminations*, New York, Schocken Books, 1969, p. 20.
15 E. Said, 'Reflections on exile', in *Out There*, op. cit., p. 357.
16 Ibid., pp. 364–5.
17 Gary Snyder, *The Practice of the Wild*, op. cit.,pp. 23–4.
18 Edward Said, 'The voice of a Palestinian in exile', in *Third Text* 3/4 (Spring–Summer, 1988), p. 48.
19 All quoted in Lucy R. Lippard, *Mixed Blessings. New Art in a Multicultural America*, New York, Pantheon, 1990, pp. 23, 30, 170, 47, 41, 151.
20 Walter Benjamin, *Illuminations*, op. cit., p. 73.
21 Pham Van Ky, *Des Femmes assises ça et là*, Paris, Gallimard, 1964, pp. 8, 18. The quoted passage was translated in J.A. Yeager, *The Vietnamese Novel in French. A Literary Response to Colonialism*, Hanover, University Press of New England, 1986, pp. 151–2.
22 Elaine K. Chang, 'A not-so-new spelling of my name: notes toward (and against) a politics of equivocation', forthcoming in *Displacement. Cultural Identities in Question*, ed. Angelika Bammer, Bloomington, Indiana University Press.
23 See, for example, the articles published in *Traverses* 41–2 (issue on 'Voyages'), 1987, more particularly those written by J.C. Guillebaud, J.D. Urbain, P. Curvel, P. Virilio, V. Vadsarid, P. Sansot, C. Wulf, F. Affergan and C. Reichler.
24 See J. Culler, 'Semiotics of Tourism', *American Journal of Semiotics* 1–2, 1981, p. 130.

25 Jean-Didier Urbain, 'Le Voyageur détroussé', *Traverses*, pp. 43, 48.
26 Walter Benjamin, *Illuminations*, op. cit., p. 81.
27 Christoph Wulf, 'La Voie lactée', *Traverses* 41, 1987, p. 128.
28 Marguerite Duras as interviewed by Xavière Gauthier in *Les Parleuses*, Paris, Minuit, 1974, pp. 11–12.
29 Marguerite Duras in E. Marks and I. de Courtivron (eds) *New French Feminisms. An Anthology*, Amherst, The University of Massachusetts Press, 1980, pp. 111–12.
30 Jean-Claude Guillebaud, 'Une Ruse de la littérature', *Traverses* 41, 1987, p. 16.

Part I

Neighbours

Chapter 2

Discovering new worlds: politics of travel and metaphors of space

Jacques Rancière

At the end of the Gospel of John, as in Matthew and Luke, the angel of the resurrection tells the holy women to warn the apostles to move towards Galilee, where Jesus will precede them. This appears to contradict the beginning of the Acts of the Apostles, which infers that they had remained in Jerusalem. And the contradiction invites us to have a closer glance at the singularity of that journey back home. The apostles have to come back to their land, to their home or 'here', and they must do so to discover the 'here' as a 'there', a place where 'he' – the Lord whose body fulfils the meaning of the holy scripture – has preceded them, precedes them in any time.

Now the Gospel of John relates that journey in the shape of a strange appendix, strange enough to have commentators think that the passage has been added by another writer. In fact it looks like a new performance of one of the most famous episodes of the gospel, the miraculous catch of fishes. Let us look at the scene.

The apostles, we are told, have been fishing the whole night without success. At daybreak they hear somebody calling them from the shore and telling them to throw the net on the right side of the boat. So they do and, of course, they catch plenty of fish and recognize the one on the shore as the Lord.

Nothing new in a sense but the scene itself has a curious tonality, familiar in itself. We are told that Peter, who was naked, dresses and dives into the lake straightaway to reach the shore. And when the apostles come ashore, they see a fire of burning coals with fish on it, and some bread.

Of course, we are aware that this is a symbolic representation: the light of the Word coming into the world, and becoming flesh. In a sense, it is the prologue of John's gospel illustrated for the children in the shape of a rather crude and artless symbolism. That's why the passage was taken to be the addition of another, a more naïve writer. But precisely this new performance of the miracle merges the great mystery of Incarnation, the great mystery of the Word made flesh, with everyday life as if it was to link definitively Incarnation with little scenes and little narratives of fishing and eating; of ordinary life and people, boats and nets, the dawn on the water

and the heat of the charcoal. Then the great mystery of the Word made flesh comes to be identified with the modest power of the little narrative of labour and days. We are told that the miracle happened *there*. Far from the town of the book and the doctors of the law: not too far, just as far as necessary. It is like additional evidence for the great mystery; but correspondingly it endows everyday life, on the mere condition of a slight displacement, with the virtuality of the miracle, the virtuality of its ordinary flesh becoming the body of Truth.

What makes the point more relevant is the oddness of the whole appendix, which relentlessly starts again, relates new meetings, and gives new evidence. It looks as if the writer were on the verge of getting out of the book; of making the perilous leap out of the narrative; as if he were obliged to go overboard on the reliability of the narrative. He can't stop proving that 'he', the Lord, was there and that he too, the writer, was there – that he is really the one that the Lord chose to stay there and bear witness to the truth of the whole narrative of the Word made flesh, which obliges him to witness to his own having been there and having been called by the Lord to bear witness and so on.

It is not a distant voyage from Jerusalem to Tiberias. But this shows us precisely what is theoretically at stake in travelling: not discovering far countries and exotic habits, but making the slight move which shapes the mapping of a 'there' to a 'here'. That mapping is the additional way, that is to say the human way of making flesh with words and sense with flesh.

Let me put this differently: the very space of theoretical travelling is the narrow and vertiginous gap that separates the inside of the book from its outside. Travelling is making the book true out of itself, in the *hic et nunc* which is its negation and has to become its confirmation. We all know the drastic opposition framed by Plato's *Phaedrus* between two modes of discourse. On one side, the living *logos* is endowed with the power of getting written in the very soul of he who receives it. On the other side, the dead letter – the written word – is like a painting, unable to give help to itself, unable to say but indefinitely the same thing. Now I would assume that travelling is the way of overcoming the opposition. In fact, there are two ways of overcoming the opposition. There is the Book of Life, the book which is more than a book, the Holy Scripture whose promise is fulfilled by the advent of the Word made flesh, and there is the little 'book of life', the narrative of the slight move which meets the point of a living word which is neither voiced by a 'father' of the *logos* nor written in dead characters. The living word the traveller meets is written in the very flesh of things, in the very framing of natural scenery. It is written 'here' but it is only visible on condition that a traveller goes 'there' and relates the coincidence of its *ecceity* with the discovery of a new land.

I have tried to exemplify it with the journey of the young Wordsworth in revolutionary France as he related it in *The Prelude*. Let us look at the way

his verse framed the meeting. He had decided to go away from the dusty books and classrooms. He crossed the Channel and he had to go through France to reach the point of the journey: the snowy mountains of the Alps. Then he met something he had not come for: the French Revolution and, more specifically, its brightest day, the great Festival of the Federation. He didn't care so much about politics. As he tells us: 'Nature then was sovereign in my mind'.

Now this is precisely the meeting point of the living word in the *ecceity* of its incarnation. Nature was the very divinity whose reign was being celebrated in those days of July 1790. Just as he came ashore he met the identification, under the concept of Nature, of the harvest and flowers of July with the emblems of the Revolution. He met the sun shining down through the shade of the elms, the flowers of the triumphal arches or the garlands in the windows, Liberty dancing beneath a starry sky, the ripening of the grapes on the hills as the boat slid along the Saône, the scenes of fraternization with the plucking of violins and the songs in the taverns of Burgundy, the maiden spreading the haycock on the slopes of the Alps. As he said, he saw 'no corner of the land untouched'. The visible and tactile evidence of liberty and brotherhood needed no book, no theoretical or political statement in written letters, in 'dead' letters, because the book of life was before the eyes of the travellers, a book where one could only read

> Lessons of genuine brotherhood, the plain
> And universal reason of mankind.

What is at stake here is something much deeper than the enthusiasm of a young man. For we know that the scene has been replayed many times and not only because other generations of enthusiastic young men and women came in turn. What the young poet and traveller in the land of Revolution lighted upon was the very point of meeting of the modern aesthetic revolution with the modern political utopia.

Roughly speaking, the modern aesthetic revolution can be summarized in the main themes of the Kantian *Kritik der Urteilskraft*, published at the same time: the abolition of the distance between the *eidos* of Beauty and the spectacle of the sensitive; the power, proper to the object of the aesthetic judgement of being appreciated without a concept; the free game of the faculties which witnesses a power of reconciliation between Nature and freedom, even if no concept of the reconciliation is to be determined. As for the modern political utopia, I don't designate by this term the projects of ideal communities. Utopia for me is not the distant island, the place which is nowhere. It is the power of mapping together a discursive space and a territorial space, the capacity to make each concept correspond to a point in reality and each argument coincide with an itinerary on a map.

This power is first of all the power of the traveller who goes along, walking and sketching the little scene on his pad. Wordsworth is generally

taken to have been the first who discovered and made poetry discover Nature. What he had discovered, I think, is more accurately the way of seeing along the walk, of drawing the sketch in which Nature presents itself to itself, signifies itself without the aim of signifying, and gives their flesh to the key signifiers of politics: people, freedom, community, etc. In the very first verses of *The Prelude*, we can read:

> Should the chosen guide
> Be nothing more than a wandering cloud
> I cannot miss my way

That power of safely wandering with a wandering cloud as a guide is given a name in the following verses: the name of liberty, not English native freedom but French or Latin liberty. In the close association of this name with the movement of walking, we can't help hearing the echo of the French revolutionary *Chant du départ*: 'La liberté guide nos pas' (Liberty guides our steps). The traveller could recognize in the scenery of Nature the evidence of political liberty because the liberty of its own wandering 'as a cloud' guided his feet, preceded them in the same way as the Lord had preceded the apostles on the shore of Lake Tiberias. With such a precedency, walking, seeing and sketching in a glance become the enactment of a power of schematization through which Nature presents itself as ruling the community. Therefore politics itself can the aestheticized, that is to say, it can be appreciated without a concept. A worn-out topic of ethics reminds us that 'Travelling does not heal one's soul.' True enough, it doesn't: it does much more. Travelling means healing the very defect of the concept, giving it the body in which we can 'read' it, see it in the *hic et nunc* of its sensitive incarnation.

This does not necessarily require great popular movements, festivals and demonstrations of the marching people. This does not require long walks, not even the fragrances of the harvest and the summer flowers, the sunny sky, ripening grapes, pretty maids and happy dances which delighted the young English poet. It is enough that we can recognize, in Hegelian terms, 'the rose of the concept' in the 'cross' of any little scene. Most of us have experienced it. It was just a matter of taking the bus or the train up to the terminal of certain suburban lines: there the miracle could happen. A gloomy winter sky on blocks of concrete flats or barracks made of planks, zinc or cob was enough to fulfil the promise if it allowed the visitor to meet at 'its' place, under the shape of 'its' identity, a proletariat or a common people long dreamed of and found there, so close and so different. There it was, the reality of the concept was there in its *ecceity*, far from the books, no more in deceiving words and yet exactly similar to that which the book had made us hope, the words had made us love. Here it was there, identical to itself because it was identical to the occupation of a space.

There is a strong image of this in Rossellini's *Europe 51*. In the film,

Ingrid Bergman plays the part of an upper-class lady whom her cousin, a communist, sends to see the other side of the society in order to heal her own pain. Then she takes the bus up to the suburbs, goes into the concrete block, and in a single glance is given everything. This astonishing vision is a very simple sight. In a single shot, she sees the Other, the common people at home. We realize, by following her, that it is indeed easy to grasp the common people in one shot. No need of picturesque details, popular accent and so on: the common people is first of all a framing of the visible. There is a rectangular form and many people in the frame and that's all you need. The common people is a frame in which many people are included. That formal matrix generates by itself an *ethos*, it generates ethical quali-ties of the common people: being close together in a small space means being in the warmth of community and solidarity.

One shot is thus enough to give the *ecceity* of the concept. *Hoc est corpus meum*. The process of identification is first of all a process of spatialization. The paradox of identity is that you must travel to disclose it. The Same can be recognized on condition that it be an Other. It is identical to its concept in so far as it is elsewhere, not very far but somewhere else, requiring the little move. Now discovering his or her identity is framing the space of that identity. Identity is not a matter of physical or moral features, it is a question of space. Spatialization presents by its own virtue the identity of the concept to its flesh. It ensures that things and people stay at 'their' place and cling to their identity. We can even feel it in the horrific narrative of travelling down to the hell of popular misery which flourished in nineteenth-century literature and political rhetoric.

All of us have read some of those little and dramatic narratives of short travel towards the slums or cellars of the suburbs. The narrative is always framed in the same *topos*: the obscurity of a den where the noxious air seizes the visitor. He walks in the mud and obscurity without seeing anything and suddenly, on the mouldy straw of a muddy mattress, he perceives a creeping shape or several shapes thrown together, intermixed. Then he goes closer and he discovers that the creeping beast is a human being, a child, a little girl, an old woman. He touches it to be sure it is human. Then he leaves, returning to the Houses of Parliament, the Academy, or some other 'central' place and relates how the things are on the other side/underground of the society which is close by. He says: I've been there, I entered the slum, felt the noxious air, saw the mouldy straw and the intermixed shapes of a bestial humanity, living in mud, covered and 'dressed' with rags picked up in the mud of the streets. *Hoc est corpus eorum*.

Of course, those narratives were an appeal to fear and pity. I would assume, however, that this was not the main point. The first concern was not provoking fear or pity. It was localizing. Horrible as the underworld may be, it is still a world. It is a place where you can find the disease of

society, designate and touch it with your fingers. People are pitiful or dreadful but they are there, clinging to their place, identical to themselves – and all the more identical to themselves as they have less self, as their 'self' is hardly distinct from the dirt and mud which is 'their' place. The descent into hell is not simply a pitiful visit to the land of the poor – it is also a way of making sense, a procedure of meaning. The hell is always a Lethe, a river of the dead, the river of truth. It gives way to a truth rising, as it were, from the dark core of the earth.

Frightening as it might seem, it was still reassuring to envisage society as threatened by a power lying beneath it, in the underground. Because the main threat would lie in the discovery that society had no underground: no underground because it had no ground at all. The enigma and threat of democracy is not the army of the shadows in the underground. The enigma and threat of democracy is merely its own indeterminacy. This means that people have no place, that they are not 'identical' to themselves: that indeterminacy in fact is a permanent challenge to the rationality of policy and the rationality of social knowledge. Spatialization is a way of conjuring with the challenge of safely grounding reasonable democracy and rational social knowledge.

I would exemplify this point with reference to a paradigmatic voyage of politics and science in a new world. I refer to Tocqueville's *Democracy in America*, which properly is a theoretical discovery of the New World. I quote from his letter to the Comte Molé where he comments rather oddly on his book:

> In America, all the laws stem, as it were, from the same thought. The whole society is grounded, so to speak, on a sole fact. Everything follows from a unique principle. One could compare America to a big forest pierced by a multitude of straight roads leading to the same point. One only needs to arrive at the crossroads [*rond-point*][1] and everything becomes visible at first sight.

We recognize here the process of framing in a glance the space of an identity. However, something in the image seems out of place. The central point from which one can see the whole perspective, all the radiant roads, is in fact the kind of place you hardly find in the United States, a country where streets and roads cross at right angles. It looks much more like the perspective of the 'jardins à la française', designed according to the central point of view of the sovereign.

Of course you may say that the '*rond-point*' and the forests are mere metaphors; that, clearly, the meaning of the metaphor is that all the features of American political life and society are intelligible as the enactment of a unique and central principle, which is the 'equality of conditions'. I agree this is a metaphor. But the question will immediately be raised at a higher level: why does Tocqueville need a metaphor? Why does

he need this royal metaphor to explain the power of equality? What makes the spatial representation – even when it is not exactly well-fitting – necessary to the formulation of political science?

We can answer the question providing we go back to the political requirement involved in the scientific enquiry. What Tocqueville is looking for in America is 'good' democracy, reasonable democracy, for he comes from the land of 'bad', unreasonable democracy. 'Bad' democracy is a democracy that entails a problem concerning the framing of the visible. Democracy, as everyone has known since Plato, is the realm of 'appearances'. It is the state of things in which everyone asks to be visible. The very core of democracy is the conflict concerning visibility. And correspondingly, democracy is the state of things in which nobody is ever sure of what he or she is seeing because nobody is at his or her 'own' place.

Tocqueville finds the land of good democracy in a land where the conflict for visibility and the trouble of the visible no longer exist. His metaphor shapes a fairyland of democracy, a space where any point is similar to any other point, and where people don't see one another but are equally seen by the observer standing at the central – the royal – point. The forest of democracy is the space in which democracy is everywhere identical to itself, where it is at the same time opaque to itself and transparent for the observer – the king or the scientist who grasps in one glance the reign of likeness. America then is the land that conjures up the theatre of democratic visibility. It is the land of a *mimesis*, in which the concept of democracy is embodied in its very absence. The utopian solution to the problem of democracy is spatialization. Space is the *mimesis* of the concept.

The utopia still goes on. 'America is our utopia', Baudrillard says. As I try to argue, utopia is not the fairyland where all wishes are fulfilled. Utopia fulfils only *one* wish: the wish of seeing things and people identical to their concept. Ultimately, the best accomplishment of the wish is the desert-like representation of the likeness of the space to itself. Baudrillard's description of America thus follows that of Tocqueville. True enough, he knows that America is not a land of European *ronds-points* and radiant perspectives. He describes a land of freeways crossing other freeways at right angles. There is no central meeting point in this critical and nihilistic travel. However, the observer on its freeway carries in his or her imagination a portable *rond-point* or circular vantage point and sees everywhere the similarity of one place to any other. The desert, the space of an absolute likeness of 'here' and 'there', which can only be reached through a long journey, such might be the last utopia of social science, the term of all the travels operating the slight move to meet the identity of the concept with itself – and finally with its absence. The village and the desert, the miracle of the Word made flesh embodied in everyday life and the identity of the space to itself, the place for the *ecceity* of the *hoc est corpus meum*

and the place for the invisible identity of the *ego sum qui sum*, such are the two scriptural paradigms for the writing of social science.

The village is the main paradigm of the history of mentalities. Its principal concern is giving words 'their' flesh and its main device is the territorialization of meaning. Any production of meaning has to be taken as the expression of the spirit of a place. And the more wayward the production is, the more it has to be pinned down to the expression of a place. The best evidence of this is given by the way in which historians come to terms with heresy. Heresy means severance. It means a life divided, put out of its place, severed from itself by words. Now the turn of the historians of mentalities is dismissing the severance, giving heresy 'its' place in the warmth of the village community. Heresy then becomes a culture of the village, both the expression of the earthiness of peasant life, work and sociabilities and the naïve figuration by peasants of a heaven alike to the likeness of peasant life.

The desert is the paradigm of a certain sociology. The diagrams of Bourdieu's books show us an abstract map of the distributions of positions and movements in the social field. Now, if we look closer, we can see that the scientific diagram consists only of names scattered on the page – names of institutions, of scholars, writers, academists. The diagram is a kind of *Who's Who* scattered on the page. One needs the scientist's eye to perceive that display as the diagram of the deep forces operating in the symbolic field of power. This is the point: the more we say, like the child in Anderson's tale, that we see nothing but a scattered *Who's Who*, the more we are faulted for not knowing what science is. Science requires that we meet the place, the circular point from which the scattered *Who's Who* is perceived in one glance as the likeness of society to itself. The diagram, with its invisible difference, is the metaphor of scientific identity, the place for the demonstration of the absolute uniqueness of the *ego sum qui sum* of the scientist.

It seems to me that in contemporary political debate, as in social science or critical theory, we are now facing the necessity and difficulty of breaking away from the old schema of the identifying travel. The schema of identifying travel is finding the same by moving to the place of the other. Most of our political and theoretical vision has been framed within the categories of that travel. The question thus arises of a countermarch: discovering the other in the same; that is to say, referring to Wordsworth's verse, learning to miss one's way.

I have referred to Rossellini's *Europe 51*. Those who know the film will remember that, after the first and happy visit to the common people's home, there is a second visit. The second time, the lady is alone, without her guide, and something happens. As she departs and is about to take the bus home, she loses her way. It is just a moment, but it is a decisive one. On the other side of the road, near the river, a confused event catches her

attention. Her glance and her path are diverted and she enters a space which is no more 'home', a 'there' which is no 'here', where the marks of identity are blurred over. It is only a step aside. But that step aside turns out to be, for her, the beginning of a radical adventure, the dissociation between 'here' and 'there'. She had come elsewhere to see the people in their place and find her peace. But, on the contrary, she will lose her place and become more and more a stranger to herself.

Losing one's way may be a matter of chance. But what is enacted in this cinematic moment is no 'chance meeting'. It is a power of refiguration, a power of coming over the tracks of the first journey – the happy journey – and blurring them over. The power of refiguration itself is the enactment of a power of becoming a stranger to oneself. I think that we have to investigate in social science and political thinking the way to such a refiguration, to a social science taking into account that there is no reason why a speaking being should be 'there' rather than 'here', no special place for the sameness of any of us. We have to investigate the modalities of a heterological science.

ACKNOWLEDGEMENTS

I express my gratitude to Andrée Lyotard-May who helped me to resolve some translation difficulties and to Adrian Rifkin who has carefully revised my draft and suggested many corrections. Without their help my English would have been far more unreadable.

NOTE

1 The word 'rond-point' conveys not only a point where roads or routes cross, but also a circular meeting-point with radiant perspectives.

Chapter 3

The becoming threshold of matrixial borderlines

Bracha Lichtenberg-Ettinger

> Mythological travellers' tales are analogous to psychological experiences, to identity transformation, to artistic processes and works, to aesthetic experiences, and to patterns of cognition. It is through their power to evoke all of these that such tales are constituted as mythologies.

EXODUS

The moment at which Moses was called upon by God to lead the people of Israel out of Egypt presents itself as a symbolic ceremony of initiation of wandering and exodus, a mythical moment that delineates transitional states, migrations and emigrations, wandering or nomadism, exiles and mainly inverted exiles [Exodus III]. (I call 'inverted exiles' a migration towards an unknown desired destination, towards a promised Jerusalem that you do not know; I reserve the word 'return' for migrations towards a known destination; and 'exile' for movements of expulsion and casting out from a desired place, abandonment of the desired place for an anywhere, like the movement of a refugee in a time of emergency).

In the biblical text, a unique set of elements is woven together and we can single them out as components of a model for the future developments that they point to, distinguish and initiate.

In the system of the Hebrew language, several pathways of meaning are folded into each signifier, enriching the event that a very short text delivers as its content. In Hebrew, because of opened passages between words and their roots, each word quivers, trembles and ejects several meanings, even before insertion into a context. Meanings are created not only through the signified and through the passage from one signifier to another, but also within the 'scope' of the signifier. The links between the different possibilities offered by the signifier operate whether we cast a light on them or not.

In this short text we find, at a meeting place *behind the desert*, an invisible God, a subject chosen by Him, the declaration of the Exodus, and three transformations in the denomination of God by Himself. The first denomination, the one which is at the core of my argument is, in Hebrew: EHIE ASHER EHIE. Several theological, philosophical, and psycho-analytical channels stem from this name which was translated into the Latin, Greek, French and English as: *I am that I am*, or *I am that is*.

I am that I am signifies an immanent being, a superposition of present and presence, an a priori subject, a tautological identity, a congruence of signifier and signified, of an identifying *I* and an identified *I*, a conjunction of centre, origin and identity, in present time and space. Such a name of God seals the unity of God and Father: *I am that I am* is the name of the Father. The Father, says Derrida, is what is. The question 'What is?', is always: 'What is the Father?'. This is an entity in the sense of both being and presence. Such a being of the Father is 'Truth completely present and full of Logos' (Derrida 1972: 192), 'full and absolute presence of being' (ibid.: 193). Being as an indication of presence ensures a centre, 'a fantasy of control', 'a consciousness of an ideal *maîtrise*' (ibid.: 391). Derrida doesn't like this God of 'eidos' (of the signified and the presence), and he goes back as far as ancient Egypt to find a God of *différance* (Thot). *Différance* and *Ecriture* (writing) are patricide (ibid.: 189): the disappearance of 'eidos' and the appearance of Plato's 'epekeina tes ousias' behind being and presence (ibid.: 193).

How could such an anti-difference God portend the Exodus? Indeed, the God who presents himself to Moses had no such name. EHIE means in Hebrew: *I will be*, or *I will become*. The verb 'to be' and the verb 'to become', contrary to European languages, are the same one in Hebrew, and this verb is here employed in the future tense. The name of God, at this initiatic moment, presents itself as an entity without a centre, without certainty, without origin, without presence – and not present. EHIE signifies absence of identity, future without content. It reflects, expresses or invokes different aspects of wandering: movements from place to place, from one time to another, to a time without a present or a presence, to a future with no prescribed content. The repetition within the name, far from fortifying a tautology, portrays a double transformation, a double movement. This name suggests a repetition as a 'movement by which the presence of the being is lost' (Derrida 1972: 195). EHIE ASHER EHIE is a future departure leading to another future departure with no resting point or destination. It indicates a movement of desire with no objective, no destination. Any fantasy that occupies the place of the object of desire of the first *I will be/become* is expelled by the second *I will be/become*. The repetition itself traces a chain of future distances, and thereby evacuates any fantasy objects.

I will be/become that I will be/become appears only once in the Bible, and

it reduces itself to only one *I will be/become* in the next sentence, a contraction in which I see an allusion to the cabbalistic idea of contraction as a principle of creation (in Hebrew: TSIMTSOUM).

Being and becoming, although coinciding in Hebrew, are incompatible in French and English. To indicate this conjunction should have been in fact a painful dilemma for translation. But, the total abolition of becoming and future from this name is a criminal displacement, worthy of Freud's statement: 'In its implications the distortion of a text resembles a murder: the difficulty is not in perpetrating the deed, but in getting rid of its traces' (Freud 1985: 283). The idea of *différance* is embedded in this word EHIE already, before being inscribed by its repetition. *I will be/become that I will be/become* also means *I will become another then I will be*. The double *I will* is an anticipation of transgression and a transgression of anticipation.

This name implies a complicated 'postmodern' discourse all by itself. 'The dimension of subjectivity is inaugurated in Postmodernism through the subject *qua* emptiness of the substance' (Žižek 1991: 67); the post-modern discourse evolves around the search for a space without presence which inscribes traces of time without present and the 'ex-centring' of subjects and objects leading to the idea of endless nomadism.

The idea of *I am* is precisely what the name EHIE eliminates, and it is no wonder then, that a God called *I will be/become* appears at this highly symbolic moment of the onset of nomadism and inverted exile. He also appears in a place which is a kind of *no place*. Moses, who is already in the desert, which corresponds to a representation of a no-place fit for an emptying of identity and a rupture of historic or organic continuity, opens a distance from the desert, to meet God 'behind the desert' (or as the English text says, 'at the backside of the desert' (Exodus III.1).

This fatal abolition of the dimensions of future and becoming from God's name constitutes, in my view, not only a displacement of *différance* by present and presence, but also a forclusion[1] of a feminine dimension which I have called *matrix*, and an exclusion of certain transformational processes linked to it, which I have called *metramorphosis*.

THE BECOMING THRESHOLD OF BORDERLINES

I have proposed the concepts *matrix* and *metramorphosis* to conceptualize femininity in representation, in subjectivity and on the symbolic level (Lichtenberg-Ettinger 1992; 1993b). The structure and processes of the prenatal stages in their encounter with the feminine are viewed as models for unconscious processes within a *matrixial stratum or subjectivization* concerning borderlines, limits, margins, fringes, thresholds, links and transformations of the co-emerging *I* and *non-I(s)*.

Intra-uterine fantasies in adults or children point to a primary recog-nition of an outside to the *me*, which is composed of the inside of an-other

(the womb – the *matrix*). In my view, these are traces of *joint* recordings of experience relating to feminine invisible bodily specificity and to late prenatal conditions, emanating from joint bodily contacts and joint psychic *borderspace*. I have hypothesized that a certain awareness of a borderspace shared with an intimate stranger and of a joint *co-emergence in difference* is a feminine dimension in subjectivity. Such awareness alternates with that of being *one*, either separate or fused.

The matrixial awareness accompanies us from the dawn of life and is traced in the psyche by primitive modes of experience-organization in terms of readjustments and retunings of sensorial impressions. *Affected time–space–body instances* induce psychic events and traces corresponding to an archaic level, and the concepts of *connectivity* and the *sub-symbolic*[2] suggest a way of conceptualizing the organization of the *matrixial stratum of subjectization*. From the matrixial angle, subjectivity is an encounter in which partial subjects co-emerge and co-fade through continual retunings and transformations via external/internal borderlines and borderlinks. I took the intra-uterine meeting as a model for processes of change and exchange, of *relations-without relating*, in which the *non-I* is a *partner-in-difference*. In the *matrix*, we can speak of the co-appearance of *partial subjects* which can also be simultaneously seen from a phallic angle as 'entire' subjects or as one another's object. A matrixial encounter engenders diffused traumas, traces, pictograms, fantasies and unconscious connections and readjustments in both its partners.

Archaic encounters in the *real* create mental counterparts. The partial subject-to-be, i.e. the *post-mature* infant in the womb during the latest prenatal phase (in whom, according to Winnicott, fantasy life already appears), has a certain awareness of the matrixial affects and sensations which will find their place in the *après-coup* inside the network of subjectivity. I see the *matrixial stratum of subjectivization* (for both sexes) as a joint feminine and prenatal psychic zone, i.e. latest intra-uterine prenatal events and the *female bodily invisible specificity* inscribe human sub-symbolic traces which are discernible, which can be used in inter-subjective processes of exchange and transformation, and which filter into the ulterior developmental phases, potentially creating symbolic traces in the *après-coup*.[3]

On the symbolic level, I see in the transformations in both *I* and the *Other* (in terms of the transgression within the borderline feminine/prenatal zones) an archaic creative process.[4] The diffuse readjustments of *distance-in-proximity* between partial subjects emerge from their links. Sometimes the *I* is phallic – alone or fused with the other phallic *non-I(s)*; at other times the *I* is matrixial – a partial subject in a *matrix* of *I–non-I*. The matrixial and phallic strata do not only moderate each other, they also alternate constantly in relation to the same objects or events, and the same object can be phallic at one moment and matrixial in the next. In a

matrixial perspective, the focus shifts from separate elements or subjects towards the *borderlines*, the *borderspace* and the *borderlinks* between part-objects and partial subjects, and towards the processes of transformation which take place jointly by means of these borderlines/space/links.

The *matrix* is not a physical organ but a concept and symbol that points towards the *real* and invokes imaginary 'feminine' structures. The womb, which is the primary meaning of the word *matrix*, is generally held to symbolize a mythical area of undifferentiated archaic sensations, prior to subjectivity and outside any symbolic order; an invisible passive space of origin. Chora, in the work of Kristeva, and the 'figure-matrice', in the work of J.-F. Lyotard, follow Plato's concept of Khôra, which signifies an original receptacle outside of the realm of the symbolic. 'The figure-matrice: not only is it not seen, but it is no more visible than it is readable' (Lyotard 1985: 278): it cannot be expressed in words or in images. In these concepts, the feminine and maternal keep their traditional significations of passivity, invisibility and exclusion from the symbolic universe.

I consider the *matrix*, on the other hand, as a symbol of the recognizable traces of sub-symbolic operations. The *matrix* is an assemblage or a zone of encounter of a particular kind, different from the idea of the one-sided position of the passive receptacle. In the *matrix*, a meeting occurs between co-emerging *I* and unknown *non-I*. Neither of them assimilates nor rejects the other, and their energy does not consist in either fusion or repulsion.

The internal *non-I* is defined, in our culture, from biology and through immunology to psychoanalysis, as negative and threatening to the *I*. Further, the hostile foreign but internal body, like sickness, psychosis or virus, is what is constructed as *non-I*. I take the intra-uterine meeting as a model for human subjectivizing processes which reflect multiple, plural and/or partial strata of subjectivization whose elements recognize each other without knowing each other, and in which the *non-I* is not an intruder. When *I* and *non-I* become acquainted with each other, it is then that mechanisms of identity and comparison, assimilation or repulsion may come into operation, and the participants will partially or incompletely leave the matrixial *becoming* symbolic plane and move to a phallic symbolic plane. In the case of human psychological development for example, they will leave the prenatal feminine *matrix* to become subjects or separate elements that relate to each other according to patterns known as autism or symbiosis, which in my view are already phallic patterns.

The *phallus* signifies *all and any demanded object*, the whole of the field between demand and desire. The *phallus* conditions desire; it is 'the mailman who introduces the object of desire' (Lacan 1961–2: 9.V.62). Lacan claims that even the maternal object – the breasts – are a *phallus*, and indeed we have to agree that inside the existing psychoanalytical paradigm, any object is phallic. I have elaborated this subject in the first three chapters of 'Metramorphic Borderlinks' (Lichtenberg-Ettinger

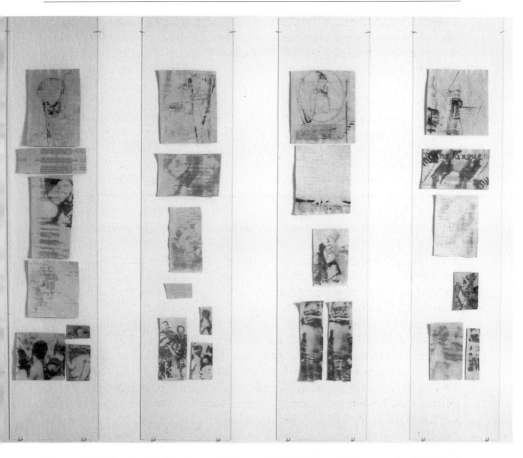

Figure 3.1 Bracha Lichtenberg-Ettinger, *Matrixial Borderline nos 1–4*, 1990–1 (all works: indian ink, xerox, charcoal, pencil, pastel, paper, plexiglass and wood frame – 160 × 35 cm each).

(forthcoming)). In my opinion the *phallus* does not cover the whole of the symbolic network and all the possible attitudes towards the Other and the object; under a certain prism, the breast may be perceived as either phallic or matrixial.[5]

The *matrix*, then, symbolizes more than one and less than one partial subjects, part-objects or fragments and elements,[6] their joint borderspaces, and the range of subjectivizing contacts – borderlinks – between them, known and not-known, but discerned and discerning, with neither assimilation nor rejection. The *matrix* is an engraving of various traces of the feminine bodily specificity in the *real* (and also those of the foetus) in its passage from the sub-symbolic on to the *symbolic*. At the same time, as a model it implies a special connection between the *I* and the stranger/

Other on the cultural or sociological level, and not only in psychoanalysis. The *matrix* suggests ways of recognizing the Other in his/her otherness, difference and unknown-ness.

When I speak of the unknown Other, this can mean: the Other who is not known by 'me' (an Other as a subject) and unknown elements of the self and of the Other – the Other as a partial subject, a part-object, a Lacanian *objet a* (*objet a* is the object of desire, object of the phantasy). In other words, the *matrix* is a symbol for emerging composition of *I* and *non-I(s)*, of partial or potential self and not-selves which while in co-existence and co-emergence are unknown or anonymous to each other. In a matrixial way, on the social level, some-selves discern one another as *non-I* without aspiring to swallow one another in order to become one or the same, without abolishing differences to make the Other a *same* in order to accept him/her, and without attacking and expelling so that only one of them can occupy the physical/mental territory.

By elements, partial subjects or internal part-objects, I mean not only fragments of a lost, broken 'whole' fighting their way into the *symbolic*, but also the 'holes' in a discourse, and the borderspaces around imaginary or real fragments. The borderlinks are metramorphic. Even if the models for this plural or fragmented and shared subjectivity are the culturally and *individually* archaic repressed prenatal state and the invisible feminine womb, being in touch with their traces is not pathological.

The *matrix* implies links between the feminine aspect of subjectivity and unknown others. I have called the various processes of change and exchange that occur in the *matrix*: *metramorphosis*. It deals with relationships that are asymmetrical and not mirroring one another; with the co-emergence of several elements or (partial) subjects together; with influences without domination of one over another. It deals with transformations in emergence, creation and fading-away, of *I(s)* and *non-I(s)*, and with transformations of the borderlines and transgressions of the links between them. *Metramorphosis is the becoming-threshold of borderlines.*

Metramorphosis is an out-of-focus passage of non-definite compositions along *slippery borderlines becoming thresholds*, which transform together but differently, allowing relations-without-relating between the *I* and the unknown *non-I*. In its function as a passage to the *symbolic, metramorphosis*, acting from the matrixial borderspace to create and redistribute traces of joint transformations in the encounter, does not follow the routes of male Oedipal *castration*. Passing through the filter of the symbolic *matrix, relations-without-relating, difference-in-togetherness* and *distance-in-proximity*[7] between *I* and *non-I* become non-phallic, meaningful, psychological processes. When a matrixial alliance or covenant is created between the *I* and the unknown stranger(s), their fields change and expand *via* their borderlinks. From an ethical prism, in the matrixial stratum of subjectivization there is no *I* without an unknown *non-I*, since *subjectivity*

is an encounter with the Other. *Metramorphosis* accounts not only for transformations of several aspects, several part-objects or partial subjects together, but also for transformations of objects that are shared by several subjects, partial or not. *Metramorphosis* not only is the *effect* of joint investments by the *I* and the *non-I* in one another and in a shared borderspace, but it also constitutes a primary dimension of all matrixial configurations, in which elements are effected *via* links. *Metramorphosis* alternates between memory and oblivion, between what is about to be and what is already, between what will be and what will become possible, between what has already been created and what has been lost. *Metramorphosis* has no focus, it is a discernibility which cannot fix its 'gaze', and if it has a momentary centre, then it always slides away towards the peripheries. In such an awareness of margins, perceived boundaries dissolve in favour of new boundaries; borderlines are surpassed and transformed to become thresholds; limits conceived but continually transgressed or dissolved allow the creation of new borderlines, thresholds and limits. *Metramorphosis* accounts for transformations of in-between moments. These becoming-symbolic inscriptions are different or escape from the phallic symbolic inscription.

The *matrix* gives meaning to a *real* which might otherwise pass by unthinkable, unnoticed and unrecognized. Glimpses of future without present are connected to anticipated futures; processes of becoming are connected to broken memory; *matrix* is a zone marked by alliances between *I* and *non-I* in the midst of becoming and emerging, or eclipsing and fading away. It is a zone of encounter between the most intimate and the most distanced unknown. Its most internal is an outer limit, its outermost is the inner limit, and the limits themselves are flexible and variable.

As a psychological stratum of subjectivization, *matrix* precedes postnatal symbiosis. I would suggest that the human being arrives at symbiosis equipped with a certain awareness of the distinction between the *I* and the *non-I* and with a certain recognition of a matrixial shared space, with investments in the *non-I* and in the shared space; and that both *I* and *non-I* are somehow accessible in their difference from that same moment in which any accessibility of the *I* is possible.

The matrixial stratum of subjectivization continues to operate alongside and subsequent to symbiosis, and it can be recognized by the human subject not only in states of regression but also by retroactive psychological moves. Acknowledgement of other subjects as unknown but not hostile or intrusive foreigners, and as nevertheless connected to the self, in a way that turns both the self and the other into partial subjects taking part in and producing change in a *common shared subjectivity* (multiple or partial) through neither fusion nor rejection, differentiates the idea of the *matrix* from the idea of symbiosis and from phallic Oedipal ideas.

The woman experiences the *matrix* in a double manner: first, like the

Figure 3.2 Bracha Lichtenberg-Ettinger, detail from *Matrixial Borderline no. 3.*

male infant, *in* the womb and at the level of psychic development appropriate to this stage; and second, as someone who *has* a womb, at various levels of maturation and consciousness and whether or not she is, or becomes, a mother. This second kind of experience, linking late fantasies to early archaic ones, retroactively gives meaning to the early phase and might facilitate awareness of a whole range of internal and external phenomena. In other words, feminine sexual difference connected to bodily specificity allows women a doubled access to the *matrix*, and this reinforces the link between the symbolic *matrix* and women, but the *matrix* is not reserved to women only. As I said, *matrix* is accessible not necessarily through regression to earlier stages of development, but as a retroactive recognition of early traces through later experiences. It creates an-other way of sublimation and it belongs to the general human symbolic network.

 This retrospective access to the general human latest prenatal/feminine encounter is facilitated but not conditioned by the fact of having a womb. However, this potential facility for access puts women in a privileged

position with respect to this stratum of subjectivization; this is one of the reasons why I see the *matrix* as feminine. This doesn't mean though that having or not having a womb determines different ways of recognition, since the *matrix*, as a symbolic filter that is different from the *phallus*, is at the disposition of both sexes. Other reasons why *matrix* is a feminine dimension derive from conceptual considerations, from its differences from the concept of the *phallus*. Phallus is for Lacan a neutral concept, equivalent to the concept of the symbol itself. In my view, the *phallus* is a masculine concept that should not monopolize the whole symbolic network (Lichtenberg-Ettinger 1992: 176–208).

Through the notion of the *matrix*, feminine otherness connects with the idea of multiple or fragmented subjectivity which is *normal and not schizo- phrenic*. *Matrix* allows the symbolization of prenatal processes, but also of certain aspects of postnatal, pre-Oedipal strata of subjectivization. It allows acknowledgement of the difference of the other on the inner psychic level, on the level of object-relations and on the external social-political level. This concept deals both with early recognitions of invisible differ- ences recorded in the psychological space and sub-symbolically registered in a non-phallic way, and with the repressed difference of feminine sexuality from the perspective of the woman.

Lacan points out the connection between the problematic nature of the topic of femininity and the question of creation and procreation and how both of these elude the *symbolic*. The feminine, when it is not described in terms of sameness and/or opposition to the *phallus* – the favourite position of the early Lacan – is what escapes it and is *missing* in the *symbolic*. For Lacan, it is impossible to formulate an-other symbolic sphere and '*the* woman', as a different, collective Other dimension, 'doesn't exist and does not signify anything' (Lacan 1975: 69). According to this theory, the subject, female or male, cannot recognize the ephe- meral part-objects and object-relationships which belong to the *real* and are related to the feminine. The feminine is associated with anxiety, with the fear of falling into pieces, of becoming a devalorized and damaged object, and of psychological disintegration resulting in undifferentiated and amoebic or fragmented, archaic condition. Otherwise she is either the *Thing par excellence*, pure object of *jouissance*, or the Other *par excel- lence*, in its eternally escaping aspect. She is in both cases completely inaccessible to both man and woman (Lacan 1968–9), compared in that only to procreation and to death, and on a less natural level, to the mysterious aspect of sublimation.

Lacan says that in the *symbolic*, nothing explains creation. By means of the concept of the *matrix*, I would like to point to the connection between the question of femininity and the questions of creation, procreation and sublimation, not as topics whose symbolization is condemned to absolute perpetual failure but as interconnectivity that rises to the symbolic surface

Figure 3.3 Bracha Lichtenberg-Ettinger, detail from *Matrixial Borderline no. 4.*

by *metramorphosis*, by out-of-focus *passages* from non-definite compositions to others. Interior and exterior phenomena that have gone through matrixial passages can be analysed and symbolically recognized following the paths of sublimation.

For Lacan, *phallus* equals *symbol*: what doesn't obey the phallic principles cannot be apprehended or recognized. I would suggest that we do not accept the axiom *phallus* = *symbol* and that some paradigmatic changes are in order: the *symbolic* is wider than the *phallus* and non-phallic processes do find symbolic expression. In the existing paradigms, however, these are not recognized as such: they are ignored or rejected. If, according to Lacan, the human being is trapped in language, I would like to add that the human being is trapped in *the language of the phallus*. In this trap, the two sexes are totally 'equal', but, unfortunately, the whole symbolic universe is unbalanced, being seen as only phallic! This trap attests to a lacuna in psychoanalytical theory, to the incapacity to distinguish the *matrix* and to account for it. Symbolic disavowal of matrixial elements in favour of phallic elements repeatedly occurs in analytical interpretations (Lichtenberg-Ettinger 1993a: 182–3).

As a logical structure, it is possible to think of the *matrix* through the minus sign: *matrix* as what our phallic consciousness cannot attain, or as *symbol* minus *phallus* . But such a negative definition, hinted at by Lacan in the 1970s, is not sufficient; it falls into the traditional trap of phallic culture. The symbol of the *phallus* can be seen as dealing with reality from the perspective of whole objects, unity, the equal, sameness, one-ness, Oedipal castration, totality and symmetry, with unconscious processes of metaphor and metonymy that regulate the symbolic systems and fit the Oedipal stage (and also the pre-Oedipal stages in Lacanian description). This perspective, however, cannot be seen as the only possible one.

If the *matrix* points to *what is not reducible to one* and what does not 'yearn' for the *one*, then this is because it never was One. Its 'lost' objects are multiple and partial, they never had a single value and they do not stand 'alone' in the Unconscious. It deals with multiplicity, plurality, partiality, asymmetry, alterity, sexual difference, the unknown, encounters of the feminine and the prenatal in their passage from the sub-symbolic to the *symbolic* and processes of transformation of several elements in co-existence, with continual tunings of borderlines, limits, and thresholds between the partial subjects in co-emergence. The *matrix* – as symbol for temporary subjectivity comprised of elements that are partly *I* and partly *non-I*, partly known and partly unknown, that are in a process of change under the half-open eye of an unfocused (un)consciousness – designates a non-phallic *real* and evokes an imaginary dimension that is supplementary to the *phallus* as well as non-phallic desire and sublimation. At the symbolic level, the *matrix* is no more feminine than the *phallus* is masculine: it is a mark of difference. It concerns the symbolic network that is culturally shared by men and women. The vicious circle in the Lacanian paradigm by which the phallic is defined as the *symbolic* and the *symbolic* is defined as the phallic, and by which sexual difference has only one signifier – the *phallus* (either you have it or you don't) – needs to be rotated. The *matrix* is not the opposite of the *phallus*, it is just a slight shift from it, a supplementary symbolic perspective. It is a shift aside the *phallus*, a shift inside the *symbolic*.

ANTICIPATION, FUTURE WITHOUT ME, AND BECOMING-WOMAN

Back to the meeting between EHIE and Moses, beyond the desert – God refers to this encounter using a word which designates event, meeting and chance (NIKRA) (Exodus III.18) – a text in which a symbolic matrixial pattern is interwoven. Some of its aspects are waiting to be interpreted, some were lost in the translation, some were denied and repressed (Freud's famous *Moses and Monotheism* plays a role in this denial). Not only the future and the becoming have disappeared from the text, but in the

next sentence another name of God, IHVA, present in the text but forbidden from speech, does not always appear. In some translations this name disappears without leaving a trace. Even coming from God, the idea that a written word might be excluded from speech was perhaps too heretical to handle, so this name, which carries another transformation concerning being in time, was sometimes suppressed, and in any case unlike the name EHIE, this second name is not translated and therefore its special connection with time and presence remains enigmatic.

Mythological travellers' tales are analogous to psychological experiences, to identity transformation, to artistic processes and works, to aesthetic experiences, and to patterns of cognition. It is through their power to evoke all of these that such tales are constituted as mythologies. Different internal apparatuses reflect them and are reflected in them in return. This matrixial travellers' tale is a beforehand glimpse at a forthcoming inverted exile. EHIE leads us to thinking together anticipation, becoming, and 'future without me'. 'For the *I* to preserve itself, the identifying agent [first of all, in my terms, the mother as a *non-I* in its relationship to an *I* of the baby, and later on the identifying agent of the *I* of the baby] must invest the identified [the identified agent of the *I* of the baby], and the *becoming* of this identified' (Aulagnier 1979: 25). The function of anticipation of the *I* about the *I* and for the *I* is at the centre of the human project of identification and even of self-preservation.

The being of the *I* as a becoming opens in the psyche the category of temporality and of difference in its most difficult aspect: 'the difference of self from self' (ibid.: 22). It is the task of the *I* to become capable to think its own temporality and to be able to invest what the flux of time imposes on it as a difference between itself and *itself*. For that, *I* must be able to think, anticipate and invest the space of future-time. One of the difficulties of such investment lies in the realization that accompanies it, namely, that in this future time/space, the *I* may not be alive.

In a matrixial stratum of subjectivization, first prenatal, then in co-existence with a symbiotic stratum during the first postnatal period, the maternal *non-I* is in charge of the anticipation of the *I*. 'The *I* was first an idea, a name, a thought spoken by the discourse of the other [the mother].' For a certain time, 'the *I* leaves to the other . . . the task of investing its own *time to come*' (ibid.: 24) by anticipation. Contrary to Aulagnier, I see no reason to refer to this process as beginning only after birth, neither do I see a reason for considering the first object relationship to be oral. The first matrixial meetings between *I* and *non-I*, just like the symbiotic meetings, are retroactively accounted for by later symbolization. This retrospective aspect of symbolization allows access to the prenatal. The moment of birth doesn't have to present a mental barrier. The effects of anticipation in the maternal response during the prenatal period are crucial for later developments. In psychoanalysis we usually consider that the first pleasurable

experience is the contact between the mouth and the breast. My analytic experience leads me to emphasize the earlier object-relationship focused on *touch* and the *enveloping surface of the body*.

The maternal *I* is first investing in an *idealized I* of the child which gradually is transformed into a *future I* to which the *I* of the child can become. A *metramorphosis* takes place in which, while the investment of the maternal *I* is transformed from the *idealized I* to the *future I*, the *I* of the subject *becomes*, enters temporality, and gradually takes upon itself the anticipating function. At first it is a *non-I* which assumes the *I*'s relationships with reality, with the exterior. 'The maternal discourse and desire anticipate the space of the *I*' (Aulagnier 1979: 111). These are the very conditions for the emergence of the *I*.

In the biblical text, such an aspect of anticipation first reveals itself as *différance* within God's name between himself in the future and himself in the more distant future. It then extends to the relationships between God and Moses, and from there to the relationships between Moses and the Children of Israel. God's answer to Moses 'I will be with you' rolls over to become God's name directed to Moses. This name of God rolls over to a reduced one directed through Moses to the Hebrew people, and is exchanged for a written name not to be pronounced. The wandering will stem from these transformed names, from text and law which are rifts in the organic sequence. It is this kind of rolling and transmigration, which occurs in a text and reflects an encounter, that stems from one situation to a series of other situations and that turns a simple event into a ceremony of initiation.

Freud deals with the ambiguity in the figure of Moses, with the duality of God's name; IHVE (YEHOVA) and ELOHIM (Freud doesn't deal with EHIE) and with the regrouping tribes of vagabonds and migrants, which will be the people of Israel, by means of the mechanism of a split: splitting the people into two kinds of tribes; splitting God into two different Gods; and mainly, splitting Moses into two different persons – an Egyptian and a Hebrew, the first of them being the 'true' Moses and the other one being denied. The Egyptian Moses penetrated, 'stooped to the Jews' (Freud 1985: 286) and 'forced his faith' (ibid.: 288) upon them. Freud sees the text of Exodus as a 'piece of imaginative fiction' (ibid.: 272), a cover-up story, and looks for a truth that is not included in the story's signifiers but in historical research; a truth that was hidden there before the text covered it up.

In contrast to seeing Moses as one side of a split figure, I would also suggest that Moses is not only a paternal but a matrixial figure as well, doubly a stranger. The borderlines of his double internal and external foreignness, and of his double internal and external affiliation pass through *metramorphosis*: these two identities partly melt away, their borderlines become thresholds for a nomadic 'becoming' identity that assembles together different *I-non-I* aspects.

The maternal *non-I* 'furnishes the *I* to become, right from the beginning,

with signals of exteriority and difference in relation to the *I* of the mother'
(Aulagnier 1979: 113), and then in relation to her/himself in the co-
emergent *matrix*. Similar to the way in which a matrixial meeting composes
the psychological becoming of the *I* and *non-I*, a matrixial meeting be-
tween AHYE and Moses creates the becoming of a future new Jewish
identity through a *metramorphosis* in which both God and Moses are
transformed.

I see the process of anticipation as first of all matrixial, and not as oral-
symbiotic. The libidinal investment in symbiosis is either 'love' or 'hate'
directed either towards fusion with the other (seen as an object) or towards
its destruction. In the *matrix*, libidinal investment is directed towards co-
emergence; towards a continuum of creation and disruption in equilibrium;
towards the tuning of processes of separation without rejection and close-
ness without fusion. This means that circulation of anticipation can be a
metramorphosis, in which processes of transformation and readjustment of
each element and of the borderlines between them maintain a dynamic
of passages of 'information' and constant tuning of co-recognitions.

Both for Piera Aulagnier, in the tradition of psychoanalysis, and for
Emmanuel Levinas, in the tradition of philosophy, time is structured by
relationships to the Other. In a book we are preparing together, Levinas
modifies his idea that the woman is the origin of the concept of Otherness,
to a more specific one, saying that 'The feminine is that incredible thing in
the human by which it is affirmed that *without me the world has a meaning*'
(Levinas 1993: 17). The feminine is the possibility to think that there is 'a
reality *without me*' (ibid.: 21); the feminine is the access to a future without
me. Thus, future time is structured by a 'feminine' relationship to the
Other. EHIE is such an expression of the idea of the future as what is
absolutely without me to which *I* relates without relating. Through the
name EHIE a feminine side of God is revealed at the heart of this
mythological moment.

Through the *matrix* the *I* invests her/himself in a future in which s/he
might not be. For Piera Aulagnier this is the position of the maternal *I* in
relation to the *I* of the child; for Levinas this is the maternal position itself,
taken as a model for the feminine category of the subject. In my terms, the
metramorphosis that keeps circulating the difference of the future,
between the *I* and the *non-I*, has to deal with the extreme situation of the
death of one or the other. This extreme event is for Levinas the basis of the
feminine category: dying by giving birth. But, in the future dimension of
the *matrix*, a reference to co-existence is always maintained. The *matrix*
deals with anticipations of that which is not yet, as well as of that which is
no more.

Being structured by human relationships, the matrixial future and be-
coming dimension differs from futures like those proposed by Baudrillard
or Toffler. It allows hope in the future without Utopia and anxiety about

the future without Catastrophe. In the initiatic ceremony of Exodus, God first presents his name EHIE as a guarantee of a matrixial alliance with Moses, as a promise to be together with him in a common multiple dimension. The first exchange between God and Moses echoes the position of a child turning towards its mother to discover who s/he is, and of a mother responding to his/her need by reassurance, rather than of a father supplying information about identity. At the same time, EHIE signifies space without centre, future without objective, and this is reflected in Moses' fate. Moses will be *the wanderer* who will not attain the promised land, he will be the anticipating agent of *metramorphosis*. He will bring the people to the country but he will not enter (Numbers XIII). God says to Moses: 'Yet thou shalt see the land before thee; but thou shalt not go thither into the land which I gave the children of Israel (Deuteronomy XXXII.43). In this aspect, Moses corresponds to Levinas's feminine dimension in the human. He is not only the law-transmitter in the name of the Father, but also the matrixial figure who consciously leads the people towards a future in which he will not be.

As I have already said, EHIE signifies, as well as *future I*, the *becoming I*. EHIE as becoming indicates a process of desire without an object. A desire in a zone of proximity and co-presence of heterogeneous multiple dimensions in symbiosis is suggested by Deleuze and Guattari as the *idea of becoming*. Becoming, like molecular movement, is 'behind the threshold of perception' (Deleuze and Guattari 1980: 343), but perceivable for desire. Such becoming is indifferent to past and future, it has no memory; 'a line of becoming has only a middle' (ibid.: 360) and it passes between elements without binding them. Matrixial co-emergence is different from such a *symbiotic* heterogeneous co-existence, but such an idea of becoming is relevant to the matrixial connection between EHIE and Moses. Deleuze and Guattari's 'becoming' is always a woman, as long as the woman is the embodiment of (social) exclusion. 'All the becomings are *minoritaire*' (ibid.: 356) and they all 'start with and pass through the becoming-woman [devenir-femme]'. Becoming-woman 'is the key to any other becoming' (ibid.: 340) and sexuality is a becoming-woman for both sexes.

Whether a feminine 'future' dimension is essentially connected to women, or whether it is only a cultural and historical fiction would not change the fact that through its abolition, it is the feminine which is expelled. Similarly, we don't have to believe in God in order to argue the central cultural and historical importance of God's name. In a culture for which the Father is what is, present and presence, the promotion of present and presence at the cost of the expulsion of future and becoming (considered, wrongly or rightly, feminine) is a forclusion of the feminine, whether the feminine *exists* or not.

BEHIND THE OTHER OF THE PRESENT

In Hebrew, certain signifiers for time and space are textually in the field of the Other: the same word, or group of words belonging to the same root signifies *after*, *behind*, *later* and *the other* (ACHER or ACHAR) (Lichtenberg-Ettinger 1993b: 12–23). This word is used in the text to designate the meeting place between God and Moses: 'ACHAR HAMIDBAR': which means *behind* the desert, *after* the desert but also, the *Other* of the desert. In the formal translation: 'The backside of the desert' . . . Both the *other* and the displacement in future time have thus disappeared from the text in favour of a choice which indicates inclusion both spatially and temporally (back).

The signifier *desert* in Hebrew (MIDBAR) can mean: the space of the thing/object and/or the space of the speech/word (DAVAR). (The word commandment (ten commandments) comes from the same root.) It is through this signifier 'desert' (MIDBAR), that an impossible meeting between the word and the thing, the symbolic and the *real* (in Lacan's terms), occurs.

If the desert is already the empty space, a space for emptying identification and for escaping from it, a space of wandering in which 'nothing strikes root' (Jabès 1991: 256), as well as the signifier of this impossible place of meeting between the *real* and *symbolic*, what can the *Other of the desert* mean? In my painting I have gone back again and again to this expression, asking myself what it could mean. If, in the desert as signifier, words and things meet, then in the 'Other of the desert' as signifier, their leftovers might meet. Their leftovers are the *objet a* which is constructed as a hole in the level of the *real*, and whatever is designated as holes in The Other = *A* (which is defined at the level of the *symbolic*). Such a meeting, in the framework of Lacan's theory, cannot exist, any more than could the meeting between *real* and *symbolic*. If it could, it could have taken us to the heart of the problem of feminine difference, where the feminine is what is expelled from the *symbolic*, what is a stain in the *imaginary*, and what is a hole in the *real*.

For Lacan (in the 1970s), the feminine, or *woman* (as an abbreviation of representations of the feminine) occupies several paradoxical positions. She is the *Thing* but also a hole in the *real* (*objet a*) – 'The woman doesn't exist' (Lacan 1975: 69). She is also the Other ('The Other, in my language, can therefore only be the Other sex' (ibid.: 40)), but when by Other is designated the 'treasure of signifiers' (Lacan 1968–9: 26.III.69), she is also the hole in the Other: 'The woman doesn't exist and doesn't signify anything' (Lacan 1975: 69). Furthermore, when she is put in one of these positions, they cannot reach one another, and she, as a subject, cannot reach them. 'Is woman', asks Lacan, 'the Other, the place of Desire which, intact, impassable, slips under words, or rather the *Thing* [*La Chose*], the

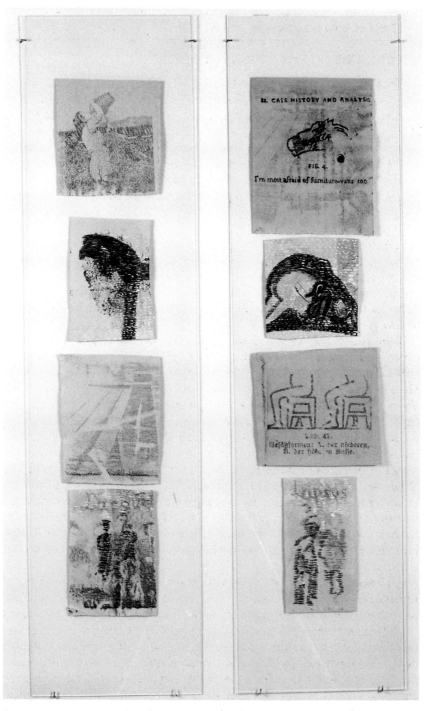

Figure 3.4 Bracha Lichtenberg-Ettinger, *Case History and Analysis nos 1–2*, 1985–91 (135 × 35 cm each). Collection, Museum of Modern Art, Oxford.

Figure 3.5 Bracha Lichtenberg-Ettinger, detail from
Case History and Analysis no. 1.

place of *jouissance*?' Woman is, he replies, a 'lack in the signifying chain, with the resultant wandering objects'. The wandering object is 'this un-attainable woman' (Lacan 1968–9: 12.III.69).

For Lacan, the *real* is that which cannot *be* within language in the symbolic network. Either the *real* is what has been left out in the process of symbolization or it is what has been totally resistant to symbolization. We can consider the *real* as whatever cannot be represented directly by the body in language, such as instincts and impulses. We can also consider it as whatever escapes in the process of human 'entry' into the realm of language, when words are divided into signifiers and the signified, form and content, symbols and images. It can also be described as archaic psychic and psychosomatic events which cannot or have not been symbolized. For Lacan, the *real* is whatever cannot be known

either because of the impossibility of symbolization or as a result of symbolization which establishes the *real* precisely as its own lack.

The woman is sometimes equated with the *Thing par excellence* and sometimes with an *objet a* – a lack in the realm of the *real* which, as we have seen, in itself is a lack in the *symbolic* Other. Alternatively, she is equated with radical otherness: *A*, a remote inaccessible symbolic 'place'. But these two positions cannot meet, since the inaccessible leftovers of each system remain in their own different domains.

Objet a corresponds to the feminine on several levels. It corresponds to the lost primordial symbiotic maternal object, to the archaic mother, to feminine sexual difference, and to the primordial incestuous mother. *Objet a* has no signifier, it is a hole in the Other as the signifier's chain.

The subject is the effect of the passage between the signifiers, and the object is its real price. The loss which is called *objet a* is that aspect or element of subjectivity that is cut from the subject on the symbolic level, and cannot become an object of specular recognition on the imaginary level. *Objet a* is the invisible *par excellence*, it is a remnant of the signified which cannot appear in representation.

Its approaching on the imaginary level produces the anxiety of the *uncanny*, alerting the subject about the danger of its encounter. *Objet a* can only appear at the cost of the disintegration of the subject, at the cost of blurring the borders of separation between object and subject. On the visual field, the *objet a* is something that lacks behind the image: a hole, an absence, a stain (Lacan 1968–9: 30.IV.69). It is also something that lacks in the *real*, which is (as we have said) itself a lack, if measured by the symbolic system. Something lacks in the *real*, says Lacan, only if there is a symbolic system.

The condition for the subject is the *coupure* (a radical cut) from the *objet a*. The subject is the place of the Other as evacuated from *jouissance*. The knowing subject is a hole in the *real*, the *objet a* is a hole in the signifying network. Similarly, the woman is a hole in the signifying network: she is therefore a kind of *objet a*, she is the surplus, the lack of a lack (a lack in the *real*-as-a-lack). She is the *Thing*, the place of *jouissance*. (It is interesting to note that Lacan suggested that the foetus is the mother's *objet a*.)

It seems to me that this 'lack of a lack' is the result of the vicious circle created by defining *phallus* as equal to the *symbolic*, which suggests the concept of man as equal to the concept of subject, and the concept of woman as its impossibility, and implies that a single point of reference dominates the entire register of the relationship of the *sexuée* (Lacan 1968–9: 14.II.69). This is a vicious circle which defines all the *symbolic* by the *phallus* and vice versa, since the *phallus* is also a signified which lacks, a signifier without a signified. Even the *objet a* is, in this paradigm, a phallic lack.

The concept of the *matrix*, this *symbol* minus *phallus*, creates a passage-

way in which sexual difference, differences in general, and their border-lines are circulating differently. The threatening, psychotic *objet a*, the frightening encounter with feminine difference and with the archaic, as they appear from a phallic perspective, may occupy a different area in a matrixial perspective. From the point of view of the *matrix* also, encoun-ters between *objet a* and the subject can be sublimated in the Other.

This might resolve two paradoxical statements of the later Lacan, the one in which he claims that sublimation keeps the woman in a relationship of love or desire of the Other at the price of her constitution at the level of the *Thing* – this insists upon the necessary of separation between Other and *Thing*, and the second, in which he claims that sublimation, considered from the perspective of the feminine, is the highest elevation of the *Thing* – which implies a meeting between Other and *Thing*.

If the *real*, as well as the *objet a* which is a lack in the *real*, are both created by the field of the Other, as Lacan thought in 1969, the encounter of the *real* with the *symbolic* or with the text is impossible since the symbolic system creates the *real* as evacuated from it and creates itself precisely as the evacuation of the *real*. The *real*'s resistance, or insistence, can be discovered in the *symbolic* in an inadequate way by the repetition of the signifier. Such a repetition might be a sign of the failure to sublimate the *objet a*. *Objet a* is inaccessible to phallic knowledge since such knowl-edge is defined as its disappearance, and is also defined as the only possible symbolic knowledge.

For Lacan, *objet a* is 'extimate'; the subject is its other side. The *objet a* as extimate is a notion joining the intimate to radical exteriority. This means that the rejection of the *objet a* in the process of constitution of the subject happens through inclusion within the subject of this rejection. Thus the extimate *objet a* is both rejected from, and included within, the subject. Unlike a foreign body, a virus, *objet a* is not destroyed, but extimated. We can imagine it as waiting inside like an encapsulated psychotic time bomb.

The subject itself constitutes traces of absence in the symbolic network, traces of passage from one signifier to another. For the later Lacan, subject and *objet a* are two different possibilities of the same structure, two faces of the same entity, and the *objet a* is what the subject is no more; they are each other's negative.

In a phallic symbolic definition indeed the only exit for a lack such as the *objet a* is hallucination and anxiety attack: manifestations of what was forcluded from the *symbolic*. This impasse can be attenuated from a matrixial symbolic perspective, where *I* co-emerge with an-other.

In this biblical text we can give an example of a *metramorphosis* which relates to a circulation of a lack, a lack of speech. God would like Moses to speak to the people as God speaks to Moses, but Moses doesn't know how to speak. This lack becomes a creative principle through relational ana-logy. That which lacks in Moses will be expressed through Aaron, who

Figure 3.6 Bracha Lichtenberg-Ettinger, *Mamalangue – Borderline Conditions and Pathological Narcissism no. 5, no. 7*, 1989–91 (122 × 40 cm each). Collection, Le Nouveau Musée, Villeurbanne.

Figure 3.7 Bracha Lictenberg-Ettinger, detail from *Mamalangue no. 5.*

joins the *matrix* through this lack, and by virtue of his difference from Moses. Aaron will be in the same position with respect to Moses as Moses is to God, and the lost speech finds its place in a *matrix* at the same time that it participates in its emergence (Exodus IV.15–16).

Indeed the emergence of the *I* entails loss, and so does the co-emergence of *I* and *non-I*. These losses are not denied by the symbolic network of the *matrix*, but within a matrixial network, what is lost to the one can be inscribed as traces in the other, and *metramorphosis* can allow the passage of these traces from *non-I* to *I* in the enlarged stratum of subjectivization. As both parts of the same stratum, traces belonging to *I* as well as to *non-I* can be redistributed anew after their initial distribution, the borderlines between what one has and what one has lost, becoming therefore, thresholds.

Thus the expression 'behind the desert', which signifies metramorphic sublimated relationships between 'leftovers', conveys in this mythical

moment a matrixial space, a subjectivity composed of 'I will be/become', and of a double foreigner, a space suitable for an initiatic ceremony of wandering and for future *metramorphoses*.

NOTES

1 In Lacanian psychoanalysis, forclusion means an expulsion from the symbolic network or an a priori non-inclusion in the symbolic network. This is the primary psychotic defence mechanism whose status can be compared to that of the repression mechanism in neurosis. See Lacan, J., *Les Psychoses*.
2 Sub-symbolization and connectivity refer to relational organization with no need for representations in order to create transformation. See Varela, F., *Connaître, les sciences cognitives, tendences et perspectives*, Paris, Seuil, 1989.
3 We cannot think of the foetus as a *partial subject* in the first months of its life. At such an early stage, as Freud claims, it is a *phallic object* for the mother and, as Lacan claims, it is the mother's *objet a*. The foetus can of course become an object of fantasy for any subject (child or adult, woman or man) at any stage and we can also think of the foetus as a *matrixial object* (not matrixial *subject*). Only when it is post-mature towards the end of pregnancy it also becomes a partial *subject*, an *I* or a *non-I*, a 'potential self' (Winnicott) belonging to a shared stratum of subjectivization. This occurs at a time when different sensitivities are sufficiently developed to serve as a basis for *après-coup* experiences and when, if born, the human being's degree of biological development allows for its survival.

I would like to emphasize that I do not want to expand the notion of the subject to embrace the foetus and that in no way am I denying the women's fundamental right to make decisions about their bodies, including decisions concerning abortion. The feminine prenatal matrixial encounter with the *unknown* external/internal intimate *non-I* is not to be confused with the *maternal/ postnatal* relations of nurture and care for the known, beloved intimate other.
4 For the elaboration of the *matrix* and the *metramorphosis* as aesthetic concepts, see Huhn, R. (1991) 'Die Passage zum Anderen: Bracha Lichtenberg-Ettingers ästhetisches Konzept der Matrix und Metramorphose', in S. Baumgart (ed.) *Denkräum zwischen Kunst und Wissenschaft*, Berlin, Reimer, 1993.
5 For a critical discussion of the concept of the *phallus*, see Irigaray, L., *Speculum*, Minuit, 1974, and Lichtenberg-Ettinger 'Matrix and metramorphosis'.
6 Elements of psychoanalysis in Bion's terms are functions of the personality which are unknowable but have recognized primary and secondary qualities and have sensible, mythical and passional dimensions. See W.R. Bion, *Elements of Psychoanalysis*, Karnac, 1989, pp. 9–13.
7 These concepts are elaborated in 'Metramorphic borderlinks' (Lichtenberg-Ettinger, forthcoming).

REFERENCES

Aulagnier, P. (1979) *Les destins du plaisir*, Paris: Presses Universitaires de France.'
Deleuze, G. and Guattari, F. (1980) *Capitalisme et schizophrénie: Mille plateaux*, Paris: Editions de Minuit.
Derrida, J. (1972) *La Dissémination*, Paris: Seuil.
Freud, S. (1985) *Totem and Taboo, Moses and Monotheism, and Other Works*, [1934] The Pelican Freud Library, vol. 13, trans. Strachey, ed. Dickinson, Harmondsworth: Penguin Books.

Jabès, E., in conversation with Lichtenberg-Ettinger, B. (1991) 'This is the desert. Nothing strikes root here', in *Routes of Wandering. Nomadism, Voyages and Transitions in Contemporary Israeli Art*, Jerusalem: The Israel Museum, pp. 9–16, 246–56.

Lacan, J. (1955–6) *Le Séminaire. Livre III: Les Psychoses*, ed. J.-A. Miller, Paris: Seuil, 1981.

—— (1961–2) *Le Séminaire: L'Identification* (unpublished).

—— (1968–9) *Le Séminaire: D'un autre à l'Autre* (unpublished).

—— (1972–3) *Le Séminaire. Livre XX: Encore*, Paris: Seuil, 1975.

Levinas, E. in conversation with Lichtenberg-Ettinger, B. (1993) *Time Is The Breath Of The Spirit*, Oxford: Museum of Modern Art.

Lichtenberg-Ettinger, B. (1991a) *Matrix et le voyage à Jérusalem de C.B.*, Artist Book (to be found at the Bibliothèque Nationale, Paris; the Museum of Israel, Jerusalem). Excerpt in *Chimères*, no. 16, Summer 1992, pp. 1–24 in G. Deleuze and F. Guattari (eds), Paris: Chimères.

—— (1991b) 'Matrix and Metramorphosis', First published in the catalogue *Feminine Presence*, Tel Aviv Museum of Art, June 1990. Revised article presented at the 5th Kunsthistorikerinnen Tagung, University of Hamburg, 19 July 1991. *Differences*, vol. 4, no. 3, pp. 176–210, 1992.

—— (1993a) 'The Matrix, female sexuality and on one or two things about Dora', in *Sihot-Dialogue. Israel Journal of Psychotherapy*, vol. VII, no. 3, pp. 175–83.

—— (1993b) *Matrix. Halal(a) – Lapsus. Notes on Painting 1985–92*, Oxford: Museum of Modern Art.

—— (forthcoming) 'Metramorphic borderlinks and matrixial borderspace', in J. Welchman (ed.) *Rethinking Borders*, London/New York: Macmillan Academics.

Lyotard, J.-F. (1971) *Discours/Figure*, Paris: Editions Klincksieck.

Zizek, S. (1991) 'Grimaces of the Real or when the Phallus Appears', *October* 58, pp. 45–68.

Chapter 4

Territories of desire: reconsiderations of an African childhood

Dedicated to a woman whose name was not really 'Julia'

Griselda Pollock

> Travellers with closed minds can tell us little except about themselves.
>
> (Chinua Achebe)[1]

> It is not difficult to transpose from physics to politics [the rule that] it is impossible for two bodies to occupy the same space at the same time.
>
> (Johannes Fabian)[2]

THE VOYAGE OUT, AND BACK

Four hundred years after Columbus's notorious voyages in 1492 to the so-called 'Americas', one hundred years after Captain Cook sailed to the 'South Seas' in 1792, that is so say, one century ago, in 1892, a painting travelled from Tahiti to Paris with a stopover in Copenhagen. Art was globe-trotting on colonial ships. The painting had been made in the South Pacific, but it had been painted for Europe (Figure 4.1). Its European producer, Paul Gauguin, was an artistic tourist travelling through colonial space in order to traverse time – both historically and psychically. Tourism has been identified as one of the key structures of consciousness associated with modernity. The anthropologist Claude Lévi-Strauss searched the 'savage mind' for the fundamental structures of human thought by travelling to South America to record the mythic tales of what television names 'the disappearing tribes'. He argued that modern society was too complex, and its structures were too smashed by rapid economic, social and psychological change to yield to comparable analysis. Dean MacCannell has, however, claimed that it is possible thus to analyse modernity. Tourism provides just such a typology of modern consciousness and he argues 'that tourist attractions are precisely analogous to the religious symbolism of primitive peoples'. MacCannell goes on to suggest

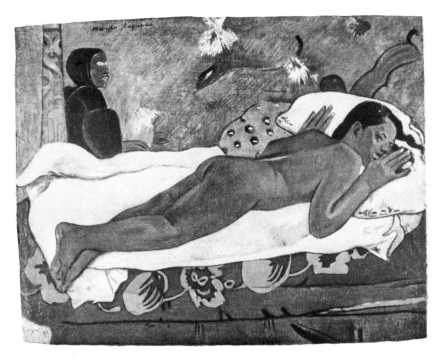

Figure 4.1 Paul Gauguin, *Manao Tupapau*, 1892 (oil on canvas, 75 × 92 cm). Albright-Knox Gallery, Buffalo.

that 'the deep structure of modernity is a totalizing idea, a modern mentality that sets modern society in opposition both to its own past and to those societies of the past and present that are treated as pre-modern or underdeveloped.'[3]

Tourism requires a territory on which this temporal ellipsis can occur. It creates a spatial encounter in what is always a fantastic landscape populated with imaginary figures whose difference must be construed and then marked in order that the sense of loss, lack and discontinuity characteristic of metropolitan modernity can be simultaneously experienced and suspended by a momentary vision of a mythic place apparently outside time, a 'before-now' place, a garden before the fall – into modernity. This experience, therefore, becomes a classic example of fetishism, a repetitious experience of knowing loss and disavowing it by substitution.

The painting that travelled and marked the voyage out and back of one of art history's paradigmatic tourists was given a title in pidgin Tahitian: *Manao Tupapau* (Figure 4.1). This translates as merely: 'Spirit: Thought'. Generously, this has been interpreted as Gauguin trying to say 'The Spirit of the Dead Watches'. A black-faced spectre stands watch over the naked

body of a young Tahitian woman lying on her stomach, her head turned towards the spectator and her hand rigid on the pillow. The painting is by Paul Gauguin. The model was Gauguin's 13-year-old Tahitian wife. Yes, I did say wife. Her name was Teha'amana, Bringer of Strength. The painting was sent first to Gauguin's Danish wife. Yes, I did say wife. Mette Gauguin was the mother of his five children from whom he had lived apart since 1887. He had come to Tahiti to earn enough money to finance the possible resumption of their marriage.[4] He had married Teha'amana within the rituals of patriarchal exchange governing the island's current kinship systems and marriage customs. Two wives, two systems, two places, two female figures in the painting whose viewing apex is one man – the apex of a triangle between two wives, two systems, two places.

Two women, therefore, mark a geographical but also cultural distance which is traversed by the masculine, European artist – a point for ethnographic transactions between cultures and genders. The trope of displacement and attempted reconnection via a triangulated structure of one man and two women, each coloured as white or dark, is the tropical journey as sexual quest for which Cleo McNelly has identified a genealogy from the beginnings of Europe's colonial invasions – the Renaissance – to one of the most compelling of contemporary anthropological texts which is at once autobiographical, and frankly autocritical. The text is *Tristes Tropiques* by Claude Lévi-Strauss, published in 1953.[5] She states that an analysis of the tropical journey as myth reveals one of its key problems: 'the objectification of the other, the native, the woman that lies at the very heart of structuralist thought'. Note the conjunctions: woman, native, other. They are the title of a series of texts produced by the Vietnamese film-maker and critic now resident in the US, Trinh T. Minh-ha which aim precisely to challenge and re-explore these overdetermined synonyms.[6] Which is the signifier, which is the signified – or are they all part of a pure signifiance – sliding down the chain of deferred meanings? Or do they all signify that which utters and is uttered by this historically precise chain, the power of privileged men of the West who are represented by indirect signification, by constituting themselves as speaking or enunciating subject in opposition to spoken or enunciated woman, native, other? I want to suggest that *woman/native/other* is the sign of a fantastic journey enacted on a cultural map whose cartographer is the violence of imperialism. Women – privileged and Western – are, however, not absent from either the map or the journey. For where there was Teha'amana, there was Mette and her daughter Aline – to whom Gauguin addressed his letters and notes about this painting and its subject, contrasting the things girls of her age would do in Tahiti and not in Copenhagen.

While claiming this signifying cluster *woman/native/other* as a trope which can be identified in Western literature since the Renaissance, Cleo McNelly connects contemporary anthropologist Lévi-Strauss to his cultural

predecessors in nineteenth-century modernity, to the poet Baudelaire and the novelist Joseph Conrad, for whom the 'native girl' combined the otherness of both race and sex to become the prime object of the tropical quest into the heart of imaginary darkness, which was, as Stuart Hall has remarked, always part of the European traveller's own baggage.[7] Thus 'the tropical journey, with its cargo of sexual adventure and questions of identity' are structured through the oppositions: here and there, home and abroad, light and dark, safety and danger, famil(iarit)y and sexuality, seeing and touching, thinking and feeling.[8] These antimonies converge to be embodied through the contrasting figures of geographically dispersed but mythically interdependent femininities: 'At either end of this journey stand two figures, each of whom has a profound mythological past: the white woman at home and her polar opposite, the black woman abroad' (ibid.). In the European imaginary, the white woman is mother, sister, wife opposed to the negative mirror-image of the black woman, 'the dark lady of the sonnets, savage, sexual and eternally other. At her best she is a "natural woman" sensuous, dignified and fruitful. At her worst she is a witch, representing loss of self, loss of consciousness and loss of meaning' (ibid.). It is her irreducible strangeness which gives her value and makes her an object of white man's fascination but never a subject of historical acknowledgement or recognition of her cultural, historical and psychological status as a subject.

Gauguin's painting was produced within that antimony. But it also contains within its space an internal doubling which juxtaposes the two aspects of the 'dark lady' in awkward and menacing combination. The one promises a warm, lovable 'naturally' sensuous young woman on the bed, her sexuality not so much offered to, as sadistically anticipated by the viewer. She is watched by the other – a dark forbidding figure conjured up by Gauguin aesthetically as a pastiche of a carved ancestral figure culled from several cultures indiscriminately, whose aesthetic order this European man can only perceive as so strange and other that it is like death itself. It is this duality which in fact reflects what I have called Gauguin's 'avant-garde gambit', which the painting was meant to enact on his professional behalf when it took its place in the gallery showrooms of Durand Ruel in Paris in 1893. Gauguin's painting relies upon intended reference to, but also a calculated a displacement of, a major avant-garde representation: Manet's *Olympia* (Figure 4.2), painted in 1863, but reinserted into the cultural politics of the 1980s by its purchase for the French nation and accession to its museum of modern art, the Luxembourg, in 1890.[9] There Gauguin had made a copy of it, a canvas also exhibited in Paris in 1893 at another gallery from that in which *Manao Tupapau* was being shown. Like *Olympia*, Gauguin's painting juxtaposes two female figures. Manet's painting, I suggest, can be read as a critically *anti-Orientalist* project, which not only redefines the culturally heterogeneous female body in art – the nude –

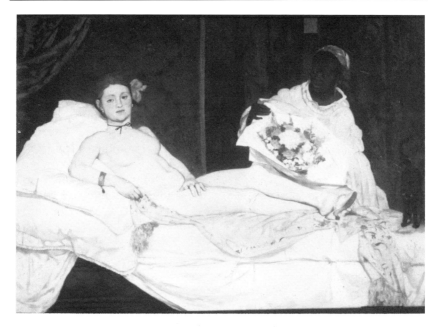

Figure 4.2 Edouard Manet, *Olympia*, 1863 (oil on canvas, 130.5 × 190 cm).
Musée d'Orsay, Paris.

as site of a distinctly modern sexuality, commercial and classed, but inflects
the specific colonial phrasing of that trope with a demythicizing reference
to modernity in the person of the African attendant/partner.[10] She wears
both a turban and an ill-fitting European dress. In *Olympia*, therefore, two
stock characters from the Western artistic imaginary, the nude white
woman at her toilet or in her boudoir attended to by an African woman,
(examples are by Nattier, *Mlle Clermont at her Bath* 1733 (London,
Wallace Collection) and Debat-Ponsan, *Massage* 1883 (Toulouse, Musée
des Augustins)) are set into a proletarian working relationship to each
other, and *against* the spectator, who is challenged by the armed and self-
arming stare of the reclining woman, and is resisted by the preoccupation
of the other woman with her own other. 'Laure' looks to 'Olympia' to
whom she is presenting the flowers. Gauguin's painting misrecognizes the
politics of his reference text, the Manet, and, in that state of semiotic
insensitivity or ideological blindness, his work re-orientalizes its theme.[11]
Both Gauguin's figures are 'other', doubling the image of dark lady and
juxtaposing but also linking her youthful sexuality to age and death. The
look of the reclining woman is 'disarmed' by the exposure of her body in
this vulnerable pose. Gauguin wrote to his Danish wife about this painting,
omitting details of the marital arrangements which had made the painting
possible, in order to 'arm' her (Mette) 'against the critics when they

bombard you with their malicious questions'.[12] The weaponry he supplied
to deflect the recognition of an overt display of a colonial erotica was a
spurious tourist fabrication of out-of-date ethnography peppered with
invented notions of ancient religions and current superstitions which
displaces his, Gauguin's sadistic voyeurism on to her, Teha'amana's, cul-
turally specific paranoia. Tahitians, he 'explains', are afraid that spirits of
the dead stalk you in the dark. His own 'tourist attraction' (in the dual
sense of what attracts and that which is the attraction) leans cynically upon
'the religious symbolism of primitive peoples', confirming MacCannell's
supposition about modern tourism.

The mundane restaging of the cultural trope of woman/native/other by
Gauguin's painting and the sexual, personal and professional transactions
it was produced to perform serve to illustrate my point of departure (*sic*) in
the overdetermined relations of woman to territorialized otherness,
whether in the cultural texts or the texts of their critical analysts. I want to
disorder the standard narratives of the tropical journey by inserting
woman-to-woman narratives in feminized geographies. These confront
issues of difference which cannot be reduced to this sliding system of
signifiers down a phallocentric chain of eternal pairings. Here contra-
dictions and desire do not figure themselves on the bodies of the other, of
woman as other, as native, as difference. Instead they propose an inter-
subjective locus for complex psycho-social transactions which expose the
racism installed in the structures of subjectivity as part of the very cultural
identity of the white child, and specifically the colonial child. I will draw
here upon the transforming feminist conceptualization of a symbolic
shaped by the matrix advanced by Bracha Lichtenberg-Ettinger, who
argues for another model for that of Self and Other, proposing a stratum of
subjectivity based on the coexistence in space of the several, an I and some
non-Is, unknown to me in some dimension, and yet not Other.[13] These
disorderly thoughts and images will keep circling back to the problem of
the territorialization of desire – the question of the native reframed as a
matter of nativity, and its elective displacement, of the impossible fantasies
of belonging and identity confronted by the telos of nativity, death. I want
to explore the historical and political nature of the migration between
the two.

I have started with Gauguin's painting not because its hallowed place in
art history's complicity with the tropical journey and its imperial foun-
dations needs to be challenged – that has been begun at least in my recent
book on *Gender and the Colour of Art History*.[14] The painting and the art
historical analysis to which it gave rise allow me to establish the visual track
of this essay: triangulation between two women and a man, images of
doubling, of returned gazes, of coloured oppositions, of pairs and, eventu-
ally, alliances and 'elective affinities'. An unexpected exchange can occur
between the past being studied and the present in which it is studied,

between an art historical icon and its critical analyst. What makes my reading not only possible but urgent, for me at least, are the traces of my own placement in a history I can find shadowed within the doubles, triangles and circuits of desire enacted in the cultural forms of another moment of that historical trajectory. And the traffic runs both ways. My own subjective formation within another legacy of colonial tourism creates a position from which the Gauguin painting can be read to yield meanings that counter and indeed refuse art history's collaboration with the painting's founding, colonial myths. This, far from collapsing back into a self-indulgent kind of *ego-histoire*, the subjective moment of one history becomes the objective gaze that can read another history of the subject, of historically framed masculinities and femininities in their specific and unanticipated connections.

Given the growing fashion for postmodern suspension of both the etiquettes and even the concepts of historical research and writing, I must make one further qualification of this project. The movement in this essay involves several voices: art historian, story-teller, personal reminiscence, feminist critic. These are all 'me', the enunciative subject of this discourse. My subjectivity informs unconsciously and consciously all that is noticed, attended to, considered significant and then written. But at specific points that implicit condition of all discourse becomes the explicit object of analytical enquiry in which the 'author' acts as both analyst and analysand. The tactic is not to centre this rhetorically 'personal' self, to make the autobiographical subject the ultimate referent of the text – a truly colonial move – but precisely in order to decolonize the texts by analysing in order to displace a specific historical subject and subjectivity, that of the white woman, from the picture. In contradistinction to the collapse of historical perspective into the autobiographical circle, I aim to create the space for a politically sensitive project: autohistory, in which avowing all aspects of the self becomes a necessary part of a reflexive and responsible acknowledgement of the historicity of all subjectivities. Thus autohistory can refuse the ideological delusion of a separation between the public and the private, the professional and the personal at all levels of the text, and in terms of its writing strategies as well as its contents, since the two are inextricably involved. I want to use this paradox and dare to traverse the polite boundaries that maintain a symbolic distance between the territory of history and desire of the historian.

MIGRATION AND RETURN: A TIME FOR TELLING TALES

I want to move to another register of story-telling, which will serve, despite the disjuncture it effects, to stage an alternative model of both doubled woman-to-woman relations and a triangulation which is decidedly non-

Western and non-Oedipal. It also suggests other, feminist ways to read the 'religious symbolism of primitive peoples'.

Let me tell a story about some economic migrants, a family driven by the terrible famine in their own land to seek food and survival in a neighbouring country. A mother, her husband and their two sons travel around a land-locked sea to the mountainous regions they have watched from afar. Disaster, however, soon befalls the family. The father dies. The two sons marry local women, going against a deeply held prohibition in their home culture to mingle with the women of their adopted land. They pay a price for breaking the taboo, for 'sleeping with the enemy', for they too fall ill and die. The relicts of this sad tale are thus three women: a bereaved widow, and two childless daughters-in-law. The widow decides to go home and bids her two daughters-in-law return to their own mothers, to their blood kin. Eventually after protest, one does. But the younger refuses to abandon her mother-in-law. She then says:

> Do not urge me to leave you, to turn back and not to follow you.
> For wherever you go, I will go.
> Wherever you live, I will live.
> Your people shall be my people.
> Your God shall be my God.
> Where you die, I will die and there I will be buried.
> Thus and more may the Lord do to me if anything but death parts me
> from you.

This is a powerful affirmation of personal loyalty. Item by item, the daughter-in-law identifies the typical criteria of our belonging, of cultural identity and its relation to matters of location, of religion and, significantly if surprisingly, of death. It poses a shift of identity as primarily one of movement, a journey ('Where you go, I will go'). This relocation is consolidated by settling in a place ('Where you live, I will live'), followed by a entry into a community ('Your people shall be my people'), the acquisition of the culture signified through its God/gods, its belief system. The declaration is sworn, like a marriage vow, until death do us part.

The story, which some of you will have recognized, comes from the Book of Ruth, included in both the Hebrew and Christian Bibles. Within the Jewish context of its origin, it is read annually on the early summer festival which celebrates *the* covenant. The delivery of the Law at Mount Sinai is defined as a covenant between God and his chosen people, who at the time were landless exiles, fugitives from slavery in a powerful empire, from which they had escaped but seven weeks before. In the wilderness of total social abjection, this motley stateless crowd was to be constituted as a people/culture by the Law providing for ethical guidance in every social, moral, economic, legal and ritual area of life. This episode marks an important shift in the history of human religions. Religion, here rep-

resented as an ethical and social code taken on as an agreement between two parties, makes a major break from contemporary ancient religions and cultures which were seen to be literally geographical. Most gods were territorial, associated with bits of land or even special features of the landscape. Judaism is the religion of choice and covenant made with a wandering tribe in a desert.

Paradoxically, it is the foreign woman who *chose* to be Jewish: Ruth, who has become the symbolic figure of the covenant between a people and their God. Yet the Jewish people were given choice at the symbolic moment at the foot of Mount Sinai, and it is this idea which defines Judaism's theological distance from the notions of race and nation which since the late eighteenth century have framed anti-semitism, and popular misconceptions of Judaism and the Jewish people. Ruth was, however, not only a non-Jew. She was a Moabite, and for the historical Israelites, that meant she was a prohibited other, *the* stranger. Yet she became the most famous proselyte to Judaism, a moment of acknowledgement of the stranger as someone who can be assimilated and not as that which can only induce either aggression and violent resistance or fascinated and ultimately disfiguring desire. The Greek word 'proselyte' is often seen as a mere synonym for the Latin term 'convert'. In fact, proselyte means immigrant. Conversion implies change from one currency or substance to another, while the concept of proselyte as immigrant involves displacement and admission in a way that may uproot the immigrant from a native culture, but provides other ways of transacting outside of the native/other dichotomies.

The promises Ruth makes to Naomi involve movement, relocation and cultural transformation, but above all, they signify a covenant between two people, formed in difference, able to resolve that difference without self-annihilation. Although this text is usually used as an example of someone choosing Judaism, it places God neither first nor last, but only as the penultimate change in a longish list which primarily stresses person-to-person loyalties. The last sentence is often paid scant attention, yet it is crucial: 'Where you die, I will die and there will I be buried'. This statement will resonate profoundly for small and battered migrant communities for it acknowledges the obligations on family members to secure appropriate burial for relatives. To die childless and without relations is to die alone, unprotected and forgotten. Thus this text introduces the vitally important question of memory. The continuity of a people is composed of its many acts of particular remembering. What is vital is not so much its nativity, but its history, which is a continuous and living act of collective memorial which does not depend necessarily on the land of origin or birth. Ruth's reference to death and burial is symbolically necessary to complete the transition from being a native through the process of migration to a new – I almost use the word – patriation. I want to indicate a changed relation

to the territory – the land of one's birth, of one's ancestors, versus the adopted community amongst whom one may choose to die and rest. But in this case it cannot be a matter of patriation for the transaction is between two women and it thus becomes the model of a matrixial relation: the insider and the outsider – the migrant who returns with another migrant, going in the opposite direction – who form a mutually acknowledging alliance.

Cultural identity is hinged on how we refuse death through cultural memory, living in the presence of tradition and historical change. Modernist tourists were in the act of refusing the space and time of their own cultural death while inflicting it on everyone else. Modernity appears to uproot, deracinate, detraditionalize societies. It thus makes difficult, if not impossible, the sense of belonging which could only be found by a migration in time and space backwards to the pre-modern pasts where other peoples's memories, or the fictions of them, could be 'colonized' to do service for what the Western moderns felt they had lost; to arm them against what they felt they were experiencing, a living death. Travel thus becomes a fetishizing activity, journeying as disavowal of both the present and of death.

What I want to stress is that the cultural displacement Ruth chooses is stated as allegiance to a person, namely Naomi. It is an astonishing act of *woman-to-woman* covenanting. Yet in the history of Western art, for which the Book of Ruth has served as a source, there is no visual representation of this transaction. Instead we find many paintings of the harvesters of Naomi's rich kinsman, Boaz, in whose fields Ruth was sent to glean. The text itself also displaces the matrix and the matriline, created by Ruth and Naomi's alliance, so that it would seem that two quite different narratives inhabit this one text.[15]

The subsequent chapters of the Book of Ruth dramatize the Jewish law of the levirate (when a kinsman must take up his deceased kin's land and line) as the means of Ruth's integration into the Bethlehem society. This law is adamantly patrilineal. For in this second narrative, it is only by virtue of her status as the widow, the relict property of her husband and thus of her father-in-law Elimelech, that Ruth enters this community. She has no status except as she is an adjunct to the father-in-law's land which, like her womb, has been left unharvested and barren. Jewish law provides for the redemption of this wasted land by calling upon the next of kin to take up the inheritance and make it fruitful again in the name of the deceased. The claiming of the property inheritance involves any other relics of the dead kin. Ruth the Gleaner is also Ruth the Gleaned. The text is inconsistent even here. For at times Ruth appears as owner or inheritor; at others she is merely part of the inheritance: 'When you acquire the property from Naomi and from Ruth the Moabite, you must also acquire the wife of the deceased so as to perpetuate the name of the deceased upon his estate.'

I am drawing attention here to this contrary position of the figure of Ruth within this narrative. In its patriarchal form she is woman, the sign to be exchanged, the body whose potential to labour and give birth is acquired as part of a property. Reduced to her female body, woman forms a continuity with the land as property, as attribute of man, lacking the phallus to make her productive by planting of his seed. Like his land, she must become the conduit for his line and name.

The conflict between the patrilineal and the matrilineal narratives in this text is resolved by the birth of a male child.[16] The local women of Bethlehem proclaim, however: 'a son is born to Naomi' – thus replacing the lineage of the father (-in-law, Elimelech) with that of the mother (-in-law, Naomi). And yet, the sentence structure is ambiguous, for it is as if Naomi gave birth to the said son, and thus had her maternal desire gratified. The child can be seen as the gift of the loving woman who has chosen to be with her. Thus birth ceases to function merely as timeless cycle of female biological reproduction in which one woman can more or less stand in for another in a constant replication. Instead the child registers as part of a symbolic activity. Furthermore, Ruth enacts what Kaja Silverman has argued is one crucial and underexplored aspect of specifically feminine desire, namely the wish to fulfil the desire of the mother, by giving her a child. These transactions utterly displace, for a moment, the typical phallic economies that govern women and children in the fulfilment of masculine desire and patriarchal law.

The transitivity – or heterogeneity – of the text is continued in the next sentence. For having had the child proclaimed as hers, Naomi puts the child to her own breast. She thus suckles her 'grandson', forming a completely non-phallic triangle composed of the two mothers and their son. The maleness of the offspring doubles as the signifier of desire under the sign of the phallus and as the gift between mother and daughter which marks the terms of their union. The restoration to Naomi of the power of life is utterly at odds with the imagery of the patrilineal narrative of Naomi's barren state and Ruth's function as unfertilized property. I want to suggest that this triangle of bonded women of different cultures connected via a nativity, via the son one bears to ensure matrilineal continuity of the other, offers this relation as a matrixial model directly counter to that enacted in modern, patriarchal tourist fantasy of the tropical quest.

The patriline has the last word, however, for tacked on to the end of the book is a seemingly bizarre listing of the genealogy of the house of the future King David, Ruth's great grandson, from whose lineage she and her mother-in-law-in-love are completely absented. The son who binds the mother and daughter-in-law (two women) can also function as their stake in the other, patrilineal system which effectively excludes them at the level of the signifieds but uses their female bodies at the level of its signifiers. Thus we arrive at these incompatible yet coexisting equations: phallus as

property; nativity as connection. I want to use the story of Ruth and Naomi and their child as the 'matrixial' axis on which to pivot us into a feminist perspective on migration, nativity, death and alliance in both a post-biblical and a postcolonial era.

ANOTHER TIME, ANOTHER PLACE: AN AFRICAN CHILDHOOD RECONSIDERED

A photograph from a family album – a necessary reference to and moment of respect for Jo Spence who alerted us to the historical and the ideological in the everyday and every family archive – registers a social and political complex across the bodies of two women and several children casually framed in a photographer's viewfinder (Figure 4.3). It is a scene on a beach. As such it could be anywhere. I know it was taken in December 1950 at a popular holiday resort called St Michael's-on-Sea, near Durban on the Indian Ocean coast of South Africa. It is a poor photograph, messy, badly composed, with too much extraneous detail. Yet the amateur's weak compositional skill has made the photograph an unexpected document of its place of origin which resonates far beyond the reaches of its casual occurrence in a family album. Including what is typically off-screen yet foundational in constituting the social and historical specificity of the scene and of the seeing, the photograph emerges out of its archive as a document both political and personal. In the middle ground a European mother and child are caught in an almost emblematic moment. It would not take Victor Burgin or Mary Kelly to tell us what fantasy was activated in the person carrying the camera by that moment of transient intimacy – a sturdy toddler busy with some newly acquired skill practised under the quiescent attention and enveloping gaze of its attentive mother (Figure 4.4).

The photographer was too far away from what had made him take out his camera (the photographer was surely the father) and so his object of desire is encumbered with extraneous tote bags and other people. Stranger still, his activity has become the object of a gaze within the photograph. The picture thus looks back at him, from a point off-centre (Figure 4.5). That steady gaze makes him a pure Lacanian subject – 'photographed'.[17] He is a picture for the unconsidered but not invisible other in the field of vision he does not control. The man photographing his little family is being watched by a woman who halts her work to look across at his leisure – his tourist snap (Figure 4.6). She is an African employed to look after European children whose mother is absent. While the coupling of adult woman and child pretends to simulate the dyad at the other side of the scene, it refutes that unity of mother and child, representing instead its socio-cultural antithesis or underside. Furthermore the African woman is the third figure in the triangle which appears in the photo only in its ideal, and idealized, holiday form as the maternal dyad.

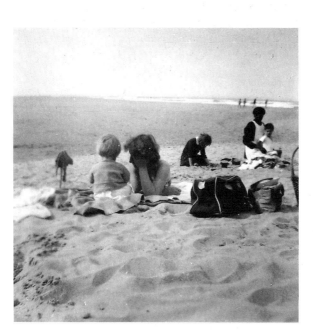

Figure 4.3 Family photograph, taken at St Michael's on Sea, South Africa, 1950.

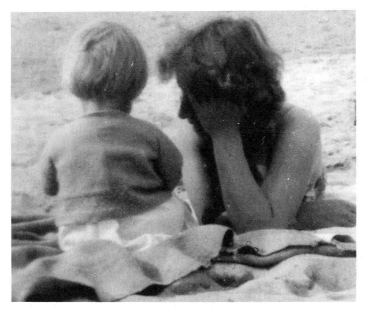

Figure 4.4 Detail of Figure 4.3.

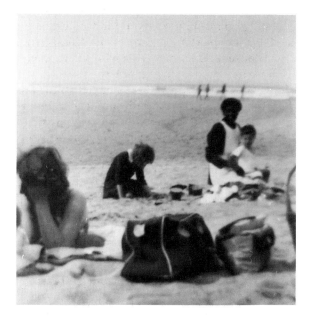

Figure 4.5 Detail of Figure 4.3.

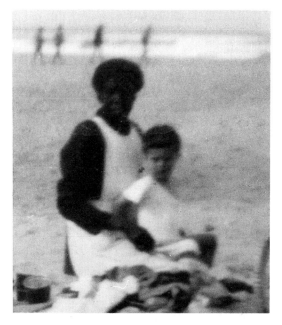

Figure 4.6 Detail of Figure 4.3.

The dark lady and the white wife/mother occur in the same space and time of the photograph, their relations and contradiction not, however, contained by the mastering gaze of the masculine tourist/artist/ photographer we encountered in first section of the chapter. Two mothering women coexist but not in any chosen covenant or alliance such as occurs in the biblical story of Ruth and Naomi. Across the times and spaces of their production and uses, unexpected transactions emerge between an utterly mundane family snap and one of the icons of Western modernism – *Olympia* (Figure 4.2). I note the sorority between the African women in their borrowed costumes of servitude caring for the white woman, or her children, while acknowledging the shocking incongruity of the comparison within our normal codes of academic divisions between the historically relevant and personally mundane. In Manet's case, the figure of 'Laure' is raised by his calculated strategies of proto-modernist disruption to being a critical signifier in a way that cannot seriously be claimed for the chance concurrence of the two women in a family snap. Here, in the photograph, however, instead of the containment of a black woman's gaze – or its murder and exploitation in the Gauguin painting (Figure 4.1), where it became the gaze of death in the place of sexuality – we unexpectedly encounter a returned and critical look. In Barbara Kruger fashion, this gaze puts its other – the absent European gaze which, *pace* Linda Nochlin, is the real meaning of the Orientalist project – on the spot.[18] Her gaze punctures the space which should frame and contain the European dyad as simply and universally 'mother and child'. Yet because of what Richard Dyer has suggested is the racism imprinted in the technologies and lighting codes of Western photography itself, her African face threatens to dissipate into what Christopher Miller, writing of French Africanist discourse, has called 'blank darkness'.[19]

A final observation – in my developing theme of the polarized woman as the axis of the tropical journey, this photograph contains within one frame both white woman and dark lady, although syntactically and politically, they are rigidly separated (except, perhaps, in the tiny mind/imaginary of the white Euro-African child). I recognize the critical danger of what I am saying – a self-indulgence perhaps to focus on my white self – a fulfilment of Lubaina Himid's astringent remarks about how white people keep seeing themselves at the centre of other people's pictures where they absorb the efforts and energies of others. I cannot speak for the African woman in that picture as I cannot even speak for the African woman, whose real name was not 'Julia', who normally cared for me on that beach and at home in South Africa. I can speak to and about my white mother, who played her part in that woman's servitude. I can also admit that my desire – forged in the series of psychic losses which are always historically textured – is 'territorialized' upon a black woman's nurturing body.

I, placed now as the viewer in and yet not in the place of the

photograph's producer, can therefore respond to her African gaze, which once was as comforting to me, the colonialist/economic migrant's child, as that of the white mother with her own child which occupies the intended foreground of the image.

Childcare is labour and mostly the labour of women. It is a matter of class, of gender and of race, as here. Some privileged women pay others to do their childcare. It is one of the major employer–employee relations between women – a class system at the heart of the socially permeable bourgeois household.[20] In South Africa, African women are employed by European women to look after the latter's children, while their own black children are left at home with relatives – in the townships if they are lucky, in the homelands if not. The child in the photograph was thus cared for for seven years. Emotional bonding and psychic formation took place in the socially and culturally permeable household of the Western bourgeoisie as postcolonial economic migrants. My parents left England in 1947 to escape postwar cold and rationing for a tropical journey that was a quest for somewhere better to raise a family. The white child born into this situation is the perplexed meeting point – a subjective nexus – of the social and cultural contradictions which are resolvable neither by sexuality nor by conversion (Figure 4.7).

The child, however innocent, is being formed as a bearer of the dominant order of *whiteness* through an Oedipalization which is profoundly historical, social and, I am arguing here, racial. The situation is not neutral but one in which differences of culture and class are being patterned as hierarchy because the economic relations between the leisured mother (white), who displaces her child, and the working mother (black), who is robbed of her own – i.e. between employer and servant – are enacted at the level the child grasps as a series of affects, complexes, loyalties and losses. The white child is a token of unequal exchange which infantalizes the adult African woman because what she does as an adult identifies her with the realm and status of her childish charge. The servant/employee's paid work makes her stay 'at home' with the child, thus freeing the white mother/employer to enjoy the personal freedoms the leisured bourgeoisie usually allows to its men: to meet with friends, to play golf or bridge, to do voluntary work, or indeed to be a journalist, to be politically active against apartheid, to belong to women's organizations like Black Sash, to travel, to take lovers, to write – to create herself as a bourgeois individual.

Liberation for some women in this situation is gained at the price of another's servitude and personal pain. But the point is that the freedom this white mother achieves is a version of what we typically associate with the bourgeois man in our accounts of the metropolitan bourgeoisie at home. He is the privileged traveller through and occupant of public spaces of money, exchange, leisure and power. In the mid-twentieth century, the postcolonial racist society allows some women access to his privilege but

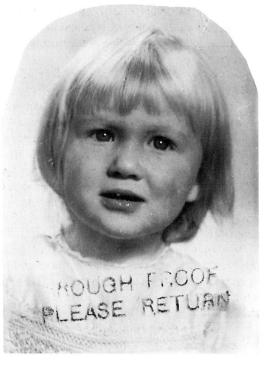

Figure 4.7 'Rough proof' – childhood portrait.

only by overlaying the gender of African women with the multiple sub-
ordinations of race and class.

In writing his biography of Flaubert – another of the tropical travellers of
the sexual quest – Sartre discusses the formation of class consciousness in
the child of the bourgeoisie by suggesting that class is invisible within the
family, following Marx perhaps who wrote:

> Upon the different forms of property, upon the social conditions of
> existence, rises an entire superstructure of distinct and peculiarly
> formed sentiments, illusions, modes of thought and views of life. The
> entire class creates and forms them out of its material foundations and
> corresponding social relations. The single individual, who derives them
> through tradition and upbringing, may imagine they form the real
> motives and starting point of his activity.[21]

It takes a historical but always social moment of crisis or conflict for that
individual – the child of my discourse – to see its parents in the eyes of
others, for class consciousness to be forced upon the child; just as Sartre
argues a Jewish child only recognizes himself or herself as Jewish in the
eyes of the anti-semite other. In the images by which Sartre attempts to

explain his thesis on social identity and the role of the other, which Franz Fanon elaborated in relation to the postcolonial experience, and which recurs in Carolyn Steedman's analysis of class and subjectivity, *Landscape for a Good Woman*, there is often a 'castrating' moment in which the black or working-class child is the traumatized witness to the revelation of a social lack in the parent, who, up to that point, has been imagined as a figure of authority and power.[22] The child has to recognize, with the resultant injury to its own narcissism (since its identity is formed through identification, i.e. introjection of the imago of its parents), the death of omnipotence and plenitude in the figure with which the child identifies. It is thus wounded by the authoritative gaze of the empowered social other, which reduces her/his own beloved caretaker. In one sense this 'castrating' moment is the social re-enactment, or staging on the plane where social and psychic realities interface, of the Freudian schema of the male child's trauma at the site of apparent female, i.e., the mother's genital insufficiency which is symbolic of her want of power and authority. I want to combine both models – or rather map the social and the psychic on to each other to extend both – in the triangulated structure within the family. The typical triangle of the Freudian story is between a son and his sexually differentiated parents. The one I want to overlay is that between a female child and two women, a mother and a nanny who are by this 'moment' inscribed differentially in terms of class and race. What the 'white' child (or rather the one who will become 'white' by this lesson) learns is a structure of difference and authority relative to which she must take up not merely a gender position (she could potentially identify with both women because they are both of her gender) but also one of class and race (Figure 4.8). Or, we could put it thus, she must adjudge between two positions, one in which privilege comes to be inscribed through a differentiation of power that is represented linguistically as a physical and cultural difference, as race. This difference is thereby not recognized as the result of class, of social relations, cultural exploitation and so forth; rather here, like Freud's schema, anatomy – skin colour, voice, looks – seems to give the difference a natural origin.

In the situation of colonial childcare within the colonizer's household, the (white) child, abandoned by its mother, and the (black) mother, deprived of her child/ren, are thrown together across the rifts of class and culture into a potentially compensatory dependency in which they may both, in a state of loss and deprivation, find surrogate bodies to cuddle and be cuddled by. Their world is already one of metaphors and metonyms. For each is the substitute for that for which each 'really' longs. This dyad is triangulated not by the father so much as by the economically and culturally empowered white mother. She represents for the white child the desired but distanced ideal, whose attraction as a figure of identification is intensified precisely by her mobility in the world, her difference from the

Figure 4.8 'Underdeveloped'/'Overexposed' – childhood portrait.

'beloved' *native* surrogate mother, confined by her and with her to the realm of the domestic, the infantile, the powerless.[23]

The typical Freudian model of Oedipalization has offered a means of explaining the formation of human infants in sexual difference (limited as its effectivity was to the male child). In its postcolonial situations, the white girl child, in whom I am primarily interested here, is positioned simultaneously in two hierarchies: as a child subject to the power of the mother who appears free to come and go, to be absent and to determine access to her increasingly idealized person; and, secondly, she is identified with what remains behind at home, in the thus 'subordinated' realm. The African nanny belongs there with her, but also *to* her, creating for the child a fantasy of control sanctioned by the conditions of employment and

artificially created poverty. The child is thus 'empowered' *vis-à-vis* a figure whose adulthood and authority should – but by this token does not – maintain her in a position of authority towards the child, her charge.

The colonialist's child has a stake through which to traverse the division, namely her physical similarity to the mother which is signified not as gender but as *whiteness*, as race. The child can thus imagine an identification with the power and authority the mother represents *vis-à-vis* the African nanny. Thus, like the penis in the system of phallic sexual difference, an insignificant physical detail – skin colour – is invested with the power of signification, signifying within the colonial symbolic its racism. Not to identify with the mother and her culture – her gods, her people, her lodges and her death (to recall the terms of Ruth's cultural identification) is to be infantilized and blackened, to be like the *native* and the *other* and, in all its patriarchal negativity, *woman*.

Colonialism colours gender, and gender inferiority can be displaced by cultural power expressed through race, in a way that then makes the articulations of a specifically feminist consciousness in South African struggles seem utterly diversionary from the overwhelming obscenity and violence of that society's racism. It should be noted, none the less, how important debates about women's rights have become in the arguments advanced by African women in the formulation of a new constitution for South Africa, in ways that demand reconsideration of the double legacy of sexism through both traditional and colonial patriarchies.[24] The question of white women's implication through the very fact of gender identification in the psychological formation and perpetuation of racism needs also to be acknowledged – opening the way for woman-to-woman alliances in the struggle against a racism that white women may actually carry inside them as part of their sense of being 'women' and being 'white' in such a culture.

I am playing a dangerously loose game of analogies, trying to imagine ways to discuss the formations of a white colonial/ bourgeois femininity in terms that echo those used to explicate the paradoxes of 'masculinity' in difference theory. It is argued there that the distance forced between men and their mothers – discovered to be lacking the phallus as signifier of social power and authority – generates the profound contradiction between the desire for the lost object and the compulsion to debase and punish the body which seems a constant reminder not so much of *its* deficiency, as of the lack within the masculine subject, as a result of its being outcast from the maternal space. Masculinity is the psychic journey with these two faces of a lost and desired but dreaded and often punished femininity at its poles – the dark and the white ladies of the tropical journey that is always taking place inside the white man's head. If psychoanalysis has allowed us a psycho-political theory of the contradictions of phallocentric sexist societies and their masculinities, might it also provide terms to analyse the formation of the white child girl as well as boy in colonial societies – to

grasp the formation of racism as a contradictory pressure of divided maternal imagos produced in societies where the gendered division of childcare is further patterned through race as well as class?

As the little white girl I was, born and formed in this socio-psychic complex, I know the twin forces that conflict between identification with the white mother and its possible freedoms for a woman in a still bourgeois world, and the lost fantastic identification with a black woman, who, whatever her own pain and desperate sense of exploitation and loss, generously gave me her care and nurtured me at the cost of her own daughter's need for her mothering. In the racist formation of the white child – whatever the politics of her later years – there is a danger of being trapped in the psychic time and space in which a mythical Africa and its landscape, colours, textiles and music become an imagined but forbidden native space, the metonymic image of the woman whom she the once-child imagines was one of her lost mothers. In her autobiography and celebration of black South African women's courage and creativity, *Call Me Woman*,[25] Ellen Kuzwayo records her meeting with a white woman, Elizabeth Wolpert, who came to Soweto in search of African women's self-help groups in order to establish a trust in memory of a black woman named Maggie Magaba who nursed her as a child. Elizabeth Wolpert translated that childhood debt into an alliance, a covenanting for social activist struggle which brought traditional strangers into political alliance in the manner of Ruth and Naomi. I was deeply struck by Elizabeth Wolpert's action. I thought, 'That's a way to turn from the trap and engage in the political struggle for change.' But then, I couldn't do anything like it. I do not even know 'her' name.[26]

When I was younger, people would ask: Where are you from? Identity is so often a matter of origins. As a white child of a postcolonial twentieth century, I honestly could not answer the real question: Who are you by birth? Of what place are you a 'native'? I could, by way of trying not to be rude, give as a reply the itinerary of my childhood. Born in Bloemfontein, I grew up in Johannesburg, then moved to Toronto, Canada, and later settled in Francophone Catholic Quebec until, in my mid-teens, I was brought to England. I had two nationalities (South African and Canadian), dropped one (South African) and picked up another (British). Then I used to alter this disjointed story a bit and say simply I was born in Africa and hoped no further revealing specification would be necessary. It was, I realize now, not mere embarrassment about having to admit to being by birth a white South African, though that was real enough. I now recognize that I was expressing the *territorialization* of my desire, a formation of desire in childhood and in specific social relations whose only links with actual people I once loved was, typically, displaced on to a land, a landscape, a territorial signifer: Africa. The word 'Africa' became a signifier not of property but of loss and permanent exclusion, and thus

functioned not dissimilarly from the woman/native/other modality of Western masculinity. It was a signifier of the lost mother(s) of a particular, historical femininity. I cannot go back to this 'Africa' for it is not a spatial but a temporal journey. It is to be hoped that I can never go back to that 'Africa' – politico-economic configuration of colonialism and apartheid whose destruction is being actively struggled for in this our present.

I am using these stories of locations, identities and beginnings to reconsider the question of nativity, nationality and migration: to fracture the notion of origins as the source of identity both in the colonial discourse on 'natives' and in its own fantasies about nativity, i.e. relations to a 'fantastic' maternal space and sign. Shall I be like Ruth and affirm loyalty to a chosen national identity – to Britain, to Canada? Or do I remain a South African by 'birth', a 'white' by acculturation, and thus a 'racist' by psychological formation in such a society? At what point can we make these issues political, a matter of covenants, alliances and chosen realignments which involve rejection of original formations and the refashioning of new, painful but negotiated affiliation? But to what South Africa could I want to belong – that of my childhood written in my desire and memory, or to a new and painfully struggled-for democratic space to which I cannot claim any connection? Or can we, like Ruth, throw off a culture, a formation, a tradition and an upbringing, and decide negatively: that is, *not* to belong to any myth of origin, in terms of time or space? Rather the project is to enter into dialogues, political transactions on the symbolic territories of the international women's movements. A critically self-examining feminist project allows us the possibilities both of escaping from the political hysteria – hysterics suffer from reminiscences – of colonial formations and of producing futures, new lives for our 'children' or our political and cultural progeny based on acts of alliance.

I suspect that, in the words of Janina Bauman, writing of the complex choices in her life as a Jewish survivor in postwar communist Poland, that we all have 'a dream of belonging', made acute not because of tourism but precisely because of the twentieth century's epidemic condition of migration, refugeeism, diaspora.[27] Can we be proselytes without a claim to a land, to nativity and its correlate nationhood, or worse nationalism? The moral of my tale, my own story, as well as Gauguin's story, is that we need to resist and disrupt the territorialization of desire – all forms of nationalism and identity politics, and join Lubaina Himid's well-travelled modern women, in breaking up the maps and in talking strategies of revenge on the power structures that are the bringers of death across the whole of the earth. In her powerful painting *Five* (acrylic on canvas 5′ × 4′, 1991) shown in her major 1992 exhibition, *Revenge*, at the Rochdale Art Gallery, two black woman sit at a round table (Figure 4.9). They are engaged in energetic dialogue in an interior in which 1920s Paris (international modernism) vies with ancient African Egypt, signified in formalized papyrus

Figure 4.9 Lubaina Himid, *Five*, 1992. Leeds, City
Art Gallery, on loan.

flowers (writing, culture, history) and a luminous and intense yellow (the
lightness an antidote to that colonially invented 'blank darkness'). On the
table is a jug of water which appeared in several paintings. Water is used
thematically throughout this exhibition. It connotes both the water of the
most terrible journeys, the middle passage, endured but not survived by
over 20 million African people in the era of European enslavement and
early capitalism. It is also a celebratory reference to the water beloved and
creatively used by Islamic civilizations in Africa in their gardens and
architecture. Lubaina Himid's work ambitiously creates a figuration of the
historical politics of contemporary cultural practice: where black women
take the initiative to focus on the immediate historical dangers and dilem-
mas in which the cultural forms of canonized Western and male modernism
are revealed to be profoundly implicated as having provided an imagery
and an aesthetic for the colonial and postcolonial touristic projects of the
Western bourgeoisies.

 She takes over the colour which Gauguin used as his avant-garde gambit,
the colour that made a 'brown Olympia' according to one leading critic, the
colour that made Tahiti exotic, strange, edenic. She gives it a historical
articulation, makes it articulate concrete histories of art and cultures. But

the colour axis she refuses is the black/white opposition – the white and the dark lady. She had tried to intervene in this in a major installation, *A Fashionable Marriage* (1987), which critically reworks its referent text, Hogarth's *The Countess' Morning Levée*, from the series *Marriage à la Mode* (1743). The African slave serving coffee to the eager listener is replaced by a self-confident black woman artist, yet she still finds herself upstaged by the keen white feminist artist into whom she keeps pouring her energy. In the *Revenge* series there can only be black women in the picture for that is the only way to resist the power of the colonial trope which makes the black 'woman, native and other'. But as a white woman, I can be party to this dialogue, if I am prepared to listen and participate in a space that is not a matter of doubles and triangles. For the space is open in the painting, and the table is round, and we all need to discuss strategies of revenge for what Gayatri Spivak calls the 'abject script modern western history has bequeathed to us'.

I am wrenching Lubaina Himid's painting from its original place in a large and major exhibition where its meaning was created as a part of complex artistic syntax of women journeying to rewrite the travels of Columbus in 1492, perhaps loosening it from its own act of artistic decolonization and reconstruction of a new cartography written to the measure of black women's desire. I am asking of it to mark a break with the doubling of women so far encountered within the culture of colonial and postcolonial Europeans, be it in the work of Gauguin or my own childhood album. Perhaps I am hoping it can be connected to the story of Ruth – to woman-to-woman covenants across cultures, to reciprocal tenderness between 'strangers', to created loyalties and constructed solidarities, to dialogical moments of reciprocated gazes and listened-to voices. 'After Mourning comes Revenge', Lubaina Himid has written.[28] Against modernity's spatial travels – colonialism in all its forms and legacies – in order to return in time, we need a present, which is here and now, and it is between us. So I end with an image that utterly displaces from sight both the white man and the white woman, but creates a space at the table of political strategizing for anyone who will listen and form not an Oedipal or any other kind of triangle, but the matrixial space of the several in which singularity and similarity, difference and divergence can form the basis of negotiated connection and political covenant for transformation bound neither by nativity nor by death.

NOTES

1 Chinua Achebe, 'An image of Africa', *Research into African Literatures* 9, 1978, p. 12.
2 Johannes Fabian, *Time and the Other: How Anthropology Makes its Object*, New York, Columbia University Press, 1983.

3 Dean MacCannell, *The Tourist: A New Theory of the Leisure Class*, New York, Shocken Books, 1976, p. 8.

4 Bengt Danielsson, *Gauguin in the South Seas*, trans. Reginald Spink, London, George Allen & Unwin, 1965, gives a full account of Gauguin's time in Tahiti, and his incomplete grasp of the language. I want to mention here Amanda Holiday's film called *Manao Tupapau*, which explores the experience of Teha'amana modelling for the painting. The film is distributed by Cinenova.

5 Cleo McNelly, 'Nature, women and Claude Lévi-Strauss', *Massachusetts Review* 16, 1975, pp. 7–29; Claude Lévi-Strauss, *Tristes Tropiques* [1955] trans. J. & D. Weightman, New York, Athenaeum, 1975.

6 Trinh T. Minh-ha, *Woman, Native, Other: Writing Postcoloniality and Feminism*, Bloomington, Indiana University Press, 1989.

7 McNelly is thinking of Conrad's *Heart of Darkness* (1902), in which we read of a 'dark lady'. 'She walked with measured steps, draped in striped and fringed cloths, treading the earth proudly, with a slight jingle and flash of barbarous ornaments. She carried her head high; her hair was done in the shape of a helmet; she had brass leggings to her knees, brass wire gauntlets to the elbow, a crimson spot on her tawny cheek, innumerable necklaces of glass beads on her neck; bizarre things, charms, gifts of witch-men, that hung about her, glittered and trembled at every step . . . She was savage. And wild-eyed and magnificent; there was something ominous and stately in her deliberate progress. And the hush that had fallen suddenly upon the whole sorrowful land, the immense wilderness, the colossal body of fecund and mysterious life seemed to look at her, pensive, as though it had been looking at the image of its own tenebrous and passionate soul.' (Penguin edition, 1973, pp. 100–1). For a feminist reading of Baudelaire's involvement with the 'dark lady', see Angela Carter *Black Venus*, London, Picador Books, 1985, for a short story told in the persona of Jeanne Duval.

8 McNelly, op. cit., p. 10.

9 For discussion of the avant-garde as a game of reference, deference and difference, see my *Avant-Garde Gambits 1888–93: Gender and the Colour of Art History*, London, Thames & Hudson, 1993. This section of the chapter draws on the longer discussion in that book.

10 Orientalism, initially theorized by Edward Said in *Orientalism*, London, Routledge & Kegan Paul, 1978, has been widely used to analyse the visual imagery of Europe's cultural transactions with its colonial others, specifically, but not exclusively in the Islamic world of North Africa and the near East. Linda Nochlin's article 'The imaginary Orient', reprinted in *The Politics of Vision*, London, Thames & Hudson, 1991, reviews recent exhibitions of such paintings and provides a critical reading of them to which we are all indebted.

11 I am indebted to Mieke Bal, *Reading Rembrandt*, Cambridge, Cambridge University Press, 1991, for her analysis of iconography and both critical uses of reference texts and failures to do so: see Ch. 5, 'Recognition: reading icons: seeing stories'.

12 Paul Gauguin, *Letters to his Wife and Friends*, trans. Henry J. Stenning, London, The Saturn Press, 1949, Letter 134, pp. 177–8.

13 Bracha Lichtenberg-Ettinger, 'Matrix and Metramorphosis', *Differences* 4: 3, 1993, and her essay included in this volume.

14 Griselda Pollock, *Avant-Garde Gambits 1888–93: Gender and the Colour of Art History*, London, Thames & Hudson, 1993.

15 Two famous examples are paintings by Nicholas Poussin *Summer* (from his *Four Seasons*) and J.F. Millet, *Harvesters Resting*, 1852.

16 My thinking about this part of the text is indebted to Naomi Segal, 'Reading as a feminist: the case of Sarah and Naomi', *University of Leeds Review* 32, 1989/90, pp. 37–57.

17 I am thinking about Lacan's later formulations on the constitution of the subject: 'In the scopic field the gaze is outside. I am looked at, that is to say I am a picture. This is the function that is found at the heart of the institution of the subject in the visible. What determines me, at the most profound level, in the visible, is the gaze that is outside. It is through the gaze that I enter light and it is from the gaze that I receive its effects. Hence it comes about that the gaze is the instrument through which light is embodied and through which . . . I am photographed' (J. Lacan, *Four Fundamental Concepts of Psychoanalysis* [1973], ed. J.A. Miller, trans. A. Sheridan, Harmondsworth, Penguin Books, 1979, pp. 95–6). For further commentary on this concept see K. Silverman, *The Acoustic Mirror*, Bloomington, Indiana University Press, 1988, pp. 161–2.

18 Linda Nochlin, 'The imaginary Orient', in *The Politics of Vision*, London, Thames & Hudson 1991, pp. 33–59.

19 The reference to Linda Nochlin is from Nochlin, op. cit. R. Dyer, 'White', *Screen* 29: 4, 1988, pp. 44–65; C. Miller, *Blank Darkness, Africanist Discourse in French*, London and Chicago, University of Chicago Press, 1985.

20 Feminists have done a lot of work on the critical importance of the working-class women who cared for and contributed to the formation of bourgeois children at both social and psychic levels, for instance L. Davidoff, 'Class and gender in Victorian England' in *Sex and Class in Women's History*, ed. Judith L. Newton *et al.*, London, Routledge & Kegan Paul, 1983; J. Gallop, *Feminism and Psychoanalysis: The Daughter's Seduction*, London, Macmillan, 1982.

21 K. Marx, *The Eighteenth Brumaire of Louis Bonaparte* [1852], reprinted in *Marx and Engels Selected Works In One Volume*, London, Lawrence & Wishart, 1968, p. 117; J.-P. Sartre, 'Class consciousness in Flaubert', *Modern Occasions* 1: 3, 1971.

22 F. Fanon, *Black Skin White Masks* [1952], London, Pluto Press, 1986; C. Steedman, *Landscape for a Good Woman*, London, Virago, 1987. Steedman writes about two such scenes: one when her mother is criticized by a middle-class social worker, the other when her father is chastized for picking flowers in a public park by the park warden.

23 It is very rare that white children in these situations ever see their black nannies in their own contexts, for both servants' quarters and trips to the African workers' homes are severely prohibited. The restrictions are of course broken, but for me, the memories of visiting Julia in her 'shack' hidden in our garden, with its bare walls and floors, its bed up on bricks, its utter contrast to the luxury in which my family and I lived were painful moments – a confusion of feelings about the awful conditions in which someone so loved and needed by me was made to live by others whom I also was meant to love and respect. Responses to this situation as a child are limited – political activism later may be a result of this other kind of 'witness' to social 'castration'. But this unacknowledged body of feelings which are carried by children raised in these circumstances can have other outcomes – in the case of the male child, sexual uses and abuses, enacted upon African women, which parallel the formulation of bourgeois masculinity in the European household with its working-class nannies and child minders, which Freud analysed in his paper 'On the universal tendency to debasement in the sphere of love' [1912] *Freud Pelican Library: On Sexuality Vol. 7*, Harmondsworth, Penguin Books, 1977.

24 Thandabantu Nhlapo, 'Women's rights and the family in traditional and

customary law', and Frene Ginwala, 'Women and the elephant: the need to redress gender oppression' in *Putting Women on the Agenda*, ed. Susan Bazilli, Johannesburg, Raven Press, 1991.

25 Ellen Kuzwayo, *Call Me Woman*, London, The Women's Press, 1985.

26 African women employed as domestic servants are often, like working-class women in the metropolitan countries were, given names by their employers. African identity is thus eroded by the employee being known only in the household by obviously European names, like Julia, Daniel, Pius, Sarah and so forth.

27 J. Bauman, *A Dream of Belonging*, London, Virago, 1989.

28 Lubaina Himid, *Revenge*, 1992, Rochdale Art Gallery, Rochdale, England. Catalogue edited by Jill Morgan and Maud Sulter.

Part II

Home and away

Chapter 5

Home and identity

Madan Sarup

THE MEANINGS OF HOME AND THE POLITICS OF PLACE

Wherever I go I come across people meeting together to hear, read and discuss questions about identity: personal identity, social identity, national identity, ethnic identity, feminist identity . . . In Raymond Williams's *Keywords*[1] there is idealism, ideology, image, but no reference to identity. Now it has become a key word; there are conferences, lectures, books and articles on every aspect of identity that one can think of. There are talks and discussions on the meanings of home and place, displacement, migrations and diasporas. Distinctions are made between immigrants, economic migrants, refugees and exiles. There is also a great deal of interest in the self, subjectivity, and in recent developments in the theory of the subject. How does one represent oneself? There is talk about different positionalities. Identity can be displaced; it can be hybrid or multiple. It can be constituted through community: family, region, the nation state. One crosses frontiers and boundaries. I am not complaining about all this interest in identity. I am fascinated by it.

I know that my involvement derives from my interest in my childhood and my identity. Born in India, I was brought over here to be educated at the age of 9. The war started and my father returned to India. My mother had died when I was 5 and the only memory I have of her is that I was not allowed to go into the room where she was dying. My father died in the partition of India in 1947, and I believe that when I was told that he had died I did not understand. To me he just continued to be absent. I will not tell the full story here, but I do often think of my fifty years here in England. Am I British? Yes, I have, as a friend pointed out, a 'white man's' house, and I've forgotten my mother tongue, but I do not feel British. I think of myself as an exile and it's painful here, *and* there in India when I return for short visits. I don't have the confidence to become, as some have suggested, cosmopolitan. But like so many others, I am preoccupied by ideas of home, displacement, memory and loss.

A migrant is a person who has crossed the border. S/he seeks a place to make 'a new beginning', to start again, to make a better life. The newly arrived have to learn the new language and culture. They have to cope not only with the pain of separation but often with the resentments of a hostile population.

Whilst writing I often keep thinking of home. It is usually assumed that a sense of place or belonging gives a person stability. But what makes a place home? Is it wherever your family is, where you have been brought up? The children of many migrants are not sure where they belong. Where is home? Is it where your parents are buried? Is home the place from where you have been displaced, or where you are now? Is home where your mother lives? And, then, we speak of 'home from home'. I am moved when I am asked the phenomenological question 'Are you at home in the world?' In certain places and at certain times, I am. I feel secure and am friendly to others. But at other times I feel that I don't know where I am.

What exactly does the word 'home' mean when it is used in everyday life? We speak of *homecoming*. This is not the usual, everyday return, it is an arrival that is significant because it is after a long absence, or an arduous or heroic journey. If some food is *home-made*, it connotes something cooked individually or in small batches. It is not something mass-produced, it is nutritious, unadulterated, wholesome. We often say to visitors, '*Make yourselves at home*'; this means that we want people to act without formality, we would like them to be comfortable and to relax. It was '*brought home to me*' means that I was made to realize fully, or feel deeply, and that what was said reached an intimate part of me. We also say 'It is time you were told some *home truths*'. These are truths about one's character or one's behaviour that are unpleasant and perhaps hurtful, and which can be expressed only in a caring environment, where people are concerned about you. A home truth is something private. Many of the connotations of home are condensed in the expression: *Home is where the heart is*. Home is (often) associated with pleasant memories, intimate situations, a place of warmth and protective security amongst parents, brothers and sisters, loved people.

When I think of home I do not think of the expensive commodities I have bought but of the objects I associate with my mother and father, my brothers and sisters, valued experiences and activities. I remember significant life events, the birth of the children, their birthday parties . . . Particular objects and events become the focus of a contemplative memory, and hence a generator of a sense of love. Many homes become private museums as if to guard against the rapid changes that one cannot control. How can the singing of a particular song or the playing of a piece of music have such an emotional charge? I play a tape of 'La Paloma'. Why am I in tears?

But what are we to make of home-sickness? In Freud's fascinating essay

'The Uncanny', he remarks that the fantasy of being buried alive induces the feeling of uncanny strangeness, accompanied by 'a certain lasciviousness – the fantasy, I mean, of intra-uterine existence'. He continues:

> It often happens that neurotic men declare that they feel there is something uncanny about the female genital organs. This *unheimliche* place, however, is the entrance to the former *Heim* of all human beings, to the place where each one of us lived once upon a time and in the beginning. There is a joking saying that 'Love is home-sickness'.[2]

Of course, I realize that the notion of home is not the same in every culture, and I know that the meaning of a metaphor used in the 1930s is not the same as its meaning in the 1990s. Nevertheless, I want to suggest that the concept of home seems to be tied in some way with the notion of identity – *the story we tell of ourselves and which is also the story others tell of us*. But identities are not free-floating, they are limited by borders and boundaries.

When migrants cross a boundary there is hostility *and* welcome. Migrants (and I am one) are included and excluded in different ways. Whilst some boundary walls are breaking down, others are being made even stronger to keep out the migrant, the refugee and the exile. A distinction I have found useful is that between *space-based* action (an action which a person can move on from) and *space-bound* action (which is limiting to the agent).

Any minority group when faced with hostile acts does several things. One of its first reactions is that it draws in on itself, it tightens its cultural bonds to present a united front against its oppressor. The group gains strength by emphasizing its collective identity. This inevitably means a conscious explicit decision on the part of some not to integrate with 'the dominant group' but to validate its own culture (religion, language, values, ways of life).

Another feature of groups is that sometimes grievances are displaced; in some situations, for example, political interests can only be articulated in, say, religious terms because no other vehicle for expression is available. In Britain a group of people in the Secular Society are militantly anti-religious, and they are hostile to Hindhu, Muslim, Sikh and Christian groups for their religious views. But for members of many ethnic minority groups, their religion is an aspect of their culture, a valuable support in an hostile environment.

Some people don't feel at home where they are, they are unhappy and they look back. Millions of people in the world today are searching for 'roots', they go back to the town, the country or the continent they came from long ago. They try and learn something of that culture, that history. These are the people who in some way have found it difficult 'to form roots', to become firmly established. By learning about their 'roots',

they (hope to) gain a renewed pride in their identity. It is nearly always assumed that to have deep roots is good. For example, Melanie Klein, the psychoanalyst, writes that if the good object is deeply rooted, temporary disturbances can be withstood and the foundation laid for mental health, character formation and a successful ego development.[3]

Recently I read of some refugees who fled from persecution. Many of them, because of their traumatic experiences, could not write down their memories. They were expected to 'bury' their past. Some of the younger refugees blamed their parents for not being strong enough to protect them. They did not think much about their future – it was too uncertain – but they often thought about where they had come from, their home, their place.

> It's been said that people with a good memory don't remember anything because they don't forget anything: similarly, perhaps, the person with roots takes them for granted, while the person with no roots whatsoever is vividly aware of them, like some phantom ache in an amputated limb.[4]

Roots are in a certain place. Home is (in) a place. Homeland. How do places get produced? Why has there been a 'resacrilization' of place? The first point to note is that places are not static, they are always changing. We must remember how capital moves, how places are created through capital investment. Capital is about technological change and the expansion of places. Places should always be seen in a historical and economic context.[5] In recent years, money capital has become more mobile. Places are created, expanded, then images are constructed to represent and sell these places. Of course, there is always some resistance ('class struggle in space') to this process.

In contrast to this Marxist view there is a phenomenological approach. Heidegger, for example, believed that place is the locale of Being.[6] He was very aware that time and space have been transformed through techno-logical change. He shared with Marx a dislike of the market and was antagonistic to the fetishization of commodities. In Heidegger's view there were authentic and inauthentic places. He thought about 'dwelling', about place and placelessness. He was aware of rootedness and thought of those people who had lost their rootedness in place. There is an enormous richness in the ambiguity of the meaning of the word 'place'. I want to emphasize that places are socially constructed, and that this construction is about power. Capital moves about the globe and creates a *hierarchy* of places.

Whilst the political economy approach emphasizes technical rationality, the phenomenological, Heideggerian approach stresses experience. But an important theoretical question is: where does money come from? Where does our food come from? It could be said that both Heidegger and Marx

see the world, but that Heidegger does not want to address the external, material aspects of it.

Now, some readers may say that this argument is based on a binary opposition: modernism (Marx) versus tradition (Heidegger) and that there are many other positions. Though we know that place is often associated with tradition, we often forget that tradition, too, is always being made and remade. Tradition is fluid, it is always being reconstituted. Tradition *is* about change – change that is not being acknowledged.

THE JOURNEY OF THE MIGRANT

We are born into relationships that are always based in a *place*. This form of primary and 'placeable' bonding is of quite fundamental human and natural importance. This insight is beautifully expressed in a moving and thought-provoking book about the problems that emigrants have to face: language, nostalgia, loss, search for identity. Eva Hoffman's biography *Lost in Translation* is in three parts: Paradise, Exile, The New World.[7] The first part is about Eva's childhood in Cracow, Poland. She writes about her Jewish parents' suffering during the war, her family and friends, her schooling. A fascinating evocation of a happy childhood, Eva describes her perceptions and memories in a vivid, sensuous manner. This part ends with a description of her parents' disaffiliation and the emigration of her family, when she is 13, to Canada.

In the second part of the book Eva focuses on her alienation and her problems with the English language. She remarks: 'the problem is that the signifier has become severed from the signified. The words I learn now don't stand for things in the same unquestioned way they did in my native tongue.' Gradually, Polish becomes a dead language, the language of the untranslatable past. She finds her Polish words don't apply to her new experiences . . . and the English words don't hook on to anything. This part of the book is a thoughtful discussion about life in a new language (the subtitle of the book), and her anxieties about identity:

> 'This is a society [an American says] in which you are who you think you are. Nobody gives you your identity here, you have to reinvent your self everyday.' He is right I suspect, but I can't figure out how this is done. You just say what you are and everyone believes you? But how do I choose from identity options available all round me?[8]

In part three, Eva gives an account of how she gradually begins to feel at home in 'The New World'. At first she shares with her American generation an acute sense of dislocation and the equally acute challenge of having to invent a place and an identity for herself without the traditional supports. Feelings of anomie, loneliness and emotional repression drive

Eva to therapy. She is asked: why do so many Americans go to psychia-
trists all the time? She replies:

> It's a problem of identity. Many of my American friends feel they don't
> have enough of it. They often feel worthless, or they don't know how
> they feel? . . . maybe it's because everyone is always on the move and
> undergoing enormous changes, so they lose track of who they've been
> and have to keep tabs on who they're becoming all the time.[9]

At the end of the book Eva acknowledges that she is being remade,
fragment by fragment, like a patchwork quilt. She is becoming a hybrid
creature, a sort of resident alien. For me the book raises many interesting
questions. How do frames of culture, for example, hold the individual
personalities in place? How are places imagined and represented? How do
they affect people's identities? How do the worlds of imagination and
representation come together?

Eva Hoffman's book makes clear that identity is changed by the journey;
our subjectivity is recomposed. In the transformation every step forward
can also be a step back: the migrant is here and there. Exile can be
deadening but it can also be very creative. Exile can be an affliction but it
can also be a transfiguration – it can be a resource. I think what I am trying
to say is that identity is not to do with being but with becoming.

EXILES, STRANGERS, FOREIGNERS

Edward Said has remarked that when some people think of exiles they
think of those famous American and British writers who sought a change in
the creative surroundings. 'Joyce and Nabokov and even Conrad, who
write of exile with such pathos, but of exile without cause or rationale.'[10]
Perhaps, instead, one should think of the uncountable masses, those exiled
by poverty, colonialism, war.

Many words in the exile 'family' can be divided between an archaic
or literary sense and a modern, political one: for example, banishment/
deportation; exodus/flight; émigré/immigrant; wanderer/refugee. All
migrants, refugees, exiles come to the frontier. The frontier does not
merely close the nation in on itself, but also, immediately opens it to an
outside, to other nations. All frontiers, including the frontier of nations, at
the same time as they are barriers, are also places of communication and
exchange. Frontiers, argues Geoffrey Bennington, are places of separation
and articulation (acts or modes of joining); *boundaries* are constitutively
crossed or transgressed.[11]

There are many sorts of travellers; some live on the borderline, the
border between two states. The states could be feeling and thought, private
and public, or Polish and English. One often hears the remark, 'They have
a foot in each camp'. These may be migrants who don't want to give up

their own culture or assimilate with the new group. The borderline is always ambivalent; sometimes it is seen as an inherent part of the inside, at other times it is seen as part of the chaotic wilderness outside.

I wasn't sure which word to use (émigré, migrant, refugee, outsider or alien?) till I read Julia Kristeva's *Strangers to Ourselves*.[12] She too was once a stranger when she arrived in Paris from Bulgaria in 1966.[13] Her book, an examination of the history of foreigners in Europe, deals with the stranger, as well as the idea of *strangeness within the self*, a person's deep sense of being, as distinct from outside appearance and one's conscious idea of oneself. She shows how the foreigner is thought of in different ways at different times, and she states that the modification in the status of foreigners that is imperative today leads one to reflect on our ability to accept new modalities of otherness.

THE RIGHTS OF A FOREIGNER

Who is a foreigner? The one who does not belong to the group, who is not 'one of them', the other. The foreigner can be defined only in negative fashion. The foreigner is the Other. Kristeva writes:

> The foreigner is the other of the family, the clan, the tribe. At first he blends with the enemy. External to my religion, too, he could have been the heathen, the heretic. Not having made an oath of fealty to my lord, he was born on another land, foreign to the kingdom or the empire.[14]

With the establishment of nation states, the foreigner is the one who does not belong to the state in which we are, the one who does not have the same nationality. Today, *legally*, the word foreigner refers to a person who is not a citizen of the country in which he or she resides.

Kristeva discusses how the spreading of the French Revolution's ideas over the continent triggered the demand for the *national* rights of peoples, not the *universality* of humankind. The situation now seems to be that only those people recognized as citizens of a sovereign state are entitled to have rights. But what happens to peoples without a homeland? How are those who are not citizens of a sovereign state to be considered?[15] It is not surprising that there is some sympathy for the resurgence of nationalism, whereby those who lost their residence attempt to reconstruct their homeland.

Many people have noted the paradox that it is through legislation that we improve the status of foreigners, and yet it is precisely with respect to laws that foreigners exist. Kristeva remarks that it is philosophical and religious movements, going beyond the political definitions of man, that often grant foreigners rights that are equal to those of citizens. These rights, however, may be enjoyed only within some future utopian place.

One of the main problems in modern societies is the conflict between the

rights of man and/or the rights of the citizen. It seems that one can be more or less a man to the extent that one is more or less a citizen, that he who is not a citizen is not fully a man. Between the man and the citizen there is a scar: the foreigner. What, then, are the rights of a foreigner? It is argued by Kristeva that foreigners are deprived of the following rights (in contrast with those that citizens enjoy in contemporary democracies):

- First, the foreigner is excluded from *public service* in all periods and in all countries (barring a few exceptions).
- Second, the right to own *real estate* is variously handled but generally denied non-natives.
- Third, though foreigners have some civil rights, they are denied *political rights*. The denial of the right to vote actually excludes foreigners from any decision that might be taken with respect to them. Foreigners do not participate in the legal process that leads to the adoption of laws.

In short, to enter the territory of the country, to maintain a residence there, to work there, sometimes even to speak out . . . the foreigner must ask permission from the appropriate authorities.

It is not surprising that there are some people who either do not wish to or cannot either become integrated here or return from whence they came. The arguments on both sides are well known. It is often said that foreigners eventually remain loyal to their country of origin and are harmful to our national independence. But others say that foreigners share in the building of our economic independence and consequently should enjoy the political rights that endow them with the power of decision.

Foreigners, then, are people who do not have the same rights as we do. They seem to have two roles: they can be positive (revealers of the tribe's hidden significance) or negative (intruders who destroy the consensus). In a sense, the foreigner is a 'symptom': psychologically, s/he signifies the difficulty we have of living as an other and with others. Politically, the foreigner underlines the limits of nation states. Kristeva perceptively remarks that we are all in the process of becoming foreigners in a universe that is being widened more than ever, that is more than ever heterogeneous beneath its apparent scientific and media-inspired unity.[16]

On the one hand, it is interesting to leave one's homeland in order to enter the culture of others but, on the other hand, this move is undertaken only to return to oneself and one's home, to judge or laugh at one's peculiarities and limitations. In other words, the foreigner becomes the figure on to which the penetrating, ironical mind of the philosopher is delegated – his double, his mask.

STRANGERS AND STIGMA

Consider the following quotation: 'woman is the other of man, animal the other of the human, stranger the other of native, abnormality the other of norm, deviation the other of law-abiding, illness the other of health, insanity the other of reason, lay public the other of the expert, foreigner the other of state subject, enemy the other of friend.'[17]

All visions of artificial order, states Zygmunt Bauman, are by necessity inherently asymmetrical and thereby dichotomizing. In dichotomies the second term is but the other of the first, the opposite (degraded, exiled, suppressed) side of the first and its creation. Dichotomies are exercises in power and at the same time their disguise. They split the human world into a group for whom the ideal order is to be erected, and another which is for the unfitting, the uncontrollable, the incongruous and the ambivalent.[18]

There are friends and enemies. And there are strangers. Friends and enemies stand in opposition to each other. The first are what the second are not, and vice versa. Like many oppositions, this one is a variation of the master opposition between the inside and the outside. The outside is negativity to the inside's positivity. The outside is what the inside is not. The enemies are the *wilderness* that violates friends' *homeliness*, the *absence* which is a denial of friends' *presence*. The repugnant and frightening 'out there' of the enemies is both the addition to, and displacement of, the cosy and comforting 'in here' of the friends.

Obviously, it is the friends who define the enemies; it is the friends who control the classification and the assignment. Whilst friends are associated with co-operation, enemies, on the other hand, are associated with struggle. The opposition between friends and enemies is one between being a subject and being an object of action. This opposition sets apart beauty from ugliness, truth from falsity, good from evil.

Now, the stranger is neither friend nor enemy; we do not know, and have no way of knowing which is the case. The stranger is one member of the family of undecidables. The term is associated with the work of Jacques Derrida.[19] Let me explain – undecidables discussed by Derrida include the pharmakon, the hymen and the supplement. The supplement: in French this word has a double sense: to supply something that is missing, or to supply something additional. The pharmakon is a Greek word which means remedy and poison. The hymen is another ambivalent Greek word standing for both membrane and marriage, which for this reason signifies at the same time virginity – the difference between the 'inside' and the 'outside' – and its violation by the fusion of the self and other.

Strangers are, in principle, undecidables. They are unclassifiable. A stranger is someone who refuses to remain confined to the 'far away' land or go away from our own. S/he is physically close while remaining culturally remote. Strangers often seem to be suspended in the empty space

between a tradition which they have already left and the mode of life which stubbornly denies them the right of entry. The stranger blurs a boundary line. The stranger is an anomaly, standing between the inside and the outside, order and chaos, friend and enemy.

Strangers, Bauman argues, are anomalies who can be dumped into tribal reserves, native homelands, or ethnic ghettos. Keeping strangers at a mental distance through locking them up in a shell of exoticism does not, however, suffice to neutralize their inherent, and dangerous, incongruity. An otherwise innocuous trait of the stranger becomes a sign of affliction, a cause of shame. The person bearing this trait is easily recognizable as less desirable, inferior, bad and dangerous. There is cultural exclusion of the stranger. S/he is constructed as a permanent Other.[20]

Stigma is a convenient weapon in the defence against the unwelcome ambiguity of the stranger. The essence of stigma is to emphasize the difference; and a difference which is in principle beyond repair, and hence justifies a permanent exclusion.[21] Many strangers try and erase the stigma by trying to assimilate. The harder they try, however, the faster the finishing-line recedes. Unlike an alien or a foreigner, the stranger is not simply a newcomer, a person temporarily out of place. S/he is an eternal wanderer, homeless always and everywhere. The nightmare is to be up-rooted, to be without papers, stateless, alone, alienated and adrift in a world of organized others. Fellow members of one's own group are thought to be human and trustworthy in ways that others are not. One's own group provides a refuge.

In terms of their biographies, contemporary individuals pass a long string of widely divergent social worlds. At any single moment of their life, individuals inhabit simultaneously several such divergent worlds. The re-sult is that they are 'uprooted' from each and not 'at home' in any. One may say that the stranger is universal because of having no home and no roots. The stranger's experience is one most of us now share. Amidst the universal homelessness individuals turn to their private lives as the only location where they may hope to build a home. In a hostile and uncaring world what can one do?

MARKING THE BOUNDARY

To conclude, I want to suggest that identity is a construction, a conse-quence of a process of interaction between people, institutions and prac-tices. Moreover, because the range of human behaviour is so wide, groups maintain boundaries to limit the type of behaviour within a defined cultural territory. Boundaries are an important point of reference for those partici-pating in any system. Boundaries may refer to, or consist of, geographical areas, political or religious viewpoints, occupational categories, linguistic and cultural traditions.

Some theorists, like Kai Erikson (drawing on Durkheim), have written that the only material for marking boundaries is the behaviour of its participants. According to this view, a deviant represents the extreme variety of conduct to be found within the experience of the group.[22] Within the boundary the norm has jurisdiction. Durkheim asserted, firstly, that a social norm is rarely expressed as a firm rule; it is really an accumulation of decisions made by a community over a long period of time. Secondly, that the norm retains its validity only if it is regularly used as a basis for judgement. Each time a deviant act is punished, the authority of the norm is sharpened, the declaration is made where the boundaries of the group are located. This is the way in which it can be asserted how much diversity and variability can be contained within the system before it loses its distinct structure. In short, deviants and agencies of control are boundary-maintaining mechanisms.

This thesis was first applied by Durkheim to deviance. I want to suggest that the deviant has been replaced by the immigrant. In traditional folklore there were demons, witches, devils. Now we have visible deviants: the foreigners. In Europe today it is largely black migrants who perform the function of marking the boundary. Harsh sanctions are taken against migrants who, feeling threatened, often emphasize their cultural identity as a way of self-protection. They are forced into segregated areas and their sense of alienation reinforced. The newcomer is seen as an intruder. There is a common assumption that there is only one norm: the dominant norm is the correct one, and that others must adjust.

I want to suggest that the social system appoints many incomers to spend a period of service testing the boundary. Migrants mark the outer limits of group experience, they provide a point of contrast which gives the norm some scope and dimension. At present the norm stresses similarity, but what would happen if the norm changed and if the norm stressed difference? What would happen if there was a recognition of the diversity of subjective positions and cultural identities?

NOTES

1 Raymond Williams, *Keywords*, London, Fontana, 1976.
2 'The Uncanny' (1919), in Sigmund Freud, *Art and Literature*, vol. 14, The Pelican Freud Library, Harmondsworth, Penguin Books, 1981, p. 368.
3 See Juliet Mitchell (ed.), *The Selected Melanie Klein*, Harmondsworth, Penguin Books, 1986.
4 Christopher Hampton, *White Chameleon*, London, Faber, 1991.
5 See, for example, David Harvey, *The Condition of Postmodernity: An Enquiry into the Origins of Cultural Change*, Oxford, Basil Blackwell, 1989.
6 Martin Heidegger, *Being and Time*, New York, Harper & Row, 1962.
7 Eva Hoffman, *Lost in Translation: Life in a New Language*, London, Minerva, 1991.
8 Ibid., p. 160.

9 Ibid., p. 263.
10 Edward Said, quoted by Timothy Brennan, 'The national longing for form', in Homi Bhabha (ed.), *Nation and Narration*, London, Routledge, 1990, p. 60.
11 Geoffrey Bennington, 'Postal politics and the institution of the nation', in ibid., p. 121.
12 Julia Kristeva, *Strangers to Ourselves*, London, Harvester Wheatsheaf, 1991. I am indebted to Kristeva's study for much of what follows in this section.
13 'To work on language, to labour in the materiality of that which society regards as a means of contact and understanding, isn't that at one stroke to declare oneself a stranger/foreign [étranger] to language?' Kristeva asks defiantly in the first sentence of *Séméiotiké*. It is, then, in her own exiled and marginalized position as an intellectual woman in Paris in the late 1960s that we can locate the formative influences on Kristeva's work. See Toril Moi (ed.), *The Kristeva Reader*, Oxford, Basil Blackwell, 1986, p. 3.
14 Kristeva, op. cit., p. 95.
15 The forced movement of unhappy, courageous people around the world continues remorselessly. In the newspapers, as I write, there have been pictures of desperate faces peering out of bus windows, eyes full of the appalled realization that they are probably seeing their home countries for the last time. I am referring to the reports (*The Guardian*, 19 Dec. 1992) of the 400 Palestinian deportees. As I write, they are living on a bleak hillside in the no-man's land between Israeli-controlled South Lebanon and the Lebanese army. They were neither being allowed by Israel to return, nor allowed by Lebanon to go on.
16 Kristeva, op. cit., p. 104.
17 In this section I have drawn on Zygmunt Bauman, *Modernity and Ambivalence*, Cambridge, Polity Press, 1991, p. 8.
18 A French writer, Hélène Cixous, has made the following list of binary oppositions: Activity/Passivity; Sun/Moon; Culture/Nature; Day/Night; Father/Mother; Head/Emotions; Intelligible/Sensitive; Logos/Pathos. These correspond to the underlying opposition man/woman. She argues that these binary oppositions are heavily imbricated in the patriarchal value system. Each opposition can be analysed as a hierarchy where the 'feminine' side is always seen as a negative, powerless instance. For one of the terms to acquire meaning, she claims, it must destroy the other. The 'couple' cannot be left intact; it becomes a battlefield where there is a struggle for signifying supremacy. In the end, victory is equated with activity, and defeat with passivity. See Hélène Cixous and Catherine Clement, *The Newly Born Woman*, Manchester, Manchester University Press, 1986, p. 63.
19 Jacques Derrida, *Disséminations*, London, Athlone Press, 1981, pp. 71, 99.
20 A well-known example of the construction of the Other is the discourse of Orientalism – a style of thought based on the distinction made between the Orient and the Occident. It is only by examining Orientalism as a discourse that we can understand the systematic discipline by which European culture was able to manage, and even produce, the Orient. Orientalism is not just a European fantasy about the Orient, but a created body of theory and practice. It is a relationship of power. See Edward Said, *Orientalism*, Harmondsworth, Penguin Books, 1985, and his recent book, *Culture and Imperialism*, London, Chatto & Windus, 1993.
21 Erving Goffman, *Stigma: Notes on the Management of Spoiled Identity*, Harmondsworth, Penguin Books, 1968.
22 Kai Erikson, *Wayward Puritans*, Chichester, Wiley, 1966.

Chapter 6

For a politics of nomadic identity

Chantal Mouffe[1]

As we approach the end of the century, we are witnessing a vast process of redefinition of collective identities and the creation of new political frontiers. This is, of course, linked to the collapse of communism and the disappearance of the democracy/totalitarianism opposition which had, at least since the end of the Second World War, served as the principal political boundary, enabling us to differentiate friend from foe. This, however, presents us with a double difficulty.

1 In Eastern Europe the unity that was forged in the fight against communism has evaporated and we are now seeing the multiplication of identities based on ethnic, regional and religious antagonisms. These represent a formidable challenge in the construction of a pluralist democracy in these countries.
2 In the West the meaning of democracy was founded on the differences established between its own system of governance and those of the 'other' that rejected it. Thus, the identity of democracy has now been destabilized by the loss of its erstwhile enemy; it has to be redefined by the creation of a new political frontier.

This situation tends to promote the growth of the extreme right, who can focus on a new enemy: the internal enemy represented by immigrants, particularly those who differentiate themselves by their ethnic origin or religion. These foreigners are portrayed as endangering national identity and sovereignty by various political movements which are doing their best to produce new collective identities and to re-create a political frontier by means of a nationalist and xenophobic discourse.

Today's democracies are thus confronted with a great challenge. In order to face up to this challenge, they must stop ignoring the political and must not delude themselves about the possibility of a consensus which would banish antagonism forever. This means questioning the liberal rationalism

which is at the root of the current lack of vision afflicting political thought as it attempts to come to terms with the great upheavals taking place in the world today. It is as if the West were expecting to celebrate the ultimate victory for liberal democracy but can now only stand stunned by the conflicts over ethnic origin, religion and identity which, according to their theories, should be things of the past. In place of the generalization of post-conventional identities so dear to Habermas, and the disappearance of antagonisms proclaimed by liberals, today we can see only the multiplication of specificities and the emergence of new rivalries.

Some try to explain the situation as the perverse legacy of totalitarianism, others as a so-called 'return of the archaic', as if it were merely a temporary delay on the road leading to the universalization of liberal democracy. As 'the end of History' has already been declared, many seem to think that all this is no more than a slight hiccup, a bad spell to get through before rationality finds its feet again and imposes its order. In other words, one last desperate cry of the political before it is definitively destroyed by the forces of law and universal reason.

It is clearly the political itself and the question of its elimination which is at stake here. And it is the inability of liberal thought to understand the nature of the political and the fundamental part played by antagonism which makes it blind to the true nature of the present situation. This situation requires a clean break with the objectivism and essentialism which dominate political analysis. But liberal thought employs a logic of the social based on a conception of being as presence, and which conceives of objectivity as being inherent to things themselves. This is why it is impossible for liberal thought to recognize that there can only be an identity when it is constructed as a 'difference', and that any social objectivity is constituted by the enactment of power. What it refuses to admit is that any form of social objectivity is ultimately political and must bear the traces of the acts of exclusion which govern its constitution.

The political cannot be grasped by liberal rationalism as it shows the limits of any rational consensus, and reveals that any consensus is based on acts of exclusion. Liberalism affirms that general interest results from the free play of private interests and its concept of politics is of the establishment of a compromise between the different competing forces in a society. Individuals are portrayed as rational beings driven by the maximization of their own interests and basically acting in the political world in an instrumental way. It is the idea of the market applied to the political; interests are already defined independently from the political; so what is important is the process of allocation which allows a consensus to be created between the different participants. Other liberals, those who rebel against this model and who want to create a link between politics and morality, believe that it is possible to create a rational and universal consensus by means of free discussion. They believe that by relegating disruptive issues to the

private sphere, a rational agreement on principles should be enough to administer the pluralism present in modern society.

According to this rationalist theory, everything to do with passions and with antagonism which might lead to violence is thought of as archaic and irrational, the remains of a bygone age where 'soft commerce' had not yet established the superiority of interests over passions.

But this attempt to annihilate the political is doomed to failure because politics cannot be domesticated in this way. As was understood by Carl Schmitt – a man whose views it would be wrong to ignore because of his subsequent political activities – the political derives its energy from the most diverse sources and 'every religious, moral, economic, ethical, or other antithesis transforms into a political one if it is sufficiently strong to group human beings effectively according to friend and enemy'.[2]

Confronted with the rise of particularisms and the resurgence of an ethnic and exclusive nationalism, the defence and extension of the democratic project requires that we take multicultural issues into account. This means tackling the question of different types of identities in a new way, based on an understanding of the political: this is inevitably impossible for those who believe in the liberal rationalist and individualist conception. The latter does its utmost to get rid of the political as the domain of power struggles, violence and confrontations with the enemy. But the political cannot be made to disappear simply by denying it; such a rejection leads only to impotence – the impotence which characterizes liberal thought when it finds itself confronted with a multiplication of different forms of demands for identity. To solve this dilemma, we must understand that the condition governing the creation of any identity the affirmation of a difference. Then we have to ask ourselves what type of relationship can be established between identity and otherness, to defuse the ever-present danger of exclusion which this identity-difference dynamic inevitably contains.

I shall use the concept of the 'constitutive outside' (*extérieur constitutif*) as a basis for tackling these different issues. This concept unites a number of the themes expounded by Jacques Derrida around his notions of 'supplement', 'trace' and '*différance*'. Its aim is to highlight the relationship between any identity and the fact that the creation of identity often implies the establishment of a hierarchy: for example, between form and matter; essence and contingency; black and white; man and woman. Once we have understood that every identity is relational and that the affirmation of a difference is a precondition for the existence of any identity (i.e. the perception of something 'other' than it which will constitute its 'exterior'), then we can begin to understand why such a relationship may always become a terrain for antagonism. Indeed, when it comes to the creation of a collective identity – basically the creation of an 'us' by the demarcation of

a 'them' – then there will always be the possibility that this 'us/them' relationship will become one of 'friend and enemy', i.e. one of antagonism. This happens when the 'other', who up until now has been considered simply as different, starts to be perceived as someone who is rejecting 'my' identity and who is threatening 'my' existence. From that moment on, any form of us/them relationship – whether it be religious, ethnic, economic or other – becomes political.

Looking at the issue of identity in this way transforms the way we think of the political. The political can no longer be located as present only in a certain type of institution, as representative of a sphere or level of society. It should rather be understood as a dimension inherent in all human society which stems from our very ontological condition. To clarify this new approach, it is helpful to distinguish between 'the political' (which describes the dimension of antagonism and hostility between humans – an antagonism which can take many different forms and can emerge in any form of social relation) and 'politics' (which seeks to establish a certain order and to organize human co-existence in conditions that are permanently conflictual because they are affected by 'the political'). This view, which attempts to keep together the two meanings encompassed by the term 'politics' – that of 'polemos' and that of 'polis' – is totally foreign to liberal thought; that, incidentally, is the reason why liberal thought is powerless in the face of antagonism. But I believe that the future of democracy points towards the recognition of this dimension of the political, for to protect and consolidate democracy we have to see that politics consists of 'domesticating hostility' and of trying to defuse the potential antagonism inherent in human relations.

So politics concerns public activity and the formation of collective identities. Its aim is to create an 'us' in a context of diversity and conflict. But to construct an 'us', one has to be able to differentiate it from a 'them'. That is why the crucial question for democratic politics is not how to arrive at a consensus without exclusion, or how to create an 'us' which would not have a corresponding 'them', but rather it is how to establish this 'us' and 'them' discrimination in a way that is compatible with pluralist democracy. This presupposes that the 'other' is no longer seen as an enemy to be destroyed, but as a 'counterpart' who could be in our place in the future. The aim is to transform an antagonism into an agonism. Here we might take inspiration from the thoughts of Elias Canetti, who in *Crowds and Power* showed that the parliamentary system exploits the psychological structure of warring armies by presenting a combat where actual killing is rejected in favour of allowing the opinion of the majority to decide on the victor. According to Canetti:

The actual vote is decisive, as the moment in which the one is really

measured against the other. It is all that is left of the original lethal clash and it is played out in many forms, with threats, abuse and physical provocation which may lead to blows or missiles. But the counting of the vote ends the battle.[3]

Far from seeing democracy as something natural, arising independently and self-evidently as a necessary corollary to mankind's moral evolution, it is important that we realize its improbable and uncertain character. Democracy is a fragile construction: never definitively acquired, it is a conquest which has to be forever defended against possible attacks. The prime task of democratic politics is not to eliminate passions, nor to relegate them to the private sphere in order to render rational consensus possible, but to mobilize these passions, and give them a democratic outlet. Instead of jeopardizing democracy, agonistic confrontation is its very condition of existence. Of course, democracy needs a certain degree of consensus – at least the rules of the democratic game have to be respected if it is to survive, but it also needs the constitution of collective identities around clearly differentiated positions. Voters must be given true choices and real alternatives amongst which they can choose. If Niklas Luhman is right and modern democracy does indeed essentially hinge on the 'splitting of the summit' which is created by the distinction between the government and the opposition, then we will also see the danger which the increasingly blurred boundaries between right and left-wing opposition constitute. Unclear dividing lines block the creation of democratic political identities and fuel the disenchantment with traditional political parties. Thus they prepare the ground for various forms of populist and anti-liberal movements that target nationalist, religious and ethnic divides. When the agonistic dynamism of the pluralist system is unable to unfold because of a shortage of democratic identities with which one can identify, there is a risk that this will multiply confrontations over essentialist identities and non-negotiable moral values.

It is only when we acknowledge that any identity is always relational and that it is defined in terms of difference that we are able to ask the crucial question: how can we fight the tendency towards exclusion? Again, Derrida's view might help us to find an answer. As the notion of a 'constitutive outside' itself implies, it is impossible to draw an absolute distinction between interior and exterior. Every identity is irremediably destabilized by its 'exterior'. This is an important point and I should therefore like to examine its political implications.

On a general philosophical level, it is obvious that if the constitutive outside is present inside every objectivity as its always real possibility, then the interior itself is something purely contingent, which reveals the struc-

ture of the mere possibility of every objective order. This questions every essentialist conception of identity and forecloses every attempt conclusively to define identity or objectivity. Inasmuch as objectivity always depends on an absent otherness, it is always necessarily echoed and contaminated by this otherness. Identity cannot, therefore, belong to one person alone, and no one belongs to a single identity. We might go further, and argue that not only are there no 'natural' and 'original' identities, since every identity is the result of a constituting process, but that this process itself must be seen as one of permanent hybridization and nomadization. Identity is, in effect, the result of a multitude of interactions that take place inside a space whose the outlines are not clearly defined. Numerous feminist studies and investigations inspired by 'postcolonial' concerns have shown that this process is always one of 'overdetermination', which establishes highly intricate links between the many forms of identity and a complex network of differences. For an appropriate definition of identity, we need to take into account both the multiplicity of discourses and the power structure that affects it, as well as the complex dynamic of complicity and resistance which underlies the practices in which this identity is implicated. Instead of seeing the different forms of identity as allegiances to a place or as a property, we ought to realise that they are the stake of a power struggle.

What we commonly call 'cultural identity' is both the scene and the object of political struggles. The social existence of a group is always constructed through conflict. It is one of the principal areas in which hegemony exists, because the definition of the cultural identity of a group, by reference to a specific system of contingent and particular social relations, plays a major role in the creation of 'hegemonic nodal points'.[4] These partially define the meaning of a 'signifying chain', allowing us to control the stream of signifiers, and temporarily to fix the discursive field. As for 'national' identities, the perspective based on concepts of hegemony and articulation allows us to come to grips with those identities, to transform them instead of rejecting them, whether in the name of anti-essentialism or universalism. In fact, it could be dangerous to ignore the libidinal cathexis which can be mobilized around the signifier 'nation', and it is a futile hope to expect the creation of a post 'conventional' identity. The struggle against the exclusive type of ethnic nationalism can be carried on only if some other form of nationalism is articulated, a kind of 'civic' nationalism, upholding pluralism and democratic values. Here we find questions that are of great import for democratic politics, and we should heed the warning offered us by the difficulties encountered in reunified Germany, namely that liberal and rationalist illusions of a 'post nationalist' identity can have dangerous consequences.

Contrary to what is popularly believed, a 'European' identity, conceived as

a homogeneous identity which could replace all other identifications and allegiances, will not be able to solve our problems. On the contrary, if we think of it in terms of 'aporia', of double genitive, as an 'experience of the impossible', to use Derrida's words from his *L'Autre cap*, then the notion of a European identity could be a catalyst for a promising process, not unlike what Merleau-Ponty called 'lateral universalism', which implies that the universal lies at the very heart of specificities and differences, and that it is inscribed in respect for diversity. If we conceive of this European identity as a 'difference to oneself', as 'one's own culture as someone else's culture',[5] then we are in effect envisaging an identity that accommodates otherness, that demonstrates the porosity of frontiers, and opens up towards that 'exterior' which makes it possible. By accepting that only hybridity creates us as separate entities, it affirms and upholds the nomadic character of every identity.

By resisting the ever-present temptation to construct identity in terms of exclusion, and recognizing that identities comprise a multiplicity of elements, and that they are dependent and interdependent, we can 'convert an antagonism of identity into the agonism of difference',[6] as William Connolly put it, and thus stop the potential for violence that exists in every construction of an 'us and them'. Only if peoples' allegiances are multiplied and their loyalties pluralized will it be possible to create a truly 'agonistic pluralism'. Because where identities are multiplied, passions are divided.

If a discussion of identity is to be of real significance, it must be placed in the wider context of the paradoxes of pluralist democracy. Indeed, there is in such a democracy something enigmatic and paradoxical which several of its critics have emphasized and which stems from the articulation between liberalism and democracy which it has established. Undoubtedly there are two types of logic which come into conflict with each other because the final realization of the logic of democracy, which is a logic founded on identity and equivalence, is made impossible by the liberal logic of pluralism and difference, because the latter prevents the establishment of a complete system of identifications.

These two logics are incompatible, yet this does not mean that the system as such is not viable. On the contrary, it is precisely the existence of this *tension* between the logic of identity and the logic of difference which makes pluralist democracy a regime particularly suited to the indeterminacy of modern politics. There is no doubt that due to this articulation between liberalism and democracy, liberal logic – which tends to construct every identity as positivity and as a difference – necessarily subverts the totalization which is the aim of the democratic logic of equivalence. Far from complaining about this, we should rejoice, because it is this tension between the logic of equivalence and the logic of difference, between equality and liberty, and between our identity as individuals and our

identity as citizens, which provides the best protection against every attempt to effect either a complete fusion or a total separation. We should therefore avoid suppressing this tension because if we try to eliminate the political we risk destroying democracy. The experience of modern democracy is based on the realization that these conflicting logics exist – one aiming to achieve complete equivalence, the other to preserve all differences – and that their articulation is necessary. This articulation must be constantly re-created and renegotiated: there is no point of equilibrium where final harmony could be attained. It is only in this precarious 'in-between' that we can experience pluralism, that is to say, that this democracy will always be 'to come', to use Derrida's expression, which emphasizes not only the unrealized possibilities but also the radical impossibility of final completion. Far from creating the necessary background for pluralism, any belief in a final resolution of all conflict, even if it is conceived as an asymptotic approach to the regulative idea of non-distorted communication as expounded by Habermas, will put it in danger because paradoxically the very moment that it was completed would also be the moment of its destruction. True pluralist democracy is therefore to be seen as an 'impossible good', that is to say, as something that exists only as long as it cannot be perfectly achieved. The existence of pluralism implies the permanence of conflict and antagonism and these should not be seen as empirical obstacles which would make impossible the perfect realization of an ideal existing in a harmony which we cannot reach because we will never be capable of perfectly coinciding with our rational selves.

It is therefore important for democracy and for the construction of democratic identities to have a framework that allows us to think of difference as being the condition of both possibility and impossibility to create unity and totality. This framework invites us to abandon the dangerous illusion of a possible resumption of otherness in a unified and harmonious whole, and to admit that the other and its otherness are irreducible. This is an otherness which cannot be domesticated, and as Rodolphe Gasché has said:

> This alterity forever undermines, but also makes possible, the dream of autonomy achieved through a reflexive coiling upon self, since it names a structural precondition of such a desired state, a precondition that represents the limit of such a possibility.[7]

NOTES

1 This paper was originally published in a different translation in *REPRESENTATIVES: Andrea Fraser, Christian Philipp Müller, Gerwald Rockenschaub*, the catalogue of the Austrian Pavilion at the 45th Venice Biennale, 1993 (Bundesministerium für Unterricht und Kunst, Vienna 1993).

2 Carl Schmitt, *The Concept of the Political*, New Brunswick, Rutgers University Press, 1976, p. 37.
3 Elias Canetti, *Crowds and Power*, Harmondsworth, Penguin Books, 1973, p. 220.
4 For discussion of this concept, see Ernesto Laclau and Chantal Mouffe, *Hegemony and Socialist Strategy, Towards a Radical Democratic Politics*, London, Verso, 1985, Chapter 3.
5 Jacques Derrida, *L'Autre cap*, Paris, Editions de Minuit, 1991, p. 16.
6 William E. Connolly, *Identity/Difference*, Ithaca and London, Cornell University Press, 1991, p. 178.
7 Rodolphe Gasché, *The Tain in the Mirror*, Cambridge, Mass., Harvard University Press, 1986, p. 105.

Refugees and homecomings: Bessie Head and the end of exile

Rob Nixon

One morning in Johannesburg a few years back, I was roused early by the dawn chorus of the telephone. In my penumbral, precaffeinated state I found myself listening to an agitated voice inquiring from the far end: 'Hello, excuse me, are you the ANC Repatriation Office?' It took me some little while to awaken to the fact that I was neither in the grip of one of my recurrent bureaucracy nightmares nor being enveloped by yet another variant of the South African dementia. For that week I had moved in to share a house with Mzwai Booi, a guerrilla leader, recently returned from Moscow and Lusaka, who had landed the absolutely mind-bending job of chief orchestrator of the exiles' return.

To speak of the culture of exile at this moment in the South African struggle is to speak above all of the culture of return. Or, more precisely, about the culture of re-entry. For the word 'return' among the South African, as among the Palestinian, diaspora carries a hugely resonant set of expectations which current conditions have scarcely begun to satisfy. 'Return' has accrued associations with reclamation and restitution. As in all anti-colonial struggles, the word summons to mind, above all, emotional and economic claims on the land.

South African repatriation has come not through liberation but through a by now blood-stained amnesty replete with cynical military efforts to foster violence and deepen inter-ethnic rifts. The freedom to pass through customs without fear of arrest surely marks an advance, but it remains an insufficient criterion for return. South Africans have experienced the attenuation of exile without the fullness of return; without, that is, anything approaching liberation, deliverance, or what the Martinican poet, Aimé Césaire once called 'the rendezvous of victory'.[1]

Mzwai Booi reaffirmed my sense that homecoming does not allow for simple restorations. When I met him, Booi would, as a reprieve from his heady week at the Repatriation Office, drive off on a Sunday night and join the tuxedoed ranks attending concerts and operas in the heart of Johannesburg. There he sought to satisfy the quite classical aesthetic enthusiasms he had acquired through a seven-year stint in Moscow. During

fifteen years of enforced absence from the rural hamlet of his birth – a time spent in cities as divergent as Moscow and Lusaka – Booi had become a total metissage, someone who, for all his absorption in the South African struggle, had travelled out of range of simple cultural allegiances and reclamations. He had become, in short, what Salman Rushdie calls an irrevocably 'translated person'.[2]

The closure of South African exile should spur us to reassess the literature which that condition inspired – a challenge to be undertaken not simply in a commemorative but also in a prospective spirit. The arrival of wave upon wave of 'translated' people reminds us that words like banishment, uprootedness, loss and yearning cannot contain the state of exile. It can be a deadening condition but it can be, equally, a cruelly creative one, forcing people to achieve complex, often imaginatively provisional ways of being. This creativity wrought from loss can be an asset during an era when the ground rules of both South African and Palestinian politics are shifting underfoot, an era that has heightened our need for resourceful, even visionary improvisation.

Officially the epoch of South African exile that began in the late 1950s ended in 1990. One of the ANC's specific conditions for entering into negotiations was the unconditional return of all exiles. But the returnees have had to face the immense breach between their often apocalyptic sense of anticipation and the abject conditions of contemporary South Africa. The principal revolution has been the revolution in expectations unleashed by the unbannings, the re-entries, and the release of prisoners. As in the ex-Soviet Union and much of Eastern Europe, the rhetoric of endings has produced an upward spiral of political expectations amidst downward spiralling economic circumstances.

For the liberation movement to have wrested the right of re-entry from the South African regime is in itself an achievement. However, while re-entry offers promise in so far as it breaks the deadlock of banishment, we should put this promise in perspective: only 10 per cent of the South African exiles who have come back have found jobs. The prospects are dim – especially for demobilized guerrillas who, from the perspective of business and industry, are not heroes of the struggle, but underqualified men and women with tatty bush-war cvs.

Indeed, in the case of the 'returnees', this upsurge in expectations has only compounded the often airy hopes that burgeon so freely in exile. While glorious anticipation helps make the years of banishment bearable – providing a bedrock of solidarity and exhortation – such assumptions become an encumbrance when people re-enter. To speak of the politics of memory at this juncture, therefore, is to speak very much of memories of wounded expectations.

All this has put the ANC in an acute dilemma. The moment of re-entry has increased the organization's responsibilities in circumstances where it

possesses minimal institutional power. It possesses neither the funds and infrastructure to provide jobs, nor the facilities to help people adjust to re-entry in a trough of local and global recession. Consequently, while the ANC has made repatriation a condition of negotiations, it has also, privately, urged exiles who hold jobs overseas to remain abroad.

So much South African, like Palestinian literature of the post-Second World War era, has arisen out of the experience of exile that it is salient to ask how this moment of re-entry transfigures our perception of that corpus of work. All exiles, whether writers or not, share a certain churning in the stomach as they ride the emotional waves that surge between memory and expectations. What distinguishes writers, however, from most other exiles is the professionalizing of their reliance on that violent passage between past and future which so often becomes the source of their inspiration and reputation. Many such writers become habituated to blanking out the alien present – it becomes the least relevant, most distant, most insubstantial of tenses. Time is lived, instead, in a loop of backward and forward projections; the replay and fast forward buttons moving the tape in the same direction, towards an often desperate jumbling of past and future. This *mélange* serves as an imperfect compensation for their losses while sustaining their hopes. Such a convergent experience of time is particularly rampant among exiles who immerse themselves in anti-colonial struggles, where the power of these projections gets intensified by the belief that the impetus of history and justice are on one's side.

With the end of exile, that loaded phrase 'back home' is changed utterly in all its temporal and spatial implications. 'Back home' can no longer serve as a place and a time quarantined from the realm of choice. With the lifting of the proscriptions on re-entry, the exiled writer gains new options but also loses the familiar sense of deferred responsibility. Some South African authors have now elected to return, many others have not. Others still have engineered sabbatical homecomings – taking the precaution of temporary leave from their American and European jobs while they hazard a trial rendezvous with their erstwhile homeland.

The decision to re-enter may offer release; it may also provoke, in the same breath, an outpouring of trepidation. On the one hand, return, however compromised, presents the prospect of imaginative renewal. This is a priceless prospect for writers who have found themselves plumbing an ever-shallower pool of recollections, the initial wrong of banishment having been compounded by that secondary injustice, the evaporation of memory. Yet the promise of replenishment has its threatening side, too, for it draws writers away from the imaginative obsessions that sustained them in exile, obsessions which, however melancholy, came over the years to offer a version of security.

The very notion of exile is, of course, susceptible to a lurking theatricality. In its most catholic usage, it can signal little more than a fashionable

alienation and attract some dubious claimants. Breyten Breytenbach, who was barred from South Africa after marrying a Vietnamese woman, has shown irritation at the licence with which the term 'exile' is invoked. He has given voice to a fatigue not just with the histrionics of imitation exiles, but with those more rightful claimants to the title, who have allowed themselves to become immobilized by their condition. Breytenbach excoriates those who

> on auspicious occasions bring forth the relics and sing the cracked songs and end up arguing like parakeets about what 'back home' was really like. They lose the language but refuse to integrate the loss, and accordingly will think less, with fewer words and only morbid references to suspend their thoughts from. They are dead survivors waiting for postcards from the realm of the living. The clock has stopped once and for all, the cuckoo suffocated on some unintelligible Swiss sound.[3]

To such moribund exiles, re-entry may offer a second chance, either kickstarting their creativity or forcing them to face their terminal inertia. So, too, the advent of the freedom to re-enter – whether in Eastern Europe, the CIS, Palestine or South Africa – can help to flush out those ersatz exiles who wore the title like a literary lapel badge.

Although exile is an affliction, those who refuse to concede ruination may transform it into a cultural resource. That which disfigures may, with determination and fortune, become transfiguring. This is worth bearing in mind when we reflect on the amnesias of nationalism, those conscientious forgettings that help mould a shared sense of memory.[4] The phrase assumes a fresh force if we bring it to bear on all the shards of memory that get ferried back with each re-entering exile. Such jagged memories afford us the chance to reconceive the cultural barriers between the indigenous and the alien, the significant and the inconsequential, indeed, to imagine the nation anew.

The need for such reconceptions is sharpened in contemporary South Africa by the rigid divides between relevant and irrelevant writing that arose under the pressures of the apartheid–anti-apartheid agon. It is surely no coincidence that the fiercest critic of those divides, Njabulo Ndebele, is himself an erstwhile exile. Arguably South Africa's finest cultural critic and an accomplished writer of fiction, Ndebele charges that the range of experience admitted by the main currents of South African writing has been unhealthily narrowed by the pressure on writers to display relevance, commitment and political engagement – to write, that is, visibly in the service of the struggle.

Ndebele seeks, in his essays, to weigh the literary and political cost of the anti-apartheid imperative. The predominance of accusatory politics in much of the literature produces in Ndebele's words, 'not knowledge but

indictment' and has, paradoxically, a dehumanizing effect. The familiar panoply of victims, revolutionaries and sell-outs

> appear as mere ideas to be marshalled this way or that in a moral debate. Their *human* anonymity becomes the dialectical equivalent of the anonymity to which the oppressive system consigns millions of oppressed Africans. Thus, instead of clarifying the tragic human experience of oppression, such fiction becomes grounded in the very negation it seeks to transcend.[5]

Thus, Ndebele has called for alternative forms of writing that are less Manichean and reactive: for forms that refuse to subordinate the cultural resources of black communities to the dynamics of racial conflict.

Ndebele has voiced a particular concern that South African anti-apartheid literature is obsessively urban, that it has driven rural experience and indigenous styles of story-telling into the forgotten margins of the country's literature, disregarding them as a source of cultural renewal. The patterns of exile that predominated among South Africans assume a direct relevance to Ndebele's observation. For like most Palestinians, the majority of South Africans who fled abroad did not resettle in Europe and North America but became proximate exiles who crossed over into neighbouring countries where they often remained vulnerable to the predations of South Africa's regional imperial designs. These people experienced exile principally as a rural plight. However, South Africa's literary exiles proved to be atypical of this broader movement: most of them headed for those venerable magnets of the bohemian diaspora – London, Paris, New York, Chicago and Berlin.

Some literary exiles, like Dennis Brutus, played a considerable role in giving the struggle international dimensions, by helping import it into the power centres of world politics and the media. However, such cosmopolitan exiles could not offer the specific kind of regenerative literature that Ndebele has urged, namely one that reconceives rural experience as a neglected resource and refuses to confine black experience to the rhythms of the apartheid–anti-apartheid two-step.

It is in this regard that the life and writings of Bessie Head, who lived as a refugee for most her adult life, assume a singular value. Head's angular perspectives challenge her readers into reconceiving the barriers between the indigenous and the alien, between the significant and the inconsequential; indeed, into re-imagining the amnesias of the culture at large. Head is the only exiled South African writer of note to have avoided the rutted literary routes that led from her native land to Europe and North America; she decided instead to move to the frontline state of Botswana, in her words, just 'one door away from South Africa'.[6] Consequently, her imaginative perspective was one of rural internationalism achieved through

neighbourhood exile, where the cross-cultural differences were offset by regional continuities.

The extremity of Head's estrangements from tradition placed her under relentless pressure to improvise a sense of community and ancestry. Stranded at what one commentator has called the 'crossroads of dispossession', she compensated for her losses by reconceiving herself through a set of fragile, surrogate allegiances.[7]

Head bore the burden of a doubly illegitimate birth: she was conceived out of wedlock and, in apartheid argot, 'across the colour bar'. Thus her entry into the world placed her in a transgressive relationship to the racial and gender dictates of her society, portending the torments of her later life in exile. She was 13 before her origins were revealed to her:

> I was born on the 6th July 1937 in the Pietermaritzburg mental hospital. The reason for my peculiar birthplace was that my mother was white, and she had acquired me from a black man. She was judged insane, and committed to the mental hospital while pregnant.[8]

Head's mother, Bessie Amelia Emery, came from an upper-class, white South African family renowned for breeding race-horses. When Emery fell pregnant, her parents had her locked away in a mental asylum on the grounds of 'premature senile dementia'.[9] She gave birth to Head whilst in the asylum and six years later, in 1943, committed suicide there. Head never met her mother, nor did she ever learn the name of her father, who fled the Emery estate without leaving a trace.

Head was named not by her parents but by the apartheid state: 'My mother's name was Bessie Emery and I consider it the only honour South African officials ever did me – naming me after this unknown, lovely, and unpredictable woman'.[10] Thus at Head's christening, the distinction between private and public realms disappeared, foreshadowing her almost lifelong sense of the power that the nation state wielded over the most intimate facets of her identity – an awareness underscored by her suspicious treatment during exile.

By the age of 13, Head had experienced four sets of parents: her biological parents; the Afrikaans foster parents who adopted her as an infant only to return her a week later complaining that she 'appeared to be black'; the mixed-race foster parents into whose care she was then delivered; and finally, the state, which acting *in loco parentis*, removed the young girl from these second foster parents and placed her in an orphanage as a ward of the state. Thus, from an early age, Head came to experience the ideas of home and the family not as natural forms of belonging but as unstable artifices, invented and reinvented in racial terms, and conditional upon the administrative designs of the nation state.

Head's sense of familial and racial estrangement was compounded by the fact that, until the age of 42, she was denied the moorings of nationality.

Her first 27 years were spent in South Africa as a disenfranchised, 'mixed-race' woman, and the next 15 years in Botswana, where she was denied citizenship and forced to live as a stateless refugee. This was partly the result of South African regional imperial designs, which placed pressure on the Botswanans to deny sanctuary to South Africans fleeing apartheid. While in Botswana, Head, like her mother before her, was interned in a mental asylum – if only temporarily. She thus lived the uncertainty of the word asylum in both its psychological and political meanings: the etymological roots of the term may promise sanctuary, but it is more often experienced as brutal confinement.

Having been rejected by both her natal land and her adopted country, Head experienced the nation state first and foremost as a gruelling administrative experience. From 1964 to 1979 her official identity remained sandwiched between two of the world's most risible, immobilizing documents – a South African exit permit (which barred her from returning) and a United Nations Refugee Travel Document. Both of these effectively denied her a national identity.

When an American literary journal innocently sent Head a questionnaire about her writing habits, she responded ruefully: 'I am usually terrorized by various authorities into accounting for my existence; and filling in forms, under such circumstances, acquires a fascination all of its own'.[11] As a result of the perennial, reciprocal suspicion between her and all national authorities, she approached questionnaires with the expectation not that they would ratify her identity, but that they had been devised to invalidate it.

Philip Schlesinger has described the nation as

> a repository, *inter alia*, of classificatory systems. It allows 'us' to define ourselves against 'them' understood as those beyond the boundaries of the nation. It may also reproduce distinctions between 'us' and 'them' at the intra-national level, in line with the *internal* structure of social divisions and relations of power and domination.[12]

Schlesinger's remarks are directly pertinent to South Africa, where the classificatory obsessions of British imperialism, inherited and transformed by Afrikaans nationalists, insured that most black South Africans lived the nation state as a brutally administered form of disinheritance. This experience of the nation state as a set of institutions destructively reinventing people by categorizing them is forcefully evoked by Don Mattera, a 'mixed-race' author of Head's generation. Writing of the era when apartheid bureaucrats sought to institutionalize a revamped version of the category 'coloured', Mattera recalls how: 'A twilight people . . . were being conceived on the drawing board of apartheid. A hybrid species, signed, sealed and stamped into synthetic nationhood.'[13]

Head's liminal status as a 'mixed-race' South African left her particularly

resistant to the synthetic projections of the nation in categorically racial terms. Yet she might have become less resistant to the idea of the nation *per se* had her negative experience of the mutually reinforcing exclusions of nation and race not been repeated, disturbingly if less violently, in Botswana after she moved there in 1964. In Serowe, the village where she finally settled, she found that the inhabitants identified themselves strongly in ethnic nationalist terms as Batswana. Like many such communities, they consolidated their identity by defining themselves in opposition to certain outcast groups. The lot of the pariahs fell principally, in Serowe, to the lighter skinned 'Bushmen' or 'San', for whom the Batswana reserved a special term of disdain – 'Masarwa' (pl. 'Basarwa'). To her mortification, Head found herself cursed as a 'half-caste' and 'low breed' alongside the so-called 'Basarwa'.[14] The familiarity of the insult must have sharpened her agony, for 'Boesman'/'Bushman' was a standard slur spat at 'coloureds' by white South African policemen and farmers. The traumas of adoption had come full circle: the orphan whose foster parents had rejected her for appearing too black was now derided, in her adopted village, for seeming insufficiently so. Having left the racist nationalism of South Africa behind her, Head found herself in a situation where the Botswanan state refused to accept her as a national and members of her local community vilified her in racial terms.

Reading between the lines, one begins to discern the discriminatory rationale behind the bracketing of Head with the 'Basarwa'. From both a white colonial and a Batswana perspective, the nomadic character of the 'San' or 'Basarwa' militated against their claims to ownership of the land. Indeed, the abusive term 'Masarwa' bears the contradictory meaning of 'a person from the uninhabited country'.[15] This formulation for per-petuating the cycles of dispossession is reminiscent of the catastrophic colonial designation of Palestine as 'a land without a people' and Palestinians as 'a people without a land'. In both instances, the argument begins by designating a people as nomadic, proceeds by claiming that this precludes them from owning land, and thereby deduces that such landless people cannot, by definition, suffer dispossession. The motive for and consequence of this rationale is the accelerated dispossession of the people in question, be they Palestinians or 'San'.

It would thus seem that discrimination against people envisaged as 'wanderers' – Jews, Romany, Palestinians, and 'San' – is not confined to the West. Moreover, a related version of this prejudice is projected on to refugees as 'undesirable' in their errancy. Thus the earmarking of Head as a pariah in Botswana brought together the perceptions of her as a 'tribeless half-caste', as ethnically similar to the 'landless Basarwa', and as a refugee. To compound matters, she bore the stigma of the single mother – a 'loose' woman, anchored neither through land nor marriage to the agrarian system of property that determined social value.[16] The certification of

Head as insane and her confinement in Lobatse Mental Institution in 1971 may have further exacerbated the perception of her as 'wandering' and 'loose' – given the mutually confirming projections in some societies of 'madwomen' as 'strays', and 'stray' women (i.e. single ones, especially single mothers) as unhinged. Lynette Jackson's groundbreaking work on the construction of female madness in certain Southern African mental institutions is particularly suggestive in this regard.[17]

In short, the circumstances of Head's birth were not the only forms of liminality she had to contend with: as a first-generation so-called 'coloured', an orphan, a changeling, a refugee, an inmate of an insane asylum, and a single mother, she led a profoundly disinherited life on every front. Moreover, as a mixed-race woman writer engaging with rural themes in Southern Africa, Head worked without the sustenance of a literary lineage.

Head's prose is peopled largely with two types: characters whose sense of belonging is an unsettled, precarious achievement rather than a birthright, and those who risk or forfeit their inherited privileges by breaking with claustral traditions. Indeed, Head repeatedly projected forms of community and ancestry that could not be premised on the unexamined authority of inherited tradition. Her own vexed relationship to questions of origins, succession, legacies, heritages and bloodlines left her with a deep-seated suspicion of traditions, above all of national ones, whose invented authority rests on the assumption that the nation is both natural and born of a continuous historical lineage.

Although the nation is a political and bureaucratic invention, the discourse of nationalism commonly imbues it with the natural authority of blood-lineage by representing the nation as a set of familial bonds. Etymologically, the word 'nation' is rooted in the idea of conception, while the pervasive figure of Mother of the Nation has been attached to women as diverse as Winnie Mandela, Eva Perón, and the Queen Mum. More broadly, the language of nationalism is a language of new nations being born: of motherlands, fatherlands, homelands, adopted lands and neighbouring countries. So, when we speak of the exiles' homecoming, their imagined destination is at once a national and a domestic space.

Feminist theorists of nationalism like Anne McClintock, Elleke Boehmer, Floya Anthias and Nira Yuval-Davis have analysed the contradictions between the frequent projection of the idea of the nation through a female idiom and the exclusion of women from the statutory rights available to 'nationals', whose normative identity has been institutionalized as male.[18] At a rhetorical level, however, as Donald Horowitz argues, ethnic national groups, with their hereditary and hierarchical obsessions, tend to perceive themselves as 'super-families'.[19] Thus, the analogues between national and family ties have proved crucial to political efforts to portray the nation as a self-evident category authenticated by historical and bio-

logical continuities. This process suppresses the irrational, incoherent and contingent dimensions to nations whose ancestry and boundaries are not emanations of an organic past but largely the products of repeated bureaucratic interventions.

The administrative labour of presenting the nation as a surrogate work of nature is manifest, for instance, in the title of the American Department of Immigration and Naturalization, the body responsible for transmogrifying so-called resident 'aliens' into 'naturalized' Americans. Anyone who has struggled through that labyrinthine paper tunnel can testify to the perversity of construing the process of nationalization as a form of integrating people into something natural. The discourse of 'undocumented immigrants' depicts much more accurately outsiders' experience of the nation as a bureaucratic and not an organic phenomenon.

Many of the fundamental criteria for social acceptance – notably those of family, race and nation – frequently assume or invoke the authority of blood-lineage. Because Head's relationship to these categories was so radically and traumatically marginal, she could never live the illusion of their naturalness. As such, her best books – *Serowe: Village of the Rain Wind*, *The Collector of Treasures* and *Tales of Tenderness and Power*[20] – offer radical insight into the contingencies underlying efforts to seal group membership or exclusion on grounds of blood, nature or ancestry. Her books testify, moreover, to her determination to reconceive herself as a writer of 'mixed ancestry' in far more than the narrowly racial sense.

In exile, Head forcibly remade herself outside the pseudo-natural matrix of familial, racial and national traditions which had formed the very grounds of her ostracism. Bypassed by nationalism, Head reconceived herself in exile as a transnational writer. While her books are set in Botswana, they convey a powerful sense of the incessant border crossings of refugees, migrant workers, prostitutes, school children, missionaries and armies that score Southern Africa as a whole. Head's writing thus helped her convert the sense of cross-cultural belonging foisted on her by the state into an allegiance of her own.

Alone among the host of black South African authors who were exiled by apartheid, Head set the bulk of her writings not back in the South Africa of memory, but in her present surroundings. As a result, her writings are full of loss, but scoured of nostalgia. By the mid-1970s, she had decided to immerse herself in local history as a strategy for survival. The act of writing fiction and an oral history of her adopted village helped this denationalized orphan improvise a genealogy.

Southern Africa's precolonial history and its transition from colonialism to independence form the backdrop to many of Head's exile writings. Yet she was neither a cultural preservationist nor an advocate of modern nationalism as a progressive force. Increasingly, she saw the issues of precolonial, colonial and postcolonial experience through the optic of

women's relation to male authority structures, property and the land. Her writings suggest, too, that the core colonial issue of land is ineradicably gendered. While passionately supporting the idea of independence, she came to feel first-hand women's and men's unequal access to the fruits of nationhood.

Head's mistrust of the sweeping narratives of national politics was compounded by her very intimate sense of what they routinely bypass, especially women's experience, rural life and oral traditions. Relatedly, one senses Head's anxiety that racial domination, through its power to provoke anti-racism, would continue to preoccupy black forms of self-definition; it would thereby hamper – in much the way that Ndebele feared – efforts to set more independent imaginative co-ordinates.

It is hardly surprising that Head grew to be obsessed with memory. Yet as a writer comprehensively orphaned by the familial and national past, she was well placed to recognize the imaginative violence that may accompany selective memory, how it may connive in the creation of brutally exclusive stories of who does and does not belong. The estrangements, the idealism and resourceful affiliations of her work all testify to a vision of national community not as a passively transmitted set of birthrights, but as the offspring of active remembrance and zealous amnesias. To compensate for her cavernous past, Head determined to become the agent of her own origins; to this end, she wrested an alternative train of memories from her adopted village and from Southern Africa as a region.

Defecting from both colonial and anti-colonial standards of what constitutes significant event, Head declared wryly, 'I have decided to record the irrelevant.'[21] Her faith in the redemptive value of the irrelevant and the mundane is at times most reminiscent of Walter Benjamin. Indeed, her ambushes on the ordinary recall Benjamin's remark that 'To articulate the past historically does not mean to recognize it the way it really was. It means to seize hold of a memory as it flashes up at a moment of danger.'[22] Those whom calamity has left stranded in the present may develop uncommon powers for discerning history in the most fragmentary of things.

Head's exaltation of the ordinary is intertwined with her fascination with everything impure and unsettled. She once portrayed herself as surviving by 'performing a peculiar shuttling movement between two lands'.[23] While most of her fiction is set in Botswana, she felt that the persistent violence of her imagination betrayed her South African beginnings. That is, her subject matter and her sensibility had been shaped on either side of the national divide.

'The circumstances of my birth', Head once wrote, 'seemed to make it necessary to obliterate all traces of a family history.'[24] Nothing was given to her: she lived her dream of belonging as an ongoing and always unfinished labour. Her investment in this dream hinged on a paradox. As an orphaned, uprooted and stateless writer, she experienced a profound

craving for the certainties of what she called a 'whole community'. Yet at the same time, she felt with the intimacy of her bones, the violence from which wholeness, sameness, origins, shared extraction, and the assurances of rooted community are born.[25]

At a time when she faced ostracism on local and national fronts, Head expressed her resolution to belong in one of her standard familial metaphors: '[T]he best and most enduring love is that of rejection. . . . I'm going to bloody well adopt this country as my own, by force. I am going to take it as my own family.'[26] Having lived, as a child, through the shallow, artificial genealogies produced by successive adoptions and rejections, she determined to become with a vengeance the agent of her own origins. She wrested from Serowe a surrogate history, an alternative trail of memories to that other, never wholly obliterated past of familial abandonment, racial rejection, colonial domination, and national disinheritance.

In striving to remake herself, Head came to rely on another, more unsettling trail of memories. Particularly during the buildup to her confinement in a Botswanan mental hospital, she feared that she was destined to recapitulate her mother's life. She was fully aware of the pathological circumstances of her mother's incarceration – they were symptomatic of what she once called 'the permanent madness of reality' under apartheid.[27] Yet none the less, Head found herself haunted by the possibility that her mother had transmitted to her the burden of madness.[28] As the daughter of a 'stray' woman, she feared that she, too, might have to pay the ultimate price for her 'errancy'. Certainly, in her autobiographical writings of the late 1960s and early 1970s, one senses her lurking anxiety that just as racism had pursued her to Serowe, so too, congenital madness would find her out and return her to the grip of the past.

However, as she began to cobble together a sense of belonging, so she came to reimagine her mother's transgressive bequest; there had been, as she once put it, 'no world as yet' for what Bessie Emery had done.[29] Head observed, similarly, of her own achievements:

> The least I can ever say for myself is that I forcefully created for myself, under extremely hostile conditions, my ideal life. I took an obscure and almost unknown village in the Southern African bush and made it my own hallowed ground. Here, in the steadiness and peace of my own world, I could dream dreams a little ahead of the somewhat vicious clamour of revolution and the horrible stench of evil social systems.[30]

Her sense here of the creativity born from isolation implies a quite different perception of 'errancy'. Head came to see her mother's actions increasingly less as a threat, passed down to her, of regression into insanity, than as an exhortation to invent audaciously a world adequate to such visionary error. Through her imaginative insistence that the inconceivable take its

place within the orbit of the ordinary, Head was, as she recognized, dreaming in advance of her time.

Head's work was apt to project a degree of social acceptance which, in her life, she knew only as a wavering prospect. Such determined optimism quietened in her fiction the cadences of desolation that distinguished her letters. If, to the last, Head's integration into Serowe remained on paper somewhat ahead of her integration in daily life, she at least acquired a degree of allegiance and acceptance unimaginable in the 1960s and early 1970s. Moreover, she had engineered for herself a spread of commitments that spanned writing as a vocation, the village, the Southern African region, and those rural women who sought a greater share of Botswana's unevenly distributed state of independence. In the process of forging these ties, Head exposed a cluster of amnesias in Southern African writing and yielded a greatly expanded sense of its prospects.

With a few notable exceptions, 'coloureds' have been admitted into white South African literature mainly as shiftless, 'tribeless' people burdened by their 'impurity' in plots staging the relentlessly fateful repercussions of miscegenation. While Head's life and work were wrought from tragedy, neither remained merely tragic. Indeed, together they provide one of the richest anticipations of Salman Rushdie's simple, resonant remark that 'notions of purity are the aberration'.[31] In negotiating her impacted sense of loss and her imposed sense of deviancy, Head admitted a whole new range of possibilities to the phrase 'mixed ancestry'. Remote from racially charged determinisms, those words came to celebrate the hardwon if fitful freedom to elect and reject one's affinities and provenance. Head's foreign sojourn may have been thrust upon her, but she turned it to advantage, dreaming a little ahead of her time, not least in her insistence that the inconceivable assume its rightful place within the compass of the ordinary.

Head's determination to redeem the irrelevant gives her writings a distinctive resonance amidst the post-exile turmoil of South African life. One of the most exacting challenges in the current milieu is how to accommodate those vast tracts of culture that have been sidelined, trivialized, or mutilated by the dictates of the apartheid–anti-apartheid agon. In a society facing the monumental difficulty of producing a culture of tolerance from a ruinous culture of violence, the exiles' Janus-faced vision may offer a symbolic challenge to blind and murderous chauvinisms. Re-entering exiles should thus be recognized as cross-border creations, incurable cultural *non sequiturs*, who can be claimed as a resource rather than spurned as alien, suspect or irrelevant.

NOTES

1 Aimé Césaire, 'Notebook of a return to native land', in *Collected Poetry*, trans. Clayton Eshelman and Anette Smith, Berkeley, University of California Press, 1983, p. 77.
2 Rushdie, quoted in Stuart Hall, 'Our mongrel selves', *New Statesman and Society*, 19 June 1992, p. 8.
3 Breyten Breytenbach, 'The long march from hearth to heart', *Social Research* 58, 1 (Spring 1991), p. 70.
4 On this issue, see especially Benedict Anderson, *Imagined Communities*, London, Verso, 1983.
5 Njabulo Ndebele, 'Turkish tales: some thoughts on South African fiction', in *The Rediscovery of the Ordinary: Essays on South African Literature and Culture*, Johannesburg, COSAW, 1991, p. 23.
6 Bessie Head, 'Preface to witchcraft', *A Woman Alone*, ed. Craig MacKenzie, Portsmouth, New Hampshire, Heinemann, 1990, p. 27.
7 Caroline Rooney, ' "Dangerous Knowledge" and the poetics of survival: a reading of *Our Sister Killjoy* and *A Question of Power*', in Susheila Nasta (ed.), *Motherlands: Black Women's Writing from Africa, the Caribbean and South Asia*, London, The Women's Press, 1991, p. 118.
8 Bessie Head, quoted in Susan Gardner, ' "Don't ask for the true story": A Memoir of Bessie Head', *Hecate* 12, 1986, p. 114.
9 Letter dated 31 October 1968, in Randolph Vigne (ed.), *A Gesture of Belonging. Letters from Bessie Head, 1965–79*, London, S A Writers, 1991, p. 65.
10 Quoted in Gardner, ' "Don't ask for the true story" ', p. 114.
11 Bessie Head, in 'Bessie Head', *Contemporary Authors*, ed. Ann Evory, vol. 29–32, Detroit, Gale Research Co., 1978, p. 288.
12 Philip Schlesinger, *Media, State and Nation*, London, Sage, 1991, p. 174.
13 Don Mattera, *Sophiatown. Coming of Age in South Africa*, Boston, Beacon Press, 1989, p. 150.
14 This terrain is a terminological minefield. There is no indigenous 'San' term covering the many formerly nomadic groups whom other Africans and Europeans have variously gathered together under the umbrella terms 'Masarwa', 'San', and 'Bushman'. 'Masarwa' is unacceptable as it is the term of abuse dished out by the Batswana who have historically dispossessed and enslaved the 'San'. Although 'San' has achieved a certain anthropological respectability (if that is not a contradiction in terms), it too is derogatory in origin and has been flatly rejected by the people themselves. A number of commentators have observed that, despite its origins in colonial racism, 'Bushman' is the term most commonly embraced from within the culture. (See Megan Biesele and Paul Weinberg, *Shaken Roots: the Bushmen of Namibia*, Marshalltown, SA, EDA Publications, 1990, p. 72; Casey Kelso, 'The inconvenient nomads deep inside the deep', *Weekly Mail*, July 24–30, 1992, p. 12.) Is this endorsement from within a defiant appropriation of a previously abusive term? Or has it been adopted in Botswana as an alternative to 'Masarwa', which is associated with the people's principal contemporary source of oppression and dispossession, namely the Botswanan state? Even if the racist connotations of 'Bushman' can be overturned, the problem of the term's gender specificity is insurmountable.
15 Quoted in Rooney, 'Dangerous Knowledge . . . ', p. 227.
16 A largely autobiographical version of the projection of Head as sexually 'loose' on grounds of ethnicity and marital status is to be found in *A Question of Power* [1974]; rpt London, Heinemann, 1986.

17 In some remarkable research into the discourse of madness in Rhodesian mental hospitals between 1932 and 1957, Jackson observes how African women who appeared single in public spaces were sometimes apprehended by the authorities and institutionalized as mad on the grounds that they were, in the medical argot, found 'stray' at the 'crossroads'. ('Stray women and the colonial asylum', unpublished paper delivered at the Institute of Commonwealth Studies, London, 26 October 1991). As recently as the first half of this century, certain British women were locked away in mental asylums on the grounds that giving birth out of wedlock was a mark of insanity. (See Steve Humphries, *A Secret World of Sex: Forbidden Fruit, the British Experience 1900–1950*, London, Sidgwick & Jackson, 1988.)

Strictly speaking, Head was not an unmarried but a single mother, as she was estranged from her husband who had remained behind in South Africa. However, this distinction appears to have made little difference to Botswanan perceptions of her as a woman with a child but no husband in train.

18 See Anne McClintock, 'No longer in a future heaven: women and nationalism in South Africa', *Transition* 51 (1991), pp. 150 ff.; Elleke Boehmer, 'Stories of women and mothers: gender and nationalism in the early fiction of Flora Nwapa', in Nasta (ed.), *Motherlands*, pp. 3–11; Floya Anthias and Nira Yuval-Davis, 'Introduction', in Anthias and Yuval-Davis (eds), *Woman–Nation–State*, London, Macmillan, 1989, pp. 1–15; and Andrew Parker *et al.*, 'Introduction', in *Nationalisms and Sexualities*, ed. Andrew Parker *et al.*, New York, Routledge, 1992, pp. 1–8.

19 Donald Horowitz, *Ethnic Groups in Conflict*, Berkeley, University of California Press, 1985, p. 35.

20 *Serowe: Village of the Rain Wind*, Oxford, Heinemann, 1981; *The Collector of Treasures*, Oxford, Heinemann, 1977; *Tales of Tenderness and Power*, Oxford, Heinemann, 1990.

21 *A Woman Alone*, p. 99.

22 Walter Benjamin, *Illuminations*, trans. Harry Zohn (1st edition 1970), rpt London, Fontana-Collins, 1973, p. 258.

23 'Social and political pressures that shape writing in Southern Africa', *A Woman Alone*, p. 67.

24 'Biographical Notes', p. 95.

25 Paul Gilroy and Stuart Hall's critiques of Raymond Williams are salient to Head's ambiguous experience of settled community. Gilroy and Hall point out the racial and ethnic nationalist implications of Williams' unquestioning affirmation of the value of 'rooted settlements'. See Gilroy, *There Ain't No Black in the Union Jack: The Cultural Politics of Race and Nation*, London, Unwin Hyman, 1987, pp. 49–50; Hall, 'Our mongrel selves', pp. 6–8.

26 Letter dated 2 April 1968, in *A Gesture of Belonging*, p. 58.

27 'Preface to witchcraft', p. 27.

28 See 'Biographical notes', p. 95, and letter dated 4 June 1984 in *A Gesture of Belonging*, p. 164.

29 Letted dated 31 October 1968, in *A Gesture of Belonging*, p. 65.

30 *A Woman Alone*, p. 28.

31 Salman Rushdie, 'Minority literatures in a multi-cultural society', in *Displaced Persons*, ed. Kirsten Holst Petersen and Anna Rutherford, Sydney, Dangaroo Press, 1988, p. 35.

Part III

Crossroads

Chapter 8

Soft-soaping empire: commodity racism and imperial advertising

Anne McClintock

Doc: My, it's so clean.
Grumpy: There's dirty work afoot.
(Snow White and the Seven Dwarfs)

EMPIRE OF THE HOME

In 1899, the year the Anglo–Boer war erupted in South Africa, an advertisement for Pears' Soap in *McClure's Magazine* accounted:

> The first step towards LIGHTENING THE WHITE MAN'S BURDEN is through teaching the virtues of cleanliness. PEARS' SOAP is a potent factor in brightening the dark corners of the earth as civilization advances, while amongst the cultured of all nations it holds the highest place – it is the ideal toilet soap.

The advertisement (Figure 8.1) figures an admiral decked in pure imperial white, washing his hands in his cabin as his steamship crosses the oceanic threshold into the realm of empire. In this image, private domesticity and the imperial market – the two spheres vaunted by middle-class Victorians to be naturally distinct – converge in a single commodity spectacle: the domestic sanctum of the white man's bathroom gives privileged vantage on to the global realm of imperial commerce. Imperial progress is consumed at a glance: time consumed as a commodity spectacle, as *panoptical time*.

On the wall, the porthole is both window and mirror. The window, icon of imperial surveillance and the Enlightenment idea of knowledge as penetration, is a porthole on to public scenes of economic conversion: one scene depicts a kneeling African gratefully receiving the Pears' Soap as he might genuflect before a religious fetish. The mirror, emblem of Enlightenment self-consciousness, reflects the sanitized image of white, male, imperial hygiene. Domestic hygiene, the ad implies, purifies and

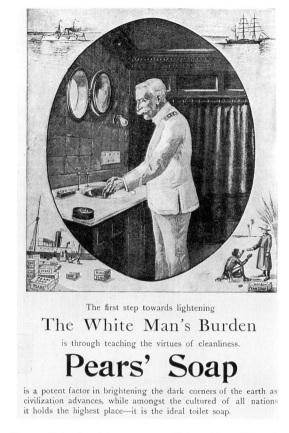

The first step towards lightening

The White Man's Burden

is through teaching the virtues of cleanliness.

Pears' Soap

is a potent factor in brightening the dark corners of the earth as
civilization advances, while amongst the cultured of all nations
it holds the highest place—it is the ideal toilet soap.

Figure 8.1 A white man sanitizing himself as he
crosses the threshold of empire.

preserves the white male body from contamination as it crosses the danger-
ous threshold of empire; at the same time, the domestic commodity
guarantees white male power, the genuflexion of Africans and rule of the
world. On the wall, an electric light bulb signifies scientific rationality and
spiritual advance. In this ad, the household commodity spells the lesson of
imperial progress and capitalist civilization: civilization, for the white man,
advances and brightens through his four beloved fetishes: soap, the mirror,
light and white clothing – the four domestic fetishes that recur throughout
imperial advertising and imperial popular culture of the time.

The first point about the Pears' advertisement is that it figures imperial-
ism as coming into being through domesticity. At the same time, imperial
domesticity is a domesticity without women. The commodity fetish, as the
central form of the industrial enlightenment, reveals what liberalism would
like to forget: the domestic is political, the political is gendered. What

could not be admitted into male rationalist discourse (the economic value of women's domestic labour) is disavowed and projected on to the realm of the 'primitive' and the zone of empire. At the same time, the economic value of colonized cultures is domesticated and projected on to the realm of the 'prehistoric' fetish.

A characteristic feature of the Victorian middle class was its peculiarly intense preoccupation with boundaries. In imperial fiction and commodity kitsch, boundary objects and liminal scenes recur ritualistically. As colonials travelled back and forth across the threshold of their known world, crisis and boundary confusion were warded off and contained by fetishes, absolution rituals and liminal scenes. Soap and cleaning rituals became central to the ceremonial demarcation of body boundaries and the policing of social hierarchies. Cleansing and boundary rituals are integral to most cultures; what characterized Victorian cleaning rituals, however, was their peculiarly intense relation to money.

I begin with the Pears' Soap ad because it registers what I see as an epochal shift that took place in the culture of imperialism in the last decades of the nineteenth century. This was the shift from *'scientific' racism* – embodied as it was in anthropological, scientific and medical journals, travel writing and ethnographies – to what can be called *commodity racism*. Commodity racism – in the specifically Victorian forms of advertising and commodity spectacle, the imperial Expositions and the museum movement – converted the imperial progress narrative into mass-produced consumer spectacles. Commodity racism, I suggest, came to produce, market and distribute evolutionary racism and imperial power on a hitherto unimagined scale. In the process, the Victorian middle-class home became a space for the display of imperial spectacle and the reinvention of race, while the colonies – in particular Africa – became a theatre for exhibiting the Victorian cult of domesticity and the reinvention of gender.

The cult of domesticity became indispensable to the consolidation of British imperial identity – contradictory and conflictual as that was. At the same time, imperialism gave significant shape to the development of Victorian domesticity and the historic separation of the private and public. An intricate dialectic emerged: the Victorian invention of domesticity took shape around colonialism and the idea of race. At the same time, colonialism took shape around the Victorian invention of domesticity and the idea of the home.[1] Through the mediation of commodity spectacle, domestic space became racialized, while colonial space became domesticated.[2] The mass marketing of empire as a system of images became inextricably wedded to the reinvention of domesticity, so that the cultural history of imperialism cannot be understood without a theory of domestic space and gender power.

COMMODITY RACISM AND THE SOAP CULT

At the beginning of the nineteenth century, soap was a scarce and hum-drum item and washing a cursory activity at best. A few decades later, the manufacture of soap had burgeoned into an imperial commerce. Victorian cleaning rituals were vaunted as the God-given sign of Britain's evolution-ary superiority and soap had become invested with magic, fetish powers. The soap saga captured the hidden affinity between domesticity and empire and embodied a triangulated crisis in value: the undervaluation of women's work in the domestic realm; the overvaluation of the commodity in the industrial market; and the disavowal of colonized economies in the arena of empire. Soap entered the realm of Victorian fetishism with spectacular effect, notwithstanding the fact that male Victorians promoted soap as the very icon of non-fetishistic rationality.

Both the cult of domesticity and the new imperialism found in soap an exemplary mediating form. The emergent middle-class values – monogamy ('clean' sex which has value), industrial capital ('clean' money which has value), Christianity ('being washed in the blood of the lamb'), class control ('cleansing the great unwashed'), and the imperial civilizing mission ('washing and clothing the savage') – could all be marvellously embodied in a single household commodity. Soap advertising, in particular the Pears' Soap campaign, took its place at the vanguard of Britain's new commodity culture and its civilizing mission.

In the eighteenth century, the commodity was little more than a mun-dane object to be bought and used – in Marx's words, 'a trivial thing'.[3] By the late nineteenth century, however, the commodity had taken its privi-leged place, not only as the fundamental form of a new industrial economy, but also as the fundamental form of a new cultural system for representing social value.[4] Banks and stock exchanges rose up to manage the bonanzas of imperial capital. Professions emerged to administer the goods tumbling hectically from the manufactures. Middle-class domestic space became crammed, as never before, with furniture, clocks, mirrors, paintings, stuffed animals, ornaments, guns and a myriad gewgaws and knick-knacks. Victorian novelists bore witness to the strange spawning of commodities that seemed to have lives of their own. Meanwhile huge ships lumbered with trifles and trinkets, plied their trade between the colonial markets of Africa, the East, and the Americas.[5]

The new economy created an uproar, not only of things, but of signs. As Thomas Richards has argued, if all these new commodities were to be managed, a unified system of cultural representation had to be found. Richards shows how in 1851 the Great Exhibition of Things at the Crystal Palace served as a monument to a new form of consumption: 'What the first Exhibition heralded so intimately was the complete transformation of collective and private life into a space for the spectacular exhibition of

commodities.'[6] As a 'semiotic laboratory for the labour theory of value', the Great Exhibition showed once and for all that the capitalist system not only had created a dominant form of exchange, but was also in the process of creating a dominant form of representation to go with it: the voyeuristic panorama of surplus as spectacle. By exhibiting commodities not only as goods, but also as an organized system of images, the Great Exhibition helped to fashion 'a new kind of being, the consumer, and a new kind of ideology, consumerism'. The mass consumption of the commodity spectacle was born.

Victorian advertising reveals a paradox, however. As the cultural form entrusted with upholding and marketing abroad the middle-class distinctions between private and public and between paid work and unpaid work, advertising also from the outset began to confound those distinctions. Advertising took the intimate signs of domesticity (children bathing, men shaving, women laced into corsets, maids delivering nightcaps) into the public realm, plastering scenes of domesticity on walls, buses, shopfronts and billboards. At the same time, advertising took scenes of empire into every corner of the home, stamping images of colonial conquest on soap boxes, match boxes, biscuit tins, whiskey bottles, tea tins and chocolate bars. By trafficking promiscuously across the threshold of private and public, advertising began to subvert some of the fundamental distinctions that commodity capital was bringing into being.

From the outset, moreover, Victorian advertising took explicit shape around the reinvention of racial difference. Commodity kitsch made possible, as never before, the mass marketing of empire as an organized system of images and attitudes. Soap flourished not only because it created and filled a spectacular gap in the domestic market, but also because, as a cheap and portable domestic commodity, it could persuasively mediate the Victorian poetics of racial hygiene and imperial progress.

Commodity racism became distinct from scientific racism in its capacity to expand beyond the literate propertied elite through the marketing of commodity spectacle. If, after the 1850s, scientific racism saturated anthropological, scientific and medical journals, travel writing and novels, these cultural forms were still relatively class-bound and inaccessible to most Victorians, who had neither the means nor the education to read such material. Imperial kitsch as consumer *spectacle*, by contrast, could package, market and distribute evolutionary racism on a hitherto unimagined scale. No pre-existing form of organized racism had ever before been able to reach so large and so differentiated a mass of the populace. Thus, as domestic commodities were mass-marketed through their appeal to imperial jingoism, commodity jingoism itself helped reinvent and maintain British national unity in the face of deepening imperial competition and colonial resistance. The cult of domesticity became indispensable to the

consolidation of British national identity, and at the centre of the domestic cult stood the simple bar of soap.[7]

Yet soap has no social history. Since it purportedly belongs in the female realm of domesticity, soap is figured as beyond history and beyond politics proper.[8] To begin to write a social history of soap, then, is to refuse, in part, the erasure of women's domestic value under imperial capitalism. It cannot be forgotten, moreover, that the history of Victorian attempts to impose their commodity economy on African cultures was also the history of diverse African attempts either to refuse, appropriate, or negotiate European commodity fetishism to suit their own needs. The story of soap reveals that fetishism, far from being a quintessentially African propensity, as nineteenth-century anthropology maintained, was central to industrial modernity, inhabiting and mediating the uncertain threshold zones between domesticity and industry, metropolis and empire.

EMPIRE OF THE HOME: RACIALIZING DOMESTICITY

Before the late nineteenth century, washing was done in most households only once or twice a year in great, communal binges, usually in public at streams or rivers.[9] As for body washing, not much had changed since the days when Queen Elizabeth I was distinguished by the frequency with which she washed: 'regularly every month whether she needed it or not'.[10] By the 1890s, however, soap sales had soared, Victorians were consuming 260,000 tons of soap a year, and advertising had emerged as the central cultural form of commodity capitalism.[11]

The initial impetus for soap advertising came from the realm of empire. For Britain, economic competition with the United States and Germany created the need for a more aggressive promotion of products, and led to the first real innovations in advertising. In 1884, the year of the Berlin Conference, the first wrapped soap was sold under a brand name. This small event signified a major transformation in capital, as imperial competition gave rise to the creation of monopolies. Henceforth, items formerly indistinguishable from each other (soap sold simply as soap) would be marketed by their corporate signature (Pears', Monkey Brand, etc.). Soap became one of the first commodities to register the historic shift from a myriad small businesses to the great imperial monopolies. In the 1870s, hundreds of small soap companies plied the new trade in hygiene, but by the end of the century, the trade was monopolized by ten large companies.

In order to manage the great soap show, an aggressively entrepreneurial breed of advertisers emerged, dedicated to gracing their small, homely product with a radiant halo of imperial glamour and racial potency. The advertising agent, like the bureaucrat, played a vital role in the imperial expansion of foreign trade. Advertisers billed themselves as 'empire builders', and flattered themselves with 'the responsibility of the historic

imperial mission'. Said one: 'Commerce even more than sentiment binds the ocean sundered portions of empire together. Anyone who increases these commercial interests strengthens the whole fabric of the empire.'[12] Soap was credited not only with bringing moral and economic salvation to the lives of Britain's 'great unwashed', but also with magically embodying the spiritual ingredient of the imperial mission itself.

In an ad for Pears', for example, a black and implicitly racialized coal-sweeper holds in his hands a glowing, occult object. Luminous with its own inner radiance, the simple soap-bar glows like a fetish, pulsating magically with spiritual enlightenment and imperial grandeur, promising to warm the hands and hearts of working people across the globe.[13] Pears', in particular, became intimately associated with a purified nature, magically cleansed of polluting industry (tumbling kittens, faithful dogs, children festooned with flowers), and a purified working-class, magically cleansed of polluting labour (smiling servants in crisp white aprons, rosy-cheeked match-girls and scrubbed scullions).[14]

None the less, the Victorian obsession with cotton and cleanliness was not simply a mechanical reflex of economic surplus. If imperialism garnered a bounty of cheap cotton and soap-oils from coerced colonial labour, the middle-class Victorian fascination with clean white bodies and clean white clothing stemmed not only from the rampant profiteering of the imperial economy, but also from the unbidden realms of ritual and fetish.

Soap did not flourish when imperial ebullience was at its peak. It emerged commercially during an era of impending crisis and social calamity, serving to preserve, through fetish ritual, the uncertain boundaries of class, gender and race identity in a world felt to be threatened by the fetid effluvia of the slums, the belching smoke of industry, social agitation, economic upheaval, imperial competition and anti-colonial resistance. Soap offered the promise of spiritual salvation and regeneration through commodity consumption, a regime of domestic hygiene that could restore the threatened potency of the imperial body politic and the race.

Four fetishes recur ritualistically in soap advertising: soap itself; white clothing (especially aprons); mirrors; and monkeys. A typical Pears' advertisement figures a black child and a white child together in a bathroom (see Figure 8.2). The Victorian bathroom is the innermost sanctuary of domestic hygiene, and by extension the private temple of public regeneration. The sacrament of soap offers a reformation allegory, whereby the purification of the domestic body becomes a metaphor for the regeneration of the body politic. In this particular ad, a black boy sits in the bath, gazing wide-eyed into the water as if into a foreign element. A white boy, clothed in a white apron – the familiar fetish of domestic purity – bends benevolently over his 'lesser' brother, bestowing upon him the precious talisman of racial progress. The magical fetish of soap promises that the commodity

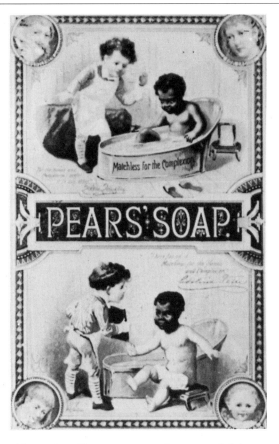

Figure 8.2 The sacrament of soap: racializing domesticity.

can regenerate the Family of Man by washing from the skin the very stigma of racial and class degeneration.

Soap advertising offers an allegory of imperial 'progress' as spectacle. In this ad, the imperial topos of panoptical time (progress consumed as a spectacle from a privileged point of invisibility) enters the domain of the commodity. In the second frame of this ad, the black child is out of the bath, and the white boy shows him his startled visage in the mirror. The boy's body has become magically white, but his face – for Victorians the seat of rational individuality and self-consciousness – remains stubbornly black. The white child is thereby figured as the agent of history and the male heir to progress, reflecting his lesser brother in the European mirror of self-consciousness. In the Victorian mirror, the black child witnesses his predetermined destiny of imperial metamorphosis, but himself remains a passive, racial hybrid: part black, part white, brought to the

brink of civilization by the twin commodity fetishes of soap and mirror. The advertisement discloses a crucial element of late Victorian commodity culture: the metaphoric transformation of *imperial time* into *consumer space* – imperial progress consumed, at a glance, as domestic spectacle.

The metamorphosis of imperial time into domestic space is captured most vividly by the advertising campaign for the Monkey Brand Soap. During the 1880s, the urban landscape of Victorian Britain teemed with the fetish monkeys of the Monkey Brand Soap. The monkey with its frying-pan and bar of soap perched on grimy hoardings and buses, on walls and shop fronts, promoting the soap that promised magically to do away with domestic labour: 'No dust, no dirt, no labour'. Monkey Brand Soap promised not only to regenerate the race, but also to magically erase the unseemly spectacle of women's manual labour.

In an exemplary ad, the fetish soap-monkey sits cross-legged on a doorstep, the threshold boundary between private domesticity and public commerce – the embodiment of what I call *anachronistic space* (see Figure 8.3). Dressed like an organ-grinder's minion, in a gentleman's ragged suit, white shirt and tie, but with improbably human hands and feet, the monkey extends a frying pan to catch the surplus cash of passers-by. On the doormat before him, a great bar of soap is displayed, accompanied by a placard that reads: 'My Own Work'. In every respect the soap-monkey is a hybrid: not entirely ape, not entirely human; part street beggar, part gentleman; part artist, part advertiser. The creature inhabits the ambivalent border of jungle and city, private and public, the domestic and the commercial, and offers as its handiwork a fetish that is both art and commodity.

Monkeys inhabit Western discourse on the borders of social value, marking the place of a social contradiction. As Donna Haraway has argued: 'the primate body, as part of the body of nature, may be read as a map of power'.[15] Primatology, Haraway insists, 'is a Western discourse . . . a political order that works by the negotiation of boundaries achieved through ordering differences'.[16] In Victorian iconography, the ritual recurrence of the monkey figure is eloquent of a crisis in value and hence anxiety at the possible breakdown of boundary. The primate body became a symbolic arena for reordering and policing boundaries between humans and nature, women and men, family and politics, empire and metropolis.

Simian imperialism is also centrally concerned with the problem of representing *social change*. By projecting history (rather than fate, or God's will) on to the theatre of nature, primatology made nature the alibi of political violence, and placed in the hands of 'rational science' the authority to sanction and legitimize social change. Here, 'the scene of origins', Haraway argues, 'is not the cradle of civilization, but the cradle of culture . . . the origin of sociality itself, especially in the densely meaning-laden icon of "the family"'.[17] Primatology emerges as a theatre

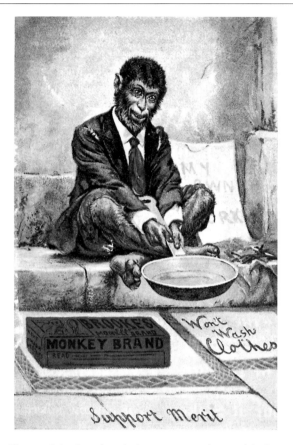

Figure 8.3 Anachronistic space – the ambivalent border of jungle and city.

for negotiating the perilous boundaries between the family (conventionally natural and female) and power (conventionally political and male).

The appearance of monkeys in soap advertising signals a dilemma: *how to represent domesticity without representing women at work*. The Victorian middle-class house was structured about the fundamental contradiction between women's *paid* and *unpaid* domestic work. As women were driven from paid work in mines, factories, shops and trades to private, unpaid work in the home, domestic work became economically undervalued and the middle-class definition of femininity figured the proper woman as one who did not work for profit. At the same time, a cordon sanitaire of racial 'degeneration' was thrown around those women who did work publicly and visibly for money. What could not be incorporated into the industrial formation (women's domestic economic value) was displaced on to the invented domain of the 'primitive', and thereby disciplined and contained.

Monkeys, in particular, were deployed to legitimize social boundaries as edicts of nature. Fetishes straddling nature and culture, monkeys were seen as allied with the 'dangerous classes' – the 'apelike' wandering poor, the hungry Irish, the prostitutes, impoverished black people, the ragged working class, the criminals, the insane, and female miners and servants – who were seen to inhabit the threshold of racial degeneration. When Charles Kingsley visited Ireland, for example, he lamented:

> I am haunted by the human chimpanzees I saw along that hundred miles of horrible country. . . . But to see white chimpanzees is dreadful; if they were black, one would not feel it so much, but their skins, except where tanned by exposure, are as white as ours.[18]

In the Monkey Brand advertisement, the monkey's signature of labour ('My Own Work') signals a double disavowal. Soap is masculinized, figured as a male product; while the (mostly female) labour of the workers in the huge, unhealthy soap factories is disavowed. At the same time, the labour of social transformation in the daily scrubbing and scouring of the sinks, pans and dishes, labyrinthine floors and corridors of Victorian domestic space vanishes – refigured as anachronistic space – primitive and bestial. Female servants disappear, and in their place crouches a phantasmic, male hybrid. Thus, domesticity – seen as the sphere most separate from the marketplace and the masculine hurly-burly of empire – takes shape around the invented idea of the primitive and the commodity fetish.

In Victorian culture, the monkey was an icon of metamorphosis, perfectly serving soap's liminal role in mediating the transformations of nature (dirt, waste and disorder) into culture (cleanliness, rationality and industry). Like all fetishes, the monkey is a contradictory image, embodying the hope of imperial progress through commerce, while at the same time rendering visible deepening Victorian fears of urban militancy and colonial misrule. The soap-monkey became the emblem of industrial progress and imperial evolution, embodying the double promise that nature could be redeemed by consumer capital and that consumer capital could be guaranteed by natural law. At the same time, however, the soap-monkey was eloquent of the degree to which fetishism structures industrial rationality.

DOMESTICATING EMPIRE

By the end of the century, a stream of imperial bric-à-brac had invaded Victorian homes. Colonial heroes and colonial scenes emblazoned a host of domestic commodities, from milk cartons to sauce bottles, tobacco tins to whiskey bottles, assorted biscuits to toothpaste, toffee boxes to baking powder.[19] Traditional *national* fetishes, such as the Union Jack, Britannia, John Bull and the rampant lion, were marshalled into a revamped

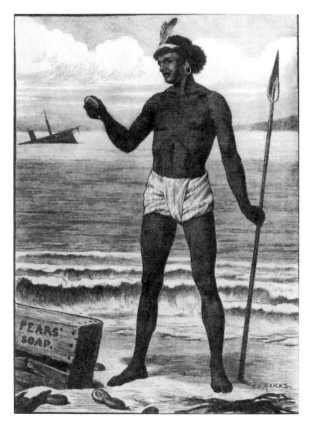

Figure 8.4 The myth of first contact with the conquering commodity.

celebration of *imperial* spectacle. Empire was seen to be patriotically defended by Ironclad Porpoise Bootlaces and Sons of the Empire Soap, while Stanley came to the rescue of the Emin of Pasha laden with outsize boxes of Huntley and Palmers Biscuits.

Late Victorian advertising presented a vista of the colonies as conquered by domestic commodities.[20] In the flickering magic lantern of imperial desire, teas, biscuits, tobaccos, Bovril, tins of cocoa and, above all, soaps beach themselves on far-flung shores, tramp through jungles, quell uprisings, restore order and write the inevitable legend of commercial progress across the colonial landscape. In a Huntley and Palmers' Biscuits ad, a group of male colonials sit in the middle of a jungle on biscuit crates, sipping tea. Towards them, a stately and seemingly endless procession of elephants, laden with more biscuits and colonials, brings tea-time to the heart of the jungle. The serving attendant in this ad, as in most others, is male. Two things happen: women vanish from the *Boy's Own* affair of

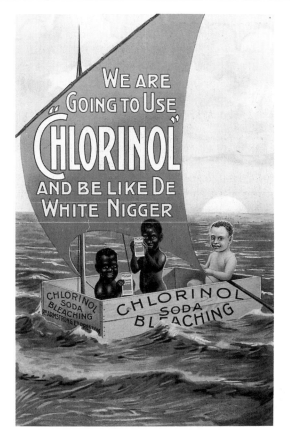

Figure 8.5 Panoptical time: imperial progress con-
sumed at a glance.

empire, while colonized men are feminized by their association with dom-
estic servitude.

Liminal images of oceans, beaches and shorelines recur in cleaning ads
of the time. An exemplary ad for Chlorinol Soda Bleach shows three boys
in a soda-box sailing in a phantasmic ocean bathed by the radiance of the
imperial dawn (Figure 8.5). In a scene washed in the red, white and blue of
the Union Jack, two black boys proudly hold aloft their boxes of Chlorinol.
A third boy, the familiar racial hybrid of cleaning ads, has presumably
already applied his bleach, for his skin is blanched an eerie white. On red
sails that repeat the red of the bleach box, the legend of black people's
purported commercial redemption in the arena of empire reads: 'We are
Going to Use "Chlorinol" and be like De White Nigger'.

The ad vividly exemplifies Marx's lesson that the mystique of the com-
modity fetish lies not in its use value, but in its exchange value and its

potency as a sign: 'So far as [the commodity] is a value in use, there is nothing mysterious about it'. For three naked children, clothing bleach is less than useful. Instead, the whitening agent of bleach promises an alchemy of racial upliftment through historic contact with commodity culture. The transforming power of the civilizing mission is stamped on the boat-box's sails as the objective character of the commodity itself. More than merely a *symbol* of imperial progress, the domestic commodity becomes the *agent* of history itself. The commodity, abstracted from social context and human labour, does the civilizing work of empire, while radical change is figured as magic, without process or social agency. In this way, cleaning ads such as Chlorinol's foreshadow the 'before and after' beauty ads of the twentieth century: a crucial genre directed largely at women, in which the conjuring power of the product to alchemize change is all that lies between the temporal 'before and after' of women's bodily transformation.

The Chlorinol ad displays a racial and gendered division of labour. Imperial progress from black child to 'white nigger' is consumed as commodity spectacle – panoptical time. The self-satisfied, hybrid 'white nigger' literally holds the rudder of history and directs social change, while the dawning of civilization bathes his enlightened brow with radiance. The black children simply have exhibition value as potential consumers of the commodity, there only to uphold the promise of capitalist commerce and to represent how far the white child has evolved – in the iconography of Victorian racism, the condition of 'savagery' is identical to the condition of infancy. Like white women, Africans (both women and men) are figured not as historic agents, but as frames for the commodity, for their *exhibition* value alone. The working-women, both black and white, who spend vast amounts of energy bleaching the white sheets, shirts, frills, aprons, cuffs and collars of imperial clothes are nowhere to be seen. It is important to note that in Victorian advertising, black women are very seldom rendered as consumers of commodities, for, in imperial lore, they lag too far behind men to be agents of history.

In the Chlorinol ad, women's creation of social value through household work is displaced on to the commodity as its own power, fetishistically inscribed on the children's bodies as a magical metamorphosis of the flesh. At the same time, military subjugation, cultural coercion and economic thuggery get refigured in such cleaning ads as a benign, domestic process as natural and healthy as washing. The stains of Africa's disobligingly complex and tenacious past and the inconvenience of alternative economic and cultural values are washed away like grime.

Incapable of themselves actually engendering change, African men are figured only as 'mimic men', to borrow V.S. Naipaul's dyspeptic phrase, destined simply to ape the epic white march of progress to self-knowledge. Bereft of the white raimants of imperial godliness, the Chlorinol children appear to take the fetish literally, content to bleach their skins to white.

Yet these ads reveal that, far from being a quintessentially African propensity, the faith in fetishism was a faith fundamental to imperial capitalism itself.

By the turn of the century, soap ads vividly embodied the hope that the commodity alone, independent of its use value, could convert other cultures to civilization. Soap ads also embody what can be called *the myth of first contact*: the hope of capturing, as spectacle, the pristine moment of originary contact fixed forever in the timeless surface of the image. In another Pears' ad, a black man stands alone on a beach, examining a bar of soap he has picked from a crate washed ashore from a shipwreck. The ad announces nothing less than the 'The Birth of Civilization'. Civilization is born, the image implies, at the moment of first contact with the Western commodity. Simply by touching the magical object, African man is inspired into history. An epic metamorphosis takes place, as Man the Hunter-gather (anachronistic man) evolves instantly into Man the Consumer. At the same time, the magical object effects a *gender* transformation, for the consumption of the domestic soap is racialized as a male birthing ritual with the egg-shaped commodity as the fertile talisman of change. Since women cannot be recognized as agents of history, it is necessary that a man, not a woman, be the historic beneficiary of the magical cargo, and that the male birthing occur on the beach, not in the home.[21]

In keeping with the racist iconography of the gender degeneration of colonized men, the man is subtly feminized by his role as historic specimen on display. His jaunty feather displays what Victorians liked to believe was colonized men's fetishistic, feminine and lower-class predilection for decorating their bodies. Thomas Carlyle, in his prolonged cogitation on clothes, *Sartor Resartus*, notes, for example: 'The first spiritual want of a barbarous man is Decoration, an instinct we still see amongst the barbarous classes in civilized nations.'[22] Feminists have explored how, in the iconography of modernity, women's bodies are exhibited for visual consumption, but very little has been said about how, in imperial iconography, black men were figured as spectacles for commodity exhibition. If, in scenes set in the Victorian home, female servants are *racialized* and portrayed as frames for the exhibition of the commodity, in advertising scenes set in the colonies, colonized men are *feminized* and portrayed as exhibition frames for commodity display. Black women, by contrast, are rendered virtually invisible. Essentialist assumptions about a universal 'male gaze' require a great deal more historical complication.

Marx notes how under capitalism 'the exchange value of a commodity assumes an independent existence'. Towards the end of the nineteenth century, in many ads, the commodity itself disappears, and the corporate signature, as the embodiment of pure exchange value in monopoly capital, finds its independent existence. Another ad for Pears' features a group of dishevelled Sudanese 'dervishes' awestruck by a white legend carved on

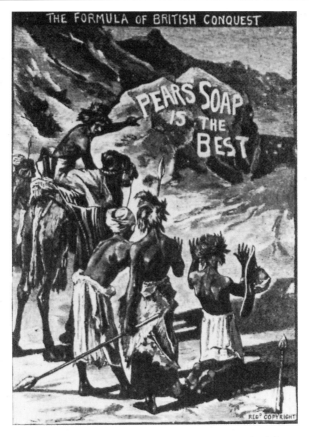

Figure 8.6 The commodity signature as colonial fetish.

the mountain face: PEARS' SOAP IS THE BEST (Figure 8.6). The significance of the ad, as Richards notes, is its representation of the commodity as a magic medium capable of enforcing and enlarging British power in the colonial world without the rational understanding of the mesmerized Sudanese.[23] What the ad more properly reveals is the colonials' own fetishistic faith in the magic of brand-names to work the causal power of empire. In a similar ad, the letters BOVRIL march boldly over a colonial map of South Africa – imperial progress consumed as spectacle (Figure 8.7). In an inspired promotional idea, the word BOVRIL was recognized as tracing the military advance of Lord Roberts across the country, yoking together, as if writ by nature, the simultaneous lessons of colonial domination and commodity progress. In this ad, the colonial map enters the realm of commodity spectacle.

The poetics of cleanliness is a poetics of social discipline. Purification rituals prepare the body as a terrain of meaning, organizing flows of value

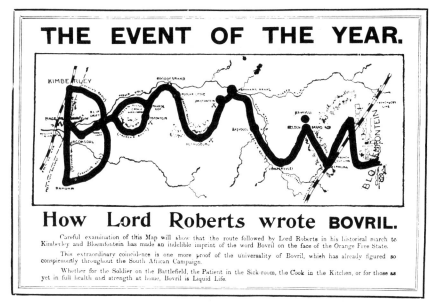

THE EVENT OF THE YEAR.

How Lord Roberts wrote BOVRIL.

Careful examination of this Map will show that the route followed by Lord Roberts in his historical march to Kimberley and Bloemfontein has made an indelible imprint of the word Bovril on the face of the Orange Free State.

This extraordinary coincidence is one more proof of the universality of Bovril, which has already figured so conspicuously throughout the South African Campaign.

Whether for the Soldier on the Battlefield, the Patient in the Sick-room, the Cook in the Kitchen, or for those as yet in full health and strength at home, Bovril is Liquid Life.

Figure 8.7 'As if writ by nature.'

across the self and the community, and demarcating boundaries between one community and another. Purification rituals, however, can also be regimes of violence and constraint. People who have the power to invalidate the boundary rituals of another people demonstrate thereby their capacity to impose violently their culture on others. Colonial travel writers, traders, missionaries and bureaucrats carped constantly at the supposed absence in African culture of 'proper domestic life', in particular Africans' purported lack of 'hygiene'.[24] But the invention of Africans as 'dirty' and 'undomesticated', far from being an accurate depiction of African cultures, served to legitimize the imperialists' violent enforcement of their cultural and economic values, with the intent of purifying and thereby subjugating the 'unclean' African body, and imposing market and cultural values more useful to the mercantile and imperial economy. The myth of imperial commodities beaching on native shores, there to be welcomed by awe-struck natives, wipes from memory the long and intricate history of European commercial trade with Africans and the long and intricate history of African resistance to Europe. Domestic ritual became a technology of discipline and dispossession.

What is crucial, however, is not simply the formal contradictions that structure fetishes, but also the more demanding historical question of how certain groups succeed, through coercion or hegemony, in containing the ambivalence that fetishism embodies, by successfully imposing their

economic and cultural system on others.[25] This does not mean that the contradictions are permanently resolved, nor that they cannot be used against the colonials themselves. None the less, it seems crucial to recognize that what has been vaunted by some as the permanent 'undecidability' of cultural signs can also be rendered violently decisive by superior force or hegemonic dominion.

FETISHISM IN THE CONTEST ZONE

Enlightenment and Victorian writers frequently figured the colonial encounter as the journey of the rational European (male) mind across a liminal space (ocean, jungle or desert) populated by hybrids (mermaids and monsters), to a prehistoric zone of dervishes, cannibals and fetish-worshippers. Robinson Crusoe, in one of the first novelistic expressions of the idea, sets Christian lands apart from those whose people 'prostrate themselves to Stocks and Stones, worshipping Monsters, Elephants, horrible shaped animals, and Statues, or Images of Monsters'.[26] The Enlightenment mind, by contrast, was felt to have transcended fetish worship, and could look indulgently upon those still enchanted by the magical powers of 'stocks and stones'. But as T. Mitchell notes, 'the deepest magic of the commodity fetish is its denial that there is anything magical about it.'[27] Colonial protestations notwithstanding, a decidedly fetishistic faith in the magic powers of the commodity underpinned much of the civilizing mission.

Contrary to the myth of first contact embodied in Victorian ads, Africans had been trading with Europeans for centuries by the time the Victorians arrived. Intricate trading networks were spread over West and North Africa, with complex intercultural settlements, long histories of trade negotiations and exchanges, sporadically interrupted by violent conflicts and conquests. As Barbot, the seventeenth-century trader and writer, remarked of the Gold Coast trade: 'The Blacks of the Gold coast, having traded with Europeans since the 14th century, are very well skilled in the nature and proper qualities of all European wares and merchandise vended there.'[28] Eighteenth-century voyage accounts reveal, moreover, that European ships plying their trade with Africa were often loaded, not with 'useful' commodities, but with baubles, trinkets, beads, mirrors and 'medicinal' potions.[29] Appearing in seventeenth-century trade lists, among the salt, brandy, cloth and iron, are items such as brass rings, false pearls, bugles (small glass beads), looking-glasses, little bells, false crystals, shells, bright rags, glass buttons, small brass trumpets, amulets and arm rings.[30] Colonials indulged heavily in the notion that by ferrying across the seas these cargoes of gewgaws and knick-knacks they were merely pandering to naïve and primitive African tastes. Merchant trade lists reveal, however, that when the European ships left West Africa again, they were laden, not

only with gold-dust and palm oil, but also with elephant tusks, 'teeth of sea-horses' (hippopotamus), ostrich feathers, beeswax, animal hides and 'cods of musk'.[31] The absolute commodification of humanity and the colonial genuflexion to the fetish of profit was most grotesquely revealed in the indiscriminate listing of slaves amongst the trifles and knick-knacks.

By defining the economic exchanges and ritual beliefs of other cultures as 'irrational' and 'fetishistic', the colonials set about disavowing them as legitimate systems. The huge labour that went into transporting cargoes of trifles to the colonies had less to do with the appropriateness of such fripperies to African cultural systems, than with systematically under-valuing these alternative systems with respect to merchant capitalism and market values in the metropolis.

A good deal of evidence also suggests that the European traders, while vigorously denying their own fetishism and projecting such 'primitive' proclivities on to European women, colonized people and children, took their own 'rational' fetishes with the utmost seriousness.[32] By many accounts, the empire seems to have been especially fortified by the marvel-lous fetish of Eno's Fruit Salt. If Pears' could be entrusted with cleaning the outer body, Eno's was entrusted with cleaning the inner body. Most importantly, the internal purity guaranteed by Eno's could be relied upon to ensure male potency in the arena of war. As one colonial vouched: 'during the Afghan war, I verily believe Kandahar was won by us all taking up large supplies of ENO'S FRUIT SALT and so arrived fit to overthrow half-a-dozen Ayub Khans.'[33] He was not alone in strongly recommending ENO's power to restore white supremacy. Commander A.J. Loftus, hydrographer to His Siamese Majesty, swore that he never ventured into the jungle without his tin of Eno's. There was only one instance, he vouched, during four years of imperial expeditions, that any member of his party fell prey to fever: 'and that happened after our supply of FRUIT SALT ran out'.[34]

Fetishism became an intercultural space, in which both sides of the encounter appear to have tried on occasion to manipulate the other by mimicking what they took to be the other's specific fetish. In Kenya, Joseph Thomson, FRGS, posed grandly as a white medicine man by conjuring an elaborate ruse with a tin of Eno's for the supposed edification of the Masai:

Taking out my sextant and putting on a pair of kid gloves – which accidentally I happened to have and which impressed the natives enor-mously, I intently examined the contents . . . getting ready some ENO'S FRUIT SALT, I sang an incantation – in general something about 'Three Blue Bottles' – over it. My voice . . . did capitally for a wizard's. My preparations complete, and Brahim [sic] being ready with a gun, I dropped the Salt into the mixture; simultaneously the gun was

fired and, lo! up fizzed and sparkled the carbonic acid . . . the chiefs with fear and trembling taste as it fizzes away.[35]

While amusing himself grandly at the imagined expense of the Masai, Thompson reveals his own faith in the power of his fetishes (gloves as a fetish of class leisure; sextant and gun as a fetish of scientific technology; Eno's as a fetish of domestic purity) to hoodwink the Masai. 'More amusing', however, as Hindley notes, is Thompson's own naïvety, for the point of the story is that 'to persuade the Masai to take his unfamiliar remedies, Thomson laid on a show in which the famous fruit salt provided only the "magic" effects'. Eno's power as domestic fetish was eloquently summed up by a General Officer, who wrote and thanked Mr Eno for his good powder: 'Blessings on your Fruit Salt,' he wrote, 'I trust it is not profane to say so, but I swear by it. There stands the cherished bottle on the Chimney piece of my sanctum, my little idol – at home my household god, abroad my vade mecum.' The manufacturers of Eno's were so delighted by this fulsome dedication to their successful little fetish that they adopted it as regular promotion copy. Henceforth, Eno's was advertised by the slogan: 'At home my household god, abroad my vade mecum.'

In the colonial encounter, Africans adopted a variety of strategies for countering attempts to undervalue their economies. Amongst these strategies, mimicry, appropriation, revaluation and violence feature the most frequently. Colonials complained rancorously at the African habit of making off with property that did not belong to them, a habit that was seen not as a form of protest, nor as a refusal of European notions of property ownership and exchange value, but as a primitive incapacity to understand the value of the rational market economy. Barbot, for example, describes the Ekets as:

> the most trying of any of the Peoples we had to deal with . . . Poor Sawyer had a terrible time; the people had an idea they could do as they liked with the factory keeper, and would often walk off with the goods without paying for them, which Mr Sawyer naturally objected to, usually ending in a free fight, sometimes my people coming off second best.[36]

Richards notes how Henry Morton Stanley, likewise, could not make Africans (whom he saw primarily as carriers of Western commodities) understand that he endowed the goods they carried with an abstract exchange value apart from their use value. Since these goods 'lack any concrete social role for them in the customs, directives, and taboos of their tribal lives, the carriers are forever dropping, discarding, misplacing, or walking away with them. Incensed, Stanley calls this theft.'[37]

From the outset, fetishism involved an intercultural contestation fraught with ambiguity, miscommunication and violence. Colonials were prone to fits of murderous temper when Africans refused to show due respect to

their flags, crowns, maps, clocks, guns and soaps. Stanley, for one, records executing three African carriers for removing rifles, even though he admits that the condemned did not understand the value of the rifles or the principle for which they were being put to death.[38] Other carriers were executed for infringements such as dropping goods in rivers.

Anecdotes also reveal how quickly colonial tempers flared when Africans failed to be awestruck by the outlandish baubles the colonials offered them, for it wasn't long before the initial curiosity and tolerance bestowed on the colonials' exotica turned to derision and contempt. In Australia, Cook carped at the local inhabitants' ungrateful refusal to recognize the value of the trinkets they brought them:

> Some of the natives would not part with a hog, unless they received an axe in exchange; but nails, and beads, and other trinkets, which, during our former voyages, had so great a run at this island, were now so much despised, that few would deign so much as to look at them.[39]

De Bougainville similarly recalls how a native from the Moluccas, on being given 'a handkerchief, a looking-glass, and some other trifles . . . laughed when he received these presents, and did not admire them. He seemed to know the Europeans'.[40] As Simpson points out: 'The handkerchief is an attribute of "civilization", the tool for making away with the unseemly sweat of the brow, the nasal discharge of cold climates, and perhaps the tears of excessive emotion.' The white handkerchief was also (like white gloves) the Victorian icon of domestic purity and the erasure of signs of labour. The Moluccans' refusal of handkerchief and mirror expressed a frank refusal of two of the centrally iconic values of Victorian middle-class consumerism.[41]

In some instances, elaborate forms of mimicry were created by Africans to maintain control of the mercantile trade. The Tlhaping, the southern-most Tswana, as the Comaroffs point out, having obtained beads for themselves, tried to deter Europeans from venturing further into the interior by mimicking European stereotypes of black 'savagery', and por-traying their neighbours as 'men of ferocious habits' too barbaric to meddle with.[42]

In the realm of empire, fetishism became an arena of constant conflict and negotiation over social value. The fetish signifies a conflict in the realm of value and is eloquent, amongst other things, of a sustained African refusal to accept Europe's commodities and Europe's boundary rituals on the colonials' terms. The soap saga and the colonial cult of domesticity reveal that fetishism was original neither to industrial capitalism, nor to pre-colonial economies, but was rather, from the outset, the embodiment and record of an incongruous and violent encounter.

NOTES

I explore this complex dialectic of race, class and gender in more detail in *Imperial Leather. Race, Gender and Sexuality in the Colonial Contest*, New York and London, Routledge, 1994.

1 See Jean and John L. Comaroff, 'Home-made hegemony: modernity, domesticity and colonialism in South Africa', in Karen Tranberg Hansen (ed.), *African Encounters with Domesticity*, New Brunswick, Rutgers University Press, 1992, pp. 37–74.
2 Commodity spectacle, though hugely influential, was not the only cultural form for the mediation of this dialectic. Travel writing, novels, postcards, photographs, pornography and other cultural forms can be as fruitfully investigated for the relation between domesticity and empire. I focus on commodity spectacle since its extensive reach beyond the literate and propertied elite gave imperial domesticity particularly far-reaching clout.
3 Karl Marx, 'Commodity fetishism', *Capital*, vol 1. Quoted in Thomas Richards, *The Commodity Culture of Victorian Britain. Advertising and Spectacle 1851–1914*, London, Verso, 1990.
4 See Richards' excellent analysis, especially the Introduction and Chapter 1.
5 See David Simpson's analysis of novelistic fetishism in *Fetishism and Imagination. Dickens, Melville, Conrad*, Baltimore, Johns Hopkins University Press, 1982.
6 Richards, op. cit., p. 72.
7 In 1889, an ad for Sunlight Soap featured the feminized figure of British nationalism, Britannia, standing on a hill and showing P.T. Barnum, the famous circus manager and impresario of the commodity spectacle, a huge Sunlight Soap factory stretched out below them. Britannia proudly proclaims the manufacture of Sunlight Soap to be: 'The Greatest Show On Earth'. See Jennifer Wicke's excellent analysis of P.T. Barnum in *Advertising Fictions: Literature, Advertisement and Social Reading*, New York, Columbia University Press, 1988.
8 See Timothy Burke, 'Nyamarira that I loved: commoditization, consumption and the social history of soap in Zimbabwe', in *The Societies of Southern Africa in the 19th and 20th Centuries*, Collected Seminar Papers, no. 42, vol. 17, Institute of Commonwealth Studies, University of London, 1992, pp. 195–216.
9 Leonore Davidoff and Catherine Hall, *Family Fortunes, Men and Women of the English Middle Class*, London, Routledge, 1992.
10 David T.A. Lindsey and Geoffrey C. Bamber, *Soap-Making. Past and Present. 1876–1976*, Nottingham, Gerard Brothers Ltd.
11 Ibid., p. 38. Just how deeply the relation between soap and advertising became embedded in popular memory is expressed in words such as 'soft-soap' and 'soap-opera'.
12 Quoted in Diana and Geoffrey Hindley, *Advertising In Victorian England 1837–1901*, London, Wayland, 1972, p. 117.
13 Mike Dempsey (ed.), *Bubbles. Early Advertising Art from A. & F. Pears Ltd*, London, Fontana, 1978.
14 Laurel Bradley, 'From Eden to Empire. John Everett Millais' Cherry Ripe', *Victorian Studies*, Winter 1991, vol. 34, no. 2.
15 Donna Haraway, *Primate Visions. Gender, Race, and Nature in the World of Modern Science*, London, Routledge, 1989, p. 10.
16 Ibid., p. 10.
17 Ibid., pp. 10–11.

18 Quoted in Richard Kearney (ed.), *The Irish Mind*, Dublin, Wolfhound Press, 1985, p. 7. See also L.P. Curtis Junior, *Anglo-Saxons and Celts. A Study Of Anti-Irish Prejudice in Victorian England*, Bridgeport, Conference on British Studies of University of Bridgeport, 1968; and Seamus Deane, 'Civilians and barbarians', in *Irish's Field Day*, London, Hutchinson, 1985, pp. 33–42.

19 During the Anglo–Boer war, Britain's fighting forces were seen as valiantly fortified by Johnston's Corn Flour, Pattisons' Whiskey and Frye's Milk Chocolate. See Robert Opie, *Trading on the British Image*, Harmondsworth, Penguin Books, 1985, for a collection of advertising images.

20 In a brilliant chapter, Richards explores how the explorer and travel writer, Henry Morton Stanley's conviction that he had a mission to civilize Africans by teaching them the value of commodities, 'reveals the major role that imperialists ascribed to the commodity in propelling and justifying the scramble for Africa', in T. Richards, *The Commodity Culture of Victorian Britain*, London, Verso, 1990, p. 123.

21 As Richards notes: 'A hundred years earlier the ship offshore would have been preparing to enslave the African bodily as an object of exchange; here the object is rather to incorporate him into the orbit of exchange. In either case, this liminal moment posits that capitalism is dependent on a noncapitalist world, for only by sending commodities into liminal areas where, presumably, their value will not be appreciated at first can the endemic overproduction of the capitalist system continue.' Ibid., p. 140.

22 Thomas Carlyle, *The Works Of Thomas Carlyle*, The Centenary Edition, 30 vols, London, Chapman and Hall, 1896–99, p. 30.

23 Richards, op. cit., pp. 122–3.

24 But palm-oil soaps had been made and used for centuries in West and equatorial Africa. In *Travels in West Africa*, Mary Kingsley records the custom of digging deep baths in the earth, filling them with boiling water and fragrant herbs, and luxuriating under soothing packs of wet clay. In southern Africa, soap from oils was not much used, but clays, saps and barks were processed as cosmetics, and shrubs known as 'soap bushes' were used for cleansing. Male Tswana activities like hunting and war were elaborately prepared for and governed by taboo. 'In each case,' as Jean and John Comaroff write, 'the participants met beyond the boundaries of the village, dressed and armed for the fray, and were subjected to careful ritual washing (*go foka marumo*).' Jean and John Comaroff, *Of Revelation and Revolution. Christianity, Colonialism and Consciousness in South Africa*, vol. 1, Chicago, University of Chicago Press, 1991. In general, people creamed, glossed and sheened their bodies with a variety of oils, ruddy ochres, animal fats and fine coloured clays.

25 For an exploration of colonial hegemony in Southern Africa, see Jean and John Comaroff, op. cit.

26 Daniel Defoe, *The Farther Adventures of Robinson Crusoe*, in The Shakespeare Head Edition of the Novels and Selected Writings of Daniel Defoe, 14 vols, Oxford, Basil Blackwell, 1927–8, vol. 3, p. 177.

27 W.J.T. Mitchell, *Iconology. Image, Text, Ideology*, Chicago, University of Chicago Press, 1986, p. 193.

28 Cited in Mary Kingsley, *West African Studies*, London, Macmillan, 1899, p. 622.

29 David Simpson, *Fetishism and Imagination. Dickens, Melville, Conrad*, Baltimore, Johns Hopkins University Press, 1982, p. 29.

30 'Trade goods used in the early trade with Africa as given by Barbot and other writers of the seventeenth century,' in M.H. Kingsley, op. cit., pp. 612–25.

31 Kingsley, op. cit., p. 614.

32 Fetishism was often defined as an infantile predilection. In Herman Melville's *Typee*, the hero describes the people's fetish-stones as 'childish amusement . . . like those of a parcel of children playing with dolls and baby houses'. *The Writings Of Herman Melville*, The Northwestern-Newberry Edition, edited by Harrison Hayford, Hershel Parker and G. Thomas Tanselle, Chicago, 1968, pp. 174–7.

33 D. and G. Hindley, *Advertising in Victorian England, 1837–1901*, p. 99.

34 Ibid., p. 98.

35 Ibid.

36 Kingsley, op. cit., p. 594.

37 Richards, op. cit., p. 125.

38 Ibid.

39 Quoted in Simpson, op. cit., p. 29.

40 Ibid.

41 Barbot admits that the Africans on the west coast 'have so often been imposed on by the Europeans, who in former ages made no scruple to cheat them in the quality, weight and measures of their goods which at first they received upon content, because they say it would never enter into their thoughts that white men . . . were so base as to abuse their credulity . . . examine and search very narrowly all our merchandize, piece by piece . . . '. It did not take long, it seems, for Africans to invent their own subterfuges to hoodwink the Europeans and win the exchange. By Barbot's account, they would half fill their oil-casks with wood, add water to their oil, or herbs to the oil to make it ferment and thus fill up full casks with half the oil. Kingsley, op. cit., p. 582.

42 Jean and John Comaroff, op. cit., p. 166.

Travelling to collect: the booty of John Bargrave and Charles Waterton

Stephen Bann

The ideology of travel implies a departure from a place and a return to the same place: the traveller enriches this place with a whole booty of knowledge and experience by means of which he states, in this coming back to the 'sameness', his own consistency, his identity as a subject.

(Louis Marin)[1]

My work at the moment is in a state of transition between two travellers, and collectors: John Bargrave (1610–80) and Charles Waterton (1782–1865). Bargrave is known – if he is known at all – for the Cabinet of Curiosities which he assembled during fifteen years or so of enforced European travel during the English Civil War and Commonwealth.[2] Waterton is, perhaps, slightly better known as the author of *Wanderings in South America*, an account of his travels originally published in 1825 and republished several times in the course of the nineteenth century.[3] He features in the annals of natural history as the self-proclaimed pioneer of the art, or science, of taxidermy. What I intend to do in this chapter is to ask certain questions about the activities of travel and collecting, which imply a comparative judgement on these two, highly individual cases. Inevitably, my main examples will be taken from one of these two figures, namely John Bargrave. He took care that his journeys should be recorded by visual documentation, as in the miniature painting by Mattio Bolognini which showed him contemplating the map of Italy, with his two travelling companions, in 1647. His knowledge of the country, assimilated and supplemented by the taller of his two companions, John Raymond, resulted in the publication of the first Italian guidebook in the English language, published in London in 1648.[4]

An immediate question is prompted by Marin's formulation. The traveller goes from the same to the same, and consequently emphasizes 'his own consistency, his identity as a subject'. But, of course, this series of definitions can and must be expanded. The traveller goes from the same to the other, and then back to the same: the 'booty of knowledge', the 'experience' gained, is a factor of contact with, and appropriation of, that

otherness. The traveller affirms 'identity as a subject'; but what if that identity was not simply suspended, provisionally, by the act of departure, but already in doubt, or problematized, by the circumstances which led to the departure in the first place? What if the identity, to which the traveller returned, were a conflictual identity, which remained in play in the subject's relationship to the 'booty' accumulated? I ask all these questions, confident of not being able to provide wholly satisfactory answers. But the whole issue boils down to one, blindingly clear question: what is a subject, within history? Julia Kristeva has tried, in *Histoires d'amour*, to analyse successive states of the Western subject in, and constituted by, representation.[5] I would like to envisage a micro-history of the Western subject, since the Renaissance, as it has been inflected by the experience of otherness and objecthood – by travel and collecting, the systole and diastole of a certain cultural identity.

The first relevant point here involves a pun on the word 'subject'. John Bargrave was a 'subject' of Charles I, member of a staunchly Royalist family whose leading member, the Dean of Canterbury, had been publicly insulted, imprisoned and allowed to die incarcerated at the opening of the Civil War: he starts his continental travels under the impulsion of this dramatic event, and a result of his own expulsion from his College Fellowship at Cambridge. Setting out from the kingdom which is no longer a kingdom, but in a state of flagrant illegality in his view, he projects upon Europe the lineaments of the ideological conflict that is the cause of his exile. Why is the striking frontispiece to the travel book adorned with two figures emblematic of Rome and Venice, who are linked to one another by chains? Briefly, because for Bargrave, the Venetian republic suffers in relation to Rome and to the Catholic church the same imposition of tyrannical power as England herself would be suffering, if the Pope could carry out his Machiavellian intention of destabilizing the English Crown and reasserting ecclesiastical control.

By contrast, Charles Waterton, born a century after Bargrave's death, suffers as a member of an old Catholic, recusant family, from the penal legislation directed at such families from the time of the Reformation onwards: only under the reign of Mary had the Watertons been entitled to hold government office, and Charles himself was to refuse to take the oath enjoined in Peel's Catholic Emancipation Act of 1829, presumably because of his sense of total alienation from the British political scene. What did he look for, and perhaps go out to seek, in the forests and rivers of South America? To a certain extent, he looked for and found the accelerating decay of European colonial empires, which were being overtaken in the new processes of independence and nationhood. But more important to him was the abiding evidence of the civilizing role of the Jesuit fathers, who had permeated the Spanish and Portuguese colonies. The Society of Jesus, who for John Bargrave represented the secret hand of papal policy in a

Europe still polarized between Catholic and Protestant, was for Charles Waterton a symbol of enlightened guidance on a global basis which he was willing to defend against the attacks of his anti-papist fellow countrymen:

> When you visit the places where those learned fathers once flourished, and see, with your own eyes, the evils their dissolution has caused; when you hear the inhabitants telling you how good, how clever, how charitable they were; what will you think of our poet laureate, for calling them, in his 'History of Brazil', 'Missioners, whose zeal the most fanatical was directed by the coolest policy?'[6]

So what do Bargrave and Waterton bring back, from their experience of the other, to testify to their trials as political subjects, their relative degrees of disenfranchisement from the body politic? Bargrave brings back the portraits of the Cardinals of the Roman church, bought in sheets at Rome in 1660, and bound up into a book on his return to England. But he then annotates the volume, over a period of nearly twenty years, with extracts transcribed from the virulently anti-papist writings of Gregorio Leti, and infiltrates into this withering commentary on the naked ambitions of their Eminences his own elaborate hypothesis of a Popish plot against the Crown of England. Waterton, by contrast, brings back from South America the body of a red howler monkey, which he then, through his skill as a taxidermist, makes up into the figure of a 'Nondescript' (see Figure 9.1), using the rear end of the monkey for this purpose. There has been a suggestion, which I am not able to verify, that Waterton modelled the features of the Nondescript after the customs officer who charged him duty on his specimens at Liverpool in 1820, and it would accord nicely with my view of him if this representative of governmental authority, situated precisely at the point of transition between the same and the other, were being caricatured in this way! What is certain is that Waterton allowed his hijacked monkey carcase to be seen as a parody of the idea of racial supremacy: its features, he suggested, 'are quite of the Grecian cast'.[7]

Waterton brings back specimens of the tropical fauna which he then transforms, at home, in two opposed yet functionally interdependent ways: he stuffs exotic birds, such as the astonishing Toucan, in such a way that they will appear to be alive,[8] while at the same time he makes a secondary semantic conversion, so to speak, of the howling monkey's rear end: he assembles individual specimens into a complex political allegory of the National Debt, using goodness knows whose skin to fashion the gloomy countenance of 'Old Mr Bull [that is, John Bull] in trouble', assailed by lizards which have taken on the aspect of mocking and triumphant devils.[9]

Monstrosity therefore functions for Waterton both as the threatening other side of 'life-like' representation, and as the vehicle of political satire. Home is both the place where the effulgent beauty of the tropical fauna is re-created, and stabilized for the benefit of future generations; but it is also

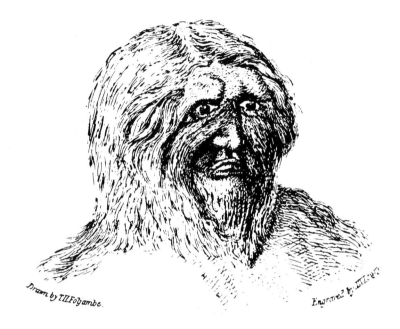

A NONDESCRIPT

Figure 9.1 J.H. Foljambe, drawing after Charles Waterton, 'A Nondescript', *c.* 1825.

a place of conflictual identity, which entails the reprocessing of the animal remains and their incorporation in a demonstration of ideology. The relevant analogy in John Bargrave's case is perhaps his image of 'Queen Christina of Sweden being received into the Catholic Church at Innsbruck' (see Figure 9.2).[10] On the simplest level, this is a matter of pure record. Bargrave tells us that he sketched this event, which took place in 1655, having stayed in Innsbruck for the express purpose of witnessing it, and had the plate from which this unique print is taken cut for him in the same city. Bargrave visualizes the history that he sees in the process of being made. But when he incorporates the image in the politically loaded discourse of the College of Cardinals, he gives it a new meaning, which connects with the anti-papist propaganda of the text. Christina, the Protestant Queen whose unorthodox mode of dress and behaviour was compounded by her decision to abdicate her throne and be received into

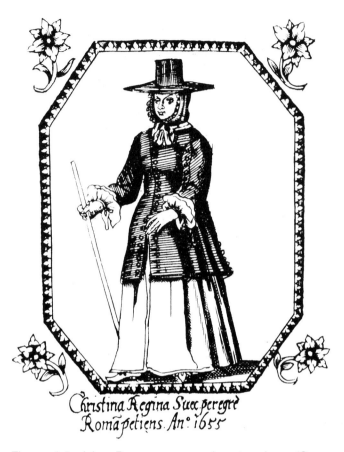

Figure 9.2 John Bargrave, engraving to show 'Queen Christina of Sweden being received into the Roman Catholic Church', Innsbruck, 1655.

the Catholic church, is truly a monstrosity from Bargrave's Pan-European point of view.

Both of these 'souvenirs' brought home by traveller/collectors seem to me, then, to presuppose a sequence of subjective positions, which apply equally to Bargrave and to Waterton, though they are worked through in quite different ways. Let me call them, for the sake of clarity: the experiencing subject, the creative subject, and the ideological subject. The experiencing subject is exposed to the other – whether it be the South American rain forest or the dangerous jungle of seventeenth-century Europe – and registers the beauty and/or singularity of a particular phenomenon. The creative subject re-presents that experience, initially in the form of the tropical bird, or the exotically dressed Queen. The

ideological subject then converts the object or image into a new system of meanings and purposes. Of course you will say that the idea of a pure 'experiencing' subject is a fantasy. Charles Waterton knew, and had to know, about the classifications of ornithology before he could single out the fine specimens for repatriation. John Bargrave had to know of the political significance of the doings of a Swedish Queen before he could, or would, judge worthy of record an event concerning her. That is why I spoke earlier of 'subjective positions'. But my contention is that the sequence of operations presupposed in these three conceptually distinct states of the subject does indeed provide a reinforcement of the 'identity' which I mentioned initially, with reference to Marin's quotation. 'Consistency' of the subject is, I am suggesting, many-layered; but it is consolidated by successive chains of experience and action; in the course of their constitution, the subject tests out a wide variety of positions, some of which imply power, and others powerlessness, or lack. The traveller is not always in control, the collector even less so: the traveller/collector acquires an identity as a result of the oscillation of the subjective states that he imposes on the world, and the world imposes on him.

I want finally to examine one further issue that is necessarily implied in my decision to compare traveller/collectors from two different centuries, who lie on different sides of what Foucault, at any rate, would have regarded as an epistemological break. Waterton is part of the culture that produced Shelley's *Prometheus Unbound*, and Mary Shelley's *Frankenstein*. He does indeed say at one point, in his essay 'On preserving birds': 'you must possess Promethean boldness, and bring down fire, and animation, as it were, into your preserved specimen'.[11] He also creates monsters. The fact that, as a Catholic recusant and patron of the Jesuit order, he is politically at the antipodes from the free-thinking poet and the daughter of the pioneer of women's rights does obviate his belonging within the epistemic matrix of what we could generally call Romanticism: he shows its manic side in the myth of re-creating life outside of representation, just as he shows its depressive side in the ironic conversion of his specimens to political uses. Bargrave is quite independent of this framework of reference, as can be seen most clearly in considering one of his most striking collected objects: 'the finger of a Frenchman'.

Bargrave tells us the story of his acquiring this truncated finger in a particularly full entry in the catalogue of his museum, which is one of its most unusual and helpful features. The scene is 'a great monastery of the Franciscans', in Toulouse, where the earth had the remarkable property of mummifying the bodies of the dead, with the consequence that they could be removed after a couple of years, and stored in the vaults of the church. Bargrave was shown, as he tells us:

the corps of a soldier, that died by the wound of a stabb with a dagger in his breast, upon the orifice of which one of his hands lay flatt, and when they pulled away the hand, the wound was plainly seen; but let the hand go, and it returned to its place with force, as if it had a resort or spring to force it to its proper place.[12]

Desiccation has made the body into a mechanical toy, which is both the simulacrum of a former identity, and the vehicle of a repetitive, predictable effect. That this is not seen as degrading, or sinister in the least degree, must presuppose a high degree of repression in Bargrave's account of the experience. Yet the experience, such as it was, is justified by its epistemo-philic dividend. Again Bargrave recounts:

They proffered me the whole body of a little child, which I should out of curiosity have accepted of, if I had then been homeward bound; but I was then outward bound for the grand tour of France (or *circle*, as they call it), and so again into Italy.[13]

Bargrave rejects the whole body of the child, and accepts instead the fractured finger. 'Curiosity', which Krzysztof Pomian so well describes as being a regime between theology and science, is the motive which recuper-ates the disquieting experience.[14] As Pomian also warns us, 'curiosity' is characterized especially by the 'desire for totality': 'it cannot better be represented than by Venus or a nymph, half-naked and accompanied by a Cupid in an enthusiast's private museum'. A finger is a poor substitute for this body in its totality, veiled by the inscrutable processes of mummifica-tion, yet rendered irresistibly attractive by its singular way of challenging the desire to see, precisely by repressing the fact of death.

Yet, at the same time as he lets us in on the secret of his epistemophilia, Bargrave indicates what it is that drags him in the other direction. He is 'outward bound', on a 'grand tour' or 'circle' of France. In the 1640s, long before it became commonplace to write of the 'grand tour' – long before such a term was applied to the final phase of an eighteenth-century gentleman's education – we can see the employment of this geometrical analogy as having cognitive, and not merely conventional content. Bargrave conceptualizes his journey as having the form of a circle, or rather two circles (in Italy, it is the 'giro d'Italia'), not because he is ignorant of maps, and believes himself to be going around in a circle, but because the circle gives an ideal image of the path of a body in space. To quote from Marin again – and from the passage immediately following the one with which I began: 'The Utopian moment and space of travel . . . consists in opening up this ideological circle, in tracing out its route, a *nowhere*, a place without place, a moment out of time, the truth of a fiction'. To gloss these words, the 'circle' or 'grand tour' of France does not enclose France, as a geographical unit, or territory; it encloses the space,

or non-space of a journey, a fictional moment which is materialized, and narrativized, in the form of the souvenir.

This interpretation is strengthened, in my view, by the fact that Bargrave gives another striking geometric metaphor, which is on this occasion not even incipiently conventionalized, to describe his ultimate destination on all his journeys. This comes under the item in his catalogue describing a part of the collection:

> Several pieces of cinders, pummystone, and ashes of the Mount Vesuvius, near Naples, which was four times the poynt of my reflection, – I facing about for England from the topp, or crater, or *voragine* (as they term it) of that mountain; of which I have spoken at large in my *Itinerario d'Italia*.[15]

What this fascinating detail presupposes is that on each of his four lengthy journeys to Rome, Bargrave struck out as far as Naples, affirming by this fourfold repetition his need to conceptualize the distinction between the journey out and the journey back: in describing this spatialized moment of decision as 'the point of my reflection', he implicitly allies his physical body with that of other physical bodies, in particular, perhaps, those corpuscles thought by contemporary physicists to form the materiality of light. But if the corpuscle travels there and back again without being modified, Bargrave has enclosed in his journey the great centre of Rome, not merely as a geographical aim but as an ideological space in which he has immersed himself, in order to learn the truth of his own political situation. Of this process of enclosure defined by the journey, the cinders, pummystone and ashes collected on Mount Vesuvius are the souvenirs, as is a lively sketch of the mountain – the only geographical feature illustrated in the Italian travel book: all of them vestiges, like the finger of a Frenchman, of a traveller's desire to see and to know.

NOTES

1 Louis Marin, 'The frontiers of Utopia', in Krishan Kumar and Stephen Bann (eds), *Utopias and the Millennium*, London, Reaktion Books, 1993, p. 14.
2 Bargrave's manuscript catalogue was published, together with the annotated *College of Cardinals*, to which reference will later be made, in James Craigie Robertson (ed.), *Pope Alexander the Seventh and the College of Cardinals*, London, Camden Society, 1867. I look at his collection and career in greater detail in a forthcoming book, *Under the Sign – John Bargrave as Collector, Traveller and Witness*.
3 The edition used here is: Charles Waterton, *Wanderings in South America . . . in the Years 1812, 1816, 1820 & 1824*, London, B. Fellowes, Fourth Edition, 1839.
4 John Raymond, *An Itinerary contayning a Voyage made through Italy in the yeare 1646, and 1647*, London, 1648.

5 See Julia Kristeva, *Histoires d'amour*, Paris, Denoël, 1983; translated as *Tales of Love*, New York, Columbia University Press, 1989.
6 Waterton, *Wanderings*, pp. 87–8.
7 Ibid., p. 277.
8 See my earlier discussion of this aspect of Waterton's work, in *The Clothing of Clio – A Study of the Representation of History in Nineteenth-century Britain and France*, Cambridge, Cambridge University Press, 1984, pp. 16–17.
9 The allegorical montage is preserved in the Wakefield City Museum, together with a large number of Waterton's stuffed birds and animals.
10 The print is reproduced as a frontispiece to the Camden Society publication (see Note 2); the unique original is pasted into the *College of Cardinals* manuscript.
11 Waterton, *Wanderings*, p. 290.
12 Robertson (ed.), *College of Cardinals*, p. 130.
13 Ibid., p. 131.
14 See Krzysztof Pomian, *Collectors and Curiosities*, Cambridge, Polity Press, 1990, p. 64. For 'curiosity', see ibid., pp. 45–64.
15 Robertson (ed.), *College of Cardinals*, p. 123.

Chapter 10

Looking at objects: memory, knowledge in nineteenth-century ethnographic displays

Nélia Dias

It is commonly supposed that other people's artefacts conserved in ethnographic museums are objective data that can provide reliable knowledge. However, recent anthropological work has analysed the act of collecting and display as a cultural practice, historically determined, questioning the representative systems that have been used to transmit knowledge (Clifford 1988; Karp and Lavine 1991). It is my aim here to take nineteenth-century ethnographic displays as the basis for an examination of the connections between vision, memory and knowledge. What kind of knowledge do ethnographic museums transmit? What does it really mean *to see* a culture and to understand it by looking at objects?

Historically, anthropology has been linked with natural history, a heritage which is clearly manifested in some methodological processes – observation, collecting data and classification. The emphasis placed on observation, and the conviction that 'anthropological knowledge is based upon, and validated by, observation' (Fabian 1983: 107) contributed to the primacy of vision over the other senses. Moreover, vision became the privileged mode of knowing in anthropology. The way anthropology was built around a set of visual metaphors and its conception of knowledge 'as the reproduction of an observed world' have been criticized by Fabian (1983), Clifford and Marcus (1986), and Tyler (1987); nevertheless, these critiques are concerned essentially with the rejection of visualism within the textual mode of representation and only tangentially concerned with exhibits. If vision and anthropological knowledge are closely connected, however, what is expressly made to be seen within the space of the museum – as well as the division between the visible and the invisible – changes from one period to another. How do these changes affect the conception of knowledge and the methods of exhibitions?

We are familiar with the role of the nineteenth-century ethnographic museums as visual modes of communication, combining instruction with pleasure. In the nineteenth century the priority given to things over words, as instruments of knowledge, is most in evidence; in fact many contemporary authors contrast the incomplete and rather cold descriptions to be

found in books with the power of objects and artefacts to leave a vivid impression. Kaltbrunner's famous *Voyager's Manual* (1887) celebrates the object as 'the best, and even perhaps the only, means of giving a faithful and accurate idea, whilst avoiding the difficulty and tedium of lengthy descriptions'.

There were two types of display in the ethnographic museum of the nineteenth century: the typological arrangement and the geographical system, which function as open books in order to provide 'object lessons' in mnemonic process to museum visitors. The typological and geographical arrangements were instruments for the presentation of knowledge: they imply two simultaneous yet different ways of seeing, and two distinct types of memory.

VISION AND KNOWLEDGE

Identified as the 'natural history of man', anthropology developed as a distinctive field of enquiry in the early nineteenth century. Since its beginnings, anthropology adopted the canons of scientificity of natural history and thus emphasis was put on observation, later transformed into participant observation and its corollary, the notion of fieldwork.

The role of vision as a mode of knowing in the Western tradition has been discussed by Jonas (1954) and Ong (1967; 1969). Recently, Johannes Fabian in the wake of Ong put into question visualism in anthropology as an 'ideological current in Western thought' (Fabian 1983: 123). Although my purpose here is to explore the ways of transmitting anthropological knowledge by visible means, in museums especially, it is worth noting certain key characteristics of visual perception itself. According to Hans Jonas, sight presupposes, firstly, the 'sense of simultaneity' (Jonas 1954: 507). In other words,

> only the simultaneity of sight, with its extended 'present' of enduring objects, allows the distinction between change and the unchanging and therefore between becoming and being. All other senses operate by registering change and cannot make that distinction. Only sight therefore provides the sensual basis on which the mind may conceive the idea of the eternal, that which never changes and is always present.
>
> (Jonas 1954: 513)

Secondly, sight implies 'dynamic neutralization'. In the act of viewing, the observer is not engaged by the seen object: 'The gain is the concept of objectivity, of the thing as it is in itself as distinct from the thing as it affects me' (ibid.: 515). The idea that the observer is a non-interventionist actor in the process of viewing leads to what Jonas identifies as the third characteristic of sight, 'spatial distance'. In fact, 'sight is the only sense in which the advantage lies not in proximity but in distance' (ibid.: 517).

Since the nineteenth century, anthropological knowledge has been considered by analogy with visual activity; the anthropologist is an observer and 'being a subject is not being something that is looked at, it is being the one who is looking' (Ong 1967: 122). The way was open, as Ong had clearly noted, for the process of objectifying the Other. On the anthropological level, this means that the Other, as an object of study, is placed in another space and time ('there' and 'then') in opposition to the 'here' and 'now' of the anthropological discourse.

The tradition of grounding epistemological premises in visual analogies dates back to the Greek and Roman rhetoricians and was developed during the Middle Ages and the Renaissance as Frances Yates (1966) has brilliantly shown. The Art of Memory, as a technique of 'places' and 'images', served not only to aid memory but also to define the nature of memory and its spatial localization. Visualization and spatialization were intertwined and provided the foundations of scientific knowledge.

Following the empiricist canon of natural history, with its emphasis on collecting and classifying, anthropology adopted the taxonomist's lists of 'races' and 'artefacts' as a way of arranging and ordering the data. In a certain sense, the extreme development of exhibitions and museums in the nineteenth century reinforced the conviction 'that presentations of knowledge through visual and spatial images, maps, diagrams, trees and tables are particularly well suited to the description of primitive cultures which, as everyone knows, are supremely "synchronic" objects for visual-aesthetic perception' (Fabian 1983: 121). In fact, the specificity of the nineteenth century is not so much in the new interest in exotica, but in the place occupied, or the 'framework' within which the exotica were displayed and seen – museums. For the first time, artefacts were ordered in a systematic way, in a list or *tableau*; that is, 'in a structure that was simultaneously visible and readable, spatial and verbal' (Foucault 1963: 113). The principle of ordering artefacts in a list rests on a certain concept of culture as a whole materialized by things, a concept that was developed by Tylor, Keeper of the University Museum in Oxford: 'Just as the catalogue of all the species of plants and animals of a district represents its Flora and Fauna, so the list of all the items of the general life of a people represents that whole which we call its culture' (Tylor 1871: 8).

The conviction that 'culture' is an entity which can be visualized by looking at objects tends to confer on the individual elements the metonymic role of representing an abstract whole. The term *specimen*, used to qualify ethnographic objects during the nineteenth century, implied not only previous selection (according to criteria such as the typical and the ordinary) but also the idea that the *specimen* as an illustration of *species* stood for all the others.

To bring into presence what was absent, to make visible the invisible ('the succession of ideas' for Pitt Rivers; 'culture' for Hamy and Boas) was

one of the main problems of nineteenth-century ethnographic displays. The two classificatory systems of ethnographic objects – the typological array and the geographical one – can thus be explored as two distinct ways of seeing which presuppose different modes of acquiring and retaining knowledge.

WAYS OF DISPLAY, WAYS OF SEEING

The question of the systems of classification used to organize artefacts was one of the most controversial and debated issues in the nineteenth century. Should objects be arranged according to geographical order or should typological and morphological criteria be privileged over place of origin? Formulated as early as 1830, by Edme-François Jomard and Philipp-Franz von Siebold, the debate engaged issues of science, pedagogy and politics throughout the nineteenth century (Dias 1991). Without going into the details of the factors invoked as justifications for the primacy of one system over the other (the nature of collections, the scientific or pedagogic goals envisaged), I shall address the issue of how it was that the two classificatory principles refer back to two different ways of seeing and, perhaps, to two distinct types of memory. A classification based on morphological and typological criteria tends to privilege the external form of the artefacts, those most accessible to sight. It made it possible to follow a sequence of development for each type of object (weapon, musical instrument) from the simplest to the most complex forms, and to do so independently of the question of their geographical provenance. Any object, the use or function of which was not immediately identifiable from its visible form, was classified according to its resemblance to other objects to which it bore a technical or formal similarity. The similarities, suggested by the juxtaposition of objects that resemble each other from the point of view of form, lead the visitor to accept as *given* the concept of a linear development of material production. Moreover, as a corollary of this linear concept of development, it implies belief in the concept of the unity of the human mind.

In this mode of presentation and display, objects were perceived primarily with reference to the logical schemes rather than in terms of themselves. The theoretical presuppositions of the curator, and in this case the evolutionist's point of view, lead him to group together objects from diverse geographical regions and to classify them according to his own criteria. The object is a piece of evidence, its role is not to allow discoveries to be made but to confirm and offer recognition of the presuppositions and unquestioned assumptions that operate as *givens*. In this sense, the exhibition display characteristic of the typological classification – the *panoplies* – offered visual evidence of the close resemblances between different objects. The panoply, being more than a simple convention for the

presentation of objects, offered a visual confirmation of technological evolution. The arrangement of objects in panoplies allowed the visitor's eye to follow evolutionary stages, showing how a boomerang, throwing stick and parrying shield 'derived from a common prototypical form' (Chapman 1985: 31). The trajectory of the viewer's eye followed an equivalent to the stages of evolution, beginning with the original form, the prototype, placed at the centre of the panoply, and then following its ultimate form. 'Specimens [were] arranged according to their affinities, the simpler on the left and the successive improvements in line to the right of them', wrote Pitt Rivers in 1874. In the space of the museum, the visitor was invited to take account of the linear development of ideas. Through the sense of vision, the spectator was able to transcend the time and space of the objects to situate himself in the timeless, abstract and analytic space of the museum. In fact, it was only within this space that it was possible to juxtapose and to see the 'resemblances between the simplest polished celts and the ornate paddles found throughout the South Pacific' (Chapman 1985: 31). The eye of the visitor is not implicated in the display of the objects: it is a disinterested gaze, as what he is looking at is a theoretical construction which was addressed essentially to his mind.

Reduced to its morphological expression, the object is consumed in itself, as if its surface and external form correspond with its internal essence. In other words, by looking at the external form of the object, the visible, the visitor can attain the invisible by means of a horizontal reading. This horizontal perception is made possible by the arrangement of objects in juxtaposed series, implying that knowledge of each form depends on its relation to the forms next to it. Thus it was hardly necessary to read in depth about the significance of an object; the perception of the external form indicated its position in relation to a determinate stage of the evolutionary process. The typological arrangement of artefacts presupposed a taxonomic principle of ordering (Pitt Rivers 1891), from the simplest to the most complex, and from those most necessary to human needs (alimentation, housing, dress, defence) to the most 'superfluous' (arts, musical instruments).

It is worth noting that this hierarchical arrangement was of considerable mnemonic use. Setting up series and arranging objects in sequences had an effect similar to looking at lists and schemata in books. The list-like effect produced by the typological arrangement made possible the memorization of things in a certain order. Here we find a process similar to the one analysed by Jack Goody (1977) with reference to writing: in the manner of lists, alphabetically ordered and implying memorization word by word, typological arrangements make possible a principle of classification and ordering based on external *analogies* and on a 'natural' hierarchy of needs. The museum effect consists of convincing visitors that the hierarchical order was 'natural and obvious', by putting similar forms side by side to be

memorized. The work of committing to memory takes the form of *analogous* images arranged in tabular form. Thus the table is a way not only of organizing knowledge, but also of displaying knowledge and a way of categorizing the visible.

The list of all cultural items was like a summary table for the purpose of classification and memorization. In the typological array, the specimens revealed the invisible underlying principle (the arrangement in order, class and sub-class). 'The primary arrangement has been by form – that is to say, that the spears, bows, clubs and other objects above mentioned, have each been placed by themselves in distinct classes. Within each there is a sub-class for special localities', wrote Pitt Rivers in 1874. In a recent article, Lee Rust Brown has demonstrated how the spatial arrangement of the collections of the Muséum d'Histoire Naturelle (Paris) was closely connected with Cuvier's classification.

> The encyclopedic format of the Muséum, its careful division and sub-division, was not arbitrary – not merely alphabetical, for example – but mirrored both the latent anatomy of its subject and the patent techniques of the naturalists. . . . Through the techniques of its various exhibition media, invisible forms of classifications attained democratic visibility. Wall cases, display tables, plant beds, groups of zoo cages, the very books in the library – these devices framed particular collocations of specimens, and so worked like transparent windows through which the visitor could 'see' families, orders and classes.
>
> (Brown 1992: 64)

In a certain sense, the particular way of seeing linked with the typological array has some affinities with the *regard*, in Foucault's sense of the term, as an activity which is 'de l'ordre successif de la lecture; il enregistre et totalise' (Foucault 1963: 123). The arrangement of objects in panoplies and cases allowed the spectator's eye to follow a particular itinerary, moving from left to right, in a process somewhat analogous to that of reading. This allowed the visitor to become aware of taxonomic systems which otherwise could be explained only by discourse. In a certain way, the typological arrangement functioned as an *aide-mémoire*, allowing for the recall of information that has already been stored. The ability to recollect was made possible by the juxtaposition of objects having formal analogies. Thus it was possible to reconstruct through imagination the distinctive instruments of peoples remote in time, by adopting what Pitt Rivers had called 'the orthodox scientific principle of reasoning from the known to the unknown'. In other words, 'specimens of the arts of existing savages' have been employed 'to illustrate the relics of primeval man' (Pitt Rivers 1874: 295). Since the 'implements of primeval man that were of decomposable materials have disappeared [they] can be replaced only in imagination by studying those of his nearest congener, the modern savage.' Proceeding

from the known to the unknown implied that visible things ('the specimens of the arts of existing savages') opened the way to the invisible ('the relics of primeval man'). Thus the possibility to see the unseen ('the succession of ideas') almost became a logical exercise, requiring a high degree of imagination, rather than constituting a mere act of viewing.

It would be inaccurate to oppose the typological and the geographical systems of classification; in fact, these two modes of display were used simultaneously, although with very different aims. In the first, the aim was to demonstrate the evolution of culture as a universal principle; in the second, to show the mode of life characteristic of a particular region.

The display according to geographical criteria made it possible for the visitor to take a synoptic view of culture and, in the words of E.T. Hamy – Curator of the Musée d'Ethnographie du Trocadéro (Paris) – to 'seize, in a *coup d'oeil*, the main features of each nation' (Dias 1991: 154). With the stress laid on cultural particularities, it is not so much the external form of the object which deserves examination but the way in which the object is located in its environment, the context of its production and use, in short its *meaning*. The need to reconstruct the framework and original context of artefacts was emphasized by the French architect, Eugène Viollet-Le-Duc in 1878: 'Representing the people of a country in terms of their ordinary conditions of living is an excellent way of introducing them' (Dias 1991: 170). We thus understand the extreme development of a mode of display, the life group, which included both environmental elements and the cultural artefacts in order to contextualize societies.

By displaying scenes of everyday life, the main purpose of the life group was to explain to the visitor the peculiarities of the culture of a particular geographical area. Thus, objects were perceived in reference to their cultures; the geographical arrangement stressed the emphasis on meaning, which supplanted the formal preoccupations of the typological array. However, to find an object's meaning, it is not enough to see it in its external and material form; it is also necessary to take on the work of uncovering its place within deep structures, which requires a certain *way of seeing*. It is a question of going beyond what is given to display, namely the visible, in order to uncover the relations that cannot be perceived in the act of viewing. The hidden relations that are inaccessible to the eye depend on a certain kind of data, available only in fieldwork. The task facing the anthropologist as curator consists of finding a strategy for transporting into and displaying the invisible and the visible within the museum space; in short, of making the invisible visible. The anthropologist, through his training and skill, is able to discern the visible and the invisible, and can see things as they are. In a certain sense it seems that anthropology is also organized around what Foucault, referring to pathological anatomy, calls a 'regime of invisible visibility', as a 'perceptual and epistemological structure'. The life groups, with their emphasis on meaning, tried to make

the invisible visible by means of a particular way of seeing. Looking was encouraged to extend beyond surface visibility, and thus beyond the horizontal framework, in order to plunge vertically. Artefacts were displayed not as evidence, but in order to raise questions, allow discoveries, and challenge the values of the visitors.

Given that, unlike the typological display, the main aim of the geographical system was to allow discoveries rather than confirm the visitors' values, the life group requires a particular way of seeing which cannot be the detached look of the typological arrays. The space of a life group is not a timeless and abstract one, as was the case with the panoplies, but a concrete space which is geographically and temporally located. Paradoxically, although the life groups managed to integrate the spatio-temporal dimensions, in one respect they nevertheless also managed to present cultures in a static and unchanging timeless present.

Exhibiting native life in a specific or concrete space requires not a detached but an intervening and insisting eye. It is not without reason that in the life group the emphasis is put on the central point and on a particular way of seeing – called *coup d'oeil*. Kaltbrunner, in his *Voyager's Manual* (1887: 10) does not hesitate to affirm that the *coup d'oeil* is a 'question of practice and habit', requiring a considerable apprenticeship before being mastered. The *coup d'oeil* implies an act of selective perception, as Foucault has described it (Foucault 1963: 122); 'the *coup d'oeil* does not survey a field, it strikes at one point, the privileged, central or decisive point, whereas the *regard* is indefinitely modulated, the *coup d'oeil* goes straight . . . and goes beyond what it sees.' It is interesting to note that one of the preoccupations of Franz Boas – Curator of the anthropological collections of the American Museum of Natural History in the 1890s – was 'to gain the attention of the viewer, to concentrate it upon a single point, and then guide it systematically to the next in a series of points' (Jacknis 1985: 90). In other words, by drawing the visitor's attention to a general point and then guiding it to more specific aspects, the life group imposes a way of ordering vision and a deep and penetrating look. The aim is to select the object of sight, which implies a particular way of seeing: not the *regard* which takes in everything, but the *coup d'oeil* which 'chooses, and the line with which it traces, instantly separates the essential and the inessential' (Foucault 1963: 123). In life groups the eye is first fixed on the human group presented, and then moved towards the type of habitation and the environmental context; by an *associative* type of process, the viewer could seize and retain the cultural particularities of each geographical region. Memory functioned through the mechanism of association of ideas; which is to say that, instead of learning from lists of the enumeration and juxtaposition of objects which are *analogous* from a formal point of view, the life groups, with their *spatial anchorage*, facilitated the development of an *associative* memory. This may be one of the reasons for the

success, and the ensuing predominance, of the life group over typological classification in the great majority of European and North American ethnographic museums by the end of the nineteenth century.

Moreover, whilst the typological arrays allowed the viewer to recognize what he or she already knew before (in this case, linear evolution), life groups, on the other hand, facilitated the viewer's process of cognition, and enabled the viewer to establish his or her own correlations. In a certain way in the life group, the viewer was invited to occupy the anthropologist's place, in order to see what he or she had seen in the field. One can also find certain similarities between this and another process of presentation of anthropological knowledge – the monograph. The monograph uses a certain rhetorical process (namely the use of the present tense) in order to lead the reader into the visualized scene. In the life group, we have a particular effort to position the viewer in a specific fixed vantage point, from which he or she could have a synoptic view. This process for creating a successful illusion was developed in an acute way by Boas:

> In order to set off such a group to advantage it must be seen from one side only, the view must be through a kind of frame which shuts out the line where the scene ends, the visitor must be in a comparatively dark place where there must be a certain light on the objects and on the background.
>
> (Quoted in Jacknis 1985: 102)

It is interesting to note that for Boas, 'the only place [from which] such an effect can be had is in a Panorama Building', in other words in a place where the viewer, occupying the central point, can see without being seen.

The geographical arrangement of objects became a pedagogical principle through its ability to impress images – 'scenes' – on the memory without requiring on the part of the visitor any special training. This kind of display rendered needless the work of internalizing principles of classification and replaced them with mannequins, reconstructions of interiors, or village models, at which one could look. This presupposed the conviction of an unmediated vision, free of human intervention. The 'realistic' effect of the life group implied not a disincarnated eye but a certain degree of participation by visitors. The latter were invited to 'see' the mode of life of Breton peasants or of the New Caledonians as these were exposed in the Musée d'Ethnographie du Trocadéro.

Paradoxically, the life group, in trying to re-create the original setting of the object, gave to visitors the impression of being transported. As Boas had recognized, the aim was to 'transport the visitor into foreign surroundings. He is to see the whole village and the way people live' (quoted in Jacknis 1985: 101). Once more, the influence of the natural history mode of display – namely the *habitat group* – was decisive in anthropological practice. Realism became the dominant mode of representation in

anthropology, while the life group, with its lifelike quality, contributed to the dissolution of the borders between reality and its representation. The illusion of a close fit between the real thing and the representation created by the realistic mode of display had a considerable mnemonic effect in the visitor's mind. Realism, following Donna Haraway, 'was a supreme achievement of the art of memory, a rhetorical achievement crucial to the foundations of western science' (Haraway 1984: 36). Life group, habitat group and dioramas aimed to give to the museum's visitors the impression of travelling. However, as Boas had clearly admitted, the attempt to transport the visitor and give a sense of envelopment had failed, because the 'cases, the walls, the contents of other cages, the columns, the stairways all remind us that we are *not* viewing an actual village'. That was the reason why the author of *Race, Language and Culture* advocated the necessity of 'drawing the line [the line separating nature and plastic art] consciously rather than trying to hide it' (quoted in Jacknis 1985: 102). For Boas, the use of certain procedures – such as figures at rest and not in motion, hair painted or modelled rather than real hair, approximation of skin texture and colour – would allow the visitor to acknowledge the labour of representation created by museum displays.

CACOPHONY IN EXHIBITS

The two ways of seeing that have been developed cannot be considered as two successive and consecutive modes of viewing, but as two complementary 'scopic regimes'. In fact, it is quite controversial to presume that the *coup d'oeil* – with its ability to allow a kind of condensed and synoptic knowledge, by operating as a mental synthesis as well as a visual one (Dias 1993) – deserves a higher position than the *regard*. Both ways of seeing attempt to depict external reality in an accurate way. Beyond their intrinsic specificities, both presuppose that Culture can be materialized through tangible things, and so be exposed.

By collecting artefacts in order to testify to the experience of encountering the Other, anthropology contributes to the validation of the conviction that culture can be characterized by certain kinds of objects. In fact, the geographical array – still predominant in most ethnographic museums in Europe and North America today – tends to identify cultures with the type of manufactured artefacts they produce. As Anthony Shelton has recently noted, the monographic type of exhibition specific to the geographical display ascribes a special activity to a distinct people. In this manner, the Yoruba are represented 'by sculpture, the Hausa by domestic clothing, South and East Africa by weapons and shields' (Shelton 1992: 14). Hence arises the possibility to 'see' a culture as something singular, static, embedded in traditions and, at the same time, picturable.

However, recent exhibitions have shifted away from this kind of display

towards a cross-cultural mode of presentation. This shift has to do with the critique of the visual paradigm in anthropology and what has been called a crisis in representation. The emphasis placed on verbal metaphor – on a 'discursive rather than a visual paradigm' (Clifford and Marcus 1986: 12) – implies 'dialogism and polyphony' as modes of textual production (Clifford and Marcus 1986; Tyler 1987). To study the Other's culture in a dialogic mode requires the questioning of some traditional anthropological processes such as observation and description. Moreover, the inclusion within anthropological practice of the sense of hearing leads to a radical shift in the way external reality has been considered; this presupposes accounting the world not as static and atemporal, but as dynamic, given that 'the sense of hearing is related to event and not to existence, to becoming and not to being' (Jonas 1954: 509).

On the museological level, the critique of the visual paradigm was expressed through the incorporation of other sensorial modes, namely sound. Moreover, it is perhaps with Jacques Hainard and the Musée d'Ethnographie (Neuchâtel) that the preoccupation with the process of raising questions and creating a dialogue has been developed to a considerable extent. By placing side by side several objects belonging to different times and geographical spaces, the main purpose of the exhibitions in Neuchâtel is to contaminate the meaning of the objects and bring about dialogue between them. As Hainard has noted, 'to contaminate the meaning of the objects' is not without consequence; the risk of creating a 'kind of cacophony' is explicit (*Temps perdu, temps retrouvé* 1985: 163). In this sense, 'dialogue' and 'cacophony' are not merely verbal metaphors, they really operate on the level of museological practices. It is nevertheless worth noting that the dialogue created between objects was made possible by that which constitutes the specificity of the museum: its capacity to create a visual effect.

ACKNOWLEDGEMENTS

I would like to thank José Antonio Fernandes Dias and Brian O'Neill for their comments on some of the issues discussed in this paper and Claire Pajaczkowska for having translated it from the original French.

REFERENCES

Bann, Stephen (1988) ' "Views of the past" – reflections on the treatment of historical objects and museums of history (1750–1850)', in Fyfe, Gordon and Law, John (eds) *Picturing Power: Visual Depiction and Social Relations*, London: Routledge, pp. 39–64.
Berger, John (1972) *Ways of Seeing*, Harmondsworth: Penguin Books.
Brown, Lee Rust (1992) 'The Emerson Museum', *Representations* 40, pp. 57–80.
Chapman, William Ryan (1985) 'Arranging Ethnology: A.H.L.F. Pitt Rivers and

the typological tradition', in Stocking, George W. Jr (ed.) *Objects and Others. Essays on Museums and Material Culture*, vol. 3, Madison: University of Wisconsin Press, pp. 15–48.

Clifford, James and Marcus, George (eds) (1986) *Writing Culture: The Poetics and the Politics of Ethnography*, Berkeley: University of California Press.

Clifford, James (1988) *The Predicament of Culture. Twentieth Century Ethnography, Literature and Art*, Cambridge, Mass.: Harvard University Press.

Dias, Nélia (1991) *Le Musée d'Ethnographie du Trocadéro (1878–1908). Anthropologie et Muséologie en France*, Paris: Editions du C.N.R.S.

—— (1993) 'Regarder ou observer les "primitifs"?', in *Romantisme* (in press).

Fabian, Johannes (1983) *Time and the Other: How Anthropology Makes Its Object*, New York: Columbia University Press.

Foster, Hal (ed.) (1988) *Vision and Visuality*, Seattle: Bay View Press.

Foucault, Michel (1963) *La Naissance de la Clinique*, Paris: P.U.F.

Goody, Jack (1977) *The Domestication of the Savage Mind*, Cambridge: Cambridge University Press.

Haraway, Donna (1984) 'Teddy bear patriarchy: taxidermy in the Garden of Eden. New York City, 1908–1936', *Social Text* 11 (Winter 1984–5), pp. 19–64.

Jacknis, Ira (1985) 'Franz Boas and the exhibits: on the limitations of the museum method of anthropology', in Stocking, George W. Jr. (ed.) *Objects and Others. Essays on Museums and Material Culture*, Madison: University of Wisconsin Press, pp. 75–111.

Jay, Martin (1988) 'Scopic regimes of modernity' in Foster, Hal (ed.) *Vision and Visuality*, Seattle: Bay View Press, pp. 3–23.

Jonas, Hans (1954) 'The nobility of sight', *Philosophy and Phenomenology Research* 14, pp. 507–19.

Jordanova, Ludmilla (1989) 'Objects of knowledge: a historical perspective on museums', in Vergo, Peter (ed.) *The New Museology*, London: Reaktion Books, pp. 22–40.

Karp, Ivan and Lavine, Steven, D. (eds) (1991) *Exhibiting Cultures. The Poetics and Politics of Museum Display*, Washington, DC: Smithsonian Institution Press.

Latour, Bruno (1986) 'Visualisation and cognition: thinking with eyes and hands', *Knowledge and Society* 6, pp. 1–40.

Mitchell, Timothy (1989) 'The world as exhibition', *Comparative Studies in Society and History* 31, pp. 217–36.

Ong, Walter J. (1967) *The Presence of the Word*, New Haven, Conn.: Yale University Press.

—— (1969) 'World as view and world as event', *American Anthropologist* 71, pp. 634–47.

Pitt Rivers, Augustus Henry Lane Fox (1874) 'On the principles of classification adopted in the arrangement of his anthropological collection, now exhibited in the Bethnal Green Museum', *Journal of the Royal Anthropological Institute* 6, pp. 293–308.

—— (1891) 'Typological museums, as exemplified by the Pitt Rivers Museum at Oxford, and his provincial museum at Farnham, Dorset', *Journal of the Society of Arts* 40, pp. 115–21.

Shelton, Anthony (1992) 'The recontextualisation of culture', *Anthropology Today* 8, pp. 11–16.

Stocking, George W. (ed.) (1985) *Objects and Others. Essays on Museums and Material Culture*, Madison: University of Wisconsin Press.

Tyler, Stephen A. (1987) *The Unspeakable. Discourse, Dialogue and Rhetoric in*

the Postmodern World, Madison: University of Wisconsin Press.

Tylor, Edward Burnett (1871) *Primitive Culture: Researches into the Development of Mythology, Philosophy, Religion, Art, and Custom*, London: John Murray.

Van Keuren, David (1989) 'Cabinets and culture: Victorian anthropology and the museum context', *Journal of the History of the Behavioral Sciences* 25, pp. 26–39.

Yates, Frances (1966) *The Art of Memory*, Chicago: University of Chicago Press.

Chapter 11

The distance between two points: global culture and the liberal dilemma

Annie E. Coombes

Some years ago I was a participant at an event ostensibly set up to interrogate the relation between anthropological fieldwork and museology, organized by the CNRS in Paris. I remember it as a productive international gathering between curators and anthropologists from locations as geographically distant as Mexico and Iran. Most of the speakers professed an interest in critically reassessing some of the more challenging aspects of anthropological practice and the process of translating the multiple dialogues of the fieldwork encounter, the 'travellers' tales', into a multi-layered experience in the metropolitan museum. One speaker more than any other unwittingly dramatized for me the difficulties and complexities of this principled position and the curatorial strategies that mark its translation into a museological language.

The speaker presented his paper as a contribution to the debate on the old problem of anthropologists' and ethnographic curators' constant reproduction of a mythic 'ethnographic present', their reluctance to exhibit the hybrid results of contact with Western capitalism and their insistence in their fieldwork on prioritizing culturally 'pure' artefacts. He went on to argue for the inclusion of certain kinds of objects. One of these was a plastic laundry basket commonly found in most laundromats, which had been ingeniously transformed by an Indonesian peasant, along the lines of a traditional model, into a child's rocking cradle. The 'exhibit' illicited raucous laughter from the assembled company.

It was a laughter that made me uncomfortable and alerted me to some of the ambiguities raised by the exhibiting of transculturated objects, even where this strategy was clearly intended to unmask the myths of authenticity and origin that so often accompany exhibitions of material culture from beyond the metropolitan centres of the West. The instance dramatized for me the moment of encounter between unequal players on the global stage, where some are credited with the knowing incorporation of cultural difference and the ability to transform this encounter into a new idiom, and others unwittingly provide a spectacle of picturesque invention for the Western onlooker, borne out of the necessity of daily existence.

This, of course, is to present the problem as a clear-cut contest between two opposing constituencies and to risk silencing the productive interruptions of the West's complacent assurance of the universality of its own cultural values, provided by the many manifestations of creative transculturation by those assigned to the margins. And yet for all the recognition of the ways in which Western culture has been and continues to be enriched by the heterogeneous experience of living in a multi-ethnic society, perhaps we still need to chart some of the distances between our utopian desire to envision the 'cosmopolitan' and the 'postcolonial', and the conditions upon which such a transformation might depend. In particular, if the transculturated or 'hybrid' object, which has become the darling of the Western curatorial establishment, is to stand for the emergence of a 'postcolonial' moment, we might need to investigate that residual laughter of the Western spectator.

A number of curators whose brief is, in one way or another, to produce some kind of dialogue between what they mainly perceive as the West and the 'Rest', have clearly felt under pressure to respond to the criticism of Eurocentric chauvinism levelled at William Rubin's blockbuster show, *Primitivism in the Twentieth Century* at the Museum of Modern Art in New York in 1984. Both *Lost Magic Kingdoms and Six Paper Moons from Náuatl*, staged at the Museum of Mankind in 1986, and the by now infamous *Les Magiciens de la Terre*, at the Beaubourg and La Villette in Paris in 1989 (to take examples from both the ethnographic and the fine art establishment), adopted a particular curatorial strategy to dispel the kinds of antagonism attracted by Rubin's exhibition.

As a means of disrupting the familiar discourse of timeless anonymity and originary unity, so often reinstated in many ethnographic collections where little is done to transcend the legacy of their colonial foundations, the artist Eduardo Paolozzi was given free rein to make a selection from the collection at the Museum of Mankind and to juxtapose these with his own work and items from his scrapbooks. Apparently no longer confined to the usual preoccupation with formal affinities which we are still so familiar with as the primary narrative of the history of 'encounter' of Western modernism, Paolozzi chose to foreground a different kind of meeting. The sign of this transformed union was to be the transculturated object, the hybrid which borrowed and reinvented the detritus of global capital – Paolozzi's equivalent to the laundry basket of my earlier anecdote. There are, of course, several other details here which obviously have a bearing on the possible dialogue opened up – and closed down – through such a strategy in this context, not least the fact that Paolozzi is intimately associated with the British pop art generation of the 1960s, with its nostalgic fetishization and exoticizing of North American popular culture of the 1950s.

Les Magiciens de la Terre, similarly concerned to challenge the received

history of the one-way street of modernist encounters with cultural differ-
ence, highlighted another kind of transculturated object, which was
designed to turn the cul-de-sac into a thriving highway. No longer the
prerogative of Western modernism, all cultures were acknowledged as
participating in wholesale formal and spiritual borrowings – a mutually
enriching exchange between equal partners in the culture industry. There
is no doubt that such encounters were and are possible, and that on
another level, whatever the weaknesses of the curatorial agenda, various,
though not all, of the participants have been both financially and artistic-
ally remunerated as it were, by exposure in a fine art institution with the
international stature of the Beaubourg. Although, as Willis and Fry have
pointed out in the Australian context, in relation to the current celebration
and global marketing of Aboriginal art, such acclaim is by no means
unproblematically favourable to the artist/s in question.[1]

It may be difficult to escape the accusation of easy moralism when
expressing ambivalence about what some of us might consider to be the
pre-emptive optimism of celebrating the present traces of hybridity in
cultural products, as the cosmopolitan embodiment of the 'postcolonial'. I
have already discussed elsewhere the complexities of displaying objects
exhibiting the processes of acculturation as a strategy to mark a new
'postcolonial' present in which it might be possible to argue for a mutually
enriching exchange between the Western metropolis and those cultures
assigned (by the West) to the margins.[2] I feel, however, that further
observations may not be completely redundant in view of the evident
controversy that such a position continues to generate. In a recent issue of
Social Text, other commentators have eloquently analysed the worrying
social and political ramifications of such a term in the context of its
ascendancy in the academy – in both educational and cultural institutions –
and in relation to the process of denial and disavowal that it can be said to
mask.[3]

I want to suggest that in the cultural arena, the focus on the implied
formal or spiritual affinities, and the apparently mutually productive
exchanges that are made to reside in the sign of the transculturated object,
are part of a similarly problematic disavowal. If we accept that such an
object has a symbolic value as a kind of transaction or negotiation between
the centre and periphery, it also serves another function by comfortably
displacing the discomforting traces of the social and political transactions
and negotiations for which the transculturated object has always been a
repository. These are the 'exchanges', though rarely acknowledged, which
have always been present in colonial society from the beginning. We may,
for example, be familiar with the discourse on degeneracy as part of the
European colonizer's systematic discrediting of certain West African or
Middle Eastern civilizations.[4] But rarely is the strategic and selective re-
invention of the colonial tirade acknowledged, as it was transformed into

an anti-imperialist discourse by the same West Africans it was used against.[5]

Similarly, how many of us who saw either *Les Magiciens de la Terre* or one of the more recent Saatchi Collection exhibitions of contemporary art from 'Africa', would have guessed at the way the practice of Ndebele house painting, represented in both exhibitions by Esther Mahlangu, was the creative response to forced migration and displacement? Or that the 'hybridity' of her walls lies not only in the razor blades which are so often indicated as the formal starting point for some of her designs, but in the historical precedent which 'borrowed' a cultural form that effectively and visibly proclaimed the evidence of community – displaced but surviving – despite the colonial government's enforced dispersal of Ndebele over the Transvaal in the nineteenth century?[6] I wonder, with all this talk of the fracture and disruption of the Western 'centre' through the incursion of rai and other cultural forms into the core of the Western metropolis, which is the more disquieting migration summoned up by the walls of Mahlangu's 'houses'? And why is the history of one so loudly announced and the trace of the other so hushed?

As other commentators have observed, culture may provide a confrontation and collision but immigration has already done this.[7] Moreover, as Kevin Robins has suggested, the cultural infiltration of the Western metropolitan centre has as much to do with the processes of globalization which ambiguously, and ironically, rather than closing down the variety of ethnic forms, precipitates their expansion on a world scale, while simultaneously seeking selectively to minimize 'local' and 'domestic' distinctions in the interests of efficiency.[8] On the other hand, 'globalization entails a corporate presence in, and understanding of, the "local" arena.'[9] Saatchi and Saatchi's famous maxim, that there are more social differences between midtown Manhattan and the Bronx than there are between Manhattan and the 7th arrondissement in Paris, could well be a clue to understanding not only the effectiveness of global marketing, but the exclusion of another kind of hybridity from those exhibitions so intent on proclaiming the decentring effects of the 'encounters' in their galleries. In the British context, Corner and Harvey in an analysis of the economic and political conditions that gave rise to the 'enterprise' culture of the Thatcher era, chart the shifts in Tory rhetoric on 'community' and the implications for the second generation of 1950s immigrants.[10] From the sinister echoes of Enoch Powell's infamous 1968 speech expressed ten years later in Margaret Thatcher's publicly voiced anxieties that 'this country might be rather swamped by people with a different culture', Corner and Harvey cite the (selective) assimilationist rhetoric of the 1987 Conservative Election Manifesto: 'Immigrant communities have already shown that it is possible to play an active and influential role in the mainstream of British life without losing one's distinctive cultural traditions.'[11] They continue:

in rejecting older forms of deference and older hierarchies of taste and status, the modernizing impulse of the New Right instates the market, itself colour-blind, as the key location for identity formation For the new popularizers of capitalism . . . independence, status, and even identity are a function of the cash nexus, of the ability to spend.[12]

In this context, the continuing coincidence in the Tory rhetoric of the 1990s, of enterprise as a means of achieving a 'classless society', should perhaps alert us to the relation between the concept of 'global culture', capital and class. It is of course precisely this relationship which underpins Saatchi and Saatchi's maxim.[13]

Consequently, it is significant that for many 'World Art' exhibitions, the exchange or encounter represented is not between 'local' and 'domestic' ethnicities, the signs of the migrant collisions that are the metropolitan centre's primary constituency. Neither is hybridity seen as a symptom of diasporic formations, which it effectively marginalizes. Instead, it is firmly produced as 'postcolonial'. As a strategy, therefore, it might well signal the possibilities of imagining a new 'cosmopolitanism', but it certainly contributes little to what Stuart Hall has identified as 'the slow contradictory movement from "nationalism" to "ethnicity" [which] is also part of the "decline of the West" – that immense process of historical relativization which is just beginning to make the British, at least, feel just marginally "marginal".'[14]

In *Les Magiciens de la Terre*, for example, not only was the North African diaspora, the inhabitants of the Beaubourg's neighbouring arrondissement, not represented in the global spectacle, neither was the younger generation of black and Asian artists living in Britain and North America, whose work explicitly addresses the issue of hybridity. Of course the hybridity that engages these artists is more than simply a meeting of cultures. It is often a collision which speaks as much of resistance and anger (sometimes with humour and irony), as it may also simply retell the day-to-day experience of living in a multi-ethnic environment. Frequently their work addresses the political implications of an identity forged from converging and conflictual colonial histories. Not easily transformed through the nostalgia and romance of geographical remoteness, these works are about proximity. Discomfortingly close, they reproach history for the distance it is so often made to represent and they force it into the present.

The concept of cultural hybridity is central to an understanding of the work of all these practitioners. Sonia Boyce's earlier work of 1986, *She Ain't Holding Them Up, She's Holding On (Some English Rose)* (see Figure 11.1), and *Lay Back, Keep Quiet and Think of What Made Britain so Great*, makes clear the complexity of this generation's engagement with such a concept. Boyce uses titles and text as a play on language and the way in which idiomatic phrases become part of an internalized identity coding,

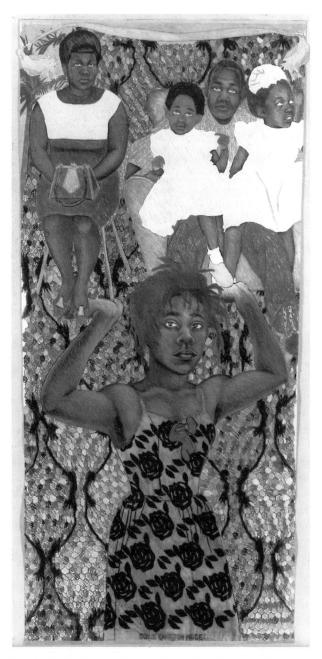

Figure 11.1 Sonia Boyce, *She Ain't Holding Them Up, She's Holding On (Some English Rose)*, 1986 (pastel, conte and crayon). Cleveland County Fine Art Collection, Cleveland Gallery, Middlesbrough.

Figure 11.2 Hélène Hourmat, *Le Goût salé des lèvres, ou le détroit de Gibraltar*, 1989 (five panels, photograph, pastel, gouache, 158 × 246 cm). The Jewish Museum, New York.

especially where they relate to quintessential notions of 'Englishness' ('English rose'). Simultaneously, the same phrases, made potent through their historical association with the era of imperial expansion in Victorian Britain ('Lay Back [and Think of England]' and 'Missionary Position') are inverted to unmask the double violence of imperialism, slavery and sexual exploitation. There is a knowing irony in deploying a lexicon that recalls the hypocrisy of middle-class Victorian Britain while also signalling the ambiguous position of white woman in that society and at the same time using that very ambiguity to suggest their complicity in the imperial endeavour. At the same time, we are not permitted to remain in the ether of Victorian Britain. Lulled by the pleasure of her decorative surfaces, the constant autobiographical references nevertheless confront us with the present. These then are also images about passage, migration and generation. They are about an 'encounter' in process.

Similarly, the work of the Paris-based artist Hélène Hourmat disrupts the implicit and stable chronology of 'home' and 'displacement', the trajectory of the Jewish diaspora in Morocco, found in the pages of her family album. *Le Goût salé des lèvres ou le détroit de Gibraltar* of 1989, juxtaposes photographs of her grandparents in a securely located 'orientalist' interior

Figure 11.3 Hélène Hourmat, *Viridiane*, 1988 (eight panels, photograph, crayon).

on the one hand, with an image of departure iconically represented through a photograph taken from the stern of a passenger vessel on the other, the temporal disjuncture reinforced through the larger portrait of her mother devoid of orientalizing accoutrements, gazing into the distance marked by the foaming wake (Figure 11.2). In *Viridiane* of 1988 (Figure 11.3), references to early photographic processes through Hourmat's painstaking hand-crafted recreation of gum bi-chromide prints, signal both the act of representation and the temporality of this moment. The hazy green portraits of her great-uncles and aunt simultaneously suggest dissolution and becoming. These, together with the grainy texture of scratched and seemingly snatched snapshot segments and enlarged photographic details, combine to produce a montage that metonymically recalls the processes of memory through the passage of time. But it is a historicized passage which disrupts the seductive nostalgia of the generalized and mythic timelessness of Europe's colonial 'Orient'. The signs of this 'Orient' are confounded for the European viewer by the presence of an unambiguously announced bourgeois identity shared by both her younger aunt, whose upper body is reproduced in evening dress, and the portraits of her great-uncles, even while they are located in disturbingly different time

frames by the historicizing gesture of the photographic technique. There is no clear passage from the past to the present here, each informs and produces the other.

In addition, the European gaze is neither invited nor necessary to the recognition of the inescapable exoticizing of the Moroccan woman. This montage may well be concerned with the eroticizing gaze but it is a dialogue between participants in an internal drama from which 'we' are excluded. It is a surface that defiantly plays back the logical possibilities of the assimilationist rhetoric historically associated with the French colonial project. These images, then, are not just about the possible mobility of cultures. Like Boyce's work, they can also be read as commentaries on the potential mobility of class. That the primary protagonists of this transformation in the work of both these artists are women, is significant. It is the coincidence of these three critical components which so effectively destabilizes the easy allocation of fixed identities.

Such critical categories have been the subject more recently of the Black Audio Film Collective's television documentary, *A Touch of the Tar Brush* (1991), written and directed by John Akomfrah and produced by Lina Gopauls. Taking as its historical reference point J.B. Priestley's visit to Liverpool in 1933, the film explores the history of exclusion, becoming and belonging that marks the trajectory of the West African and Caribbean migration and settlement in a thriving metropolitan centre scarred by the history of slavery and the commerce which it generated. We are introduced to John and Patsy Birch and their children who, through their resilience and their very existence, in Akomfrah's words, 'make a nonsense of those opponents who think Englishness is an exclusively white affair'. The Birches, others like them, and the generations that follow such 'mixed' marriages, are the living proof of the disintegration of what Akomfrah calls 'the apartheid of cultures'. They are part of the new community that effectively challenges the myth of racial purity which has so tenaciously accompanied definitions of 'Englishness'. Optimistic and hopeful, it is none the less a film that seeks to unpack the complexity of the 'hybridity' of families like the Birches. While recognizing this as an instance of the coming together of people from different cultural backgrounds to create a new community, Akomfrah indicates the historical and, importantly, continuing struggles, which led to the creation (often out of necessity) of new cultural and political institutions in Liverpool to serve the emergent community who 'dared to disprove [Powell's and we might add, Thatcher's and Major's] nightmare scenario'.[15]

It is the complicated and difficult process of 'getting there' – not the inevitability of 'arrival' – which characterizes the work I have discussed here. And it is the invoking of histories as markers of the present as much as memories of the past, which renders these examples powerful statements of the possibilities of becoming and belonging.

NOTES

1 Anne-Marie Willis and Tony Fry, 'Art as ethnocide: the case of Australia', *Third Text*, Winter 1988–9, pp. 3–21.

2 Annie E. Coombes, 'Inventing the "post-colonial": hybridity and constituency in contemporary curating', *New Formations*, Winter 1992, pp. 39–52.

3 See Anne McClintock, 'The Angel of Progress: pitfalls of the term "post-colonial"', *Social Text* 31/32, pp. 84–98; Ella Shohat, 'Notes on the "post-colonial"', *Social Text* 31/32, pp. 99–113. This is not to say that the term 'postcolonial' has not been appropriated for more productive ends. See in particular, Gayatri Chakravorty Spivak, 'Poststructuralism, marginality, post-coloniality and value' in Peter Collier and Helga Geyer-Ryan (eds), *Literary Theory Today*, Cambridge, Polity, 1990.

4 Edward Said, *Orientalism*, London, Routledge, 1978; Linda Nochlin, 'The imaginary Orient', *Art in America*, May 1983, pp. 119–31, 186–91; Lisa Lowe, *Critical Terrains, French and British Orientalisms*, Ithaca, Cornell University Press, 1991.

5 See Annie E. Coombes, *Re-Inventing Africa: Museums, Material Culture and Popular Imagination in Late Victorian and Edwardian England*, New Haven, Conn., Yale University Press, 1994. Chapter 2 deals with West African nationalist reformulations of the discourse of degeneracy in relation to nineteenth-century debates concerning colonial society and material culture from Benin City, Nigeria.

6 My thanks to Pitika Ntuli for discussions on the history of Ndebele house decoration.

7 Kevin Robins, 'Tradition and translation: national culture in its global context', in John Corner and Sylvia Harvey (eds), *Enterprise and Heritage: Crosscurrents of National Culture*, London, Routledge, 1991, pp. 21–44. On the question of globalism and culture, see 'The global issue: a symposium', *Art and America*, July 1989 and A. Appadurai, 'Disjunction and difference in the global cultural economy', *Theory, Culture and Society* 7 (2–3), 1990.

8 Robins, op. cit.

9 Ibid., p. 35.

10 Corner and Harvey, op. cit., Introduction, p. 11.

11 Ibid.

12 Ibid.

13 See Cornel West, 'Postmodern culture', in West, *Beyond Eurocentrism and Multiculturalism, Volume Two, Prophetic Reflections: Notes on Race and Power in America*, Monroe, Common Courage Press, 1993, pp. 37–43, where he discusses some of the difficulties of a voluntarist pluralism in the American context. 'Despite the hoopla about group consciousness and role models, *class* structures – across racial and gender lines – are reinforced and legitimated, not broken down or loosened by inclusion. And this indeed is the American way – to promote and encourage the myth of classlessness, especially among those guilt-ridden about their upward social mobility or ashamed of their class origins. The relative absence of substantive reflections – not just ritualistic gestures – about class in postmodern culture is continuous with silences and blindnesses in the American past' (ibid.: p. 42).

14 Stuart Hall, 'Minimal selves', *Identity*, ICA Documents no. 6, 1987, pp. 44–6.

15 John Akomfrah, *A Touch of the Tar Brush*, 1991. Distribution through Black Audio Film Collective, 7–12 Greenland Street, London NW1 0ND.

Chapter 12

The cosmopolitan ideal in the arts

Peter Wollen

I first began thinking about this essay, and about the meaning of 'cosmopolitanism', after seeing the show *Magiciens de la Terre* in Paris in 1989, an attempt, as I saw it, not simply to 'globalize' art, but also to denationalize it on a global scale at a time in which nationalist revivalism was burgeoning throughout the world, a development exacerbated still further since 1989. In the context of the bicentennial of the French Revolution, it reminded me, not of the nationalism which increasingly gave energy to the Revolution and finally transmuted into Bonapartism, but of the cosmopolitanism of Anacharsis Cloots, who in 1790 assembled an embassy of thirty-six assorted foreigners, as many as he could find in Paris to represent the 'oppressed nations of the universe', to pay their respects at the bar of the National Assembly, to congratulate it on 'restoring primitive equality among men', and to call for the overthrow of tyranny around the world, wherever peoples were 'sighing for liberty'.[1] Each wore his national costume – German, Dutch, Swiss . . . Indian, Turkish, Persian, encircled by the tricolour sash. Cloots was active in establishing the cult of universal reason, with its concomitants liberty and equality, and was the author of a heated tract on *The Universal Republic*. By 1793, he was already coming under attack for his 'Prussian' birth, despite the fact that, now nearing 40, he had lived in Paris since the age of 21 and had even been made an honorary citizen, along with Tom Paine and other 'citizens of the world'. In March 1794 he was arrested and thrown into jail (just three months after Paine). He was charged with involvement in 'a foreign plot' and subsequently guillotined. National identity had caught up with him at last.

Anacharsis Cloots was not totally forgotten. Above all, he was remembered by Herman Melville, who, in Chapter 26 of *Moby Dick*, described the motley crew of the *Pequod* as follows:

> Yet now, federated along one keel, what a set these Isolatos were! An Anacharsis Cloots deputation from all the isles of the sea, and all the ends of the earth, accompanying Old Ahab in the *Pequod* to lay the

world's grievances before that bar from which not very many of them ever came back.

This was the passage that, just over a century later, attracted the attention of C.L.R. James, who had long left his native Trinidad and was now living in the United States, writing his book on Melville, *Mariners, Renegades and Castaways*. James glossed Melville's text as follows:

Melville seems to have been fascinated by Cloots, to judge by the references in his work. But whereas Cloots thought of uniting all men in a Universal Republic, based on liberty, equality, brotherhood, human rights, etc., Melville in 1851 had not the faintest trace of these windy abstractions from the beginning of *Moby Dick* to the end. His candidates for the Universal Republic are bound together by the fact that they work together on a whaling ship. They are a world-federation of modern industrial workers. They owe allegiance to no nationality . . . They owe no allegiance to anybody or anything except the work they have to do and the relations with one another on which that work depends. And we may add that they are not to be confused with any labor movement or what is today known as the international solidarity of labor.[2]

For James, the mariners, renegades and castaways – the Anacharsis Cloots deputation – provide an allegory of the sense of community brought about by co-operative work: the creativity and honesty and wit needed to carry out and cope with a difficult task; the lack of allegiance to any authority, which stems from a sense of their own joint talents and capacities. For James, this allegory is the one that best holds out hope for the world.

For many years there has been an increasing discursive concern with 'identity' as a theoretical, cultural, personal and political issue. Yet the 'identity' of Queequeg as Pacific Islander ('native of Kokovoko'), or Tashtego as Native American, or Daggoo as African, or the rest of the crew as Tahitian or Manxman or Azorean, was not what mattered to Cloots or to Melville or to James, although Melville and James did each take pains to point out that the officer class on board the *Pequod* (and its owners) were all Americans, indeed native New Englanders. National or ethnic identity was less important to Melville than identity as a mariner, a wanderer, a people whose home was on board ship or, briefly on land, in some waterfront inn. This identity as a sailor or a traveller, as a marine nomad, was what bound these people together, rather than their national or ethnic or even cultural identity (though the *Pequod* was, of course, an all-male society). It almost seems as if, for Melville, it was on the sea or on the water that old identities forged on the land were abandoned or lost. Even on the Mississippi river-boat in *The Confidence Man* there is an 'Anacharsis Cloots Congress', which like the great river itself, united 'the

streams of the most distant and opposite zones' and poured them along, 'helter-skelter, in one cosmopolitan and confident tide'. It seems to me that cosmopolitanism should be one of the players in this discursive game, the attribution or disattribution of identity, the building or destroying of confidence – and one which is directly relevant to art and to art history.

The question of identity has been approached principally in terms of origins, as something that is given, as something native, as something inherent in place or ancestry, territorially or genetically, or else indirectly, through tradition or assignment. In this view, identity, if not plainly given, is, at best, discovered or acknowledged. Set against this approach is one that sees identity as more problematic – in the context of travel or mobility, for instance, identity has been viewed as the expression of a trajectory, as accumulated through space and over time. It can be seen as displaced, diasporic, nomadic, multiple or hybrid. But this approach too is one that locates identity in a historically given experience – this time, the given of social and/or geographic mobility or mixing. However, even diaspora can be accommodated to essentialist views through the concept of exile and a subsequent sense of loss of origin, leading to the need to recover a homeland or an identity. Roots revivalism is one obvious form of this retracing of origin, but it can take more subtle forms, forms reminiscent of Freud's 'family romance' – the search for an imaginary identity which has its basis in disavowal or denial. Sometimes it seems as if there are two types of identity: one for those who stay at home, and another for those who move around. In this sense, diasporism can seem simply a sophisticated form of the same thing, identity based on becoming rather than being, biographical (or historical) experience rather than the fatality of origin, derived from something more like a curriculum vitae than a birth certificate.

I have no doubt that diaspora theory (and especially theories of the inmixing of otherness, of hybridity, etc.) should be seen as an advance on essentialist theory, but I also feel it can be seen as a halfway house on the road to what I would call cosmopolitanism. Cosmopolitanism accepts only one given – that of being a 'citizen of the world'. It asserts the need neither for nationality, nor for an identity based upon the lived vicissitudes of expatriation, but for what we might call the voluntary assumption of 'dispatriation'. In the twentieth century, of course, 'cosmopolitan' has become a fatally pejorative term, both on the left and on the right. All too often, as indeed for Cloots, it was a sentence of death. Historically, it has been applied principally to three groups. In the eighteenth century, the cosmopolitan ideal arose among scholars, intellectuals and artists, who saw themselves as living in the transnational 'republic of letters'. Cosmopolitanism was bound up with the Enlightenment: it was the ideal of Voltaire, Diderot, Holbach, Kant, Price, Beccaria, Franklin and Paine. Like the Enlightenment, it was centred culturally in France, and evidently

still Eurocentric, but its protagonists reached out towards a utopian world order of perpetual peace, to be based on universal values, on respect and tolerance for others, and on free exchange. Voltaire attempted at least a panorama of the world's cultures, however skewed, while Turgot, Condorcet and Kant undertook projects of writing world histories. Goethe, at the end of the period, insisted on the importance of world literature. This period was effectively finished off ideologically by the rise of Romanticism (as Herder replaced Lessing), and politically by the nationalist turn taken by the French Revolution, which paradoxically spread nationalism throughout Europe along with the Enlightenment. Paine and Cloots, as we have seen, were victims who paid in Paris for the cosmopolitanism they learned there.

In the nineteenth century, cosmopolitanism mutated, persisting, if at all, not so much among intellectuals in the capital cities of Europe, as among merchants in ports and trading cities around the world. Merchants, often imbued with Enlightenment ideas about 'sweet commerce' as opposed to 'bitter warfare', chameleonically adopted the manners of whatever country they found themselves ashore. J.R. Jones has traced the rise and fall of this 'cosmopolitan bourgeoisie' in his book *International Business in the Nineteenth Century*.[3] During the early part of the century, cities such as Bombay, Buenos Aires, Hong Kong or Manchester (witness Engels and Freud's half-brothers) had local bourgeoisies with a markedly cosmopolitan background. Jardine of Jardine Matheson, for instance, began in Bombay acting as an agent successively for two Parsee merchants trading with Hong Kong (Franjee Cowasjee and Jamsitjee Jeejeebhoy), and Matheson worked for a Spanish firm in Canton. The Hong Kong and Shanghai Bank (now owners of the Midland Bank) began with Parsee and Asian Jewish capital as well as British, American and German. While it would be wrong to exaggerate this trend, there was a significant (and often radical) cosmopolitan culture in merchant milieux and especially in port cities. It survives still in the *porteño* culture of Buenos Aires. As Jones describes, this culture was mainly destroyed by increasing concentration of management in the second part of the nineteenth century, when London, for instance, began to exert direct control over the periphery, rather than dealing through local (and cosmopolitan) intermediaries. Indeed, these were now liable to be seen simply as creatures of foreign masters, if they did not 'nationalize' themselves. At the same time, of course, economic nationalism became dominant in the core economies of Europe and North America themselves, following the ascendancy of finance capital and the growth of the modern interventionist and expansionist nation state, classically described by Lenin.

In the reactionary twentieth century, cosmopolitanism became defined by triumphant nationalists and used as a slur primarily against minority immigrant and diaspora groups, especially those without a homeland, who

were perceived as deracinated and dispatriated. Jews, of course, were the prime targets, but also gypsies and homosexuals (seen as dead ends in the national gene pool) and, by metaphorical and metonymic extension, bohemians in general. The unprecedented nationalism that arose in nationalist Germany and Russia led to ever-more-savage attacks on 'rootless cosmopolitans', to use Stalin's phrase, culminating in the Nazi Holocaust and the Soviet anti-semitic campaign, which was only brought to a close by Stalin's providential death. In fact, in our century, every effort has been made to eliminate cosmopolitanism once and for all. Even the most militant opposition to this trend, which marched under the significantly compromised label of 'internationalist', became subordinate to it. Perhaps Marx, as Isaiah Berlin remarked, was the last of the Enlightenment cosmopolitans, but he also inadvertently set the agenda for the multitude of 'international' agencies and organizations that made sure that the nation state, in concert with others, retained its principal role in the world.

It was during the twentieth century that cosmopolitanism first became a negatively noted feature of the art world. In fact, cosmopolitanism was central to the two crucial periods and places in twentieth-century art: Paris at the time of Cubism, before the 1914–18 war, and New York in the 1940s. Thus Paris during the period of heroic Cubism gathered together artists from all over the world (including Latin America, the Arab world, Japan, etc., as well as the periphery of Europe) in a rich Left Bank subculture, centred around La Ruche, the Rotonde, and the cafés of Montparnasse. The forty-three Jewish artists exhibited in the 1985 show *The Circle of Montparnasse: Jewish Artists in Paris 1905–1945* (held at the Jewish Museum in New York and curated by Kenneth E. Silver and Romy Golan) came from Poland (Kisling), Ukraine (Sonia Delaunay), Lithuania (Lipchitz), Belarus (Chagall), Germany, Russia (Zadkine), Hungary, Italy (Modigliani), Latvia, Austria, Czechoslovakia, Bessarabia, Bulgaria, Sweden and the United States. Only two were born in France – Max Jacob and Isis Kischka, whose parents had emigrated to France two years before his birth. Of course, there were also many other artists of foreign origin in Paris – Picasso, Diego Rivera, Gris, Apollinaire, Mondrian, Man Ray, Larionov and Goncharova, Stuart Davis, Tristan Tzara, Dali, Ernst, Severini, Abdul Wahab, Foujita . . . through to Nina Hamnett!

Not surprisingly, there were endless attempts to sweep back this cosmopolitan tide and substitute for it a truly national French art, as documented, for instance, in Kenneth E. Silver's magisterial study *Esprit du Corps*.[4] During the First World War, France was seen as defending 'Latin culture' against the barbarian hordes, and anything smacking of Germanism (or, by extension, Orientalism) was open to vicious attack. Many painters, such as Picasso himself, turned back to Ingres, to the virtues of Mediterranean Classicism, Cartesian reason and lucidity. Cubism was railed against as 'this stupid painting made by certain

mystifiers who, for the most part, were foreigners to France, but who fooled the world by saying "Made In Paris" ' (Robert Delaunay).[5]

This theme was repeated in a number of different ways: Cocteau's call for 'a French music for France', despite (or because of) the cries of *Boche!* which greeted *Parade*; Corbusier's project of classicizing Cubism under the new title of 'Purism'; or Matisse's remark, made in 1924, that

> I do not consider it desirable in all respects that so many foreign artists come to Paris. The result is frequently that these painters carry a cosmopolitan imprint which many people consider to be French. French painters are not cosmopolites.[6]

In fact, during the 1920s, a deliberate attempt was made to differentiate the *École de Paris* (foreigners) from the *École Française* (native Frenchmen). Louis Vauxcelles, a leading critic of the day, could write about 'a barbarian horde', 'people from "somewhere else" ', in the cafés of Montparnasse, and another prominent critic, Waldemar George, in an essay entitled 'École française ou École de Paris' could talk of the École de Paris (foreigners) as 'a conscious, premeditated conspiracy against the notion of a School of France'.[7] This trend culminated in the horrors of the Second World War: in Paris, under the Nazi occupation; and elsewhere in France, under the puppet Vichy regime. Now it was the artists earlier singled out as authentically French – Derain, Dunoyer de Segonzac, Vlaminck, Friesz – who went on their official tour of Nazi Germany. The others went into exile or to the camps. Even the patriotic 'opposition' exhibited under the banner of 'Tricolour' or 'Blue, White and Red Painting'.

At this time, New York hosted its own exile community of migrant artists, refugees from the war in Europe and the occupation of France – Breton, Mondrian, Léger, Ernst, Miró, Matta, Duchamp and many others. While Picasso himself stayed in Paris, his *Guernica* arrived at the Museum of Modern Art, in its own cultural exile. It was undoubtedly the presence of these artists and their art that made it possible later to launch the New York School, aka American-Style Painting, which was modelled not, of course, on the *École de Paris*, but on the *École Française*, not on the art of foreigners but on that of native Americans. Especially important was the gallery and salon run by Peggy Guggenheim, another (repatriated) refugee. American artists were given new impetus by their contact with these expatriates, many of whom were politically active in New York against their 'own' countries of origin, for cosmopolitan reasons. Indeed, for the Surrealists, this was a point of principle. In the 1920s, the Surrealists had demonstrated repeatedly against xenophobia, with shouts of 'Long live Germany! Bravo China! Up the Riffs!', culminating in Michel Leiris's famous cry from the balcony of 'Down with France!' After his return from New York to Paris, Breton eagerly supported Gary Davis, the

self-declared 'world citizen', who renounced his American citizenship in Paris in 1948 (an incident described in Davis's book *Passport to Freedom* in Chapter 4, 'Identity Lost').[8] Indeed, the Surrealists, as is well known, had a decisive influence on Jackson Pollock, the breakthrough artist of the New York School, who, once a disciple of the nativist and nationalist painter, Thomas Hart Benton, now declared that:

> The idea of an isolated American painting, so popular in this country during the thirties, seems absurd to me, just as the idea of creating a purely American mathematics or physics would seem absurd. . . . The basic problems of contemporary painting are independent of any one country.[9]

In his classic *How New York Stole the Idea of Modern Art*,[10] Serge Guilbaut sees these statements of Pollock as an attempt to validate the American rejection of the 'national' School of Paris and to look for an 'international' alternative. Later, he argues, this 'internationalism' could be used as a front for American 'globalism'. While I certainly agree that there was an ideological and institutional struggle between New York and Paris over the future of the art world, which was indeed won by the Americans and that, as Guilbaut suggests, the discourse of Cold War 'internationalism' was no more than a cover for American hegemony, I still think it is misleading to interpret Pollock's statement in this way. It was actually made in February 1944, although Guilbaut cites it in his final chapter, 'Success: 1948'. At that time Pollock was still very much in the Surrealist milieu. It was Ernst and Matta who had praised his most recent show, at Guggenheim's gallery, while Greenberg had not yet been 'bowled over'. It is wrong to update everything that occurred in the New York art world, particularly at that time, into being an expression of postwar American national hegemony. I think that Guilbaut was mistaken to interpret Pollock's remarks, made under the influence of Surrealist 'cosmopolitanism', as little more than a mask for the American successes of 1948, during the period of the Cold War.

The history of art has generally been written in shorthand as one of nations, periods and styles – Italian Renaissance, Spanish Baroque, German Expressionism, 'American-Style Painting', and so on. In reality, the situation has been much more complex than that. Not only have paintings and artists themselves been constantly on the move, but the development of communications and media has led to increased access to the work of other peoples, even for stay-at-homes. In this century, both Paris and New York were decisively influenced by expatriate artists, even though this influence was later underplayed, denounced, denied or funnelled into a national art discourse. Indeed, in both these cases, I have tried to argue, the effect of substantial expatriate presence in the art world was to encourage a cosmopolitan turn in art, inseparable from the

breakthrough and paradigm shift which occurred in both these cities and which later, due to nationalist pressures, was shut down and 'repatriated' as typically French and American respectively. Moreover, the mobility of many different kinds of peoples, including artists rich and poor, has continued to intensify. We can even begin to speak realistically about the globalization of art and culture, as a result of the intense movement of people, art-works and information around the world, albeit concentrated in a limited network of key cities – a new 'Hanseatic League' as Saskia Sassen has called it, in her crucial book, *The Global City*.[11] These cities – the triad of New York, Tokyo and, precariously, London, now ready perhaps to join a second tier of Los Angeles, Paris, Osaka, Hong Kong, etc. – function as agglomerations of new service industries, as communications centres, and as expatriate magnets, to which immigrant workers cross in reverse the bridges built to their ex-homelands by migrating capital.

In *Billy Budd*, Melville describes a scene in Liverpool, in which, by Prince's Dock, an African sailor rollicks along,

> the center of a company of his shipmates. These were made up of such an assortment of tribes and complexions as would have well-fitted them to be marched up by Anacharsis Cloots before the bar of the first French Assembly as Representatives of the Human Race.[12]

I was struck that this latest of Melville's invocations of cosmopolitanism took place in Liverpool. It reminded me immediately of John Akomfrah's television film, *A Touch of the Tar-Brush*, which portrays the survival of the cosmopolitan and hybrid society of the Liverpool docklands, memorializes its history, and offers it as a utopian glimpse of a future, very different image of Britishness – in effect, a cosmopolitan Britishness. Of course, the port of Liverpool was a centre of nineteenth-century cosmopolitanism, just as areas of London once were, similarly evoked in Reece Auguiste's film *Twilight City*, and just as Buenos Aires was, of whose *porteño* culture, Alicia Dujovne Ortiz could write, 'I have no roots. It's a fact . . . Jews, Genoese, Castilian, Irish, Indians, Blacks all find in me a bizarre and motley meeting place. I am a crowd.'[13] Today, these nineteenth-century port cities have changed and decayed, although in the case of London, at least, they have sought to acquire a new complex atmosphere of post-smokestack or post-Fordist cosmopolitanism. They have sought to become global cities, based on a different kind of communication system – fibre optics and satellite dish rather than steamship or freighter. This cosmopolitanism is one which is still deeply stratified and polarised, socially and spatially, by class and community, with an elite and an underclass, as that of Liverpool was too, with its divide between merchant and mariner.

The art world also is both cosmopolitan and deeply stratified, but perhaps, for all its contradictions, it can begin to bridge this gap, with its

elite museums and galleries at one end of the scale, and its community projects, its street art, its professionals, its intellectuals, its bohemians, its poor at the other. In any event, I think that this micro-globalism is the most positive feature of the arts today. *Magiciens de la Terre*, by juxtaposing Kiefer with Los Linares, Clementi with Twins Seven-Seven, Tony Cragg with John Fundi, offered an image of a new kind of artistic cosmopolitanism, utopian perhaps, and still anchored in the core while trying not to privilege it at the expense of the periphery. It showed, at a minimum, that a great many artists from the periphery were the equals and betters of their more famous and privileged counterparts from the core and that, in artistic terms, the distinction was not always as obvious as it might seem. Certainly, it should have got rid once and for all of the old preconception that art comes from the core and artefacts from the periphery. If Postmodernism means anything at all, if it reflects these substantive changes in the underlying structure of the world economic system rather than being just a trend or a cultural fashion, then it must surely mean what Goethe, at the end of the first age of cosmopolitanism, said in his conversations with Eckermann, 'National literature is now a rather unmeaning truth; the epoch of world literature is at hand and everyone must try to hasten its approach.'[14] The same is true today of world art.

NOTES

1 Simon Schama, *Citizens: A Chronicle of the French Revolution*, New York, Alfred A. Knopf, 1989, p. 474. See also Anacharsis Cloots, *La République Universelle ou Adresse aux Tyrannicides*, New York, Garland, 1973.
2 C.L.R. James, *Mariners, Renegades and Castaways: the Story of Herman Melville and the World We Live In*, Detroit, Bewick/Ed, 1978, pp. 19–20.
3 Charles A. Jones, *International Business in the Nineteenth Century: The Rise and Fall of a Cosmopolitan Bourgeoisie*, Brighton, Wheatsheaf, 1987.
4 Kenneth E. Silver, *Esprit du Corps: The Art of the Parisian Avant-Garde and the First World War, 1914–1925*, Princeton, NJ, Princeton University Press, 1989.
5 Delaunay's letter to Wechsel, 12 December 1916 (kept in the Bibliothèque Nationale, Paris) is cited in K. Silver, op. cit., p. 147.
6 Matisse's remarks to a Danish interviewer are cited in Michèle C. Cone, *Artists under Vichy: A Case of Prejudice and Persecution*, Princeton, NJ, Princeton University Press, 1992, p. 52.
7 Waldemar George, 'Ecole Française ou Ecole de France?', *Formes*, July 1931, cited by Romy Golan, 'The "Ecole Française" vs. the "Ecole de Paris"' in Kenneth E. Silver and Romy Golan (eds) *The Circle of Montparnasse: Jewish Artists in Paris, 1905–1945*, New York, Universe Books, 1985, p. 86.
8 Garry Davis, *Passport to Freedom: A Guide for World Citizens*, Washington, Seven Locks Press, 1992. Davis embarked on a career of detention and deportation when his self-issued 'world passport' was rejected at frontier after frontier.

9 Jackson Pollock, in *Arts and Architecture*, February 1944, cited in Serge Guilbaut, *How New York Stole the Idea of Modern Art*, Chicago, University of Chicago Press, 1983, p. 175.
10 S. Guilbaut, *How New York Stole the Idea of Modern Art*, Chicago, University of Chicago Press, 1983.
11 Saskia Sassen, *The Global City: New York, London, Tokyo*, Princeton, NJ, Princeton University Press, 1991.
12 Herman Melville, *Billy Budd, Sailor and Other Stories*, New York, Bantam Books, Revised Classic Edition, 1984, p. 2.
13 Alicia Dujovne Ortiz, *Buenos Aires*, Paris, Éditions du Champ Vallon, 1984, p. 42.
14 *Conversations of Goethe with Eckermann*, cited in Thomas J. Schlereth, *The Cosmopolitan Ideal in Enlightenment Thought*, Notre Dame, Ind., University of Notre Dame Press, 1977, p. 18.

Part IV

Take the high road

Chapter 13

'Getting there': travel, time and narrative

Barry Curtis and Claire Pajaczkowska

The search for a place in which happiness may be found is always a metaphor for the search to recover a memory of happiness. The journey is a symbol of narrative. Narrative – as a structure of development, growth and change – the acquisition of knowledge and solution of problems – is conceived as a physical process of movement, of disruption, negotiation and return. The movement beyond liminality is marked by a literal movement outside the integrated regimes of a time and space. The 'trip' constitutes a lapse in the regular rhythms of mundane existence, it leads to a place where time 'stands still' or is reversed into a utopian space of freedom, abundance and transparency. Like Carnival, this movement implies an inversion of everyday order and, for the traveller, offers a vicarious participation in the pleasures associated with higher status, symbolically marked by exalted points of view, exclusive spaces and privileged services.

Travellers and tourists seek places of 'unspoilt' beauty. Among the spoilers of beauty are popularity and progress. The unravaged haunts of beauty offer an experience of time before the vitiating effects of modernity and all the losses of innocence that it entails. The journey and its destinations are often described as a passage through symbolic time, forwards towards a resolution of conflict and backwards towards a lost aspect of the past. Destination and destiny are etymologically linked and travel, with its timetabled arrivals and departures, provides a particularly acute experience of the relation between predestination and the free play of choice and volition. The historic past in all its sedimented inevitability is sought in relation to a personal, pre-emptive moment – the Arcadian prelude to industrialization, the innocent hedonism of the primitive, precolonial world, and the unity of self which preceded adulthood and modern self-consciousness.

The symbolism of time in travel is ubiquitous and complex. To paraphrase L.P. Hartley's much repeated phrase from his 1953 novel *The Go-Between*, there is a sense in which a foreign country is always a past – involving both alienation and an act of recovery. The connections between

time, narrative and travel are rich and strange enough to make the connections between the arrivals and departures of planes, boats and trains reassuringly mundane. The traveller is caught between the fixing of experience through maps, guides and views and the corollary of forgetting the ways of being – substituting, as Michel de Certeau has said, 'the traces for the practice'. De Certeau quotes Lévi-Strauss in the process of making further explorations in the paradoxes of travel:

> What does travel ultimately produce if it is not, by a sort of reversal, an 'exploration of the deserted places of my memory', the return to nearby exoticism by way of a detour through distant places, and the 'discovery' of relics and legends.[1]

This chapter will explore the meanings of temporal destinies sought by travellers, starting from the observation that there is, in travel, a fusion of the two fundamental axes of reality, those of time and space. In the necessary logic of everyday life, time and space have to be maintained as separate and distinct, and the inexorable demands of this reality principle are evaded only in momentary interludes of the poetic, romantic or sublime. The desire to travel is one such interlude, and its many forms – from reading travel brochures, planning the journey, imagining and recalling life within the space of the destination – intersperse a texture of leisure and euphoria into the routines of working existence. By imagining the vacation as a space in the structuring of time, work is counterbalanced by the promise of temporal alterity, and with the accompanying promise of a revitalization. Foreignness adds to this a dimension of classificatory disjunction – the pleasures and alarms of a place where they do things differently.

The meanings attributed to place are similarly complex, revolving as they do around the mediation of distance and proximity. These parallaxed binaries usually signify the continuum between safety and danger, they mark the axes that define other people as similar or strange. Here we shall explore the way in which this 'outer' journey of physical and spatial mobility can function as a metaphor for the 'interior' journey of the soul, the mind or consciousness. Philosophers have conceived thinking in terms of Bertrand Russell's 'adventures in ideas'. Religions quests for spiritual redemption take the form of pilgrimages to special 'places' of spiritual meaning. The transition from childhood to adulthood has been narrativized and ritualized in myriad forms as a rite of passage or as a necessary process of leaving home. Leaving home is a repetition of the first journey in the 'travail' of childbirth, an active and painful displacement from the safety and unfreedom of the 'maternal' home to the unknown elements and horizons of the 'big wide world'.

The 'career' of living derives its etymology from the chariot races of the ancient classical world, traditionally figured in bas-relief on the funerary

architecture of the sarcophagus as a symbol of the fast and furious journey
of life. It is normally represented as a masculine activity juxtaposed with
the stately funeral procession of female mourners who represent the
gravity and loss of the final destination of that race. The sessile condition of
'home boundedness' is gendered in most cultures as feminine; the male
journey is equated with fathering and insemination. Historical travel has
been closely associated with conquests – sexual and territorial.

The search for love generates a range of metaphors and symbols, from
the urgent need to be in the presence and space of the beloved (rarely
represented as a need to lose the solitariness of the self) to the demon-
stration of the power of love by undertaking arduous journeys, the flight of
arrows of desire, and the recognition that the 'path of true love' rarely runs
smooth. One nineteenth-century postcard represented the course of love
as a geomorphic landscape in which two tributary rivers start from the
'foothills of indifference' and run through every conceivable form of
inhospitable terrain to flow at last into the 'sea of matrimony'. The very
structure of Oedipality involves a journey and return – a necessary inte-
gration in the same place of an identity which has been secured by a
difficult journey in time.

TRAVEL TIME

Time is part of the value of travel – the 'time out' of vacation intensifies and
extends subjective temporality in a way that is often then projected on to
the holiday locale, as a place where time is condensed and diffused. Or,
travel functions to delay or interrupt the otherwise irrevocable passage of
time. Michael Leiris refers to travelling as: 'a symbolic way to stop growing
old'.[2] Perceptions of the different qualities of life associated with home and
away is part of the work of travel – the ironic counterpointing of the
workaday with the exotic is often the chief concern of postcard and other
forms of travel writing. A recent advertisement for Bacardi ironically
counterpoints the familiar with the exotic, juxtaposing the 'pub' with
a bar on the beach, four young men running along a jetty to climb into a
motor boat with 'catching the last bus home'. The leisure of the visitor
becomes the temporal register of the place. Rueful reflections on the
unhurried, uncultivated pleasures of the exotic are also a celebration
of the power relations that underpin the historically constituted privilege of
visiting.

Travel concentrates as well as broadens the mind as a result of these
experiences of unfamiliarity; it combines the pleasure of displacement with
the enjoyable role of ethnographer/consumer and the positions of height-
ened authority which accompany the power to totalize and appropriate.
Travellers are often cast in the role of structuralists, necessarily binarized,
engaged in an outsiderly process of judgement and comparison. Travellers

are confronted with the contradictory pleasures of authority and exclusion, in order to enjoy each, they must risk the other.

The encounter with 'Otherness' is often dominated by this interest in appearance and disregard for 'insides'. The 'Other' is available as a category of choice and investment, innocent of specific determination or location. In these instances, as Dean MacCannell has pointed out, it becomes pure exoticism, the indifferent world of Benetton advertising. However, relations of power are present in the literature of tourism in a displaced form. It is preoccupied with 'authenticity' and 'originality', which suggest a nostalgia for earlier times, often times when the relationship of traveller to 'native' was one that produced more cultural difference and certainly more deference. Mary Louise Pratt[3] has analysed the literature of exploration in terms of what she has called 'Victorian discovery rhetoric' and it is possible to trace the continuation of the themes she identifies as: aestheticization, density of meaning, and domination in travel writing and mediation. She demonstrates how the work of anti-tourists like Paul Theroux construct their work as decommodifications, antagonistic to the games of taste which are at work in the acquisitive prose of the brochure.

What is marked in accounts of travel is finding elsewhere what has become obsolete at home. Journeys evade the relentless progressions and supercessions of time. The sense of lost environmental pleasure, the 'elsewhen', is often expressed in terms of the 'elsewhere'. Much of the excitement of travel is in outrunning 'Time's winged chariot' and the forces of modernity. In most cases tourists from the West and North conceive travel as an escape from the present. There are exceptions, of course: visiting New York or Los Angeles from Britain could be said to be a visit to a hypothetical future. Visiting Disneyworld can be conceived as seeking an experience of mobile and synthetic time, but even in these places, an involved visiting the past is conceived as the real work of the tourist – the experiencing of history.

The literature of tourism makes a strict distinction between the activities of exploration, travel and tourism, making it clear that they constitute a hierarchy. This hierarchy operates to distinguish degrees of commitment, levels of danger, and the value of the experience that accrues. It suggests, too, a sense of the temporal deterioration of the experience of travel: that the first two categories preceded and have been eclipsed by the dominance of the 'packaged' and largely inauthentic experience of tourism. The raw and meaningful encounters that belonged to exploration and the unplanned and insouciant procedures of travel are assumed to be more and more difficult in the modern age. With informed hindsight, most of the assumptions of exploration and travel are questionable, but as 'depth models' they help to structure the discourse of tourism.

The opposite of tourism is not 'staying at home', but the involuntary travel associated with the predicament of the immigrant. If the tourist

travels, for the most part, backwards in time, then the immigrant, the exile and the diasporic travel forwards with no promise of a restored home. The uncertainties and dangers of travel are now part of the experience of the previously visited – the economic migrants and political refugees who travel with little hope of return. For those who inhabit the 'First World', their presence disrupts the pattern of 'home' and 'away', familiar and exotic. As global capitalism ensures the presence of the most familiar goods and services in the most distant places, it also makes the exotic an everyday affair.

Something of the confusion and evidence of the unsettling effects of the presence of the objects of travel at the points of departure appeared in a recent outburst by the Member of Parliament, Winston Churchill. Churchill invoked a fragment from a speech by John Major (the Prime Minister), originally delivered on St George's Day 1992, which had been dedicated to summoning the essences of Englishness: 'the long shadows falling across the country ground, the warm beer, the invincible green suburbs, dog lovers and pools-fillers . . . old maids bicycling to Holy Communion through the morning mist'. He suggested that this vision would soon be supplanted by the sound of the muzzein issuing from the towers of mosques. The anxiety conjured in these geohistorical montages suggests the necessary role of tourism as a practice that maintains normality, a process capable of keeping things in place.

Travel is a universal activity and as such has lent many metaphors to the language, particularly in relation to the narratives of living and the transitions necessary for attaining status and maturation. Travel is a form both of work and of play. Many accounts of travelling stress the rigours and pleasures involved as a necessary dialectic. As work, travel is associated with achieving transformations; the paradox of attaining distance to better understand the familiar is often deployed. As play – an activity outside normal life – it reproduces some of the conditions of childhood. Successful travel is normally understood to involve a degree of 'unwinding'. The eponymous *Accidental Tourist* in book and film, refuses to succumb to the aleatory at first, attempting to provide enough guidance and forethought to enable his readers to travel in a 'cocoon' – he has to learn to accept risk and chance. The tourist industry is predominantly dedicated to putting back into the risky business of travel some of the guarantees – the itineraries, insurance and secure destinations which are part of the experience of everyday life.

TIME TRAVEL

Travel is conceived as a restorative process and restoration involves necessary regressions and returns. Freud wrote of the childlike nature of the vacation, both restful and explorative. On vacation he always hoped for

new discoveries arising from the empowering nature of a return to the temporality of moment to moment, the experience of childhood, a holiday from teleology which could produce new insights and forge new connections. The separation that precedes all journeys reprises the first separation from the mother and the psychological birth of the individual. It is possible that the experience of travel, what has been called the 'flow state' of passage, may reprise a time of early childhood, when the temporal and spatial were still integrated, when their mutual constraints were not understood or experienced.

The literature of travel is often concerned with primal scenes and first encounters between travellers and natives. The monsters and hybrid creatures that populate the accounts of early travellers can be conceived as the outcome of a compulsive curiosity about miscegenation. Perhaps some of this anxiety lingers in a tourist fascination with habits of ingestion and procreation. Certainly, the curiosities, investments and projections that helped to construct early accounts of other cultures were imbricated with the drive to exploit and profit. Even in normal travelling, the uneasy relationship of id and superego is a source of the intense experiences often associated with encountering other ways of life; the drives to become, assimilate and acquire are strongly pursued in even the most innocent exchange of cultures.

As we have said, travelling, like speaking, is undertaken to restore something that is lacking; because of this, it often acquires a fetishistic structure. Outside the world of good sense, of regular and predictable exchanges, certain canonical experiences and objects become supervalidated. Abroad is often conceived as a place where simple self-gratification is not only possible but also constituted as a way of life (either by the natives or by the agencies of tourism). They, the natives, recognize in us an unfulfilled potential for self-realization and enjoy it in a simple disinterested way (sadly, many of the natives are interested only in their own mundane existences and selfish profits). However, in the right, well-chosen places their innocence enables 'us' to flourish and find in ourselves an exceptional capacity for enjoyment which is infectious, for them.

'They' welcome our holiday selves and enable us to live in two worlds: the world of holiday – a prior, prelapsarian space for the self, associated with childhood and redolent of happier times and, second, the world of assimilation, a possible future attainable through the renunciation of our everyday selves. 'Going native' is rarely a real option, but 'nativity' can be played with via transitional objects – souvenirs, acquired and then imported, tastes or habits, or objects that contain in themselves a transformational quality. In a recent television advertisement for Nissan, a man drives a saloon car through a carnival. He is hailed and 'recognized' (as a carnival sort of guy) by a female dancer. He then drives away and pulls up outside a house. In a comically edited sequence, he changes into less

formal clothes, his wife and child get into the car and they set off as a family. A group of motorcyclists overtakes them and waves to him; he looks embarrassed and pretends not to recognize them but his wife waves. The hybrid experiences that are on offer here are characteristic, not only of the tourist mentality – to be simultaneously home and abroad – but they inhere in a new generation of 'primitivized' biomorphic products which offer 'deep' liminal satisfaction. They combine technology with carnival, frontier with home comfort. As Jimmie Durham has said, being the lone cowboy and the shaman is 'a perfect set-up for profits, both psychological and economical'.[4]

At home the present, in all its complexity and contradiction, is oppressively indistinct. Ironically, the experience of 'being inside' obstructs processes of commodification while 'being on the outside' constitutes objective substance which is then available for consumption. The 'foreign', as well as the 'past', has the virtue of clarity and coherence and a distance that renders it desirable and appropriable. The past seems to have been replete with distinguishable entities and 'looks' that were specific to their time. The notion of 'period style' has become a popularly understood way of conceiving past times – resulting in an inevitable erasure of conflicting components of the *mis-en-scène* and the persistence of early pasts *in the past*. These constitute fixed points on the map of time before they become, in Jameson's words, 'the imperceptible thickening in a continuum of identical products and standardised spaces'.[5]

Jameson has suggested that recent times have brought 'a waning or blockage of historicity', that historical thinking has undergone 'crisis and paralysis . . . enfeeblement and repression'. He argues that historicity has involved reifying the present in order to triangulate the past, to see it in terms of 'perspective'. In more recent fictions and perceptions, historical strategies have become analogous to the more complicated perceptions offered in Science Fictions – a simultaneous awareness of the futures of pasts and the pasts of futures. The crisis of futurity has certainly registered in the realm of product design, where the validated futurist forms of the past have filled the vacuum of imaginings of viable futures of this present.

The past has become allegorically processed as a repository of ambiances, roles and kinds of experience that are periodically recycled. Historical genres and types are revised and refined in conjuncturally specific ways: as Dick Hebdige has pointed out, there are fundamental differences between the constructions of identity for subcultures at different times – 'Teddy Boy' as a style option always refers to a historical point of origin, but is inflected differently each time it reappears in specific conjunctures. Period, like place, provides opportunities for the repositioning of identity. The child will always be a father to its descendants, who will always deploy the embryo and its historical début as an iconic component of reconstituted meanings.

Time is imbricated with space in this predicament, which clearly is not just one of the postmodernity but has always constituted a stimulant for nostalgia and travel – the predicament of the indistinct nature of the contemporary or the circumambient. Leaving home is often a search for simplification or clarity. In the 'forest of gestures' that constitutes everyday life, it is hard to see the wood for the trees.

De Certeau, who is acutely aware of the 'microbe-like spatial practices' involved in the everyday unconscious activities of living, cites the work of J.F. Angoyard[6] as providing a structure for thinking about making sense of space. The *synecdochal* takes a part for the whole – concentrating the meaning of a whole area into a monument or a viewpoint. This form of distillation could also be considered as a common practice in historical understandings. The other term is the *asyndetonal* – which suppressed the linking spaces and functions similarly to temporal editing in film narratives. Time could be conceived as draining out of the everyday ambience where particular skills are needed to 'date' objects and buildings; instead it concentrates in monuments where it is narratively stored. In the 'old quarters', time lingers in a backwash of periodicity. The operation of the 'asyndetonal' abolishes the dead time of the commute, arranging 'attractions' in close proximity. In ideal tourist space there is a surreal contingency which is almost dreamlike – the beach, or the historic centre, or the red-light district are always 'minutes away'. Tourist hell occurs where meaning fails to congeal in specific sites and remains illegibly diffuse, or where the spaces between sites overwhelm the visitor with their insignificance.

TOURISM AND THE LIBIDINAL ECONOMY OF 'SELF'

If travelling implies a journey of metamorphosis and transformation, in which the self is changed by the experience of alterity encountered in a dialectic of difference, then tourism implies a circular confirmation of self-identity. Within the hierarchy of different kinds of travel, tourism, especially in the form of the 'packaged' or 'guided' tour, ranks low. As Dean MacCannell points out, the tourist wants nothing more than a discursive substitute for experience, which nevertheless masquerades as experience itself, by wanting to apprehend the 'marker' or signifier in the place of the reality of 'sight involvement'. Contempt aside, what is being indicated here is a partial recognition of the fact that most tourists do not speak the language of the culture or country they are visiting. Their encounters with the 'other' culture and country are thereby limited to the non-verbal and are thus markedly different from their experiences in their own everyday lives, where language is the invisible medium of exchange, an element as 'natural' and necessary to identification as oxygen is to respiration.

Without recourse to speech and listening, the tourist is isolated in the

intensification of the significance of non-verbal communication. Sounds and verbal noise become more important than the 'thetic' meaning of words, analogous to the hearing of songs without being able to decipher the lyrics. The significance of gesture, expression and the body is intensified. This can be a very sensual experience, as response and subjective reaction is not easily channelled into immediate discharge through speech or expression, but can be felt internally, recognized and enjoyed as a private and intensified 'object'.

Language does mediate reality, either through the highly stylized form of the guidebook, where it appears initially as a visual sign of printed words on paper, or through the speech of tour guides, which addresses the tourist as one among many. Perhaps the most conspicuous mediation is travel writing – the retrospective reconstruction of experience in epistolatory or journal form, often addressed to an absent interlocutor and thereby acknowledging the necessary experience of absence or lack on which the entry into language is predicated. When subjective response to reality is mediated by dialogue with other members of the tour group, this often leads to the accelerated intensification of relationships based on a common culture. Tourists experience, among other pleasures, that of belonging to a community of language users in temporary exile – a safety which, in everyday circumstances, is as invisible and unrecognized as the air we breathe.

For the most part then, experience 'abroad' is not mediated in the same way as experience of home. Travelled awareness implies a more physical and sensual relation to reality. The return to a preverbal, more physically and sensually grounded response to reality provides an opportunity to recover aspects of childhood spontaneity and immediacy. The powerlessness of childhood, however, is mediated by a number of rituals that demarcate 'holiday' time as 'adult', and thus confirm the option for the tourist of enjoying the benefits of regressive narcissism without the anxieties of responsibility.

There are three paradigmatic moments of tourism: eating, shopping and sightseeing. All three are transactions of incorporation, in which the tourist negotiates a highly formalized relationship or participation in, and distance from, the environment.

EATING AND INCORPORATION

Gastronomic participation in cultural difference takes place along a spectrum that moves from the familiar to the exotic. If the experience of difference creates anxiety, then this can be compensated by a quest for food that is as commonplace as possible: the friendly safety of finding chips, a recognized brand of beer or Coca-Cola; or contributing to the global success of MacDonald's with its slightly inflected but predictable

range of food offered in proximity to tourist attractions in cities throughout the world. If the experience of the familiar breeds contempt, alimentary adventuring may become part of the project of ingesting foreign culture.

When the mouth is deprived of its usual function as prime purveyor of meaning (through speech), oral pleasure can be transformed into a heightened concern for gastronomic experience. For many travellers, eating becomes one of the pleasure/anxiety elements of being abroad. Eating difference can be reimported by individuals or recognized in local supermarkets and specialist shops. Cookery books are often the gourmet cannibalization of the cuisine of peasant cultures mediated through the discerning 'taste' of culturally capitalized authors. What Picasso did with African masks in 1907, writers like Janet Ross had already done in her *Leaves from a Tuscan Kitchen*[7] of 1899. Eating the 'Other' is partly a regressive pleasure, enabling the returned visitor to experience the innocent sensuousness of pure appetite. It also, perhaps, functions as an alternative method of assimilating the otherness of a culture which cannot easily be apprehended and negotiated by language.

SHOPPING AND ACQUISITION

Shopping provides another sensual transaction with the environment. The combination of visual and other experiential pleasures that contribute to the experience of the market, or shops, or the urban milieu in which everything seems appropriable and possibly affordable, invites greater possibilities for participation and judgement than does the museum or the non-economic destinations of tourists. Shopping always activates the fantasy of acquisition and thus of 'incorporation' of a fragment of the Other. The goods 'abroad' can be sampled without concern for utilitarian constraints which may be in operation at home..

The delights of shopping in another culture can be compared with the pleasurable disorientation of a child offered access to the playthings of another household. The power of the adult is maintained in the financial transaction and gives rise to a range of rituals, such as bartering, haggling, bargain hunting, and calculating the cost of a permanent acquisition against the cost of eating, travelling or more ephemeral pleasures.

Shopping is one way in which a tourist may participate 'interactively' without having to negotiate more complex relationships to country or culture. Spending money can be a way of dissipating some of the anxiety that accumulates in a consciousness of marginalization. Tourist shoppers become part of a local economy, allaying any guilt their temporary privilege may inspire, whilst they hope at the same time to benefit from being at a source of production (even when this is an illusory assumption). The complexity and fragility of the relationship may account for cynical dismay at the sight of 'inauthentic' souvenirs – mass-produced versions of

regional artefacts. Tourists are frequently forced to confront the extent to which tourism is a part of an economy that conforms uncomfortably closely to the one they left behind.

SIGHTSEEING AND THE PRIMAL SCENE

For many tourists, the point of the experience, as opposed to the kind of experience pursued by the explorer or traveller, is the limited extent to which it impinges on their identities or the equilibria of meaning in their own lives. Tourism is not 'false consciousness', it is a negotiated interface, the assurance of a certain superficiality in the relationship to the countries and cultures visited.

The substitution of the 'moral stakes' of reality for the privileged distance of the onlooker or spectator is crucial for the tourist. The necessary distance is guaranteed by maintaining a primarily visual relationship to reality. Vision requires distance, as Christian Metz has pointed out, and provides a comfortable compromise for the conflicting needs of the intimacy of physical rapport and the narcissistic safety of solitude. As we have noted before, as tourists we are deprived of effective dialogue with the human, cultural or natural environment, remaining pleasurably stranded on the insularity of the body. This perception can be extended to suggest that the predominant sensory form which the tourist substitutes for language is vision. Sightseeing is the main activity of tourism because, with seeing, reality remains external and in its place, leaving the spectator equally free from transformation by the encounter.

Sights are determined according to a number of criteria. Michelin pioneered the awarding of stars to designate spectacular value determined by historical or picturesque considerations. All guidebooks and tourist literature offer advice on what to 'look out for', which implies the more interesting question of 'what is to be overlooked'. What guidebooks fail to mention is all visual evidence of similarity between 'abroad' and 'home'. Reference to hospitals, schools, non-historical civic buildings – all aspects of the social infrastructure of everyday life – is absent except for the phonetic translation of 'useful' phrases that indicate an instrumental use of whatever medical, banking, police, transport or administrative facilities are needed by the tourist to sustain his or her more validated experiences. The meaning of 'holiday' must be kept as free from any reference to the world of work as possible.

Just as shopping offers the tourist the reassurances of financial transaction and possession, so photography offers an equivalent in the realm of perception. Visiting sights that have been validated as pleasurable and significant involves the contemplation of preferred images in the form of postcards. The spectacular is already signified in ways that represent the manufacturer's ideas of what would constitute ideal experience. At the

summit of Vesuvius a proportion of the postcards on sale represent spectacular volcanic eruptions that correspond to the imaginative meaning and historical significance of volcanoes but suggest far from ideal circumstances for visiting the site.

Where postcards are not available or fail to satisfy, the tourists' imaginary is served by photography. As Kodak points out, photographs are a way of preserving memories and are powerful and pleasurable stimuli for reawakening forgotten experiences. But over and above this innocent desire to secure ephemeral experience for retrieval in an uncertain future, there is the act of photographing as a form of behaviour in itself. Taking photographs can be a way of maintaining a relationship of controlled proximity and distance to a lived environment. Simple manual-focus compact cameras often have an interesting three-point focus range, indicated by icons of a 'head' (for close-ups), 'two heads and torsos' (for medium shots) and 'mountains' (for long shots). In this way, the technology conveniently classifies the tasks of visibility for the interested spectator according to genres of image-making. This serves to protect from the bewildering task of focusing among the overwhelming choices offered by the visible environment. Susan Sontag has pointed to the relationship between 'shaping' experience by photography and allaying the anxieties generated by a 'ruthless work ethic'.[8]

Photographing the self, or family, or friends, or friendly strangers within the environment can also be a way of making real an experience that threatens to overwhelm with feelings of the loss of familiarity and 'realness'. 'Stendhal's syndrome' has been used to describe the feeling of being overcome by awe and emotion in situations where history, beauty and sheer unfamiliarity cause an alarming sense of faintness and disorientation. A rigorous campaign of isolating and shooting segments of the 'view', of using the mechanisms of representation to secure identity and point of view, is one way of restoring subjectivity through a process of objectification. This excessive and sometimes obsessive activity may be regarded as a compensation for the relative powerlessness of verbal language which is habitually used to assimilate and process experience.

Laura Mulvey has offered a celebrated account of how visual pleasures interact with narrative structure in classic realist cinema, using Freudian psychoanalytic theory to account for the unconscious determinants of cinema spectatorship. Her account of the activity of spectatorship (with its accompanying fantasies of agency and control) which is counterposed to the passivity of objectification and exhibitionism (with its fantasies of desirability) is also useful for thinking about photography as a component of tourist activity. The determinants of what is constituted as viable experience of the 'picturesque' may best be established with reference to the subject's knowledge and operation of the conventions of pictorial representation; but the question of what motivates the tourist to set off on

a quest for visible experience depends on a much deeper need to return to a pre-social world of imaginary plenitude.

The same could be said for the pursuit of sex. Certainly the 'desublimation' of sexual fantasy is an important component of the marketing of holidays by those whose job it is to represent destinations for the travel industry. Images of bared photogenic bodies, energetically or restfully 'at one' with the native habitat, are offered as evidence of the desirability of place and experience. The assurance being offered, beyond the immediate appeal of merging, is that there need be no frustrating gap between the desires of the body/natural and the constrictions of the social/cultural. Photographs of the naked or near-naked body signify the abolition of the frustration of restricting 'clothing' and along with that the casting-off of conventions and defences against the vulnerability of 'nakedness'.

Cultural and ethnic 'otherness', as has been recognized by writers from Franz Fanon to Sander Gilman, is a favourite place for the projection of the strangeness of sexuality, and the dark skins in which it is often presented, to white bourgeois self-identity. When they are projected in the nineteenth-century Orientalist fantasies of Ingres and Delacroix, or identified and named by Edward Said, or employed in the mundane and derivative iconography of advertised holidays in Morocco, or manifested in the rape fantasies used to advertise chocolate bars – erotic fantasies are denied as a structural component of the 'self' and are excitedly discovered in the desirability of the 'Other'.

The naked power struggle hidden in this seductive eroticization of difference remains the real dynamic of all attempts to live out such fantasies. Whether it is acknowledged as a pitiful attempt to salvage the shreds of damaged narcissism, or romanticized as a more authentic pursuit – because the 'real' is being mistaken for the physical and genital encounter with the Other – the equation of uninhibited sex with 'being away' is evident in everything from the merging of tourism and prostitution in the Far East, to the marketing of holiday romance stories. Holiday romance is ubiquitous, too, in middle-class culture and appears *inter alia* in the narratives of Rider Haggard, Paul Bowles, Henry Miller, Ian McEwan and others for whom sexuality remains a more indirect way of 'having' (authorially possessing), 'it' (an experience of alterity that can be attributed to the cause of another), 'away' (to avoid the Oedipal associations of confusing 'sex' and 'home').

'Having it away' and getting 'a bit of the other' are eloquent expressions for a crudely simple fantasy that underlies some of the meaning of the search for the exotic and the visible in the foreignness of holiday narrative. A more neutral description is that of witnessing a 'primal scene', an unconscious, possibly infantile, fantasy of being present at one's own conception. All these fantasies involve the complete interchangeability of identification with any of the roles in the narrative, that is the complete

imaginative freedom to be 'anyone', which is part of the pleasure of the anticipating the freedom to be 'elsewhere'.

On a more conscious level, this fantasy is represented by the thought that holiday time is when we are most free for rest and recreation, to recreate the self through freedom from the inexorable demands of work, to be creative with leisure time and to be free from the demands of history. As we have suggested, one of the most important aspects of leisure is access to the experience of timelessness.

NARRATIVE AS JOURNEY

We have suggested that travel can usefully be thought of as informed by discursive structures with their own subjectivities and their own narratives. Narratives of loss and retrieval are particularly significant, not only in terms of leaving home and returning, but in the profoundly imbricated structures of narrative and subjectivity. Narrative structure itself can be regarded as an intro-subjective journey. Through narrative the subject self is allowed a regressive splitting – into fragmented component selves – and is offered forms of identification for subsequent reintegration.

Film narrative offers a particularly fertile ground for narrative journeys of psychic splitting and reintegration, because of the close interrelation of image and temporality characteristic of its form. Film's fusion of moving image and temporal duration has been identified as being especially close to dream work and dream states of mind, in which regression is pleasantly evoked through discursive and symbolic structures. The discursive structures of film, particularly its use of editing – continuity, suture and shot/reverse shot conventions – augments the physiology of perception through which movement (of the eye to create a multiple retinal image) establishes meaning and coherence in vision and transforms visual stimuli into an 'image'.

Film language creates an augmented parallax vision – a narrativized embodiment of the cubist incorporation of multiple points of view and multiple subjectivities. Even the simplest cinematic narrative offers the spectator the fantasy of 'being in two places at the same time', or inhabiting the body and point of view of someone else. The escape from the restrictive limitations of body and place is gratified through a range of symbolic conventions. Beyond pleasure, this structure of travelling subjectivity also offers the spectator the intrapsychic structure necessary for the acquisition of knowledge. The 'journey' from one point of view to another corresponds to an intrapsychic journey which, by 'broadening the mind' to include other identifications, creates the triangulation points necessary for a depth of perspective required for the production of knowledge.

Knowing, travelling and narrative point of view are thus intimately and structurally linked. The 'travail' or work of passing from the blissful

ignorance of spectacle to the knowledge of cause and effect is akin to an effort of physical movement. This physical movement can incorporate the point of view of more than 'one'. This becoming 'more than one', which is a loss of the innocence of what Freud calls 'infantile omnipotence', is also, paradoxically, a becoming 'less than one', less than individual, less than unified. In narrative structure we find an expression of the human predicament: that it is the capacity to form and recognize objectification, which is the precondition for achieving subjectivity. In all journeys, of the body or soul, subjectivity is transformed by an encounter with objectifications, 'different' objects that require different forms of recognition of similarity and difference. It is a necessary activity which transforms the most casual traveller into a practising structuralist, and at a commonplace level accounts for the educational value placed on travel and the awe and apprehension which has accrued historically to intentional travellers and lonely strangers.

If the narrative structure of film is partly established through the 'apparatus' of identification, there are some films with narratives that specifically explore the subjectivity of this identification. Frequently avant-garde, Brechtian, formalist or 'art cinema' films centre on narratives that refer to the nature of the spectator–screen relationship or to the construction of the film text, but more unusually a popular film such as *Groundhog Day* achieves the same goal within its own discursive conventions.

Groundhog Day is an allegory of travel and tourism. It reverses the archetypal journey from small-town origins to big-city destinies. It is a reverse travelling often invoked in popular film as a return to more wholesome and fundamental roots, or to a confrontation with the horror of 'deep America'. For the protagonist it is an unwelcome, frustrating journey to an unsophisticated and banal ceremony in a place populated with boorish rednecks and an appalling forgotten schoolfellow, now, ironically, an insurance salesman – a man who trades on the uncertainty of the future.

By an unexplained looping of time, the protagonist is prevented from moving forward in time and space and has to live the same day over and over again. Here the narrative replicates the incremental procedures of film production and for its hero proceeds 'take' by 'take', a process of editing which he can employ to retrieve his mistakes, until he achieves a desired result. The comic effect is produced by juxtaposing his awareness of his own narrative plight, in which he is released from the effects of causation, and which proceeds from equilibrium to *identical* equilibrium, with those of people living in the ordinary world of temporality and uncertainty.

As the victim of an unauthored behavioural experiment in which he is metaphorically twinned with the eponymous weather forecasting rodent, he is doomed to repeat mistakes until altered responses lead him to a successful resolution of his conflicting desires, identifications and goals. As

he is prevented from travelling in time and space, he is forced to travel inwards into self-consciousness and thus to reconstruct his own identity rather than acting on the world outside him. His initial response to his plight is to manipulate others by enhancing his 'script' through a process of recalling and retaking. Only gradually does he begin to concentrate on remaking, and improving the reality of others, whilst employing his own infinitely renewable time to develop his own capacities. The turning point is his insight that knowledge is a kind of divinity.

The experience of *Groundhog Day* is one of finding the pleasures of travel constrained in a kind of hell of immobility and narrative occlusion which provokes crisis, delinquency, self-destruction and, only then, an inner journey of self-discovery coinciding with the discovery and exploration of a partner who becomes, eventually, a lover. What is initially a self-interested exploration motivated by sexual desire, becomes a rapport and merging which provides a delivery from arrogant self-involvement and simultaneously from the malignant spell of time and place. From being a weatherman, stranded by his masculinity and the elements which it is his job to explain, he becomes someone who knows which way the wind blows.

The device of the film is to produce a repeated and identical equilibrium, an obstructed narrative without transformation. Closure can only be achieved through 'sameness but difference' – sameness without difference is epistemological and moral despair. Travel and narrative seek to differentiate and transform the 'nothingness' of this condition. 'Sameness' constitutes the safety and promise of narcissism, a world where all difference is derisory, insignificant or threatening. Travel promises a break with this closed circle whereas 'tourism', with its metaphors of circularity and the 'already known' experience, threatens an encounter with the sign rather than with difference – a dangerous safety without suffering, effect or affect.

Apart from offering an escape from the world of work and what Freud identifies as a necessary balance between the 'pleasure principle' and the need to 'live in reality', tourism has a particular role to play in what it seeks to leave unchanged, in its circular evasion of reality. The meaning of travel as a universal symbol of growth, change and dissemination was our point of departure. But we now contemplate a different destination. Historically many people have been recruited or coerced to travel neither for leisure, not interest nor choice. In the twentieth century, hunger and fear have been among the chief motivations. The predicament of the migrant worker and refugee is largely an inversion of the experience of the tourist – their journeys are not circular, they are neither an escape from work nor a pursuit of the intensification of sensory experience.

The predicament of refugees and diasporic cultures is compounded of poverty and marginalization and the insidious appropriations of a kind of static 'tourism' in which they experience fundamental components of 'home' transformed into leisure commodities – jazz or soul music; Indian,

Greek and Chinese food; Jewish humour; Irish sentiment; and increasingly the idyll of nineteenth-century values and fantasies of precolonial primitivism. Rather than achieving refuge, what the colonized and displaced suffer most acutely from, according to Albert Memmi, is 'being removed from history and culture'.[9] The dispossessed migrant workers or political refugees have no choice but to travel, in a journey 'against the grain' of the tourist in which the return to the 'present' of home, the lost equilibrium which brings closure, coherence and the security of identification, is hopelessly deferred.

NOTES

1 Michel de Certeau, *The Practice of Everyday Life*, Berkeley, University of California Press, 1988, p. 107.
2 Quoted in James Clifford, *The Predicament of Culture*, Cambridge, Mass.: Harvard University Press, 1988, p. 165.
3 Mary Louise Pratt, *Imperial Eyes: Travel Writing and Transculturation*, London, Routledge, 1988.
4 Jimmie Durham, 'The search for virginity', in Susan Hiller (ed.) *The Myth of Primitivism*, London, Routledge, 1991, p. 291.
5 Fredric Jameson, *Postmodernism, or the Cultural Logic of Late Capitalism*, London, Verso, 1991, p. 281.
6 De Certeau, op. cit., p. 101.
7 Janet Ross and Michael Waterfield, *Leaves from a Tuscan Kitchen* (first published 1899), Harmondsworth, Penguin Books, 1977.
8 Susan Sontag, *On Photography*, Harmondsworth, Penguin Books, 1979, p. 10.
9 Quoted in Walter Rodney, *How Europe Underdeveloped Africa*, London, Bogle-L'Ouverture Publications, 1972.

Chapter 14

Travel for men: from Claude Lévi-Strauss to the Sailor Hans

Adrian Rifkin

Kitty was sick to death of time travel. As she leaned back to wait for that oh-so-sensationless moment of transference from here to whenever or back again, she tried to remember what it had been like before. Vaguely she could recall how, as a child, she had thrilled to the point where a transport would exceed the speed of light, that marginal but profoundly sexy – she now realized – shock of the transformation of your matter between time and space. Somewhere too she had read about 'differential time', a concept that went back to the very early days of human thought, and she groped for an idea, a notion, that would not be the same as the simultaneity that now made up the textures of the everyday. Textures?, she mused. Where did that word come from? she didn't even know what it meant. All she really knew was that when, like she, a busy administrator of the Hegelian process, you had to do a lot of time travel, it was terribly important to hang on to a sense of origin. But, come to think of it, how could she do even that, when neither did she have any clear idea of the meaning of difference.

(Davida Pendleton, *Time and Kitty*)[1]

'Travellers' tales' really is an embarrassment of riches, and an embarrassment is all too easy to deconstruct. To do so reeks of virtue. It would not take much effort to comb the wavelengths of the BBC or ITV for the last few years to regale ourselves with those land-rover-riding, train-hopping Englishmen, replete with their whole baggage of Anglo-Saxon bourgeois prejudice, riding roughshod in whatever might be the current ruins of Samarkand, evoking the exotic or the quotidian alike in the same breath of stale anxiety to interest the slightly more than common viewer.

Should we suppose that they are less interesting than Flaubert in Egypt 140 years before? Certainly they seem to be less literary, in the old-fashioned sense of having 'quality', managing an inscription of their experience into something infinitely less rich in metaphor and strange displacement than did their distinguished white, male – but at least sexually ambivalent – predecessor. Prudish rather than chaste, no doubt their only

real baggage is the camera crew and the immanent audience that it trails behind it, with *its* baggage of time-share brochures, broadcasting regulations, free choice of channel, or simple inattention. These travellers might, at the best, be a good example of Lévi-Strauss's grim realization, in *Tristes Tropiques*, that there is really no such thing as travel, in these days:

> Now to be an explorer is a craft, which consists not of what one might have believed, years of the studious discovery of unknown facts, but in cantering over a vast number of kilometres and getting together so many slides or moving pictures for projection.
>
> (Lévi-Strauss 1984: 10)[2]

For those of us who prefer to stay at home, and have the TV off, this is no bad thing.

Going back to the last century again, to those poems of Théophile Gautier set to music by Hector Berlioz as *Nuits d'été*, it's quite satisfying to note how a journey needs no space other than that between two lost kisses, and that the terrain of loss, separation, absence, need not be filled with anecdotal topography. Gautier knew well enough the difference between reporting a train-ride to Brittany and representing a fault in one's sense of self. 'What a distance between our lips' or 'to travel alone on the sea' – the configuration of sound and text is as telling as the account of the steamer journey that takes Lévi-Strauss from Marseilles to Fort de France in 1941. This itself is figured as estrangement with little more than the details of domestic arrangements on the boat, a comment on André Breton's overcoat or Victor Serge's aura as the ex-comrade of Lenin. Yet even in this opening sketch, one can glimpse elements of the conflict between the 'so-called primitive', and the tired-out Western city that haunts the whole of *Tristes Tropiques*. The dilapidation of the temporary sanitation, overcrowding, a junkland squalor that the West has elaborated for itself and for the rest of civilization, in good time.

Let us underline – in neither *Nuits d'été*, nor in this short, disruptive voyage, does the subject have to realize the space of lack in the realistic detail of the travelogue in order to realize itself as searching for alterity. Descriptive detail is worth little more than the curiosity of an indifferent or an inattentive public.

Its potential for significance rather lies in its transmutability, its potential as material for something else, as transcription into an unstable image of identity: – Flaubert could hardly have written Brittany and Egypt without each other, nor could he have invented any new place without either – without either, no imaginary Carthage. The metaphorical relation of these fictional sites was one that enables the displacement of different observed densities the one into the other, a reciprocal metonymy that sites meaning beyond the point of observation. And so, oddly, there is little need to worry over the countless, interesting details of the TV travelogue –

Samarkand, streets, houses, shops, suffering people, happy people and so forth. This naturalistic but highly moralized detail, as an end in itself lacks the punctum of *those* journeys that *really* tell in the histories of distance: the moment of realizing that one is in the presence of a certain density, that may only evasively be called 'exotic', a density that marks the ruin of the known or the beginning of the unknowable.

The desire for this point or punctum is the motive behind that all-pervasive journeying of modern class societies called slumming. The search for a density that is missing in the self, but contained within that self's social frameworks of a local civilization. And this, truly, is only contingently a question of distance – rather I would say, it is one of differential time, the primitive concept so dear to Kitty (who, by the way, would have shared Lévi-Strauss's horror of the slide show, had she only been around) – a concept that preceded the postmodernization of cultural theory and then began to die. And this time is the time of difference within the matrices of the self: historical, the evolution of classes in cities and the times of development that separate them; spatial, the archaeologies of these times in the networks of real estate, for example; sexual, the time it takes to get around, to find a lover is not the same for men and men, or men and women, nor for women and women; literary, you get used to certain formulations, to tropes that frustrate time; and so on.

If Lévi-Strauss never went slumming as such – though some of his descriptions of Delhi may remind us of a *flâneur*'s visits to the Parisian *Zone*, Kitty would have understood. For even she couldn't go just wherever she wanted, and certainly she couldn't translate her own time into simple space. The reversibility of time, as far as she knew, could, in the end, exist only in the pages of analytic philosophy. It was in default, then, that travelling through space as if it were time had become a respectable alternative, even if the moment at which such a journey became theory also marked the end of its being possible. Anyway, space most certainly is reversible ('she reflected'), and this enables ethnology and fiction to occupy each other's ground.

Writing in his collection of essays *Le Vol du vampire*, the French novelist Michel Tournier dedicated a few pages to Lévi-Strauss in which he notes this chilling phenomenon:

> We learned of these Indians that Lévi-Strauss had trailed and camped with them fifteen years before. That there had already been no more than a hundred of them, and that without doubt they had since entirely disappeared. It was there that I heard the word *ethnocide* used for the first time. We were, then, faced with a paradox: at the very moment when it took on the aspect of an exact science, ethnology was rewarded with a tragic dimension in the losing of its object.
>
> (Tournier 1983: 398)

Of course, nothing of the kind happened, or rather *ethnocide* took place, but ethnology developed unabated and Lévi-Strauss went on to produce the work we know. Tournier took himself off to fiction. He hesitated to send a copy of his novel, *Vendredi ou les limbes du Pacifique* (1967), to his sometime master – perhaps fifteen years seemed too long to send in his essay. Or perhaps Tournier's depictions of nature, often grotesquely sexualized, as in his image of Robinson's cactus garden (Tournier 1967: 132), read too much like a parody of Lévi-Strauss's descriptions of the Western city. And yet, he says, the filiation could have been no secret – an American critic noted that the novel was, 'Robinson Crusoe rewritten by Freud, Walt Disney and Claude Lévi-Strauss' (Tournier 1983: 400). Tournier's fiction became one, in which, as we might expect, travel was to play a major role, and, above all, travel over the boundaries of sexed and 'ethnic' identity. Perhaps what Tournier really understood from the word *ethnocide* was rather the implication of the death of the subject of ethnology in the destruction of its object. In his *La Goutte d'Or* (Tournier 1985), the story of a young Maghrébien's journey from North Africa to Paris on the tracks of his photo, once taken by a tourist, promised to him, but never sent, there is no subject other than at the congruence of representation with the contingency of places. Discrediting nature in his *Vendredi . . .* (Tournier 1967), Tournier prepares a way for returning to the sickly city as the legitimate site for an ethnology of the Western self and of its others.

It is the reinvention of such a subject, a subject for a discipline, that has become something of a fetish in France in recent years, a very particular version of the politics of identity. The eminent ethnologist Marc Augé first crosses the Luxembourg before he steps down into the Parisian underground in his *Un Ethnologue dans le métro* (Augé 1986). There he finds and redefines his own relationship to Lévi-Strauss. He realizes that the movements, gestures and skills of millions of individuals in a historically given but transforming, symbolically laden process of circulation and interchange, offer an equivalent density to that which once entranced the great ethnologist amongst the parrots of the tropical forest: 'seen from outside this nature is of a different order to our own: it manifests a superior degree of presence and permanence', as Lévi-Strauss had put it of that 'heroic confusion of lianas and rocks' (Lévi-Strauss 1984: 100–1). Yet these may be replaced by enamelled signs and corridors of iron rails, swinging doors that test the traveller with interdictions, warnings and guidance, inviting the expression of difference and alterity through their infraction. A shift or change in one of these elements is the register of the change of many others: *'beyond this sign tickets are no longer usable'* becomes *'limit of the validity of tickets'* as an effect of a restructuring of the system on a geographic and economic scale that calls to be newly sutured at the level of the symbol – situating the everyday within a new poetic. A simple indication is also a trace.

But so too is Augé's own journey the trace of a way of going round the city that itself requires an ethnology of literary production, of the coding of the city in a system of relations and tropes that both empowers and limits the ethnologist or the novelist alike as they reproduce and shift these codes in the face of the city's febrility. And the need to reinvent the city is also a matter of a transformation of popular culture, the need to register the switch between two exotics, 'class' and 'race'. In the shift from *Marouf*, the nineteenth-century operetta version of North Africa, to Reinette l'Oranaise or Cheb Khaled, French popular culture has become nothing if not North African.

It too, then, has made a journey that may be mapped in the shift from the representation of North Africa in the Expositions Universelles of the last century (I am speaking here strictly of spectator travel) to the Goutte d'Or of our own day. The demolition, in our own day, of Gervaise's laundry, from Zola's (highly ethnological) *l'Assommoir*, so regretted by Louis Chevalier, is also the death of travel in the sense that Lévi-Strauss forewarned us. Travel has crossed our thresholds, or, after a long process of accumulation, has manifested itself as no longer so much exotic, outside the self, as in the self and radically unlike it. In the modern metropolis, travel and slumming have collapsed into one another. Thus we can return to an examination of the space – this new space – in the subject without repeating the tropes of romantic desire in Berlioz or Schubert, but, maybe, learning from them.

And all this is already an embarrassment, without wondering if one should include Defoe, or Pausanias, or Xenophon, or Lady Mary Wortley Montagu, or Renaud Camus. To do this itself would open up an impossible complex of historical comparabilities, genders and sexes. It gets complicated in this way: that travel's identities and modes of procedure, moralities and self-realizations, despite the disappearance of their materials, never get entirely out of date – enforced travel in western Asia, is, if I may risk frivolity, as popular now as at the time of Xenophon. While 160 years ago, more than one Romantic artist invoked Ovid's exile in Scythia as a metaphor for his own desire to set a distance between himself and his Parisian public – the travel of exile may be intensely attractive as much in the artist's studio of the last century as over the TV dinner.

And if Lady Mary mapped and observed a woman's space without gendering it as her project, Renaud Camus, gay traveller through modern France, genders space as it is mapped. There is no other space than gay space, and so no alterity, no ethnology, no guilt, for the writer or his reader. Space and subject, code and praxis interleave in the delectation of art and sexual tricks, belonging to each other, or separate in the making of the text. This 'bathmology', the reading and writing of the levels of experience and its signs in their difference and inseparability, frees the eros of travel to identify itself with text. With Camus' diaries there is nothing to

learn from writing and therein lies their virtue. Distance is structured in the differential time of social groups, of which he himself belongs to at least two, the sexual dragueur, and the connoisseur of provincial painting, and the conjoint figuring of these doubles space with density.

But here I must back off, because I want, at least for a moment, to quit Kitty and her temporal obsessions. I want to get you to the fictional Sailor Hans, whom I have promised myself to compare to Lévi-Strauss. What I will try to do now is to stay in rooms, or at least in the cities that surround them. Rooms, or shacks even. Michel Tournier, whose little reverie on Lévi-Strauss I have already cited, was recounting his attendance at the postwar seminar in the Musée de l'Homme:

> It was in 1950. Liberated France was finding her second breath. High up in his panoramic apartment Paul Rivet still reigned over 'his' Musée de l'Homme with a jealousy only tempered on the floor below by two charming, white haired spinsters, his sisters. Around them there came together teams of researchers from twenty disciplines, who, united by a single password – *travel* – bent themselves to give a meaning to this strange and seductive notion – ethnology.
>
> (Tournier 1983: 397)

Oddly this memory recalls another: Lévi-Strauss's own recollection of travel lectures in the 'sombre glacial and dilapidated amphitheatre in the old building at the far end of the Jardin des Plantes' (Lévi-Strauss 1984: 11), or of his Sunday seminars with Georges Dumas in a room at Sainte-Anne. One has a sense of ethnology itself as the accumulating effect of different forms of travel and their attendant, social and political histories, taxonomies, etc. – a journey proper to ethnology, starting out from, but ever coming back to the museal spaces of the metropolis. Tournier, as I have said, deserted this in favour of a series of journeys appropriate to fiction, and in Lévi-Strauss's terms he was probably right to do so. In the same short essay he recounts how he interviewed his *maître* for a radio programme on the functions of language – 'What would we know of a lost society', he asks, 'if all we possessed of it was a dictionary and a grammar?' 'Everything', is the reply.

And this brings us to sailor Hans and his adventures: title figure of the novel, *Hans le marin*, written by Edouard Peisson and published in 1929. Peisson was one of those middlebrow authors who courted and won mass popularity. In 1929 he figured amongst a stratum of writers, including Eugène Dabit, who wanted a new, modern natural-ism of the people, the people and popular life as a modern literary problematic. Not a new idea, but Peisson was modernist enough in his prosody. He deploys a cinematic fast montage of nouns, action with pared-down grammar, narrative tempo through the careful animation of simple lists. Hans, a beautiful young American sailor of German[3] family

– Europe is already within him – lands in Marseilles and sets off drinking with his comrades.

He is a bit like the heroine in Claire Denis's film *Chocolat*, who comes back to an Africa where she was born and learned what the world is, but to which she belongs as little as does an African from North America who has never set foot there. Hans is a little like this and he speaks enough French to buy himself a drink with his fistfuls of dollars and a beautiful prostitute, but he doesn't know enough codes not to get himself entrapped by her, mugged, and end up penniless, without papers, without any legal or social identity, stabbed, in a hospital. He falls because he knows just enough French to go astray – he is unforeign enough to get into the low life of bars and whores, and he rises because he eventually learns enough French to master things and through their mastery to become someone else.

From the cold waiting room of the office for repatriation to the train compartment that eventually leads away nowhere, somewhere, to a new life, Hans survives by knowing and handling things, but not just as the natives do. He learns to master codes of those other survivors whose ranks he now must join: streetpeople, down-and-outs, ragpickers, gypsies – codes which are also double codes. For he takes these people, and he learns their lives and means of subsistence as if they were the raw facts of sociology. But these lives and these means are already literary codings of the popular, a little like the 'primitive' that Lévi-Strauss undoes in all his work. As Hans masters every ruse and tactic, through empathy, through observation and through desperation, he does so from inside and from the outside. He gets a little hut in the beggars' camp and, using a sailor's skill, it becomes the best of all the huts. He has sex. He can show the whole Marseille scene to tourists, the same scene that brought about his fall. Going in and out of its images with increasing fluency, he can make the tourists pay for a glimpse of those worlds whose mastery holds the key to his own independence from them.

So, like, a fieldworker and theorist, he takes control. The process is wonderfully suggested by *Lévi-Strauss* himself in *Tristes Tropiques*:

> All the while wishing to be human, the ethnographer seeks to know and judge man from a sufficiently elevated and distant point of view to abstract particular contingencies from such a society or civilisation.
>
> (Lévi-Strauss 1984: 57)

It is through the ordering of things and displaying them in their mythic series that the sailor Hans gains power over them, which is also the power of a theoretician over things, and of which the metadiscursive product is to be his purchase of a new identity. Once this is achieved, he tracks down the first prostitute, the author of his fall, whom he still obsessively desires. She no longer knows him. He kills her. He kills this code of Frenchness,

sexuality, the popular, in a final act of mastery. He thus becomes the author of his fate. However I don't want to exaggerate Hans's skills in both ethnology and ethnocide, only to underline a particular form of apprehension of the city. Peisson's narrative effectively unties its own system of ethnographic representations only to reknot them in the mythic form of the adventure novel, the skill to deconstruct hidden in the will to narrative. This construction of infinitely complex, unending superpositions of series of myth and mytheme is the commonality of the easy read and the ethnologist's travel book.

Repeatedly renounced by Lévi-Strauss as a sore, whether in the Third World or the metropolitan countries, the city of popular literature has become the fallback site, for it is here that density is realized as self. In coming back to the space of the métro, in the oh-so-short journey from home to work, there the most demanding critique of Lévi-Strauss on Mauss can find its reason. The shorter the journey, the sharper the critique. The distance between Lévi-Strauss and Augé is short enough, it is no more than the length of a corridor in the Collège de France. But the time between them is immense. It is the time between the realization that the Western city has destroyed the world of nature and the realization (already long accepted in popular literature, if not so much in urban sociology) that this city alone, having done its deadly work, is the last source of a density in which the self, alienated and distanced in the unrecognizable details, may none the less find representation in the series of its narratives.

Our proceedings, which concern the future or, rather, 'futures', have generally taken against the idea of making any kind of prescription. This is a pity as I had wanted to make one. However, in the light of Bracha Lichtenberg-Ettinger's rebuttal of an earlier prescription – one of silence – as unacceptable for women, I want to modify my own. It is intended for men's ears only, as, I now realize, this essay must have been. The future of travellers' tales, I feel certain, lies in their reading, in cultivating new arts of reading them. My prescription is to stay at home and do just that.

NOTES

1 Davida Pendleton is the pseudonym of a well-known cultural critic who is currently completing a trilogy of science fiction novels, of which I think very highly. While respecting her anonymity I would like to thank her for allowing me to quote from her unpublished manuscript.
2 All translations in this chapter are my own.
3 It is worth noting that, one decade after the Great War and at the very moment of the Jazz invasion, a German-American should be the emblem for the problem and excitement of losing one's self.

REFERENCES

Augé, Marc (1985) *La Traversée du Luxembourg*, Paris: Hachette.
—— (1986) *Un Ethnologue dans le métro*, Paris: Hachette.
—— (1992) *Non-Lieux, introduction à une anthropologie de la surmodernité*, Paris: Seuil.
Camus, Renaud (1981) *Journal d'un voyage en France*, Paris: Hachette, P.O.L.
Lévi-Strauss, Claude (1984) *Tristes Tropiques*, Paris: Plon [1955].
Peisson, Edouard (1929) *Hans le marin*, Paris: Bernard Grasset.
Tournier, Michel (1967) *Vendredi ou les limbes du Pacifique*, Paris: Gallimard.
—— (1983) *Le Vol du vampire*, Paris: Gallimard.
—— (1985) *La Goutte d'Or*, Paris: Gallimard.

Why travel? Tropics, en-tropics and apo-tropaics

Sunpreet Arshi, Carmen Kirstein, Riaz Naqvi and Falk Pankow

> Rousseau, the most anthropological of the *philosophes*: although he never travelled.[1]

Who would have thought that 'travel' could come to mean so many things? Edward Said, discussing his concept of intellectual interchange as, what he terms, 'travelling theory' notes, 'Like people and schools of criticism, ideas and theories travel – from person to person, from situation to situation, from one period to another.'[2] Recent work on travel seems to bear out Said's analogy, with 'travel' seeming to serve as a remit for work on the widest range of subjects.[3] Perhaps it was inevitable that the term would vie with 'culture' as a signifier of tremendous scope, because – if we go back to the agricultural etymology of the term – cultures do not just spring up ready-planted in their native soils; very often cultures are the result of transplantation – in other words, of a form of *travel*. And if Said's conceptualization realigns travel to a seemingly elective affinity with theory, then it is perhaps also no surprise that the meditations of Lévi-Strauss – a theoretician who has by chance become a traveller – should end up tracing, or hinting, the intellectual trajectory of Theory: firstly, from humanism to structuralism and finally – surprised to see the dying body of postwar intellectual despair bare its teeth and grimace wildly – to post-structuralism. To examine travel is to examine theory.

How, then – if at all – is the imperative towards movement theorized? We intend to argue that Claude Lévi-Strauss's *Tristes Tropiques* questions the very foundational legitimacy of travel. The problematic it raises is one of the subject thrown into the heady midst of a cultural interchange, caught between writing and experience. But travel is always mediated through discourse, so that to distinguish between delineative 'travel-writing' and tropological 'writing about writing-about-travel', whilst on the surface a useful polarization, is extremely difficult – indeed the crossing of these boundaries is essential if travel is to be theorized towards any moral and

ethical position. Such a critique needs to be built into the very *textuality* of any account of travel – in either of its two above forms – as Lévi-Strauss's text so powerfully displays. To write about travel then becomes a discussion of what it means to write – the tracing of the linguistic consecution on a page; the *movement* of meaning. Lévi-Strauss's text is saturated with this consciousness, but this means a surrender to the sheer play of *différance* both within the journey itself and in the text. It involves, in essence, an acceptance of boredom. The obverse of this, a position where boredom is held in abeyance (if ever it could be) is amply demonstrated in, to take a recent example, *Imperial Eyes* by Mary Louise Pratt, where the imperatives to travel and the imperatives to narrate merge in a textual economy that through some process of doubling end up narrating the history of colonial travelogues as *journeyed ends* in themselves. Consequently, in this instance, theory travels light[4] and we will have cause to return to Pratt's text as a means to demonstrate by juxtaposition the virtues of Lévi-Strauss's text.

Let us firstly consider a text which wears its *boredom* with travel on its sleeve – announces it, indeed, on the opening line of its opening page: 'I hate travelling and explorers. Yet here I am proposing to tell the story of my expeditions.' This quote is taken from Claude Lévi-Strauss's *Tristes Tropiques*, the most fascinating, most anguished, most contradictory (at times almost knowingly so), most *boring* of texts, explicating as it does the:

> thousand and one dreary tasks which eat away the days to no purpose and reduce dangerous living in the heart of the virgin forest to an imitation of military service. . . . The fact that so much effort and expenditure has to be wasted on reaching the object of our studies bestows no value on that aspect of our profession, and should be seen rather as its negative side. The truths which we seek so far afield only become valid when they have been separated from this dross. We may endure six months of travelling, hardships and sickening boredom for the purpose of recording (in a few days, or even a few hours) a hitherto unknown myth, a new marriage rule or a complete list of clan names, but is it worth my while taking up my pen to perpetuate such a useless shred of memory or pitiable recollection as the following: 'at five thirty in the morning, we entered the harbor at Recife amid the shrill cries of the gulls, while a fleet of boats laden with tropical fruits clustered round the hull'?

(TT, p. 7)

This section becomes the text's auto-deconstruction. Lévi-Strauss's helplessness in the face of the wave of ennui which attends his very journey is startling. It is not only an articulation of an existential despair, but also a plea for purpose, a direction, a filtering set – most predominantly, but not unselfconsciously, and hence not unproblematically, that of the West as

Master-civilization, possessor of a Master-text and Master-gaze – through which to sieve the trivial. However, and this is also part of Lévi-Strauss's problem, one has to know what to *look* for; one needs a method for assigning value (a term which litters the above extract, either in itself , or through its many counterparts – 'validity', 'worth', 'use[lessness]'). One needs to have a set of perceptual tropes[5] in mind to separate 'truths' (how judged?) from the 'dross', rather like, to invoke the old saw, being in a position to be able to tell the wood from the trees. This problematic, then, can be seen to be played out in the very structuring title of his book: as Lévi-Strauss enters the South American Tropics, saddened by the moral and epistemological uncertainty of the foundational tropics of his own discourse.

Yet Lévi-Strauss's pessimism about the form of his project and his criticisms of travelogues besotted with minutiae – a 'kind of narrative', which he says, 'enjoys a vogue which I, for my part find incomprehensible' (TT, p. 17) – do not prevent him from launching into the most procrastinatory of tales regarding the quotidian facts of preparing for a journey: the delays, the confusions, the waiting around, the missed chance of a sexual opportunity. Lévi-Strauss's oft-repeated complaints can be struck through with a deconstructive oblique sign – both refuted and yet maintaining a protestatory, if contradictory, presence. It is not until a quarter of the way into the text that Lévi-Strauss begins his anthropological account of the four tribes he has set out to study. Despite claiming to know better, an anthropological study has become a travel book. Regardless of the attested awareness of the need to sift, to order, to construct tropes, the floodgates are opened to digression, the juxtaposition of memory, and personal reflections on the state of French intellectual life. Lévi-Strauss's text ends up as perversely self-denying – denying its premises of stark analytical description and ceding to the plenitude of all experience.

Travel in Lévi-Strauss's text becomes a metaphor for existence. Again and again a structuring trope of the text seems to be a defensive assertion of what makes the anthropologist different from the traveller. What legitimates anthropology as a search for knowledge? How does it differ from travels which furnish evidence of the following kind?

> [T]ravelogues, accounts of expeditions and collections of photographs, in all of which the desire to impress is so dominant as to make it impossible for the reader to assess the *value* of the evidence put before him. . . . Nowadays, being an explorer is a trade, which consists not, as one might think, in discovering hitherto unknown facts after years of study, but in covering a great many miles and assembling lantern-slides or motion pictures, preferably in colour, so as to fill a hall with an audience for several days in succession. For this audience, *platitudes and common-places seem to have been miraculously transmuted into*

revelations by the sole fact that their author, instead of doing his plagiar-
izing at home, has supposedly sanctified it by covering some twenty
thousand miles.

(TT, p. 18, emphases added)

Against a potential colonial self, Lévi-Strauss here takes the critical
position of the Other, like the baffled African king who interrogates the
very foundations of eighteenth-century explorer Mungo Park's presence in
that country:

> When he [the African king] was told that I had come from a great
> distance, and through many dangers to behold the Joliba River, [he]
> naturally inquired if there were no rivers in my own country and
> whether one river was not like another. . . . The notion of travelling for
> curiosity was new to him. . . . He thought it impossible, he said, that
> any man in his senses would undertake so dangerous a journey merely to
> look at the country and its inhabitants.[6]

As Mary Louise Pratt comments, 'these puzzled African interlocutors
open to question the very structuring principle of the anti-conquest: the
claim to the innocent pursuit of knowledge' (IE, p. 84). Reciprocal
exchange, where the traveller decrees the worthiness of his objects of
desire, extracting them from the landscape, has as its linchpin a notion of
value, a concept which is brought into its very being – and also brought into
question – in an area of contact, be it diffuse or, as Pratt describes in an
unduly fixed form, zoned. Her use of the term 'contact zone' is paradoxical
in its suggestion of structural circumscription, for in her textual practice
Pratt is at pains to show intercultural contact as the two-way *transcultura-*
tive flow that it is, so that to fix the emanations for this cultural exchange
within even as (ultimately) limited a ring as a set zone goes against a
(deconstructively informed?) understanding that '[a]rguments about
origins are notoriously pointless' (IE, p. 138).

Further, the reciprocity implicit in her use of the signifier 'contact' is in
fact questionable. Here Pratt overlooks any rigorous theoretical discussion
of the idea of 'contact', a geometric term metaphorically applied to articu-
late a relation to the geographical contours of colonialism. There is no
necessary reason to extrapolate from the term 'contact' a notion of reci-
procity; this is to elide diachrony, to overlook where such zones of contact
come from, to see the common tangential plane of interrelation as
mutually desired. To this extent the usefulness of contact in Pratt's schema
is debatable: the question of the link between 'contact' and *causality* is not
even considered. Put simply, 'contact' might imply a *coming together* of
two distinct bodies of their own volition, on to an area unmarked and
separate from – and discursively demarcatable as separate from – the
originary points of either body (this area might then, strictly and properly,

be termed 'neutral'). Or conversely, 'contact' might imply a mechanical-causal impingement by one body on to another, stationary body. Here the motive force is unidirectional and strikes with considerable impact, although this force will rebound back from the object of the strike on to the motivatory object.[7]

We would argue that Pratt's neglect of any rigorous definition of the contact zone is based on a pragmatic textual need to have this arena available as a backdrop for all the diverse historical agents which she brings into play. It forms the all too instantaneous, yet (for her) textually necessary contextual marketplace for a simplistically 'economic' model of reciprocity, and – its material analogue – exchange. Some of the implications of this can be illustrated by reference to Pratt's discussion of a passage from Mungo Park's 'Travels in the Interior of Africa', a scene where Park is met by dancing natives and, swept along by the multitude, finds himself obliged to accommodate their ritual agenda. Pratt describes this as a 'mutual appropriation', where Park

> appropriates and is simultaneously appropriated by the ritual, required to play a role to satisfy people's curiosity, in exchange for satisfying his own. His role is a passive one, however, *in which his own agency and desire play little part.*
>
> (IE, p. 80, emphases added)

Pratt, it seems, is working with an oversimplistic notion of value and exchange. The denial of desire and agency to Park is to treat both the colonial trajectory as well as the terms themselves in too delimited a fashion. Desire is equated simplistically with agency; this leads to a failure to recognize that one very real desire is being fulfilled in this passage: *Park's desire to be there*. This desire, which underwrites the whole colonial mission, is a stage in the narrative of travel that Pratt completely elides: the process of arrival is not articulated. A crucial aspect of the formative experience of the traveller is missed out, giving him or her a unified confident appearance of self, with no formative psychological splitting *en route*.

This problem can be seen to derive from too delimited a reading of the concept of exchange itself. How else can one explain the following statement (with particular regard to the emphasized sections in both extracts), which seems to fly in the face of Pratt's above reading of Park's text:

> Reciprocity, I propose to argue, is the dynamic that above all organises Park's human-centred, interactive narrative. It is present sometimes as a reality achieved, *but always as a goal of desire*, a value. In the human encounters whose sequence makes up Park's narrative, what sets up

drama and tension is almost invariably the desire to achieve reciprocity, to establish equilibrium through exchange.

(IE, p. 80, emphases added)

The incident where Park is met by dancing natives is framed by Pratt as coming under the category of arrival scenes. Yet Park does not really in any sense *recount* (to use Pratt's significant narrativizing concept) his arrival – he simply states it; it is the natives' arrival that is emphasized rather than his own. The travellers' arrival is not articulated. Without exception, this is true of all the travel books that Pratt quotes, and this is allowed to pass without any comment. We are thrown straight into the midst of the contact zone, and the travellers have always already arrived. Again, this may be a case of an author editing a range of sources in a way that constructs consistency with the book's argument, as well as a sense of engagement for for her readers – an 'interesting' read. Yet what one can only see as a concern for the sensibilities of readers susceptible to boredom leads her to limit the textual economy of her own text, and overlook the importance of that psychological state of tedium. This form of 'writing about writing-about-travel' emphasizes travel as a form of geographically marked 'Being', at the expense of considerations of 'Becoming'.

By contrast, we would suggest that in *Tristes Tropiques*, because of its very despising of the idea of travel and its simultaneous self-acceptance that it is *itself* of that maligned genre, Lévi-Strauss's text ends up theorizing whether it is not the case that the whole narrative of movement in travel needs always to be outlined, accepting and embracing the aesthetic – and culturally specifically defined – risks of ennui. Such a move might be a way into an interrogation of what it *means* to travel, by deconstructing the process to a point of (undermined) origin; an origin which, in the case of travel, paradoxically always already constructs itself as a point of destination. Can all movement be designated as 'travel'? Where does travel begin? The journey on the plane itself? Or at the point of disembarkation? When, within the mystical economic value-system of Western capitalism, does one *know* that one has arrived? The whole question of 'arrival' can be seen to be problematized, through the text's stops and starts, its delays on board ship after ship, with fellow-passenger after fellow-traveller, its constant deferral of its 'official' purposes of anthropological investigation, Lévi-Strauss's repeated and cynical apologies for preceding chapters of 'lengthy and superfluous cogitations' (TT, p. 61) being undone by more of the same, leading one to question why they should have been included in the first place, if such is Lévi-Strauss's conclusion.

In these lengthy digressions, these painfully detailed sections of reportage – diffusing the lines between narration and description – Lévi-Strauss can be seen to be articulating a sense of the journey to another land as a constant sense of in-betweenness: what one might term an *inter-zone* – a

necessary and important counterpart to more simplistic conceptualizations of a contact zone as a narrow radius. By trivializing the *process* of travel – the journey or the voyage – through his scrupulous narrative, Lévi-Strauss ends up questioning the very notion of an opposite to trivia: the profound. Where is it to be found? What legitimates anthropology as a search for knowledge? What separates it from the (afore-quoted, but worth the risk of repetition) work of the traveller for whose unsophisticated audience 'platitudes and common-places seem to have been miraculously transmuted into revelations by the sole fact that their author, instead of doing his plagiarizing at home, has supposedly sanctified it by covering some twenty thousand miles'? (TT, p. 18) So why travel? Why do anthropology? Why do anything at all?[8]

Against this fear of the reiterative, of the 'plagiarized', is posited a desire for an absolute Other (worthy of a Lacanian initial capitalization), an ineffable noumenal uniqueness:

> If I could find a language in which to perpetuate those appearances, at once so unstable and so resistant to description, if it were granted to me to be able to communicate to others the phases and sequences of a unique event which would never recur in the same terms, then – so it seemed to me – I should in one go have discovered the deepest secrets of my profession: however strange and peculiar the experiences to which anthropological research might expose me, there would be none whose meaning and importance I could not eventually make clear to everybody.
>
> (TT, p. 62)

Is this desiring problematic one of epistemology or of 'travel' (a transported Being in an Other context)? For this passage embodies a foundational dilemma – to seek the unique, and yet to convey it by a language of correspondence, which if unattainable, if as culturally constructed and derivative as Lévi-Strauss's desired Object is unique, *undermines* the very uniqueness (in time, in space, in class (TT, p. 85)) of that Object. Is it any wonder that the book should end with the promotion of silence as an ideal state: shifting from the din of anthropological fact-mongering stock-jobbing exchange economy, to the alternative response of the aesthetic (as contrasted with, what Lévi-Strauss sees as, a consumerist) gaze as a mute feline furtive exchange?

Although *Tristes Tropiques* is not explicitly 'structural' in its methodologies, there is, perhaps, another point to be made in connection with this extract. What is being problematized here, as at so many other points in the book, is the ideal Saussurean abstraction of *langue* as structure. This structure is undermined at the very point of the *dialogic*, and the implications of this mean that at the end Lévi-Strauss's text comes to equate the very nature of a communicationally founded Being as inherently

destructive of the Other. However, lapsing into a conclusive humanistic final point of hope (that of the aesthetic), this judgement is not at all rigorously theorized in Lévi-Strauss's text, and needs to be extracted from the text's gaps and inconsistencies. In a section on the Nambikwara tribe called 'A Writing Lesson', Lévi-Strauss's own idealism motivates him to differentiate writing from speech as the Ur-criteria for 'civilization', as a foundational trope:

> Writing is a strange invention. One might suppose that its emergence could not fail to bring about profound changes in the conditions of human existence, and that these transformations must of necessity be of an intellectual nature. The possession of writing vastly increases man's ability to preserve knowledge. It can be thought of as an artificial memory, the development of which ought to lead to a clearer awareness of the past, and hence to a greater ability to organize both the present and the future. After eliminating all other criteria which have been put forward to distinguish between barbarism and civilization, it is tempting to retain this one at least: there are people with, or without, writing; the former are able to store up their past achievements and to move with ever-increasing rapidity towards the goal they have set themselves, whereas the latter, being incapable of remembering the past beyond the narrow margin of individual memory, seem bound to remain imprisoned in a fluctuating history which will lack both a beginning and any lasting awareness of an aim.

(TT, p. 298)

The importance of this section cannot be stressed enough. Writing not only is a foundational trope for dichotomizing barbarism and civilization; it not only creates value in relations of exchange – it being no accident that in Nambikwaran society 'the same individual is both scribe and money-lender' (TT, p. 298); it is also that which constitutes and validates in consciousness any form of movement – of *travel* – based on a beginning and an end; and if writing *is* the decisive criterion of civilization, then Lévi-Strauss's evaluation of both constructs is ambivalent to say the least. Writing, for Lévi-Strauss, is also a corruption of an idealized state of nature, a form of diacriticality that introduces the malignity of an *externally imposed* difference and social structuring into a previously 'uncorrupt' world. Constantly, Lévi-Strauss writes of himself as an infective agent; he is, by his very presence as an outsider, as a European, a destructive disease that has penetrated into the body politic of the aboriginal societies he examines, and for him the introduction of writing into a community is the cause of a loss of 'innocence'; in its deferral of meaning, its undoing of the Rousseauist ideal of the community of individuals self-present to each other, it is also the loss of the reciprocal *gaze* as a form of 'authentic' communicative exchange.

If it is at all worth locating Lévi-Strauss's text in the intellectual history that sees structuralism superseded by post-structuralism, then we should note that this ideal of a past as attributed by Lévi-Strauss to the Nambikwara is rejected by Derrida; in a crucial section in *Of Grammatology*, he says of Lévi-Strauss's idealization:

> This story is very beautiful. It is in fact tempting to read it as a parable in which each element, each semanteme, refers to a recognized function of writing: hierarchization, the economic function of mediation and of capitalization, participation in a quasi-religious secret; all this, verified in any phenomenon of writing, is here assembled, concentrated, organized in the structure of an exemplary event . . .[9]

The text's search for origins is constructed as an anthropological project in Lévi-Strauss's stated desire 'to reach the extreme limits of the savage' (TT, p. 332). By the end of the book, he thinks he may have succeeded, in his contact with a tribe of Indians called the 'Tupi-Kawahib', but since he cannot speak the language he is forced into a state of malcontentment as his gnawing dilemma over language – referentially destructive or productive? – reaches a climax. There is the side of him that sees an imputed difference as foolhardy: 'Was it not my mistake, and the mistake of my profession, to believe that men are not always men?' (TT, p. 333). On the other hand, there is that imperial urge that feels the foreboding of an a priori barrier of difference between Self and Other; a sense that while the barrier requires demolition, this risks the fate of the threatening return of the Other as the Same. How does one describe strangeness without drawing it into a system of sameness?

> I had only to succeed in guessing what they [the Tupi-Kawahib] were like for them to be deprived of their strangeness: in which case, I might just have stayed in my village. Or if, as was the case here, they retained their strangeness, I could make no use of it, since I was incapable of even grasping what it consisted of. Between these two extremes, what ambiguous instances provide us with the excuses by which we live?
>
> (TT, p. 333)

It would not be too melodramatic to say that the text's ever-more 'profound' concerns have shifted from questioning the existential legitimacy of anthropology and travel, to a questioning of existence itself: *Why live?* Further, these concerns with 'profundity' are reached only through an examination of the quotidian. The very nature of human existence, for the text, becomes one of destruction; a pure unspoiled state cannot be grasped in anthropological discovery because of the burden of language, so Lévi-Strauss seeks the virginal in nature ('But if the inhabitants were mute, perhaps the earth itself would speak to me' (TT, p. 333)) – a state of fulfilment which is never realized:

Where exactly does that virginity lie . . . ? I can pick out certain scenes
and separate them from the rest; is it this tree, this flower? They might
well be elsewhere. Is it also a delusion that the whole should fill me with
rapture, while each part of it, taken separately, escapes me? If I have to
accept it as being real, I want at least to grasp it in its entirety, down to
its last constituent element. I reject the vast landscape, I circumscribe it
and reduce it to this clayey beach and this blade of grass . . .

(TT, p. 333)

From this point of tropological differentiation, in a search that verges on an
obsessively, penetratively, exhaustive, atomistic minimalism, it is perhaps
inevitable that the next chapter should throw the anthropologist 'In[to] the
Forest' (TT, p. 338).

If the text is swamped with a profusion of detail, ceding, as we have put
it, to the plenitude of all experience, then that plenitude is present as an
unmanageable excess of human presence in the form of the *crowd*. It is
crucial that we return here to Pratt's text and note that her concerns with
'travel' mean that, two astonishingly brief and superficial mentions aside
(IE, pp. 221, 222), the discourse of that more modern construct 'tourism' is
hardly given any attention. What are the implications of this gap in Pratt's
text? We would argue that in both Lévi-Strauss's *Tristes Tropiques* and
Pratt's account of travel-writing, tourism becomes a limit-text that neither
book can confront. This failing is the more acute in Pratt's text since,
unlike Lévi-Strauss's ostensible work of anthropology, it claims to be a
critical study of travel in its context of colonial and postcolonial exchange
or 'trans[-]culturation'.

'Transculturation' is clearly central to Pratt's discussions. She borrows
the term from ethnographers who 'have used this term to describe how
subordinated or marginal groups select and invent from materials trans-
mitted to them by a dominant or metropolitan culture' (IE, p. 6). This axis
of selection links her text with Lévi-Strauss's tropological concerns; in
analysing Victorian 'discovery rhetoric', she tells us, she has 'found it
useful to identify three conventional means which create qualitative and
quantitative value for the explorer's achievement' (IE, p. 204). These axes
are: *aestheticization* of the landscape; the presentation of the landscape as
rich in detail, having a *density of meaning*; and finally, 'the relation of
mastery predicated between the seer and seen' (IE, p. 204). These aspects
of perception are, as she herself recognizes, a condensation of themes
which have run throughout her book. Moreover, these axes are not the
exclusive perceptive preserve of the colonizer – in the transculturative
moment they are seen to be re-appropriated, hybridized, and turned-back
by the colonized.

One transculturative moment from her text will serve to underline how
the limitations of her conceptualization feed into the lack of consideration

that is given to tourism: her discussions, in the second half of the book, of how post-independence Creoles 'reinvented' both their approach to their indigenous America and to Europe. In this respect, the writing of Domingo Faustino Sarmiento is seen as historically 'inevitable . . . a creole travel book about Europe' (IE, p. 189). As postcolonial Creole subject, Sarmiento,

> like all subjects, was constituted relationally, with respect (among other things) to Spaniards, to Northern Europeans, and to non-white Americans. Within American society, that subject imagined itself into being in part through the image of the *indigenous horde* constructed as barbarous other.
>
> (IE, p. 189 , emphases added)

Sarmiento's text begins with a prefatory fear of the monotonous, with a motivation to construct an 'interesting' narrative. This is not easy (as Pratt herself comments) because: 'civilized life everywhere reproduces the same characteristics . . . [T]he inability to observe, the lack of intellectual preparation leaves the eye clouded and myopic because of the breadth of the views and the multiplicity of objects they include.'[10] How disabling is this awareness of the monoculturalist tendencies, clearly redolent of Lévi-Strauss, of 'civilization'? As is the case with Lévi-Strauss, '[d]espite this deferential gesture, Sarmiento goes on to write his account with no evidence of the crippling of spirit he ascribes to himself in this preface' (IE, p. 190). In this account, visiting Paris, Sarmiento constructs himself as a *flâneur*: 'He does not take up the position of the seeing-man looking out panoramically over a Paris that is radically different from himself' (IE, p. 192), but rather manoeuvres through the city with ease, stopping, here and there, to *look*, noting that, 'If you stop in front of a crack in the wall and look at it attentively, some enthusiast will come along and stop to see what you are looking at; a third joins you, and if eight gather, then everyone who passes stops, the street is blocked, *a crowd forms*.'[11] Pratt's commentary on this is instructive; she says, 'Though Sarmiento does not draw the analogy, the *flâneur* is in many ways an urban analogue of the interior explorer' (IE, p. 192). This is significant because – although she fails to draw this out – it is this subaltern-inspired moment of transculturative inflection that takes travel into the realm of tourism. By the late twentieth century, transculturative flow would be heightened to such an extent that the flâneurism of tourism would intensify Sarmiento's crowds gathering to peer through the cracks in high-culture's wall. But it is problematic automatically to assign a benign passivity to this *flâneur*:

> In a parodic, transculturating gesture, Sarmiento refocuses the discourse of accumulation back on its own context of origin, the capitalist metropolis. It is the metropolitan paradigm minus one dimension,

however, that of acquisition. An alienated figure, the *flâneur* has no capital and accumulates nothing. He does not buy, collect samples, classify, or fancy transforming what he sees.

(IE, p. 192)

This is far too easy. Is transformation reciprocal? Can it occur only within a scopic arena ('what he sees')? Does it depend on the validating gaze of an Other? To all of which we should ask: why? There is something extremely worrying about this considerate liberal denial of agency to the Creole traveller.

For does not Sarmiento 'transform' the place that he visits by his very presence there? What exactly are the politics of 'transformation', and how many Sarmientos would have to descend on the streets of Paris to effect what might be seen to count as a difference? We might contrast the apparent lack of a position here with Lévi-Strauss's insistence that all activity is infective; could Lévi-Strauss fail to see Sarmiento as just as much a virus in the metropolis as the colonizers of pre-independence? If travel writing as anti-conquest ideology played a crucial role in the colonial construction and administration of non-European lands, then what of its bastard child, tourism? The failure of this type of commentary on travel writing (as exemplified here by *Imperial Eyes*) to engage with tourism as a necessary extension of its investigations means again that the ethics and theories behind travel are not dealt with. How are we to read the following rare passing reference: 'In certain white writers of the 1970's the bitter nostalgia for lost idioms of discovery and domination is a response to that challenge, as well as to the depravity of "development" and the tasteless-ness of tourism' (IE, p. 224). What is Pratt's own position with regard to this? Is tourism any more 'tasteless' than travel, and indeed what is the distinction between the two forms of movement? We get no answers, since the reference is at the very end of the penultimate section of *Imperial Eyes*. Yet one might well argue that this scant regard for tourism (particularly in its crucial and telling prefixing as *mass*-tourism), and a concentra-tion instead on the literary accounts of colonialism's agents, aligns such critiques of travel writing to just those colonial individuals' fears of the mass – from Esteban Echeverria's 'wild hordes represented . . . as chaos . . . disturb[ing] the silent solitudes of God' (IE, p. 183), and Sarmiento's savages who 'lie in ambush . . . like a swarm of hyaenas' (IE, p. 187). It is mass-tourism which shows up most explicitly the cultural and class elitism behind this fear of the crowd. Amongst the examples of travel writing which Pratt catalogues, part of the intellectual baggage that is used to reinforce the anti-conquest within those discourses is the idea of travel as *purposive* – scientific or exploratory. (Pleasure, as the purpose of travel in the examples of the female travellers that Pratt discusses, is also seen as part of an anti-conquest ideology.) Mass-tourism undermines both these

structuring tropes of 'travel' as a privileged form of movement, by *making explicit* the consumption (economic, scopic and textual) which all forms of travel are founded upon. In other words, following a Baudrillardian line of thinking, we might say that 'tourism' challenges the purported *use value* of 'travel' and shows that its 'value' mechanisms are not intrinsically meaningful, or even meaning-giving, but that it functions as *signification*, and certainly not as exchange. Exchange, we would argue, implies a two-way process based on a mutual recognition.[12] This stress on travel as a transculturative exchange (which we have identified and discussed in relation to *Imperial Eyes*) overlooks a significant element: presence as signification, as Being. This is the case with both Mungo Park as well as Sarmiento. What becomes obvious is the inability of such texts to deal with these incidents, because it is precisely at these moments that the individual is thrown into the confusion of the mass. The crowd is travel's limit-text; it undermines its foundational individualism, decentring it, whilst forcing it to face the foreboding *visibility* of power. Let us not forget that this fear of the crowd returns to haunt Sarmiento's text with regard to the 'indigenous horde', when '[l]ater as President of Argentina (1868–73), Sarmiento presided over a series of genocidal campaigns against the Pampas Indians' (IE, p. 193).

This same fear of the crowd haunts Lévi-Strauss's text throughout its pages. In the section 'In the Forest', Lévi-Strauss seems to anticipate the era of mass-tourism, as the sublime Object of desire is rewritten as nothing less than the desire for a space 'off the beaten track':

> I hated those who shared my preference, since they threatened the solitude by which I set such store; and I was contemptuous of the others for whom mountains were largely synonymous with excessive fatigue and a closed horizon, and who were therefore incapable of experiencing the emotions that mountains aroused in me. I would only have been content if the whole of society had admitted the superiority of mountains while granting me exclusive possession of them.
>
> (TT, p. 339)

Since this dilemma – a mirroring of Lévi-Strauss's linguistic problematic discussed above – is insurmountable, there is nothing for it but to fall, in preference to the once-favourite promontory view of the mountain, into an eulogizing embrace of the forest and the confusion of its decentring thicketry. But for a text that has up to now seen as its purpose the uncovering of deep structures which will reveal the essence of humanity to itself, for a text that has sought out tropes, the forest is really only a despairing solution. What might it mean to ask 'what is the point of it all?', if not the literalization of a desire for the capture of a fixed atomistic meaning/structure/trope as a means to validate experience? Lévi-Strauss's text seems, implicitly, to ask this idiomatic question.

Travel is boring and repetitive to the point of frustration, so the anthropologist 'rereads his old notes, copies them out and tries to interpret them; alternatively he may set himself some finicky and pointless task' (TT, p. 376). All of life is reiterative and the 'discovery' of obscure tribes offers no salvation; there is no Edenic state to which we can return. Thus Diderot's 'abridged' reduction of humanity's history – ' "There existed a natural man; an artificial man was introduced into this natural man, and inside the cave there arose continuous warfare which lasts throughout life" ' (TT, p. 390) – is dismissed by the structuralist as absurd because it dichotomizes and idealizes the natural against the social; wrongly, in Lévi-Strauss's view, since 'Man is inseparable from language and language implies a society' (TT, p. 390). It is questionable whether the latter condition, although a theoretical counter to Diderot's idealism, is not seen as more a curse than a reason to validate 'civilization', since language embodies reiteration:

> Since we know that for thousands of years man has succeeded only in repeating himself, we will attain to that nobility of thought which consists in going back beyond all the repetitions and taking as the starting point of our reflections the indefinable grandeur of man's beginnings. Being human signifies, for each of us, belonging to a class, a society, a country, a continent and a civilization; and for us European earth-dwellers, the adventure played out in the heart of the New World signifies in the first place that it was not our world and that we bear responsibility for the crime of its destruction . . .
>
> (TT, p. 393)

It could be said that the text collapses under the weight of this responsibility from this point onwards. Tellingly, the succeeding chapter jumps temporally to Lévi-Strauss's memories of India, *as if there were nothing else to do but to become a tourist* (TT, p. 397). A perceived responsibility for the destruction of the world is articulated, once again via an encounter with the crowd. Here, as at earlier points in the text, during Lévi-Strauss's wandering reminiscences and digressions that remove the text far from its South American concerns, it is India that becomes the tropical opposite to the underpopulated South American desert. India, a country inexorably 'advanced' down the path of population growth to the point of the maddening crowd, offers a contrasting excess of human presence where life becomes expendable by its seemingly massified and anonymous interchangeability. One beggar with outstretched hand seeking one's pitied charity is like another, so how does one decide to whom to offer aid in a symbolically futile attempt at alleviating misery and poverty? How *does* one decide? One does not. One turns instead to a time more Edenic, a time where an ideally equilibriated population ratio means that choices are far simpler or do not have to be made; to those cultures where there is space

for pure and unadulterated Being – heroic in its self-affirming 'savagery'; to those anthropological societies where one can gaze without the imposition of a tugging leprous hand demanding a payment for life. That choice, however, has already been seen by Lévi-Strauss to be an unattainable ideal, and India – as we have seen – is no answer after all.

So where does one go? Lévi-Strauss's text can only end with the most despairing pessimism. To be is to destroy:

> Every effort to understand destroys the object studied in favour of another object of a different nature; the second object requires from us a new effort which destroys it in favour of a third, and so on and so forth until we reach the one lasting presence, the point at which the distinction between meaning and the absence of meaning disappears: the same point from which we began. It is 2,500 years since men first discovered and formulated these truths. In the interval we have discovered nothing new . . .
>
> (TT, p. 411)

In the end, then, an anti-foundationalism must masquerade as a foundation, something that Lévi-Strauss himself seems to recognize in his statement that 'fluid forms are replaced by structures and creation by nothingness' (TT, p. 412). So, 'what is the use of action, if the thought guiding it leads to the discovery of the absence of meaning?' Don't think. Don't move. Don't travel. Don't analyse. Lévi-Strauss's text, in its implications, seems at times to be prescribing these negative and by conventional accounts 'pessimistic' formulas. There are clearly two choices for Lévi-Strauss: to cling to a humanism that would avoid the option of suicide, or to advocate this stagnation of inactivity.

Let us suggest that the second option is far better theorized. All activity is seen as inherently destructive, in the sense that it counters the *productive*. The consequence of seeking tropics becomes *entropy*:

> Thus it is that civilization, taken as a whole, can be described as an extraordinarily complex mechanism, which we might be tempted to see as offering an opportunity of survival for the human world, if its function were not to produce what physicists call entropy, that is inertia. Every verbal exchange, every line printed, establishes communication between people, thus creating an evenness of level, where before there was an information gap and consequently a greater degree of organization. Anthropology could with advantage be changed into 'entropology' as the name of the discipline concerned with the study of the highest manifestations of this process of disintegration.
>
> (TT, p. 414)

It needs to be stressed here that Lévi-Strauss is not seeing communication (logocentric or textual) as positive, rather the existence of writing and

communication is disruptive of total organization. Equality ('an evenness of level') is rejected in favour of an intact difference that can only be preserved on the condition of stagnation. Yet, is this too self-destructive? In the end the text opts for the less rigorous, less interesting, less theorized option of life, the author announcing deadpan: 'Yet I exist' (TT, p. 414) as a structural effect of society, rejecting the option of 'destroy[ing] myself' (ibid.). Yet this anthropologist, this Being-as-structural-effect, realizes that if travel and anthropology symbolize in concentration the futility of all activity, then no other disciplines,

> Neither psychology nor metaphysics nor art can provide me with a refuge. They are myths, now open to internal investigation by a new kind of sociology which will emerge one day and will deal no more gently with them than traditional sociology does.

> (ibid.)

In this statement he actually heralds the way for theories of post-structuralism and deconstruction, theories that capitalized on and retheorized the pessimism of Lévi-Strauss's rejected option of destruction, a nihilistic wager which his text cannot take up. If Lévi-Strauss replaces tropics with entropics, then later Derrida will suggest the apotropaic, never-quite-grasped, of *différance*:

> The paradoxical logic of the apotropaic: to castrate oneself *already*, always already, in order to be able to castrate and repress the menace of castration, *to renounce life and mastery in order to assure oneself of them*; to put into play, by ruse, simulacrum, and violence, the very thing that one wishes to conserve; to lose in advance that which one wishes to erect; to suspend that which one raises: *aufheben*.[13]

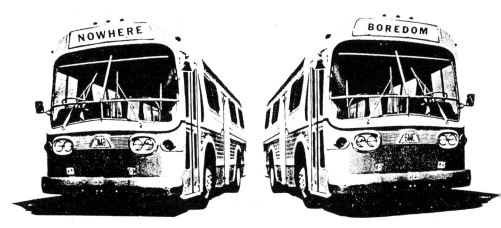

Figure 15.1 Desirable destinations (All a-bored!)

NOTES

1 Claude Lévi-Strauss, *Tristes Tropiques*, Harmondsworth, Penguin, 1992, p. 390. All further references to this text will be made within the body of this chapter and abbreviated as TT.
2 Edward Said, 'Travelling theory', Chapter 10 in *The World, the Text, and the Critic*, London, Faber & Faber, 1984.
3 This was the case for example, at both the *BLOCK* conference on 'Travellers Tales' (20–21 November 1992) and at a recent colloquium at the University of Southampton ('Travelogues: Journeys Between Cultures', 17 April 1993), at which an earlier and shortened version of this paper was delivered.
4 At a very crude empirical level there are some startling omissions. A study which attempts to demonstrate, in essence, that the genre of travel writing constructs the colonial subject as Other, makes no mention of Edward Said, never mind travelling to the remoter theoretical shores of Lévi-Strauss or Derrida.
5 This aspect of our discussion is informed by Hayden White's concept of tropes in his books *Tropics of Discourse* and *Metahistory*, Baltimore, Johns Hopkins University Press, 1990.
6 Mary Louise Pratt, *Imperial Eyes*, London, Routledge, 1992, p. 83; henceforth referred to as IE in the main body of this text.
7 These considerations on the implications of causality for the notion of 'contact' have been informed by a rereading of Fredric Jameson's *The Political Unconscious*, London, Methuen, 1986, Chapter 1. Mechanical-causality might be compared to a 'billiard-ball' effect.
8 The other side of this 'apathetic' rhetoric – 'why *not*?' – will be developed by some members of this collective in future work on nihilism.
9 Jacques Derrida, *Of Grammatology*, Baltimore, Johns Hopkins University Press, 1976, p. 126. In this now well-known section Derrida argues that Lévi-Strauss is utilizing far too narrow a definition of 'writing' and, further, that it is Eurocentrically presumptuous to deny – indeed, as Derrida argues, to *overlook* – the pre-existence of forms of writing among the Nambikwara.
10 Domingo Faustino Sarmiento, *Viajes*, Prólogo de Roy Bartholomew, Collección Clásicos Argentinos, Buenos Aires, Editorial de Belgrano, 1981, p. xiv. Quoted in M.L. Pratt, *Imperial Eyes*, op. cit., p. 190. Pratt comments: 'As an example, Sarmiento cites his own inability to see factories (a highly charged example at this point) as anything but inexplicable piles of machinery.'
11 Sarmiento, *Viajes*, p. 112, cited in IE, p. 192. Emphases added.
12 Although he does not explicitly go on to theorize tourism in this form, our economically derived formulations are inspired by the references to Jean Baudrillard, in Jonathan Culler's 'The semiotics of tourism' in *Framing the Sign*, Oxford, Basil Blackwell, 1988, p. 156.
13 Jacques Derrida, *Glas*, Paris, Galilée, 1974, p. 56. Cited in Gayatri Chakravorty Spivak, 'Speculations on reading Marx: after reading Derrida', in D. Attridge *et al.* (eds) *Post-structuralism and the Question of History*, Cambridge, Cambridge University Press, 1987, p. 30. Emphases added.

ACKNOWLEDGEMENTS

We would like to thank Judith Hargreaves, Melinda Mash and George Robertson for their valuable comments at various stages in the production of this chapter.

Backwords

Leaky habitats and broken grammar

Iain Chambers

In an age in which anthropology increasingly turns into autobiography, the observer, seeking to capture, to enframe, an elsewhere is now caught in the net of critical observation. The I/eye joins the exile of language. For the journey outwards towards other worlds today also reveals an uncertain journey inwards; an expedition that exposes tears in the maps and a stammer in the languages that we in the West have been accustomed to employ.

Whatever critical lexicon I draw upon in nominating the present (and the orbits around the various posts – postmodernity, postcolonialism, postmetaphysical thought – provide perhaps the most prominent constellation) I think that many of us, with our different histories, languages and cultural trajectories, are having to face a widening interrogation. It is as though I have fallen into a fold in time, stumbled across a sharp punctuation in the narrative, as my presence, which once apparently flowed effortlessly across the map, is brought up short, diverted, disrupted, dispersed.

Critical journeys in such a landscape can no longer be assumed to have a common destination. The utopic dream of eventual arrival (and the consolation of an intellectual, political and historical completion) now reveals a gap in which some of us begin to lose ourselves.[1] Heterogeneous and hybrid elements have disturbed the passage; languages and syntax are undermined and are no longer able to contain sense and hold things together. The locus shifts from the utopic to the heterotopic. For while utopias 'run with the very grain of language . . . heterotopias . . . dessicate speech, stop words in their tracks, contest the very possibility of grammar at its source; they dissolve our myths and sterilize the lyricism of our sentences'.[2]

Travel, in both its metaphorical and physical reaches, can no longer be considered as something that confirms the premises of our initial departure, and thus concludes in a confirmation, a domestication of the difference and the detour, a homecoming. It is caught up in a wider itinerary which poses the perspective of an interminable movement, and with it

questions connected to a lack of being placed, to the proposal of perpetual displacement.

To think, to write, to be, is no longer for some of us simply to follow in the tracks of those who initially expanded and explained *our* world as they established the frontiers of Europe, of Empire, and of manhood, where the knots of gendered, sexual and ethnic identity were sometimes loosened, but more usually tightened. Nor is it surely to echo the mimicries of ethnic absolutisms secured in the rigid nexus of tradition and community, whether in nominating our own or others' identities. It is rather to abandon such places, such centres, for the migrant's tale, the nomad's story. It is to abandon the fixed geometry of sites and roots for the unstable calculations of transit. It is to embark on the winding and interminable path of heteronomy. This means to recognize in the homesickness of much contemporary critical thought not so much the melancholy conclusion of a thwarted rationalism but an opening towards a new horizon of questions. For it is to contemplate crossing over to the 'other' side of the authorized tale, that other side of modernity, of the West, of History, and from there to consider that breach in contemporary culture which reveals an increasing number of people who are making a home in homelessness, there dwelling in diasporic identities and heterogeneous histories. Bearing witness to '. . . the pressure of dumbness, the accumulation of unrecorded life', I am pulled towards an insistent supplement whose silence cannot be filled with a ready meaning.[3]

The intellectual props of this scene – the familiar mantra of Nietzsche, Freud, Heidegger, Lacan, Foucault, Derrida – are clearly drawn from the intellectual archaeology of late European modernism, but they also mingle with voices that echo in this landscape, sharing its time, but that are clearly coming from elsewhere. These are voices, histories, languages, experiences that are simultaneously part of modernity, the metropolis, the West, and yet which continue to speak, dream, sing and imagine elsewhere: a simultaneous presence/absence that reveals a gap, an opening, an enlargement. Here I am referring in particular to the interrogation and suspension of the Eurocentric trajectory by postcolonial criticism and contemporary feminist theory; work that has opened up these authors/authorities, and myself, to further metamorphoses.[4] This complex and shifting intellectual geography provides us with a preliminary guide with which to set out along the paths of rethinking the critical tropes of travel and globalization. I will not pretend to exhaust the perspectives that all this opens up, merely to nominate rapidly, as though in a series of telegrams and postcards, some of the interrogations and possibilities that travel in these regions proposes.

The baggage we depart with already suggests that we cannot rely on the rigid poles of centre and periphery as our only compass. For amongst our belongings we have acquired more ductile understandings, associated with

asymmetrical powers and differing senses of place, in which culture is considered as a flexible and fluid site of transformation and translation rather than as the ontological stronghold of separate traditions, autonomous histories, self-contained cultures and fixed identities. This encourages me to contemplate a more open-ended sense of dwelling in culture that looks to the perspective of leaky habitats.[5]

Here I am caught in the web of living on the inside of languages, the languages of music, history, culture, identity. However unevenly inhabited, these are increasingly constituting a global space. There is here the recognition that there is no 'outside', that we are cast into these languages – that is, both thrown and formed, as Heidegger and Lacan insist – and therefore, as Michel de Certeau puts it, live in a worldly prose that is too vast to be our own. It can be said to represent a space, suitably transformed into a dwelling, that we borrow and inhabit as though nomads.

Such a configuration of critical space is bounded but yet also represents a clearing, an opening, that permits me to reconsider what Heidegger, in conversation with a Japanese interlocutor, once lamented as 'the complete Europeanization of the earth and man'.[6] For encounters in this clearing, in this instance of potential dialogue, are, of course, also encounters with, and between, different powers. Some voices speak louder and carry further than others in the contemporary economies of cultural and historical speech. However, my language is brought up short as I begin to recognize the silence of historical violence in the periphery that previously established me in the relative calm of the centre. So, the inhabiting of this opening by different voices also involves for some of us a return to the ear and a politics of listening. To borrow a concept from the American poet Susan Howe, this might be to introduce the idea of the 'stutter' into critical speech, at least into mine, as other voices, histories and bodies constantly interrupt and fracture the assumed continuum of a presumed rationality and my earlier sense of 'reality'.

While we may all now find ourselves involved in such languages, we are not reducible to them. Here we meet all the power of ambiguity: the simultaneous presence of danger and saving power in the contemporary realization of technology, of language, of identity. Here revealed in the movement from the West to the rest, and its subsequent transformation and 'betrayal' of its 'origins', lie the 'other' spaces that emerge inside the formations, institutions and relations of cultural power and global capital. For what is *also* revealed is the cultural speech, the historical performance, the processes of cultural becoming, that simultaneously disarticulates and rearticulates, that is both a translation and a travesty of any 'original' statement.

I thus find myself carried beyond the question of merely recognizing the disturbing presence of other worlds within my own. For in the concomitant

and coeval opening up of my own world and sense of belonging and being at home I am forced to reconsider the very languages I employ in nominating and securing *my* identity. This is to add to Peter Wollen's important observations on the creolization and dialects of an emerging global syntax the further displacement that the metaphor and reality of language introduce.[7] For the challenge to the West is also the challenge to the subject of the Western episteme, to the idea of a full, complete, transparent Cartesian *cogito* able to appropriate and explain the world and provide history with the *telos* of 'progress', the universality and fixity of meaning, and a subsequent grammar of agency. I am now called upon to respond to this decentring of knowledge, language and identity and its compendium of truth. It means to question the existing languages of identity and agency that presently enframe the discussion of globalization.

This is to experience 'exposure to the risk of the metaphor' (Jacques Derrida), where language turns against the claims of property secured in an ethnic source, in the techniques and technologies of ownership and control, all energetically seeking to guarantee claims to rational transparency, causal agency, historical direction and finality. It is to confuse the obvious with the opaque, and present such syntax with the differential contract of language that leads to bifurcation, inversions and the event of language simply travelling elsewhere. Here in the violent transitivity of language, that erupts most starkly across the hyphen of hybridity, space is transformed into the contingencies of historical and cultural places.

At this point, apparently on the threshold of departure from earlier European confidences, I register the loss, and laying to rest, of a body of thought. But this instance of elegy might better be considered as a return to the vulnerability of my history (Gayatri Spivak). For in these funeral rites what is celebrated is not merely the scattering of the ashes of certain critical traditions to 'the wind from outside' (Georges Bataille), but also a clearing away that creates a clearing, an opening. It is a laying to rest that simultaneously disseminates the past and clears a space in language for the living (Michel de Certeau). This is to inscribe a curb, a sense of mortality, into discourses and reasons that have historically been reluctant to register boundaries, contingencies and limits. So, the aura of loss is augmented and interrogated by a critical mourning: for we can neither return to that earlier form of life nor simply deny it. We cannot go home again but neither can we simply cancel that past, or eradicate the desire for the myth of homecoming, from our sense of being and becoming. But in the throw of the dice it is to choose to cast that heritage into the game and to oppose the close teleology of identity and authenticity with the interrogations that emerge from the radical historicity of language and existence, with that excess of transitivity in which we encounter not only the grammar of being but the fact that it speaks in many accents. In these encounters,

in the transit and travel of languages, what we refer to as our cultural, historical and individual identity is continually constituted and performed.

This encourages me to contemplate living with the responsibility for the always provisional nature of fabricated habitats that are never realized but are always in the process of becoming. In this I begin to learn the art of losing myself (as opposed to merely getting lost) and thereby gain the opportunity of falling through the gap in my consciousness, rationalism and inherited verdicts, to begin learning the languages of silence and a capacity for listening. In the interruption I am introduced to the moment of silence and the shadow of the other that disrupt the closed logic of subject and predicate, in which the not–I is not necessarily a threat, waiting to be subjected to my words and world, but is rather the opening that carries me through the rift in language into the exile of speech in which I travel towards a rendezvous structured by a relationship to the other in which I am destined never to get to the point, a final destination or ultimate conclusion.

NOTES

1 Jacques Lacan, 'The Freudian unconscious and ours', in Jacques Lacan, *The Four Fundamental Concepts of Psycho-Analysis*, Harmondsworth, Penguin Books, 1991.
2 Michel Foucault, *The Order of Things*, London and New York, Routledge, 1991, p. xviii.
3 Virginia Woolf, *A Room of One's Own*, Harmondsworth, Penguin Books, p. 89.
4 There is the work on black Atlanticism by Paul Gilroy, on hybridity and the doubling of modernity by Homi Bhabha, on the temporal realizations of ethnicities and identities by Kobena Mercer and Stuart Hall. And beyond such maps, I want to acknowledge the critical interruption of contemporary feminist theory. I am thinking here in particular of the work of Gayatri Spivak, Rosi Bradoitti, Alice Jardine and Trinh Minh–ha.
5 I have examined this question at some length in *Modernity, Culture, Identity*, London, Routledge, 1994.
6 Martin Heidegger, 'A Dialogue on Language', in Martin Heidegger, *On The Way To Language*, New York, Harper & Row, 1971, p. 15.
7 Peter Wollen, 'Tourism, language and art', *New Formations* 12, Winter 1990.

Index